THE STORY OF ART

Sr. Thereson Hurong Thi Pham

Holy Apostles College and Seminy

THE STORY OF ART E.H.Gombrich

Victoria Public Library 302 N. Main Victoria, Tx. 77901

Contents

	PREFACE 7
	INTRODUCTION On art and artists 15
I	STRANGE BEGINNINGS Prehistoric and primitive peoples; Ancient America 39
2	ART FOR ETERNITY Egypt, Mesopotamia, Crete 55
3	THE GREAT AWAKENING Greece, seventh to fifth century BC 75
4	THE REALM OF BEAUTY Greece and the Greek world, fourth century BC to first century AD 99
5	WORLD CONQUERORS Romans, Buddhists, Jews and Christians, first to fourth century AD 117
6	A PARTING OF WAYS Rome and Byzantium, fifth to thirteenth century 133
7	LOOKING EASTWARDS Islam, China, second to thirteenth century 143
8	WESTERN ART IN THE MELTING POT Europe, sixth to eleventh century 157
9	THE CHURCH MILITANT The twelfth century 171
10	THE CHURCH TRIUMPHANT The thirteenth century 185
ΙΙ	COURTIERS AND BURGHERS The fourteenth century 207
12	THE CONQUEST OF REALITY The early fifteenth century 223
13	TRADITION AND INNOVATION I The later fifteenth century in Italy 247
14	TRADITION AND INNOVATION II The fifteenth century in the North 269
15	HARMONY ATTAINED Tuscany and Rome, early sixteenth century 287

LIGHT AND COLOUR

Venice and northern Italy, early sixteenth century 325

16

	Germany and the Netherlands, early sixteenth century 341
18	A CRISIS OF ART Europe, later sixteenth century 361
19	VISION AND VISIONS Catholic Europe, first half of the seventeenth century 387
20	THE MIRROR OF NATURE Holland, seventeenth century 413
21	POWER AND GLORY I Italy, later seventeenth and eighteenth centuries 435
22	POWER AND GLORY II France, Germany and Austria, late seventeenth and early eighteenth centuries 447
23	THE AGE OF REASON England and France, eighteenth century 457
24	THE BREAK IN TRADITION England, America and France, late eighteenth and early nineteenth centuries 475
25	PERMANENT REVOLUTION The nineteenth century 499
26	IN SEARCH OF NEW STANDARDS The late nineteenth century 535
27	EXPERIMENTAL ART The first half of the twentieth century 557
28	A STORY WITHOUT END The triumph of Modernism 599 Another turning of the tide 618 The changing past 626
	A note on art books 638
	Chronological charts 655
	Maps 664
	List of illustrations by location 670
	Index and glossary 674
	Acknowledgements 687

17 THE NEW LEARNING SPREADS

Phaidon Press Limited Regent's Wharf All Saints Street London NI 9PA

Sixteenth edition (revised expanded and redesigned) 1995

First published 1950 Second edition 1950 Third edition 1951 Fourth edition 1952 Fifth edition 1953 Sixth edition 1954 Seventh edition 1955 Eighth edition 1956 Ninth edition 1958 Tenth edition 1960 Reprinted 1961, 1962, 1963, 1964 Eleventh edition (revised and expanded) 1966 Reprinted 1966, 1967 (three times), 1968 Twelfth edition (expanded and redesigned) 1972 Reprinted 1972, 1973, 1974, 1975, 1976 Thirteenth edition (revised and expanded) 1978 Reprinted 1979, 1981, 1982, 1983 Fourteenth edition (expanded and reset) 1984 Reprinted 1985, 1986, 1987, 1988 Fifteenth edition (revised and expanded) 1989 Reprinted 1990, 1991, 1992, 1993, 1994, 1995

© 1995 Phaidon Press Limited Text © 1995 E.H. Gombrich

A CIP catalogue record for this book is available from the British Library

Library of Congress Cataloging in Publication Data available

ISBN 07148 3355 x (hardback) ISBN 07148 3247 2 (paperback)

All rights reserved. No part of this publication may be reproduced, stored in a retrieval system or transmitted, in any form or by any means, electronic, mechanical, photocopying, recording or otherwise, without the prior permission of Phaidon Press Limited.

Printed in Hong Kong

PREFACE

This book is intended for all who feel in need of some first orientation in a strange and fascinating field. It may serve to show newcomers the lie of the land without confusing them with details; to enable them to bring some intelligible order into the wealth of names, periods and styles which crowd the pages of more ambitious works, and so to equip them for consulting more specialized books. In writing it I thought first and foremost of readers in their teens who had just discovered the world of art for themselves. But I never believed that books for young people should differ from books for adults except for the fact that they must reckon with the most exacting class of critics, critics who are quick to detect and resent any trace of pretentious jargon or bogus sentiment. I know from experience that these are the vices which may render people suspicious of all writing on art for the rest of their lives. I have striven sincerely to avoid these pitfalls and to use plain language even at the risk of sounding casual or unprofessional. Difficulties of thought, on the other hand, I have not avoided, and so I hope that no readers will attribute my decision to get along with a minimum of art historian's conventional terms to any desire on my part to 'talk down' to them. For is it not rather those who misuse 'scientific' language, not to enlighten but to impress the reader, who are 'talking down' to us - from the clouds?

Apart from this decision to restrict the number of technical terms, I have tried, in writing this book, to follow a number of more specific self-imposed rules, all of which have made my own life as its author more difficult, but may make that of the reader a little easier. The first of these rules was that I would not write about works I could not show in the illustrations; I did not want the text to degenerate into lists of names which could mean little or nothing to those who do not know the works in question, and would be superfluous for those who do. This rule at once limited the choice of artists and works I could discuss to the number of illustrations the book would hold. It forced me to be doubly rigorous in my selection of what to mention and what to exclude. This led to my second rule, which was to limit myself to real works of art, and cut out anything which might merely be interesting as a specimen of taste or fashion. This decision entailed a considerable sacrifice of literary effects. Praise is so much

duller than criticism, and the inclusion of some amusing monstrosities might have offered some light relief. But the reader would have been justified in asking why something I found objectionable should find a place in a book devoted to art and not to non-art, particularly if this meant leaving out a true masterpiece. Thus, while I do not claim that all the works illustrated represent the highest standard of perfection, I did make an effort not to include anything which I considered to be without a peculiar merit of its own.

The third rule also demanded a little self-denial. I vowed that I would resist any temptation to be original in my selection, lest the well-known masterpieces be crowded out by my own personal favourites. This book, after all, is not intended merely as an anthology of beautiful things; it is meant for those who look for bearings in a new field, and for them the familiar appearance of apparently 'hackneyed' examples may serve as welcome landmarks. Moreover, the most famous works are really often the greatest by many standards, and if this book can help readers to look at them with fresh eyes it may prove more useful than if I had neglected them for the sake of less well-known masterpieces.

Even so, the number of famous works and masters I had to exclude is formidable enough. I may as well confess that I have found no room for Hindu or Etruscan art, or for masters of the rank of Quercia, Signorelli or Carpaccio, of Peter Vischer, Brouwer, Terborch, Canaletto, Corot, and scores of others who happen to interest me deeply. To include them would have doubled or trebled the length of the book and would, I believe, have reduced its value as a first guide to art. One more rule I have followed in this heart-breaking task of elimination. When in doubt I have always preferred to discuss a work which I had seen in the original rather than one I knew only from photographs. I should have liked to make this an absolute rule, but I did not want the reader to be penalized by the accidents of travel restrictions which sometimes dog the life of the art-lover. Moreover, it was my final rule not to have any absolute rules whatever, but to break my own sometimes, leaving to the reader the fun of finding me out.

These, then, were the negative rules I adopted. My positive aims should be apparent from the book itself. In telling the story of art once more in simple language, it should enable readers to see how it hangs together and help them in their appreciation, not so much by rapturous descriptions, as by providing them with some pointers as to the artists' probable intentions. This method should at least help to clear away the most frequent causes of misunderstanding and to forestall a kind of criticism which misses the point of a work of art altogether. Beyond this the book has a slightly more ambitious goal. It sets out to place the works it discusses in their historical setting and thus to lead towards an understanding of the master's artistic aims. Each generation is at some point in revolt against the standards of its fathers;

each work of art derives its appeal to contemporaries not only from what it does but also from what it leaves undone. When young Mozart arrived in Paris he noticed – as he wrote to his father – that all the fashionable symphonies there ended with a quick finale; so he decided to startle his audience with a slow introduction to his last movement. This is a trivial example, but it shows the direction in which a historical appreciation of art must aim. The urge to be different may not be the highest or profoundest element of the artist's equipment, but it is rarely lacking altogether. And the appreciation of this intentional difference often opens up the easiest approach to the art of the past. I have tried to make this constant change of aims the key of my narrative, and to show how each work is related by imitation or contradiction to what has gone before. Even at the risk of being tedious, I have referred back for the purpose of comparison to works that show the distance which artists had placed between themselves and their forerunners. There is one pitfall in this method of presentation which I hope to have avoided but which should not go unmentioned. It is the naïve misinterpretation of the constant change in art as a continuous progress. It is true that every artist feels that he has surpassed the generation before him and that from his point of view he has made progress beyond anything that was known before. We cannot hope to understand a work of art without being able to share this sense of liberation and triumph which the artist felt when he looked at his own achievement. But we must realize that each gain or progress in one direction entails a loss in another, and that this subjective progress, in spite of its importance, does not correspond to an objective increase in artistic value. All this may sound a little puzzling when stated in the abstract. I hope the book will make it clear.

One more word about the space allotted to the various arts in this book. To some it will seem that painting is unduly favoured as compared to sculpture and architecture. One reason for this bias is that less is lost in the illustration of a painting than in that of a round sculpture, let alone a monumental building. I had no intention, moreover, of competing with the many excellent histories of architectural styles which exist. On the other hand, the story of art as here conceived could not be told without reference to the architectural background. While I had to confine myself to discussing the style of only one or two buildings in each period, I tried to restore the balance in favour of architecture by giving these examples pride of place in each chapter. This may help readers to co-ordinate their knowledge of each period and see it as a whole.

As a tailpiece to each chapter I have chosen a characteristic representation of the artist's life and world from the period concerned. These pictures form an independent little series illustrating the changing social position of the artist and his public. Even where their artistic merit is not very high these

pictorial documents may help us to build up, in our minds, a concrete picture of the surroundings in which the art of the past sprang to life.

This book would never have been written without the warm-hearted encouragement it received from Elizabeth Senior, whose untimely death in an air raid on London was such a loss to all who knew her. I am also indebted to Dr Leopold Ettlinger, Dr Edith Hoffmann, Dr Otto Kurz, Mrs Olive Renier, Mrs Edna Sweetmann, to my wife and my son Richard for much valuable advice and assistance, and to Phaidon Press for their share in shaping this book.

Preface to the twelfth edition

This book was planned from the outset to tell the story of art in both words and pictures by enabling readers as far as possible to have the illustration discussed in the text in front of them, without having to turn the page. I still treasure the memory of the unconventional and resourceful way in which Dr Bela Horovitz and Mr Ludwig Goldscheider, the founders of Phaidon Press, achieved this aim in 1949 by making me write another paragraph here or suggesting an extra illustration there. The result of these weeks of intense collaboration certainly justified the procedure, but the balance arrived at was so delicate that no major alterations could be contemplated while the original layout was retained. Only the last few chapters were slightly modified for the eleventh edition (1966) when a Postscript was added, but the main body of the book was left as it was. The decision of the publishers to present the book in a new form more in keeping with modern production methods thus offered fresh opportunities but also posed new problems. The pages of The Story of Art, in its long career, have become familiar to a far greater number of people than I had ever thought possible. Even the majority of the twelve editions in other languages have been modelled on the original layout. It seemed to me wrong in the circumstances to omit passages and pictures which readers might want to look for. Nothing is more irritating than to discover that something one expects to find in a book has been left out of the edition one takes from the shelf. Thus, while I welcomed the chance of showing in larger illustrations some of the works discussed and of adding some colour plates, I have eliminated nothing and only exchanged a very few examples for technical or other compelling reasons. The possibility, on the other hand, of adding to the number of works to be discussed and illustrated presented both an opportunity to be seized and a temptation to be resisted. Clearly to turn this volume into a heavy tome would have destroyed its character and defeated its purpose. In the end I decided to add fourteen examples which seemed

to me not only interesting in themselves – which work of art is not? – but to make a number of fresh points that enrich the texture of the argument. It is the argument, after all, that makes this book a story rather than an anthology. If it can again be read, and, I hope, enjoyed, without a distracting hunt for the pictures that go with the text, this is due to the help given in various ways by Mr Elwyn Blacker, Dr I. Grafe and Mr Keith Roberts.

E.H.G. November 1971

Preface to the thirteenth edition

There are many more illustrations in colour in this than in the twelfth edition, but the text (except for the bibliography) remains unchanged. The other new feature is the chronological charts on pages 655–63. Seeing the positions of a few landmarks in the vast panorama of history should help the reader to counteract the perspective illusion which gives such prominence to recent developments at the expense of the more distant past. In thus stimulating reflections on the time scales of the story of art, the charts should serve the same purpose for which I wrote this book some thirty years ago. Here I can still refer the reader to the opening words of the original Preface on page 6.

E.H.G. July 1977

Preface to the fourteenth edition

'Books have a life of their own.' The Roman poet who made this remark could not have imagined that his lines would be copied out by hand for many centuries and would be available on the shelves of our libraries some two thousand years later. By these standards this book is a youngster. Even so, in writing it, I could not have dreamt of its future life, which, as far as the English language editions are concerned, is now chronicled on the imprint page. Some of the changes the book has undergone are mentioned in the Prefaces to the twelfth and thirteenth editions.

These changes have been retained, but the section on art books has again been brought up to date. To keep in step with technical developments and the altered expectations of the public many of the illustrations previously printed in black and white now appear in colour. In addition I have added a Supplement on 'New discoveries', with a brief retrospect on archaeological finds to remind the reader of the extent to which the story of the past has always been subject to revision and unexpected enrichment.

E.H.G. March 1984

Preface to the fifteenth edition

Pessimists sometimes tell us that in this age of television and videos people have lost the habit of reading and that students, in particular, tend to lack the patience to derive pleasure from reading any book from cover to cover. Like all authors I can only hope that the pessimists are wrong. Happy as I am to see this fifteenth edition enriched by new illustrations in colour, a revised and reorganized bibliography and index, improved chronological charts and even two geographical maps, I feel the need to emphasize once more that this book is intended to be enjoyed as a story. To be sure, the story now continues beyond the point at which I left it in the first edition, but even these added episodes can only be fully understood in the light of what has gone before. I still hope for readers who would like to be told from the very beginning how it all happened.

E.H.G. March 1989

Preface to the sixteenth edition

As I sit down to add the preface to this latest edition I am filled with amazement and gratitude. Amazement, because I so well remember my very modest expectations when writing this book, and gratitude to generations of readers – dare I say all over the world? – who must have found it so useful as an introduction to our artistic heritage that they have recommended it to others in ever-increasing numbers. Gratitude, of course, also to my publishers who have responded to this demand by keeping step with the passage of time and bestowed much care on every new and revised edition.

This latest transformation is due to the present owner of Phaidon Press, Richard Schlagman, who wished to return to the original principle of keeping the illustrations before the reader's eye while studying the text, to improve the quality and scale of the illustrations, and, if possible, to increase their numbers

There was, of course, a strict limit to the realization of this last-mentioned aim, since this book would defeat its purpose if it became too lengthy to serve as an introduction.

Even so, it is hoped that readers will welcome these additions, most of all the fold-outs, one of which, page 237, figures 155 and 156, enabled me to show and discuss the whole of the Ghent altarpiece. Some other additions will be found to make good omissions in earlier editions, notably some images referred to in the text but not illustrated, such as the rendering of Egyptian divinities as shown in The Book of the Dead, page 65, figure 38, the family portrait of king Akhnaten, page 67, figure 40, the medal showing the original

project for St Peter's in Rome, page 339, figure 186, Correggio's fresco in the dome of Parma Cathedral, page 289, figure 217, and one of the militia portraits of Frans Hals, page 415, figure 269.

A few other illustrations were added to clarify the setting or context of works discussed: the whole figure of the Delphi charioteer, page 88, figure 53, Durham cathedral, page 175, figure 114, the north porch of Chartres Cathedral, figure 190, figure 126, and the south transept of Strasburg Cathedral, page 192, figure 128. I need not here explain the replacement of some illustrations for purely technical reasons, nor the purpose of enlarged details of works, but I must say a word about the eight artists I decided to include despite my determination not to allow their number to get out of control: in the preface to the first edition I had mentioned Corot as one of the painters I much admired but could not accommodate. The omission has haunted me ever since and I have repented at last, hoping that this change of mind has also profited the discussion of certain artistic issues.

Otherwise I have restricted the addition of artists to chapters on the twentieth century, taking over from the German version of this book two masters of German Expressionism, Käthe Kollwitz, who exerted such a great influence on the 'socialist realists' of Eastern Europe, and Emil Nolde for his powerful use of a new graphic idiom, pages 566–7, figures 368–9; Brancusi and Nicholson, pages 581, 583, figures 380, 382, were to strengthen the discussion of abstraction, and de Chirico and Magritte that of Surrealism, pages 590–1, figures 388–9. Morandi, finally, served me as an example of a twentieth-century artist who is all the more lovable for resisting stylistic labels, page 609, figure 399.

I have made these additions in the hope of making the developments seem less abrupt than they may have looked in the earlier editions, and therefore more intelligible. For that, of course, is still the overriding aim of this book. If it has found friends among art-lovers and students, the reason can only be that it has made them see how the story of art hangs together. To memorize a list of names and dates is hard and irksome; remembering a story needs little effort, once we have understood the role the various members of the cast play in it and how the dates point to the passage of time between the generations and the episodes of the narration.

I mention more than once in the body of this book that in art any gain in one respect may also lead to a loss elsewhere. No doubt this also applies to this new edition, but I sincerely hope that the gains far outweigh any loss.

There remains only to thank my eagle-eyed editor Bernard Dod for the devotion with which he watched over the new edition.

E.H.G. December 1994

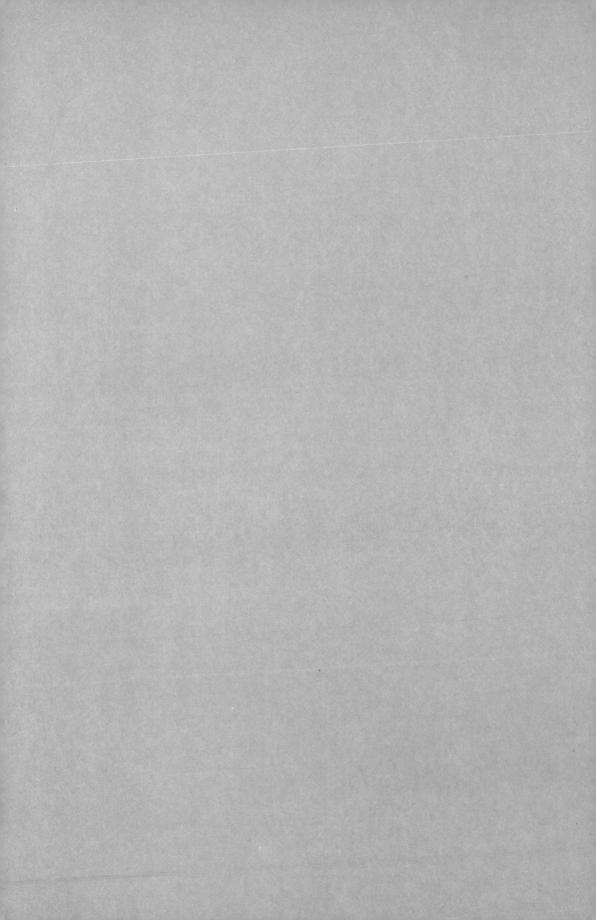

INTRODUCTION

On art and artists

There really is no such thing as Art. There are only artists. Once these were men who took coloured earth and roughed out the forms of a bison on the wall of a cave; today some buy their paints, and design posters for hoardings; they did and do many other things. There is no harm in calling all these activities art as long as we keep in mind that such a word may mean very different things in different times and places, and as long as we realize that Art with a capital A has no existence. For Art with a capital A has come to be something of a bogey and a fetish. You may crush an artist by telling him that what he has just done may be quite good in its own way, only it is not 'Art'. And you may confound anyone enjoying a picture by declaring that what he liked in it was not the Art but something different.

Actually I do not think that there are any wrong reasons for liking a statue or a picture. Someone may like a landscape painting because it reminds him of home, or a portrait because it reminds him of a friend. There is nothing wrong with that. All of us, when we see a painting, are bound to be reminded of a hundred-and-one things which influence our likes and dislikes. As long as these memories help us to enjoy what we see, we need not worry. It is only when some irrelevant memory makes us prejudiced, when we instinctively turn away from a magnificent picture of an alpine scene because we dislike climbing, that we should search our mind for the reason for the aversion which spoils a pleasure we might otherwise have had. There *are* wrong reasons for disliking a work of art.

Most people like to see in pictures what they would also like to see in reality. This is quite a natural preference. We all like beauty in nature, and are grateful to the artists who have preserved it in their works. Nor would these artists themselves have rebuffed us for our taste. When the great Flemish painter Rubens made a drawing of his little boy, *figure 1*, he was surely proud of his good looks. He wanted us, too, to admire the child. But this bias for the pretty and engaging subject is apt to become a stumbling-block if it leads us to reject works which represent a less appealing subject. The great German painter Albrecht Dürer certainly

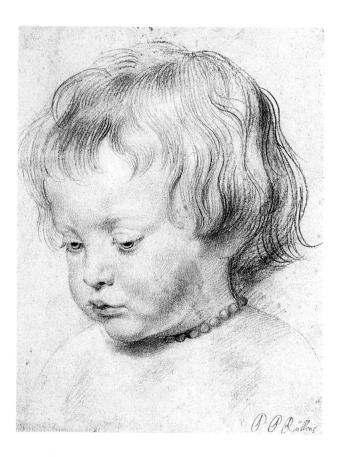

Peter Paul Rubens
Portrait of his son
Nicholas, c. 1620
Black and red chalks on
paper, 25.2 × 20.3 cm,
10 × 8 in; Albertina,
Vienna

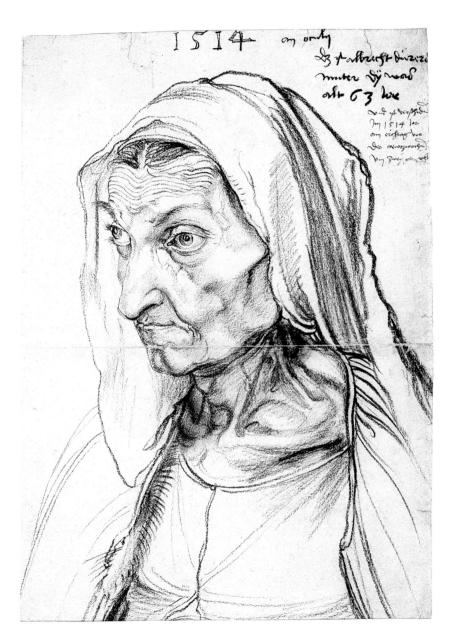

Albrecht Dürer
Portrait of his mother,
1514
Black chalk on paper,
42.1 × 30.3 cm, 16½ ×
12 in; Kupferstichkabinett,
Staatliche Museen, Berlin

drew his mother, figure 2, with as much devotion and love as Rubens felt for his chubby child. His truthful study of careworn old age may give us a shock which makes us turn away from it – and yet, if we fight against our first repugnance we may be richly rewarded, for Dürer's drawing in its tremendous sincerity is a great work. In fact, we shall soon discover that

Bartolomé
Estebán Murillo
Street arabs,
c. 1670−5
Oil on canvas, 146 × 108
cm, 57½ × 42½ in; Alte
Pinakothek, Munich

4
Pieter de Hooch
Interior with a woman
peeling apples, 1663
Oil on canvas, 70.5 × 54.3
cm, 27½ × 21½ in;
Wallace Collection,
London

the beauty of a picture does not really lie in the beauty of its subject-matter. I do not know whether the little ragamuffins whom the Spanish painter Murillo liked to paint, *figure 3*, were strictly beautiful or not, but, as he painted them, they certainly have great charm. On the other hand, most people would call the child in Pieter de Hooch's wonderful Dutch interior, *figure 4*, plain, but it is an attractive picture all the same.

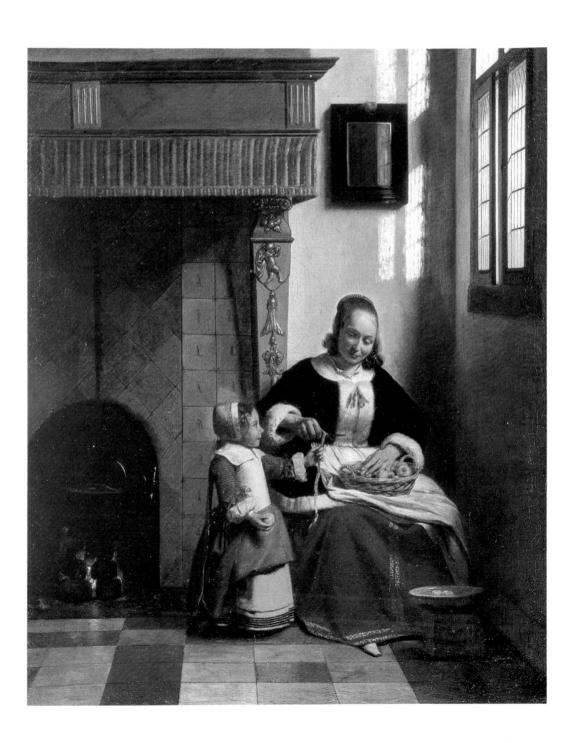

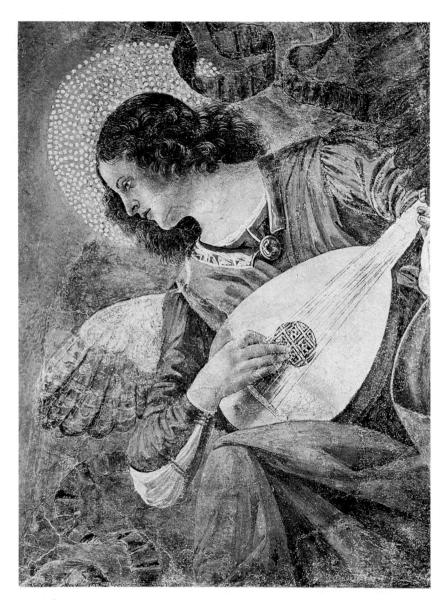

Melozzo da Forli Angel, c. 1480 Detail of a fresco; Pinacoteca, Vatican

The trouble about beauty is that tastes and standards of what is beautiful vary so much. Figures 5 and 6 were both painted in the fifteenth century, and both represent angels playing the lute. Many will prefer the Italian work by Melozzo da Forlì, figure 5, with its appealing grace and charm, to that of his northern contemporary Hans Memling, figure 6. I myself like both. It may take a little longer to discover the intrinsic beauty of Memling's angel, but once we are no longer disturbed by his faint awkwardness we may find him infinitely lovable.

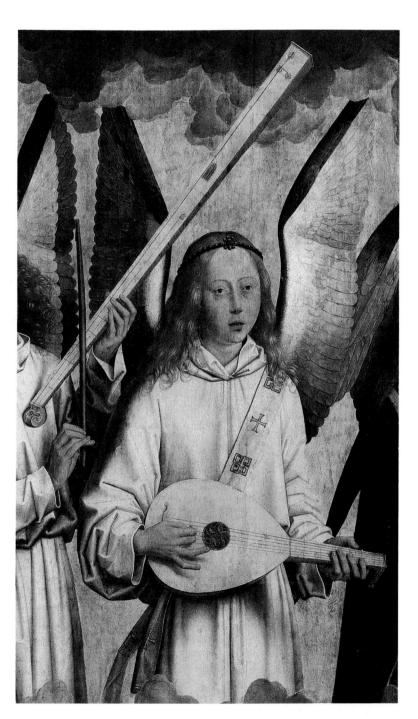

Hans Memling
Angel, c. 1490
Detail of a panel from an altarpiece; oil on wood;
Koninklijk Museum voor
Schone Kunsten, Antwerp

6

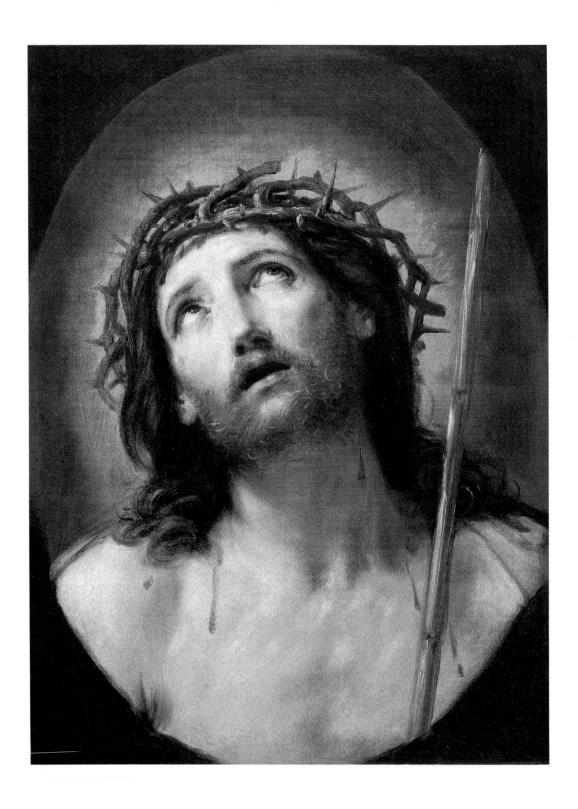

7
Guido Reni
Christ crowned with
thorns, c. 1639–40
Oil on canvas, 62 × 48 cm,
24½ × 19 in; Louvre, Paris

8
Tuscan master,
Head of Christ,
c. 1175–1225
Detail of a crucifix;
tempera on wood; Uffizi,
Florence

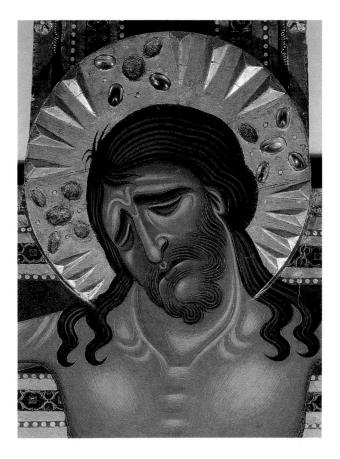

What is true of beauty is also true of expression. In fact, it is often the expression of a figure in the painting which makes us like or loathe the work. Some people like an expression which they can easily understand, and which therefore moves them profoundly. When the seventeenthcentury Italian painter Guido Reni painted the head of Christ on the cross, figure 7, he intended, no doubt, that the beholder should find in this face all the agony and all the glory of the Passion. Many people throughout subsequent centuries have drawn strength and comfort from such a representation of the Saviour. The feeling it expresses is so strong and so clear that copies of this work can be found in simple wayside shrines and remote farmhouses where people know nothing about 'Art'. But even if this intense expression of feeling appeals to us we should not, for that reason, turn away from works whose expression is perhaps less easy to understand. The Italian painter of the Middle Ages who painted the crucifix, figure 8, surely felt as sincerely about the Passion as did Reni, but we must first learn to know his methods of drawing to understand his

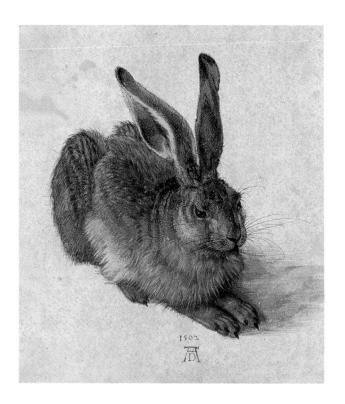

Albrecht Dürer Hare, 1502
Watercolour and gouache on paper, 25 × 22.5 cm, 9% × 8% in; Albertina, Vienna

feelings. When we have come to understand these different languages, we may even prefer works of art whose expression is less obvious than Reni's. Just as some prefer people who use few words and gestures and leave something to be guessed, so some people are fond of paintings or sculptures which leave them something to guess and ponder about. In the more 'primitive' periods, when artists were not as skilled in representing human faces and human gestures as they are now, it is often all the more moving to see how they tried nevertheless to bring out the feeling they wanted to convey.

But here newcomers to art are often brought up against another difficulty. They want to admire the artist's skill in representing the things they see. What they like best are paintings which 'look real'. I do not deny for a moment that this is an important consideration. The patience and skill which go into the faithful rendering of the visible world are indeed to be admired. Great artists of the past have devoted much labour to works in which every tiny detail is carefully recorded. Dürer's watercolour study of a hare, *figure 9*, is one of the most famous examples of this loving patience. But who would say that Rembrandt's drawing of an elephant, *figure 10*, is necessarily less good because it shows fewer details? Indeed Rembrandt was

such a wizard that he gave us the feel of the elephant's wrinkly skin with a few lines of his chalk.

But it is not sketchiness that mainly offends people who like their pictures to look 'real'. They are even more repelled by works which they consider to be incorrectly drawn, particularly when they belong to a more modern period when the artist 'ought to have known better'. As a matter of fact, there is no mystery about these distortions of nature about which we still hear complaints in discussions on modern art. Everyone who has ever seen a Disney film or a comic strip knows all about it. He knows that it is sometimes right to draw things otherwise than they look, to change and distort them in one way or another. Mickey Mouse does not look very much like a real mouse, yet people do not write indignant letters to the papers about the length of his tail. Those who enter Disney's enchanted world are not worried about Art with a capital A. They do not watch his films armed with the same prejudices they like to take with them when going to an exhibition of modern painting. But if a modern artist draws something in his own way, he is apt to be thought a bungler who can do no better. Now, whatever we may think of modern artists, we may safely credit them with enough knowledge to draw 'correctly'. If they do not

Rembrandt van Rijn Elephant, 1637 Black chalk on paper, 23 × 34 cm, 9 × 13 ½ in; Albertina, Vienna

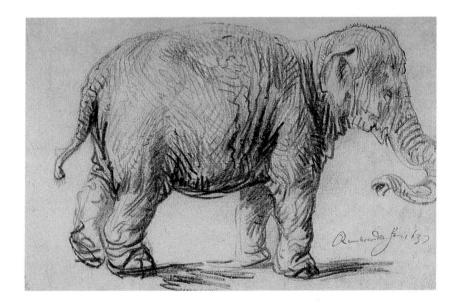

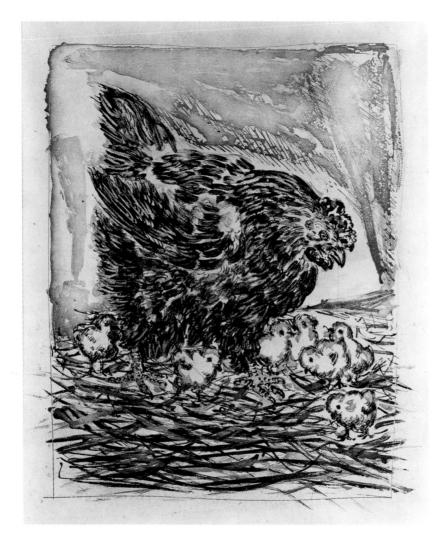

Pablo Picasso
Hen with chicks,
1941–2
Etching, 36 × 28 cm,
14½ × 11 in; illustration to
Buffon's Natural History

do so their reasons may be very similar to those of Walt Disney. Figure 11 shows a plate from an illustrated Natural History by the famous pioneer of the modern movement, Picasso. Surely no one could find fault with his charming representation of a mother hen and her fluffy chicks. But in drawing a cockerel, figure 12, Picasso was not content with giving a mere rendering of the bird's appearance. He wanted to bring out its aggressiveness, its cheek and its stupidity. In other words he resorted to caricature. But what a convincing caricature it is!

There are two things, therefore, which we should always ask ourselves if we find fault with the accuracy of a picture. One is whether the artist

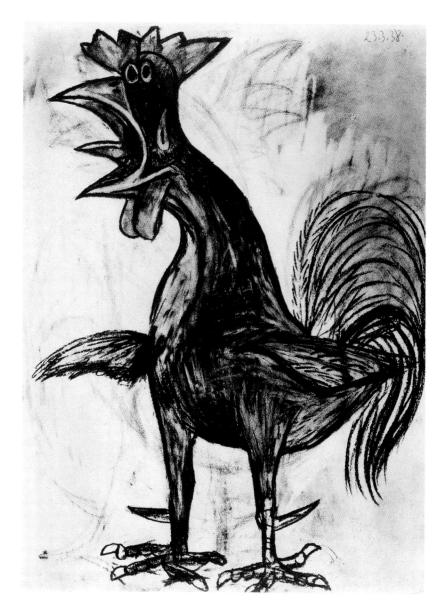

Pablo Picasso

Cockerel, 1938

Charcoal on paper, 76 × 55 cm, 30 × 21½ in;
private collection

may not have had his reasons for changing the appearance of what he saw. We shall hear more about such reasons as the story of art unfolds. The other is that we should never condemn a work for being incorrectly drawn unless we have made quite sure that we are right and the painter is wrong. We are all inclined to be quick with the verdict that 'things do not look like that'. We have a curious habit of thinking that nature must always look like the pictures we are accustomed to. It is easy to illustrate this by an astonishing discovery which was made not very long ago. Generations have watched horses gallop, have attended horse-races and hunts, have enjoyed paintings and sporting prints showing horses charging into battle

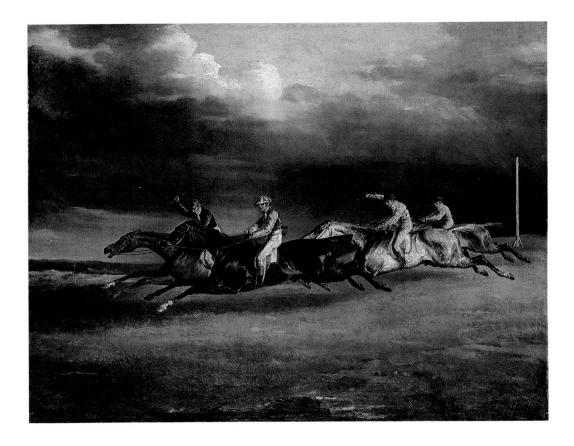

or running after hounds. Not one of these people seems to have noticed what it 'really looks like' when a horse runs. Pictures and sporting prints usually showed them with outstretched legs in full flight through the air — as the great nineteenth-century French painter Théodore Géricault painted them in a famous representation of the races at Epsom, *figure 13*. About fifty years later, when the photographic camera had been sufficiently perfected for snapshots of horses in rapid motion to be taken, these snapshots proved that both the painters and their public had been wrong all the while. No galloping horse ever moved in the way which seems so 'natural' to us. As the legs come off the ground they are moved in turn for the next kick-off, *figure 14*. If we reflect for a moment we shall realize that it could hardly get along otherwise. And yet, when painters began to apply this new discovery, and painted horses moving as they actually do, everyone complained that their pictures looked wrong.

This, no doubt, is an extreme example, but similar errors are by no means as rare as one might think. We are all inclined to accept conventional forms or colours as the only correct ones. Children sometimes think that stars must be star-shaped, though naturally they are not. The people who insist that in a picture the sky must be blue, and the grass green, are not very different from these children. They get indignant if they see other colours in a picture, but if we try to forget all we have

Théodore Géricault Horse-racing at Epsom,

Oil on canvas, 92 × 122.5 cm, 36 ¼ × 48¼ in; Louvre, Paris

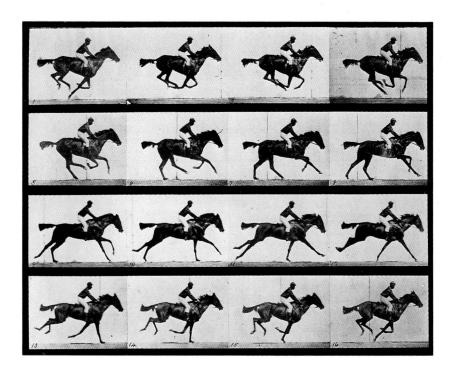

Eadweard Muybridge Galloping horse in motion, 1872

Photograph sequence; Kingston-upon-Thames Museum heard about green grass and blue skies, and look at the world as if we had just arrived from another planet on a voyage of discovery and were seeing it for the first time, we may find that things are apt to have the most surprising colours. Now painters sometimes feel as if they were on such a voyage of discovery. They want to see the world afresh, and to discard all the accepted notions and prejudices about flesh being pink and apples yellow or red. It is not easy to get rid of these preconceived ideas, but the artists who succeed best in doing so often produce the most exciting works. It is they who teach us to see in nature new beauties of whose existence we have never dreamt. If we follow them and learn from them, even a glance out of our own window may become a thrilling adventure.

There is no greater obstacle to the enjoyment of great works of art than our unwillingness to discard habits and prejudices. A painting which represents a familiar subject in an unexpected way is often condemned for no better reason than that it does not seem right. The more often we have seen a story represented in art, the more firmly do we become convinced that it must always be represented on similar lines. About biblical subjects, in particular, feelings are apt to run high. Though we all know that the Scriptures tell us nothing about the appearance of Jesus, and that God Himself cannot be visualized in human form, and though we know that it was the artists of the past who first created the images we have become

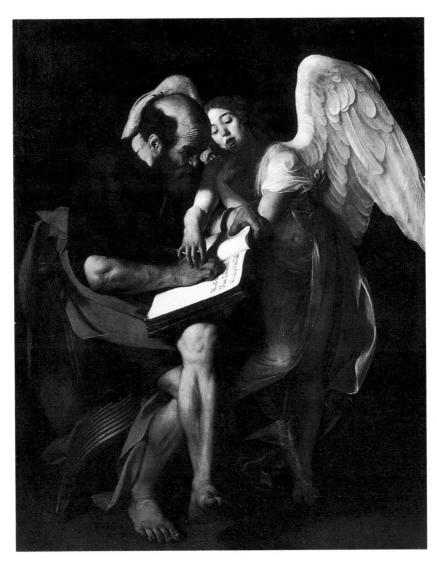

Caravaggio
Saint Matthew, 1602
Altar-painting: oil on canvas, 223 × 183 cm, 87% × 72% in; destroyed; formerly Kaiser-Friedrich Museum, Berlin

Caravaggio
Saint Matthew, 1602
Altar-painting; oil on
canvas, 296.5 × 195 cm,
116% × 76% in; church of
S. Luigi dei Francesi,
Rome

used to, some are still inclined to think that to depart from these traditional forms amounts to blasphemy.

As a matter of fact, it was usually those artists who read the Scriptures with the greatest devotion and attention who tried to build up in their minds an entirely fresh picture of the incidents of the sacred story. They tried to forget all the paintings they had seen, and to imagine what it must have been like when the Christ Child lay in the manger and the shepherds came to adore Him, or when a fisherman began to preach the gospel. It has happened time and again that such efforts of a great artist to read the old text with entirely fresh eyes have shocked and

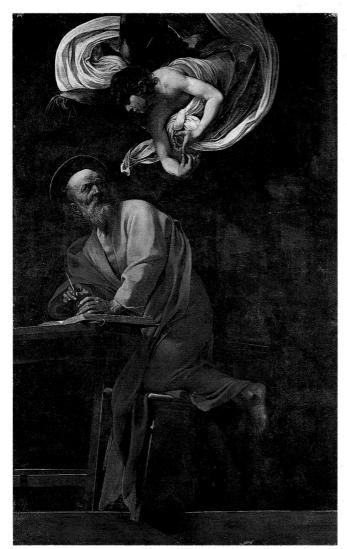

outraged thoughtless people. A typical 'scandal' of this kind flared up round Caravaggio, a very bold and revolutionary Italian painter, who worked round about 1600. He was given the task of painting a picture of St Matthew for the altar of a church in Rome. The saint was to be represented writing the gospel, and, to show that the gospels were the word of God, an angel was to be represented inspiring his writings. Caravaggio, who was a highly imaginative and uncompromising young artist, thought hard about what it must have been like when an elderly, poor, working man, a simple publican, suddenly had to sit down to write a book. And so he painted a picture of St Matthew, figure 15, with a bald head and bare, dusty feet, awkwardly gripping the huge volume, anxiously wrinkling his brow under the unaccustomed strain of writing. By his side he painted a youthful angel, who seems just to have

arrived from on high, and who gently guides the labourer's hand as a teacher may do to a child. When Caravaggio delivered this picture to the church where it was to be placed on the altar, people were scandalized at what they took to be a lack of respect for the saint. The painting was not accepted, and Caravaggio had to try again. This time he took no chances. He kept strictly to the conventional ideas of what an angel and a saint should look like, *figure 16*. The outcome is still quite a good picture, for Caravaggio tried hard to make it look lively and interesting, but we feel that it is less honest and sincere than the first had been.

This story illustrates the harm that may be done by those who dislike and criticize works of art for wrong reasons. What is more important, it brings home to us that what we call 'works of art' are not the results of some mysterious activity, but objects made by human beings for human beings. A picture looks so remote when it hangs glazed and framed on the wall. And in our museums it is very properly – forbidden to touch the objects on view. But originally they were made to be touched and handled, they were bargained about, quarrelled about, worried about. Let us also remember that every one of their features is the result of a decision by the artist: that he may have pondered over them and changed them many times, that he may have wondered whether to leave that tree in the background or to paint it over again, that he may have been pleased by a lucky stroke of his brush which gave a sudden unexpected brilliance to a sunlit cloud, and that he put in these figures reluctantly at the insistence of a buyer. For most of the paintings and statues which are now lined up along the walls of our museums and galleries were not meant to be displayed as Art. They were made for a definite occasion and a definite purpose which were in the artist's mind when he set to work.

Those ideas, on the other hand, that we outsiders usually worry about, ideas about beauty and expression, are rarely mentioned by artists. It was not always like that, but it was so for many centuries in the past, and it is so again now. The reason is partly that artists are often shy people who would think it embarrassing to use big words like 'Beauty'. They would feel rather priggish if they were to speak about 'expressing their emotions' and to use similar catchwords. Such things they take for granted and find it useless to discuss. That is one reason, and, it seems, a good one. But there is another. In the actual everyday worries of the artist these ideas play a much smaller part than outsiders would, I think, suspect. What an artist worries about as he plans his pictures, makes his sketches, or wonders whether he has completed his canvas, is something much more difficult to put into words. Perhaps he would say he worries about whether he has got it 'right'. Now it is only when we understand what he means by that modest little word 'right' that we begin to understand what artists are really after.

I think we can only hope to understand this if we draw on our own experience. Of course we are no artists, we may never have tried to paint a picture and may have no intention of ever doing so. But this need not mean that we are never confronted with problems similar to those which make up the artist's life. In fact, I am anxious to prove that there is hardly any person who has not got at least an inkling of this type of problem, be it in ever so modest a way. Anybody who has ever tried to arrange a bunch of flowers, to shuffle and shift the colours, to add a little here and take away there, has experienced this strange sensation of balancing forms and colours without being able to tell exactly what kind of harmony it is he is trying to achieve. We just feel a patch of red here may make all the difference, or this blue is all right by itself but it does not 'go' with the others, and suddenly a little stem of green leaves may seem to make it come 'right'. 'Don't touch it any more,' we exclaim, 'now it is perfect.' Not everybody, I admit, is quite so careful over the arrangement of flowers, but nearly everybody has something he wants to get 'right'. It may just be a matter of finding the right belt to match a certain dress, or nothing more impressive than the worry over the right proportion of, say, pudding and cream on one's plate. In every such case, however trivial, we may feel that a shade too much or too little upsets the balance and that there is only one relationship which is as it should be.

People who worry like this over flowers, dresses or food, we may call fussy, because we may feel these things do not warrant so much attention. But what may sometimes be a bad habit in daily life and is often, therefore, suppressed or concealed, comes into its own in the realm of art. When it is a matter of matching forms or arranging colours an artist must always be 'fussy' or rather fastidious to the extreme. He may see differences in shades and texture which we should hardly notice. Moreover, his task is infinitely more complex than any of those we may experience in ordinary life. He has not only to balance two or three colours, shapes or tastes, but to juggle with any number. He has, on his canvas, perhaps hundreds of shades and forms which he must balance till they look 'right'. A patch of green may suddenly look too yellow because it was brought into too close proximity with a strong blue - he may feel that all is spoiled, that there is a jarring note in the picture and that he must begin it all over again. He may suffer agonies over this problem. He may ponder about it in sleepless nights; he may stand in front of his picture all day trying to add a touch of colour here or there and rubbing it out again, though you and I might not have noticed the difference either way. But once he has succeeded we all feel that he has achieved something to which nothing could be added. something which is right – an example of perfection in our very imperfect world.

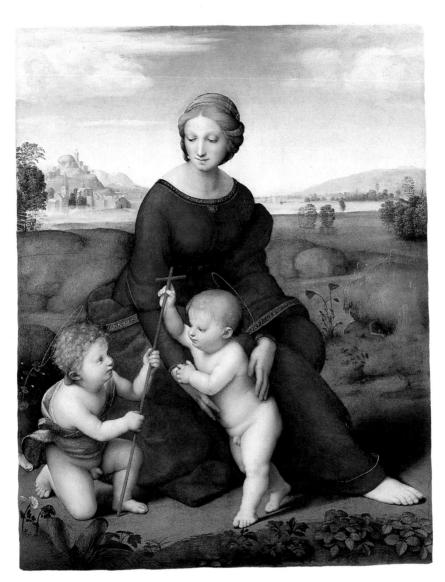

17
Raphael
Virgin in the meadow,
1505–6
Oil on wood, 113 × 88 cm,
44½× 34¾ in;
Kunsthistorisches
Museum, Vienna

Take one of Raphael's famous Madonnas: the 'Virgin in the meadow', for instance, *figure 17*. It is beautiful, no doubt, and engaging; the figures are admirably drawn, and the expression of the Holy Virgin as she looks down on the two children is quite unforgettable. But if we look at Raphael's sketches for the picture, *figure 18*, we begin to realize that these were not the things he took most trouble about. These he took for granted. What he tried again and again to get was the right balance between the figures, the right relationship which would make the most harmonious whole. In the rapid sketch in the left-hand corner, he thought

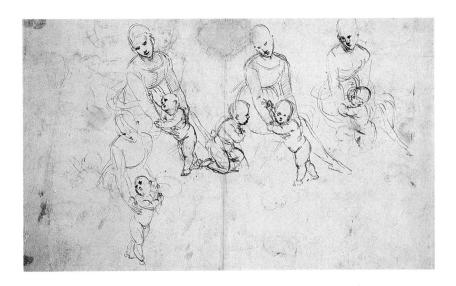

Raphael
Four studies for the
'Virgin in the meadow',
1505-6
Leaf from a sketchbook;

pen and ink on paper, 36.2

× 24.5 cm, 141/4 × 95/8 in;

Albertina, Vienna

of letting the Christ Child walk away looking back and up at His mother. And he tried different positions of the mother's head to answer the movement of the Child. Then he decided to turn the Child round and to let Him look up at her. He tried another way, this time introducing the little St John – but, instead of letting the Christ Child look at him, made him turn out of the picture. Then he made another attempt, and apparently became impatient, trying the head of the Child in many different positions. There were several leaves of this kind in this sketchbook, in which he searched again and again to find how best to balance these three figures. But if we now look back at the final picture we see that he did get it right in the end. Everything in the picture seems in its proper place, and the pose and harmony Raphael has achieved by his hard work seem so natural and effortless that we hardly notice them. Yet it is just this harmony which makes the beauty of the Madonna more beautiful and the sweetness of the children more sweet.

It is fascinating to watch an artist thus striving to achieve the right balance, but if we were to ask him why he did this or changed that, he might not be able to tell us. He does not follow any fixed rules. He just feels his way. It is true that some artists or critics in certain periods have tried to formulate laws of their art; but it always turned out that poor artists did not achieve anything when trying to apply these laws, while great masters could break them and yet achieve a new kind of harmony no one had thought of before. When the great English painter Sir Joshua Reynolds explained to his students in the Royal Academy that blue should not be put into the foreground of paintings but should be reserved for the distant backgrounds, for the fading hills on the horizon, his rival Gainsborough —

so the story goes – wanted to prove that such academic rules are usually nonsense. He painted the famous 'Blue boy', whose blue costume, in the central foreground of the picture, stands out triumphantly against the warm brown of the background.

The truth is that it is impossible to lay down rules of this kind because one can never know in advance what effect the artist may wish to achieve. He may even want a shrill, jarring note if he happens to feel that that would be right. As there are no rules to tell us when a picture or statue is right it is usually impossible to explain in words exactly why we feel that it is a great work of art. But that does not mean that one work is just as good as any other, or that one cannot discuss matters of taste. If they do nothing else, such discussions make us look at pictures, and the more we look at them the more we notice points which have escaped us before. We begin to develop a feeling for the kind of harmony each generation of artists has tried to achieve. The greater our feeling for these harmonies the more we shall enjoy them, and that, after all, is what matters. The old proverb that you cannot argue about matters of taste may well be true, but that should not conceal the fact that taste can be developed. This is again a matter of common experience which everybody can test in a modest field. To people who are not used to drinking tea one blend may taste exactly like another. But if they have the leisure, will and opportunity to search out such refinements as there may be, they may develop into true 'connoisseurs' who can distinguish exactly what type and mixture they prefer, and their greater knowledge is bound to add to their enjoyment of the choicest blends.

Admittedly, taste in art is something infinitely more complex than taste in food and drink. It is not only a matter of discovering various subtle flavours; it is something more serious and more important. After all, the great masters have given their all in these works, they have suffered for them, sweated blood over them, and the least they have a right to ask of us is that we try to understand what they wanted to do.

One never finishes learning about art. There are always new things to discover. Great works of art seem to look different every time one stands before them. They seem to be as inexhaustible and unpredictable as real human beings. It is an exciting world of its own with its own strange laws and its own adventures. Nobody should think he knows all about it, for nobody does. Nothing, perhaps, is more important than just this: that to enjoy these works we must have a fresh mind, one which is ready to catch every hint and to respond to every hidden harmony: a mind, most of all, not cluttered up with long high-sounding words and ready-made phrases. It is infinitely better not to know anything about art than to have the kind of half-knowledge which makes for snobbishness. The danger is

very real. There are people, for instance, who have picked up the simple points I have tried to make in this chapter, and who understand that there are great works of art which have none of the obvious qualities of beauty of expression or correct draughtsmanship, but who become so proud of their knowledge that they pretend to like only those works which are neither beautiful nor correctly drawn. They are always haunted by the fear that they might be considered uneducated if they confessed to liking a work which seems too obviously pleasant or moving. They end by being snobs who lose their true enjoyment of art and who call everything 'very interesting' which they really find somewhat repulsive. I should hate to be responsible for any similar misunderstanding. I would rather not be believed at all than be believed in such an uncritical way.

In the chapters which follow I shall discuss the history of art, that is the history of buildings, of picture-making and of statue-making. I think that knowing something of this history helps us to understand why artists worked in a particular way, or why they aimed at certain effects. Most of all it is a good way of sharpening our eyes for the particular characteristics of works of art, and of thereby increasing our sensitivity to the finer shades of difference. Perhaps it is the only way of learning to enjoy them in their own right. But no way is without its dangers. One sometimes sees people walking through a gallery, catalogue in hand. Every time they stop in front of a picture they eagerly search for its number. We can watch them thumbing through their books, and as soon as they have found the title or the name they walk on. They might just as well have stayed at home, for they have hardly looked at the painting. They have only checked the catalogue. It is a kind of mental short circuit which has nothing to do with enjoying a picture.

People who have acquired some knowledge of art history are sometimes in danger of falling into a similar trap. When they see a work of art they do not stay to look at it, but rather search their memory for the appropriate label. They may have heard that Rembrandt was famous for his *chiaroscuro* – which is the Italian technical term for light and shade – so they nod wisely when they see a Rembrandt, mumble 'wonderful *chiaroscuro*', and wander on to the next picture. I want to be quite frank about this danger of half-knowledge and snobbery, for we are all apt to succumb to such temptations, and a book like this could increase them. I should like to help to open eyes, not to loosen tongues. To talk cleverly about art is not very difficult, because the words critics use have been employed in so many different contexts that they have lost all precision. But to look at a picture with fresh eyes and to venture on a voyage of discovery into it is a far more difficult but also a much more rewarding task. There is no telling what one might bring home from such a journey.

STRANGE BEGINNINGS

Prehistoric and primitive peoples; Ancient America

We do not know how art began any more than we know how language started. If we take art to mean such activities as building temples and houses, making pictures and sculptures, or weaving patterns, there is no people in all the world without art. If, on the other hand, we mean by art some kind of beautiful luxury, something to enjoy in museums and exhibitions or something special to use as a precious decoration in the best parlour, we must realize that this use of the word is a very recent development and that many of the greatest builders, painters or sculptors of the past never dreamed of it. We can best understand this difference if we think of architecture. We all know that there are beautiful buildings and that some of them are true works of art. But there is scarcely any building in the world which was not erected for a particular purpose. Those who use these buildings as places of worship or entertainment, or as dwellings, judge them first and foremost by standards of utility. But apart from this, they may like or dislike the design or the proportions of the structure, and appreciate the efforts of the good architect to make it not only practical but 'right'. In the past the attitude to paintings and statues was often similar. They were not thought of as mere works of art but as objects which had a definite function. He would be a poor judge of houses who did not know the requirements for which they were built. Similarly, we are not likely to understand the art of the past if we are quite ignorant of the aims it had to serve. The further we go back in history, the more definite but also the more strange are the aims which art was supposed to serve. The same applies if we leave towns and cities and go to the peasants or, better still, if we leave our civilized countries and travel to the peoples whose ways of life still resemble the conditions in which our remote ancestors lived. We call these people 'primitive' not because they are simpler than we are - their processes of thought are often more complicated than ours - but because they are closer to the state from which all mankind once emerged. Among these primitives, there is no difference between building and image-making as far as usefulness is concerned. Their huts are there to shelter them from rain, wind and sunshine and the spirits which produce them; images are made to protect

them against other powers which are, to them, as real as the forces of nature. Pictures and statues, in other words, are used to work magic.

We cannot hope to understand these strange beginnings of art unless we try to enter into the mind of the primitive peoples and find out what kind of experience it is which makes them think of pictures, not as something nice to look at, but as something powerful to use. I do not think it is really so difficult to recapture this feeling. All that is needed is the will to be absolutely honest with ourselves and see whether we, too, do not retain something of the 'primitive' in us. Instead of beginning with the Ice Age, let us begin with ourselves. Suppose we take a picture of our favourite champion from today's paper – would we enjoy taking a needle and poking out the eyes? Would we feel as indifferent about it as if we poked a hole anywhere else in the paper? I do not think so. However well I know with my waking thoughts that what I do to his picture makes no difference to my friend or hero. I still feel a vague reluctance to harm it. Somewhere there remains the absurd feeling that what one does to the picture is done to the person it represents. Now, if I am right there, if this queer and unreasonable idea really survives, even among us, into the age of atomic power, it is perhaps less surprising that such ideas existed almost everywhere among the so-called primitive peoples. In all parts of the world medicine men or witches have tried to work magic in some such way - they have made little images of an enemy and have then pierced the heart of the wretched doll, or burnt it, and hoped that their enemy would suffer. Even the guy we burn in Britain on Guy Fawkes Day is a remnant of such a superstition. The primitives are sometimes even more vague about what is real and what is a picture. On one occasion, when a European artist made drawings of cattle in an African village, the inhabitants were distressed: 'If you take them away with you, what are we to live on?'

All these strange ideas are important because they may help us to understand the oldest paintings which have come down to us. These paintings are as old as any trace of human skill. And yet, when they were first discovered on the walls of caves and rocks in Spain, figure 19, and in southern France, figure 20, in the nineteenth century, archaeologists refused at first to believe that such vivid and lifelike representations of animals could have been made by men in the Ice Age. Gradually the rude implements of stone and of bone found in these regions made it increasingly certain that these pictures of bison, mammoth or reindeer were indeed scratched or painted by men who hunted this game and therefore knew it so very well. It is a strange experience to go down into these caves, sometimes through low and narrow corridors, far into the darkness of the mountain and suddenly to see the guide's electric torch

Bison, c.15,000—
10,000 BC
Cave paintings; Altamira,

Horse, c. 15,000–10,000 BC
Cave painting;
Lascaux, France

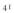

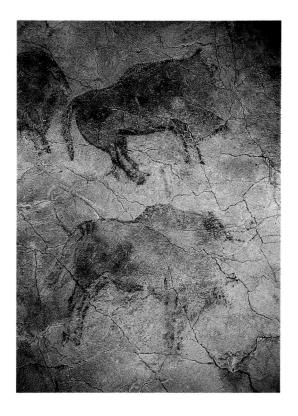

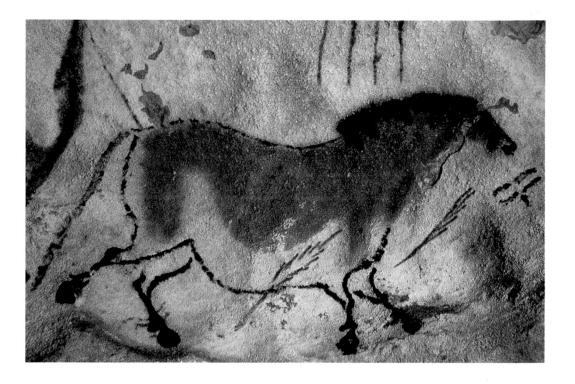

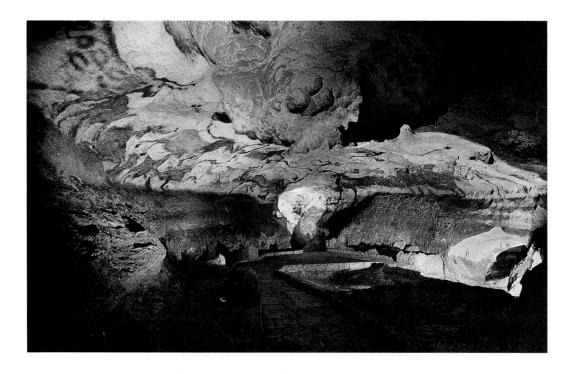

light up the picture of a bull. One thing is clear, no one would have crawled so far into the eerie depth of the earth simply to decorate such an inaccessible place. Moreover, few of these pictures are clearly distributed on the roofs or walls of the cave except some paintings in the cave of Lascaux, *figure 21*. On the contrary, they are sometimes painted or scratched on top of each other without any apparent order. The most likely explanation of these finds is still that they are the oldest relics of that universal belief in the power of picture–making; in other words, that these primitive hunters thought that if they only made a picture of their prey – and perhaps belaboured it with their spears or stone axes – the real animals would also succumb to their power.

Of course, this is guesswork – but guesswork pretty well supported by the use of art among those primitive peoples of our own day who have still preserved their ancient customs. True, we do not find any now, as far as I know, who try to work exactly this kind of magic; but most art for them is also closely bound up with similar ideas about the power of images. There are still primitive peoples who use nothing but stone implements and who scratch pictures of animals on rocks for magic purposes. There are other tribes who have regular festivals when they dress up as animals and move like animals in solemn dances. They, too, believe that somehow this will give them power over their prey. Sometimes they even believe that certain animals are related to them in some fairy-tale manner, and that the whole tribe is a wolf tribe, a raven tribe or a frog tribe. It sounds strange enough, but we must not forget that even these ideas are not as far removed from our own times as one might

Cave at Lascaux, France, c. 15,000–

think. The Romans believed that Romulus and Remus had been suckled by a she-wolf, and they had an image in bronze of the she-wolf on the sacred Capitol in Rome. Until recently they kept a living she-wolf in a cage near the steps to the Capitol. No living lions are kept in Trafalgar Square – but the British Lion has led a vigorous life in political cartoons. Of course, there remains a vast difference between this kind of heraldic or cartoon symbolism and the deep seriousness with which tribesmen look on their relationship with the totem, as they call their animal relatives. For it seems that they sometimes live in a kind of dream-world in which they can be man and animal at the same time. Many tribes have special ceremonies in which they wear masks with the features of these animals, and when they put them on they seem to feel that they are transformed, that they have become ravens, or bears. It is very much as if children played at pirates or detectives till they no longer knew where play-acting ended and reality began. But with children there is always the grown-up world about them, the people who tell them 'Don't be so noisy', or 'It is nearly bed-time'. For the primitive there is no such other world to spoil the illusion, because all the members of the tribe take part in the ceremonial dances and rites with their fantastic games of pretence. They have all learned their significance from former generations and are so absorbed in them that they have little chance of stepping outside them and seeing their behaviour critically. We all have beliefs which we take as much for granted as the 'primitives' take theirs – usually so much so that we are not even aware of them unless we meet people who question them.

All this may seem to have little to do with art, but in fact these conditions influence art in many ways. Many of the artists' works are meant to play a part in these strange rituals, and what matters then is not whether the sculpture or painting is beautiful by our standards, but whether it 'works', that is to say, whether it can perform the required magic. Moreover, the artists work for people of their own tribe who know exactly what each form or each colour is meant to signify. They are not expected to change these things, but only to apply all their skill and knowledge to the execution of their work.

Again we do not have to go far to think of parallels. The point of a national flag is not to be a beautifully coloured piece of cloth which any maker can change according to his fancy – the point of a wedding ring is not to be an ornament which can be worn or changed as we think fit. Yet even within the prescribed rites and customs of our lives, there remains a certain element of choice and scope for taste and skill. Let us think of the Christmas tree. Its principal features are laid down by custom. Each family, in fact, has its own traditions and its own predilections without which the tree does not look right. Nevertheless, when the great moment comes to

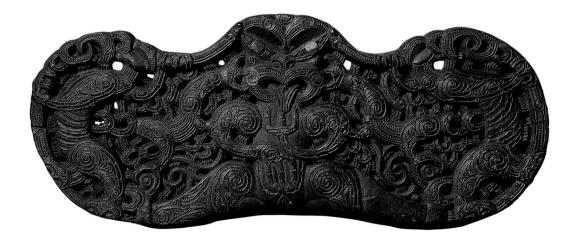

decorate the tree there remains much to be decided. Should this branch get a candle? Is there enough tinsel on top? Does not this star look too heavy or this side too overloaded? Perhaps to an outsider the whole performance would look rather strange. He might think that trees are much nicer without tinsel. But to us, who know the significance, it becomes a matter of great importance to decorate the tree according to our idea.

Primitive art works on just such pre-established lines, and yet leaves the artist scope to show his mettle. The technical mastery of some tribal craftsmen is indeed astonishing. We should never forget, when talking of primitive art, that the word does not imply that the artists have only a primitive knowledge of their craft. On the contrary, many remote tribes have developed a truly amazing skill in carving, in basket work, in the preparation of leather, or even in the working of metals. If we realize with what simple tools these works are made we can only marvel at the patience and sureness of touch which these primitive craftsmen have acquired through centuries of specialization. The Maoris of New Zealand, for instance, have learned to work veritable wonders in their woodcarvings, figure 22. Of course, the fact that a thing was difficult to make does not necessarily prove that it is a work of art. If it were so, the men who make models of sailing ships in glass bottles would rank among the greatest artists. But this proof of tribal skill should warn us against the belief that their work looks odd because they cannot do any better. It is not their standard of craftsmanship which is different from ours, but their ideas. It is important to realize this from the outset, because the whole story of art is not a story of progress in technical proficiency, but a story of changing ideas and requirements. There is increasing evidence that under certain conditions tribal artists can produce work which is just as correct in the rendering of nature as the most skilful work by a Western master. A number of bronze heads were discovered a few decades ago in Nigeria which are the most convincing likenesses that can be imagined, figure 23. They seem to be many centuries old, and there is no evidence to show that the native artists learned their skill from anyone outside.

Lintel from a Maori chieftain's house, early 19th century

Carved wood, 32 × 82 cm, 125/8 × 321/4 in; Museum of Mankind, London

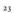

Head of a Negro, probably representing a ruler (Oni), from Ife, Nigeria, 12th–14th century

Bronze, height 36 cm, 141/8 in; Museum of Mankind, London

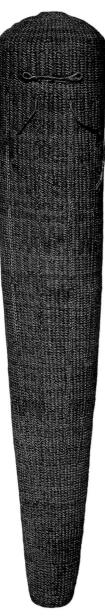

What, then, can be the reason for so much of tribal art looking utterly remote? Once more we should return to ourselves and the experiments we can all perform. Let us take a piece of paper and scrawl on it any doodle of a face. Just a circle for the head, a stroke for the nose, another for the mouth. Then look at the eyeless doodle. Does it look unbearably sad? The poor creature cannot see. We feel we must 'give it eyes' - and what a relief it is when we make the two dots and at last it can look at us! To us all this is a joke. but to the native it is not. A wooden pole to which he has given a simple face looks to him totally transformed. He takes the impression it makes as a token of its magic power. There is no need to make it any more lifelike provided it has eyes to see. Figure 24 shows the figure of a Polynesian 'God of War' called Oro. The Polynesians are excellent carvers, but they obviously did not find it essential to make this a correct representation of a man. All we see is a piece of wood covered with woven fibre. Only its eyes and arms are roughly shown by this fibre braid, but once we notice them, this is enough to give the pole a look of uncanny power. We are still not quite in the realm of art, but our doodle experiment may teach us something more. Let us vary the shape of our scribbled face in all possible ways. Let us change the shape of the eyes from dots to crosses or any other form which has not the remotest resemblance to real eyes. Let us make the nose a circle and the mouth a scroll. It will hardly matter, as long as their relative position remains roughly the same. Now to the native artist this discovery probably meant much. For it taught him to build up his figures or faces out of those forms which he liked best and which were

most suited to his particular craft. The result might not be very lifelike, but it would retain a certain unity and harmony of pattern which is just what our first doodle probably lacked. *Figure 25* shows a mask from New Guinea. It may not be a thing of beauty, but it is not meant to be – it is intended for a ceremony in which the young men of the village dress up as ghosts and frighten the women and children. But, however fantastic or repulsive this 'ghost' may look to us, there is something satisfying in the way the artist has built up his face out of geometrical shapes.

Oro, God of War, from Tahiti, 18th century Wood, covered with sinnet, length 66 cm, 26 in; Museum of Mankind, London

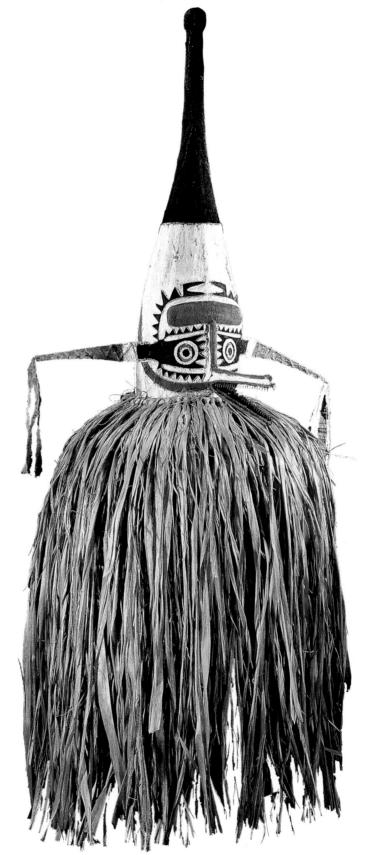

Ritual mask from the Papuan Gulf region, New Guinea, c. 1880 Wood, bark cloth and vegetable fibre, height 152.4 cm, 60 in; Museum

of Mankind, London

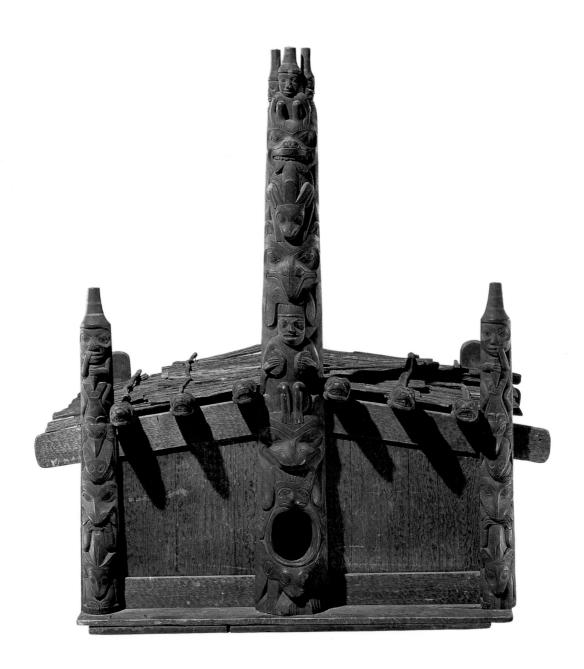

Model of a nineteenthcentury Haida chieftain's house, northwest coast Indians American Museum of Natural History, New York

In some parts of the world primitive artists have developed elaborate systems to represent the various figures and totems of their myths in such ornamental fashion. Among the native North Americans, for instance, artists combine a very acute observation of natural forms with this disregard for what we call the real appearance of things. As hunters, they know the true shape of the eagle's beak, or the beaver's ears, much better than any of us. But they regard one such feature as quite sufficient. A mask with an eagle's beak just is an eagle. Figure 26 is a model of a chieftain's house of the Haida tribe of the north-west with three so-called totem poles in front of it. We may see only a jumble of ugly masks, but to the native this pole illustrates an old legend of his tribe. The legend itself may strike us as nearly as odd and incoherent as its representation, but we ought no longer to feel surprised that native ideas differ from ours.

Once there was a young man in the town of Gwais Kun who used to laze about on his bed the whole day till his mother-in-law remarked on it; he felt ashamed, went away and decided to slay a monster which lived in a lake and fed on humans and whales. With the help of a fairy bird he made a trap of a tree trunk and dangled two children over it as bait. The monster was caught, the young man dressed in its skin and caught fishes, which he regularly left on his critical mother-in-law's doorstep. She was so flattered at these unexpected offerings that she thought of herself as a powerful witch. When the young man undeceived her at last, she felt so ashamed that she died.

All the participants in this story are represented on the central pole. The mask below the entrance is one of the whales the monster used to eat. The big mask above the entrance is the monster; on top of it the human form of the unfortunate mother-in-law. The mask with the beak over her is the bird who helped the hero, and he himself is seen further up dressed in the monster's skin, with fishes he has caught. The human figures at the end are the children the hero used as bait.

It is tempting to regard such a work as the product of an odd whim, but to those who made such things this was a solemn undertaking. It took years to cut these huge poles with the primitive tools at the disposal of the natives, and sometimes the whole male population of the village helped in the task. It was to mark and honour the house of a powerful chieftain.

Without explanation we could never understand the meaning of such carvings, on which so much love and labour were spent. It is

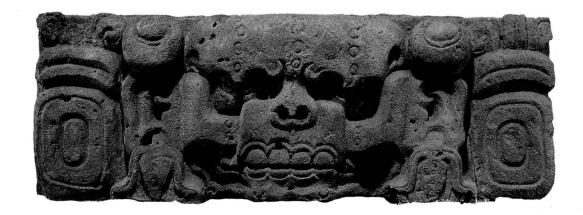

frequently so with works of primitive art. A mask such as Figure 28 may strike us as witty, but its meaning is anything but funny. It represents a man-eating mountain demon with a blood-stained face. But though we may fail to understand it, we can appreciate the thoroughness with which the shapes of nature are transformed into a consistent pattern. There are many great works of this kind dating from the strange beginnings of art whose exact explanation is probably lost for ever but which we can still admire. All that remains to us of the great civilizations of ancient America is their 'art'. I have put the word in quotation marks not because these mysterious buildings and images lack beauty - some of them are quite fascinating – but because we should not approach them with the idea that they were made for the sake of pleasure or 'decoration'. The terrifying carving of a death head from an altar of the ruins of Copan in present-day Honduras, figure 27, reminds us of the gruesome human sacrifices which were demanded by the religions of these peoples. However little may be known about the exact meaning of such carvings, the thrilling efforts of the scholars who have discovered these works and have tried to get at their secrets have taught us enough to compare them with other works of primitive cultures. Of course, these people were not primitive in the usual sense of the word. When the Spanish and Portuguese conquerors of the sixteenth century arrived, the Aztecs in Mexico and the Incas in Peru ruled over mighty empires. We also know that in earlier centuries the Mayas of Central America had built big cities and developed a system of writing and of calculating calendars which is anything but primitive. Like the Negroes of Nigeria, the pre-Columbian Americans were perfectly capable of representing the human face in a lifelike manner. The ancient Peruvians liked to shape certain vessels in the

27

Head of the death-god, from a stone Mayan altar found at Copan, Honduras, c. 500–600

37 × 104 cm, 14½ × 50 in; Museum of Mankind, London

28

Inuit dance mask from Alaska, c. 1880

Painted wood, 37 × 25.5 cm, 14½ × 10 in; Museum für Völkerkunde, Staatliche Museen, Berlin

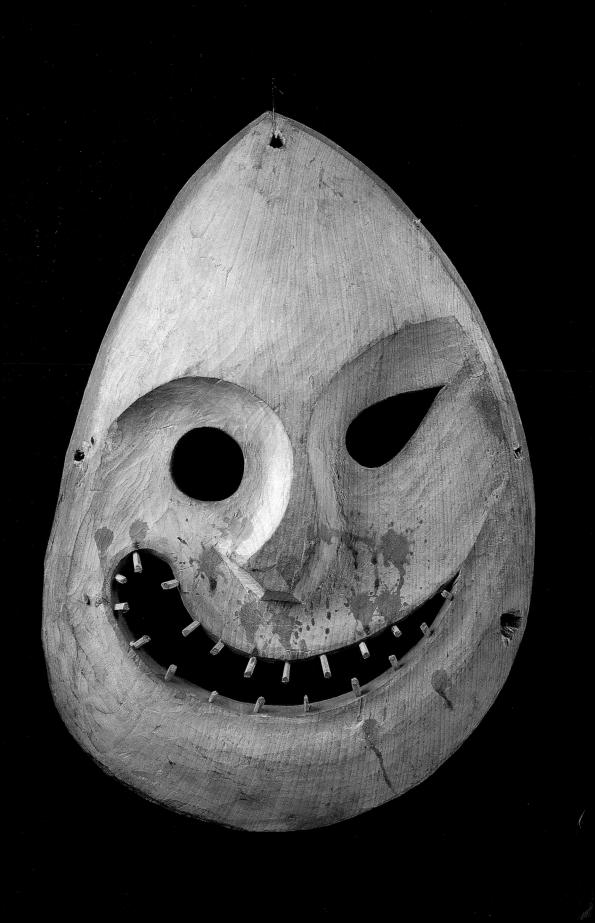

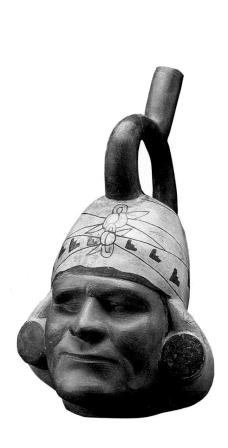

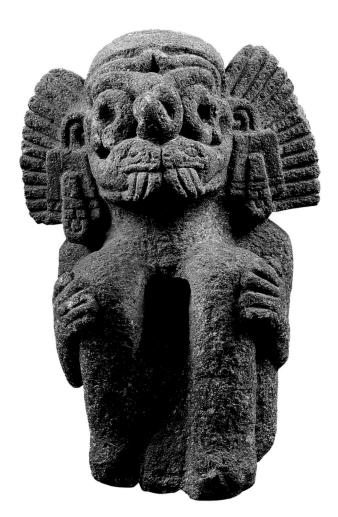

Vessel in the form of a one-eyed man, found in the Chicanná Valley, Peru, c. 250–550 AD Clay, height 29 cm, 11½ in; The Art Institute of Chicago

Tlaloc, the Aztec raingod, 14th–15th century
Stone, height 40 cm,

30

Stone, height 40 cm, 15¾ in; Museum für Völkerkunde, Staatliche Museen, Berlin form of human heads which are strikingly true to nature, *figure 29*. If most works of these civilizations look remote and unnatural to us, the reason lies in the ideas they are meant to convey.

Figure 30 represents a statue from Mexico which is believed to date from the Aztec period, the last before the conquest. Scholars think that it represents the rain-god, whose name was Tlaloc. In these tropical zones rain is often a question of life or death for the people; for without rain their crops may fail and they may have to starve. No wonder that the god of rains and thunderstorms assumed in their minds the shape of a terrifyingly powerful demon. The lightning in the sky appeared to their imagination like a big serpent, and many American peoples therefore considered the rattlesnake to be a sacred and mighty being. If we look more closely at the figure of Tlaloc we see, in fact, that his mouth is formed of two heads of rattlesnakes facing each other, with their big, poisonous fangs protruding from their jaws, and that his nose, too, seems to be formed out of the twisted bodies of the snakes. Perhaps even his eyes might be seen as coiled serpents. We see how far the idea of 'building up' a face out of given forms can lead away from our ideas of lifelike sculpture. We also get an inkling of the reasons which may sometimes have led to this method. It was certainly fitting to form the image of the raingod out of the body of the sacred snakes which embodied the power of lightning. If we try to enter into the mentality which created these uncanny idols we may begin to understand how image-making in these early civilizations was not only connected with magic and religion but was also the first form of writing. The sacred serpent in ancient Mexican art was not only the picture of a rattlesnake but could also develop into a sign for lightning, and so into a character by which a thunderstorm could be commemorated or, perhaps, conjured up. We know very little about these mysterious origins, but if we want to understand the story of art we do well to remember, once in a while, that pictures and letters are really blood-relations.

Australian Aborigine drawing a totemic opossum pattern on a rock

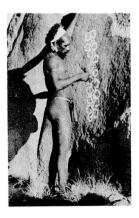

ART FOR ETERNITY

Egypt, Mesopotamia, Crete

Some form of art exists everywhere on the globe, but the story of art as a continuous effort does not begin in the caves of southern France or among the North American Indians. There is no direct tradition which links these strange beginnings with our own days, but there is a direct tradition, handed down from master to pupil, and from pupil to admirer or copyist, which links the art of our own days, any house or any poster, with the art of the Nile Valley of some five thousand years ago. For we shall see that the Greek masters went to school with the Egyptians, and we are all the pupils of the Greeks. Thus the art of Egypt has a tremendous importance for us.

Everyone knows that Egypt is the land of the pyramids, figure 31, those mountains of stone which stand like weathered landmarks on the distant horizon of history. However remote and mysterious they seem, they tell us much of their own story. They tell us of a land which was so thoroughly organized that it was possible to pile up these gigantic mounds in the lifetime of a single king, and they tell us of kings who were so rich and powerful that they could force thousands and thousands of workers or slaves to toil for them year in, year out, to quarry the stones, to drag them to the building site, and to shift them with the most primitive means till the tomb was ready to receive the king. No king and no people would have gone to such expense, and taken so much trouble, for the creation of a mere monument. In fact, we know that the pyramids had their practical importance in the eyes of the kings and their subjects. The king was considered a divine being who held sway over them, and on his departure from this earth he would again ascend to the gods whence he had come. The pyramids soaring up to the sky would probably help him to make his ascent. In any case they would preserve his sacred body from decay. For the Egyptians believed that the body must be preserved if the soul is to live on in the beyond. That is why they prevented the corpse from decaying by an elaborate method of embalming it, and binding it up in strips of cloth. It was for the mummy of the king that the pyramid had been piled up, and his body was laid right in the centre of the huge mountain of stone in a stone coffin. Everywhere round the burial

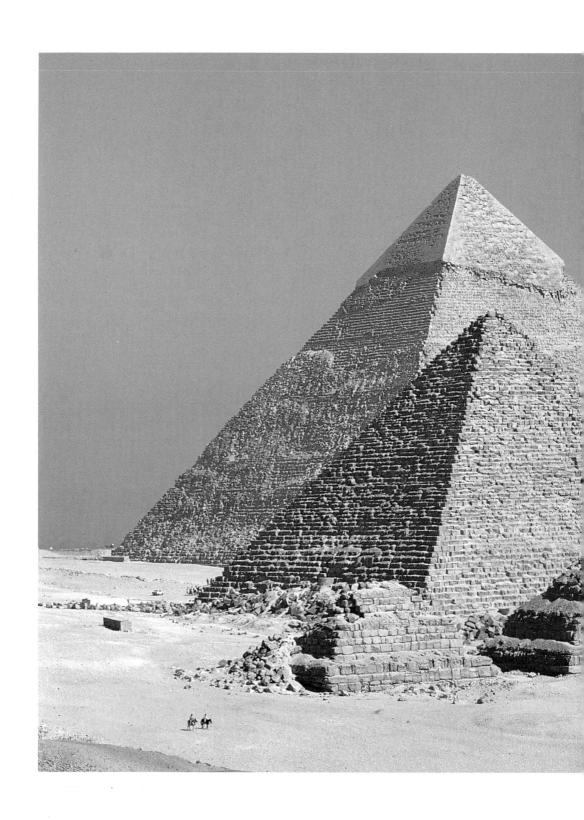

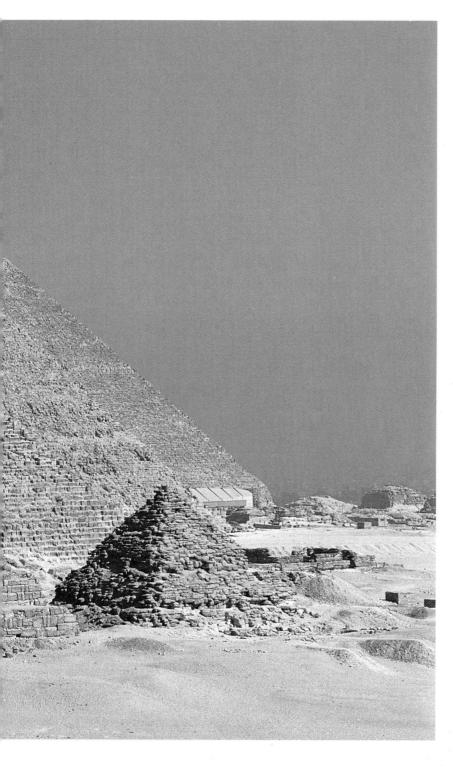

The Pyramids of Giza, c. 2613–2563 BC

chamber, spells and incantations were written to help him on his journey to the other world.

But it is not only these oldest relics of human architecture which tell of the role played by age-old beliefs in the story of art. The Egyptians held the belief that the preservation of the body was not enough. If the likeness of the king was also preserved, it was doubly sure that he would continue to exist for ever. So they ordered sculptors to chisel the king's head out of hard, imperishable granite, and put it in the tomb where no one saw it, there to work its spell and to help his soul to keep alive in and through the image. One Egyptian word for sculptor was actually 'He-who-keeps-alive'.

At first these rites were reserved for kings, but soon the nobles of the royal household had their minor tombs grouped in neat rows round the king's mound; and gradually every self-respecting person had to make provision for his after-life by ordering a costly grave which would house his mummy and his likeness, and where his soul could dwell and receive the offerings of food and drink which were given to the dead. Some of these early portraits from the pyramid age, the fourth 'dynasty' of the 'Old Kingdom', are among the most beautiful works of Egyptian art, figure 32. There is a solemnity and simplicity about them which one does not easily forget. One sees that the sculptor was not trying to flatter his sitter, or to preserve a fleeting expression. He was concerned only with essentials. Every lesser detail he left out. Perhaps it is just because of this strict concentration on the basic forms of the human head that these portraits remain so impressive. For, despite their almost geometrical rigidity, they are not primitive as are the native masks discussed in Chapter 1, pages 47, 51, figures 25, 28. Nor are they as lifelike as the naturalistic portraits of the artists of Nigeria, page 45, figure 23. The observation of nature, and the regularity of the whole, are so evenly balanced that they impress us as being lifelike and yet remote and enduring.

This combination of geometric regularity and keen observation of nature is characteristic of all Egyptian art. We can study it best in the reliefs and paintings that adorned the walls of the tombs. The word 'adorned', it is true, may hardly fit an art which was meant to be seen by no one but the dead man's soul. In fact, these works were not intended to be enjoyed. They, too, were meant to 'keep alive'. Once, in a grim distant past, it had been the custom when a powerful man died to let his servants and slaves accompany him into the grave. They were sacrificed so that he should arrive in the beyond with a suitable train. Later, these horrors were considered either too cruel or too costly, and art came to the rescue. Instead of real servants, the great ones of this earth were given images as substitutes. The pictures and models found in Egyptian tombs were connected with the idea of providing the soul with

Portrait head, c. 2551–2528 BC Found in a tomb at Giza; limestone, height 27-8 cm, I1 in; Kunsthistorisches Museum, Vienna

helpmates in the other world, a belief that is found in many early cultures.

To us these reliefs and wall-paintings provide an extraordinarily vivid picture of life as it was lived in Egypt thousands of years ago. And yet, looking at them for the first time, one may find them rather bewildering. The reason is that the Egyptian painters had a very different way from ours of representing real life. Perhaps this is connected with the different purpose their paintings had to serve. What mattered most was not prettiness but completeness. It was the artists' task to preserve everything as clearly and permanently as possible. So they did not set out to sketch nature as it appeared to them from any fortuitous angle. They drew from memory, according to strict rules which ensured that everything that had to go into the picture would stand out in perfect clarity. Their method, in fact,

The garden of Nebamun,
c. 1400 BC
Wall-painting from a tomb in Thebes, 64 × 74.2 cm, 25¼ × 29¼ in; British Museum, London

Portrait of Hesire, from a wooden door in his tomb, c. 2778–2723 BC Wood, height 115 cm, 45¼ in; Egyptian Museum, Cairo resembled that of the map-maker rather than that of the painter. Figure 33 shows it in a simple example, representing a garden with a pond. If we had to draw such a motif we might wonder from which angle to approach it. The shape and character of the trees could be seen clearly only from the sides, the shape of the pond would be visible only if seen from above. The Egyptians had no compunction about this problem. They would simply draw the pond as if it were seen from above, and the trees from the side. The fishes and birds in the pond, on the other hand, would hardly look recognizable as seen from above, so they were drawn in profile.

In such a simple picture, we can easily understand the artist's procedure. A similar method is often used by children. But the Egyptians were much more consistent in their application of these methods than children ever are. Everything had to be represented from its most characteristic angle.

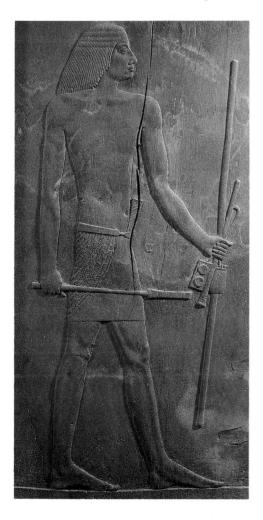

Figure 34 shows the effect which this idea had on the representation of the human body. The head was most easily seen in profile so they drew it sideways. But if we think of the human eye we think of it as seen from the front. Accordingly, a full-face eye was planted into the side view of the face. The top half of the body, the shoulders and chest, are best seen from the front, for then we see how the arms are hinged to the body. But arms and legs in movement are much more clearly seen sideways. That is the reason why Egyptians in these pictures look so strangely flat and contorted. Moreover, the Egyptian artists found it hard to visualize either foot seen from the outside. They preferred the clear outline from the big toe upwards. So both feet are seen from the inside, and the man on the relief looks as if he had two left feet. It must not be supposed that Egyptian artists thought that human beings looked like that. They merely followed a rule which allowed them to include everything in the human form that they considered important. Perhaps this strict adherence to the rule had something to do with their magic purpose. For how could a man with his arm 'foreshortened' or 'cut off' bring or receive the required offerings to the dead?

Here as always, Egyptian art is not based on what the artist could see at a given moment, but rather on what he knew belonged to a person or a scene. It was out of these forms which he had learned, and which he knew, that he built his representations, much as the tribal artist builds his figures out of the forms he can master. It is not only his knowledge of forms and shapes that the artist embodies in his picture, but also his knowledge of their significance. We sometimes call a man a 'big boss'. The Egyptian drew the boss bigger than his servants or even his wife.

Once we have grasped these rules and conventions, we understand the language of the pictures in which the life of the Egyptians is chronicled. Figure 35 gives a good idea of the general arrangement of a wall in the tomb of a high Egyptian dignitary of the so-called 'Middle Kingdom', some nineteen hundred years before our era. The inscriptions in hieroglyphs tell us exactly who he was, and what titles and honours he had collected in his lifetime. His name, we read, was Khnumhotep, the Administrator of the Eastern Desert, Prince of Menat Khufu, Confidential Friend of the King, Royal Acquaintance, Superintendent of the Priests, Priest of Horus, Priest of Anubis, Chief of all the Divine Secrets, and – most impressive of all – Master of all the Tunics. On the left side we see him hunting wildfowl

Wall-painting from the

tomb of Khnumhotep, c. 1900 BC

Found at Beni Hassan; from a drawing after the original, published by Karl Lepsius, *Denkmäler*, 1842

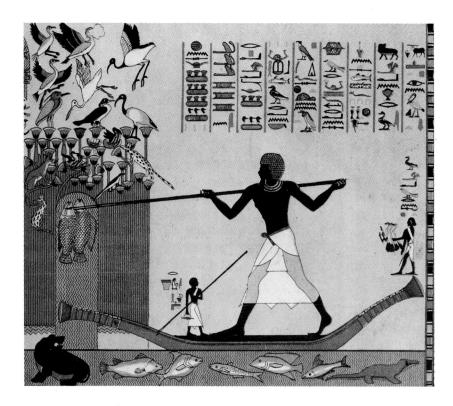

Detail of figure 35

with a kind of boomerang, accompanied by his wife Kheti, his concubine Jat, and one of his sons who, despite his tiny size in the picture, held the title of Superintendent of the Frontiers. Below, in the frieze, we see fishermen under their superintendent Mentuhotep hauling in a big catch. On top of the door Khnumhotep is seen again, this time trapping waterfowl in a net. Understanding the methods of the Egyptian artist, we can easily see how this device worked. The trapper sat hidden behind a screen of reeds, holding a cord, which was linked with the open net (seen from above). When the birds had settled on the bait, he pulled the rope and the net closed over them. Behind Khnumhotep is his eldest son Nacht, and his Superintendent of the Treasures, who was also responsible for the ordering of the tomb. On the right side, Khnumhotep, who is called 'great in fish, rich in wildfowl, loving the goddess of the chase', is seen spearing fish, figure 36. Once more we can observe the conventions of the Egyptian artist who lets the water rise among the reeds to show us the clearing with the fish. The inscription reads: 'Canoeing in the papyrus beds, the pools of wildfowl, the marshes and the streams, spearing with the two-pronged spear, he transfixes thirty fish; how delightful is the day of hunting the hippopotamus.' Below is an amusing episode with one of the men who had fallen into the water being fished out by his mates. The inscription round the door records the days on which offerings are to be given to the dead, and includes prayers to the gods.

When we have become accustomed to looking at these Egyptian pictures we are as little troubled by their unrealities as we are by the absence of colour in a photograph. We even begin to realize the great advantages of the Egyptian method. Nothing in these pictures gives the impression of being haphazard, nothing looks as if it could just as well be somewhere else. It is worth while taking a pencil and trying to copy one of these 'primitive' Egyptian drawings. Our attempts always look clumsy, lopsided and crooked. At least my own do. For the Egyptian sense of order in every detail is so strong that any little variation seems to upset it entirely. The Egyptian artist began his work by drawing a network of straight lines on the wall, and he distributed his figures with great care along these lines. And yet all this geometrical sense of order did not prevent him from observing the details of nature with amazing accuracy. Every bird or fish is drawn with such truthfulness that zoologists can still recognize the species. Figure 37 shows such a detail of figure 35 - the birds in the tree by Khnumhotep's fowling net. It was not only his great knowledge which guided the artist, but also an eye for pattern.

Birds in an acacia bush
Detail of figure 35; from a
painting after the original
by Nina Macpherson
Davies

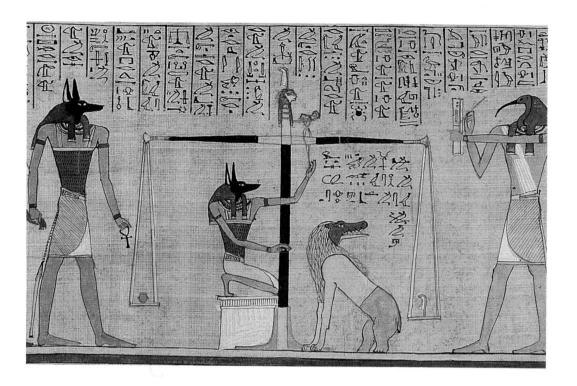

38

The jackal-faced god Anubis supervising the weighing of a dead man's heart, while the ibis-headed messengergod Thoth on the right records the result, c. 1285 BC

Scene from an Egyptian 'Book of the Dead', a painted papyrus scroll placed in the deceased's tomb; height 39.8 cm, 151/4 in; British Museum, London

It is one of the greatest things in Egyptian art that all the statues, paintings and architectural forms seem to fall into place as if they obeyed one law. We call such a law, which all creations of a people seem to obey, a 'style'. It is very difficult to explain in words what makes a style, but it is far less difficult to see. The rules which govern all Egyptian art give every individual work the effect of poise and austere harmony.

The Egyptian style comprised a set of very strict laws, which every artist had to learn from his earliest youth. Seated statues had to have their hands on their knees; men had to be painted with darker skin than women; the appearance of every Egyptian god was strictly laid down: Horus, the skygod, had to be shown as a falcon or with a falcon's head; Anubis, the god of funeral rites, as a jackal or with a jackal's head, *figure 38*. Every artist also had to learn the art of beautiful script. He had to cut the images and symbols of the hieroglyphs clearly and accurately in stone. But once he had mastered all these rules he had finished his apprenticeship. No one wanted anything different, no one asked him to be 'original'. On the contrary, he was probably considered the best artist who could make his statues most like the admired monuments of the past. So it happened that in the course of three thousand years or more Egyptian art changed very little.

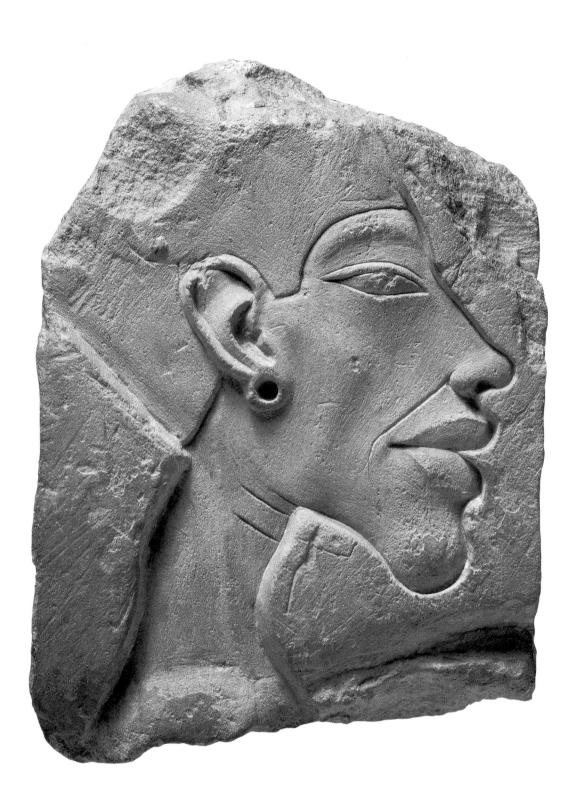

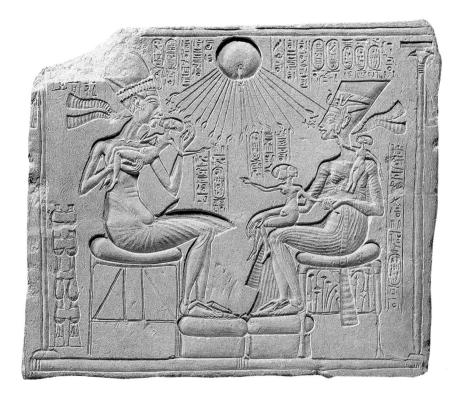

Akhnaten and Nefertiti with their children, c. 1345 BC Limestone altar relief, 32.5 × 39 cm, 12½ × 15½ in;

Ägyptisches Museum, Staatliche Museen, Berlin

39

Amenophis IV (Akhnaten), c. 1360 BC Limestone relief, height 14 cm, 5½ in; Ägyptisches Museum, Staatliche Museum, Berlin Everything that was considered good and beautiful in the age of the pyramids was held to be just as excellent a thousand years later. True, new fashions appeared, and new subjects were demanded of the artists, but their mode of representing man and nature remained essentially the same.

Only one man ever shook the iron bars of the Egyptian style. He was a king of the Eighteenth Dynasty, in the period known as the 'New Kingdom', which was founded after a catastrophic invasion of Egypt. This king, Amenophis IV, was a heretic. He broke with many of the customs hallowed by age-old tradition. He did not wish to pay homage to the many strangely shaped gods of his people. For him only one god was supreme, Aten, whom he worshipped and whom he had represented in the shape of the sun-disk sending down its rays, each one endowed with a hand. He called himself Akhnaten, after his god, and he moved his court out of reach of the priests of the other gods, to a place which is now called Tell-el-Amarna.

The pictures which he commissioned must have shocked the Egyptians of his day by their novelty. In them none of the solemn and rigid dignity of the earlier Pharaohs was to be found. Instead, he had himself represented with his wife Nefertiti, *figure 40*, fondling their children beneath the blessing sun. Some of his portraits show him as an ugly man, *figure 39* – perhaps he wanted the artists to portray him in all his human frailty or, perhaps, he was so convinced of his unique importance as a prophet that he

insisted on a true likeness. Akhnaten's successor was Tutankhamun, whose tomb with its treasures was discovered in 1922. Some of these works are still in the modern style of the Aten religion – particularly the back of the king's throne, figure 42, which shows the king and queen in a homely idyll. He is sitting on his chair in an attitude which might have scandalized the strict Egyptian conservative – almost lolling, by Egyptian standards. His wife is no smaller than he is, and gently puts her hand on his shoulder while the Sun-god again is stretching his hands in blessing down to them.

It is not impossible that this reform of art in the Eighteenth Dynasty was made easier for the king because he could point to foreign works that were much less strict and rigid than the Egyptian products. On an island overseas, in Crete, there dwelt a gifted people whose artists delighted in the representation of swift movement. When the palace of their king at Knossos was excavated at the end of the nineteenth century, people could hardly believe that such a free and graceful style could have been developed in the second millennium before our era. Works in this style were also found on the Greek mainland; a dagger from Mycenae with a lion hunt, *figure 41*, shows a sense of movement and flowing lines which must have impressed any Egyptian craftsman who had been permitted to stray from the hallowed rules of his style.

But this opening of Egyptian art did not last long. Already during the reign of Tutankhamun the old beliefs were restored, and the window to the outside world was shut again. The Egyptian style, as it had existed for more than a thousand years before his time, continued to exist for another thousand years or more, and the Egyptians doubtless believed it would continue for all eternity. Many Egyptian works in our museums date from this later period, and so do nearly all Egyptian buildings such as temples and palaces. New themes were introduced, new tasks performed, but nothing essentially new was added to the achievement of art.

Egypt, of course, was only one of the great and powerful empires which existed in the Near East for several thousand years. We all know from the Bible that little Palestine lay between the Egyptian kingdom of the Nile

Tutankhamun and his wife, c. 1330 BC
Detail of gilt and painted woodwork from the throne found in his tomb;
Egyptian Museum, Cairo

Dagger, c. 1600 BC Found at Mycenae; bronze inlaid with gold, silver and niello, length 23.8 cm, 9½ in; National Archaeological Museum, Athens

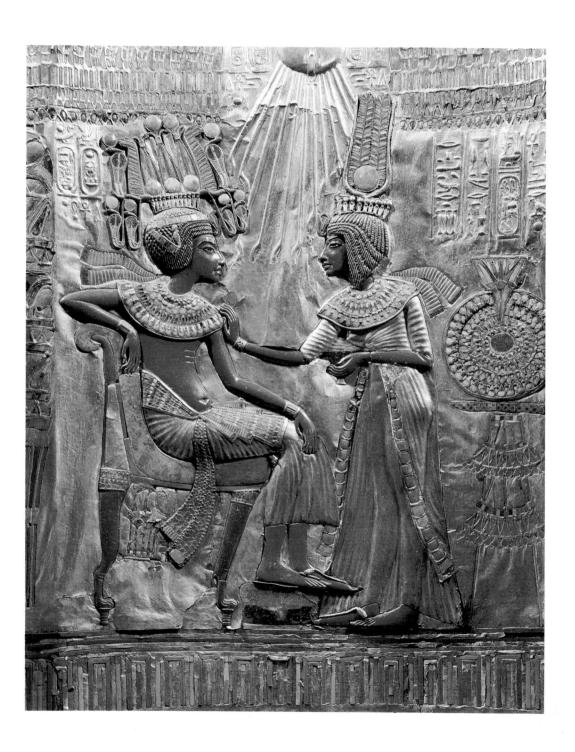

and the Babylonian and Assyrian empires, which had developed in the valley of the two rivers Euphrates and Tigris. The art of Mesopotamia, as the valley of the two rivers was called in Greek, is less well known to us than the art of Egypt. This is at least partly due to accident. There were no stone quarries in these valleys, and most buildings were made of baked brick which, in course of time, weathered away and fell to dust. Even sculpture in stone was comparatively rare. But this is not the only explanation of the fact that relatively few early works of that art have come down to us. The main reason is probably that these people did not share the religious belief of the Egyptians that the human body and its likeness must be preserved if the soul is to continue. In the very early times, when a people called the Sumerians ruled in the city of Ur, kings were still buried with their whole household, slaves and all, so that they should not lack a following in the world beyond. Graves of this period have

been discovered, and we can admire some of the household goods of these ancient, barbarous kings in the British Museum. We see how much refinement and artistic skill can go together with primitive superstition and cruelty. There was, for instance, a harp in one of the tombs, decorated with fabulous animals, *figure 43*. They look rather like our heraldic beasts, not only in their general appearance but also in their arrangement, for the Sumerians had a taste for symmetry and precision. We do not know exactly what these fabulous animals were meant to signify, but it is almost certain that they were figures from the mythology of these early days, and that the scenes which look to us like pages from a children's book had a very solemn and serious meaning.

Though artists in Mesopotamia were not called upon to decorate the walls of tombs, they too had to ensure, in a different way, that the image helped to keep the mighty alive. From early times onwards it was the custom of Mesopotamian kings to commission monuments to their victories in war, which told of the tribes that had been defeated, and the booty that had been taken. *Figure 44* shows such a relief representing the king who tramples on the body of his slain foe, while others of his enemies beg for mercy. Perhaps the idea behind these monuments was not only to keep the memory of these victories alive. In early times, at least, the

Fragment of a harp, c. 2600 BC Found in Ur; gilt and inlaid wood; British Museum, London

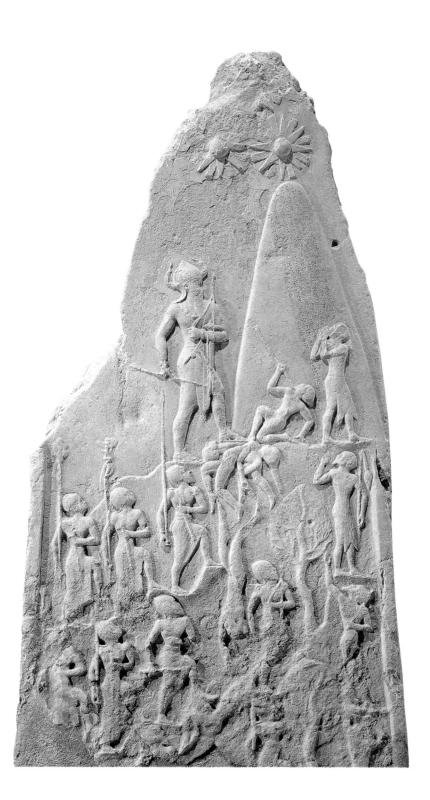

44 Monument of King Naramsin, c. 2270 BC Found in Susa; stone, height 200 cm, 79 in; Louvre, Paris

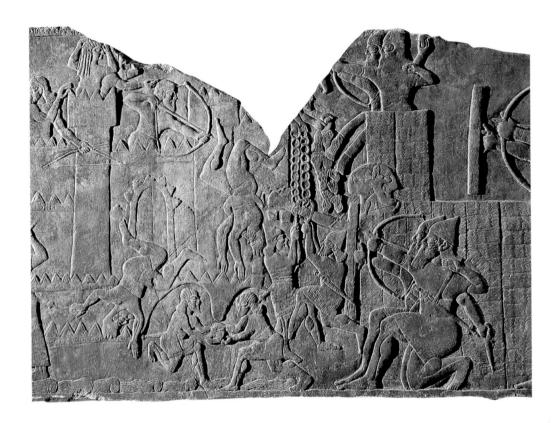

ancient beliefs in the power of the image may still have influenced those who ordered them. Perhaps they thought that, as long as the picture of their king with his foot on the neck of the prostrate enemy stood there, the defeated tribe would not be able to rise again.

In later times such monuments developed into complete picture-chronicles of the king's campaign. The best-preserved of these chronicles date from a relatively late period, the reign of King Asurnasirpal II of Assyria, who lived in the ninth century BC, a little later than the biblical King Solomon. In them we see all the episodes of a well-organized campaign; *figure 45* shows the details of an attack on a fortress, with the siege machines in action, the defenders tumbling down, and on the top of a tower a woman wailing in vain. The way in which these scenes are represented is rather similar to Egyptian methods, but perhaps a little less tidy and rigid. As one looks at them, one feels as if one were watching the news of 2,000 years ago. It all looks so real and convincing. But as we look

45

Assyrian army besieging a fortress, c. 883–859 BC

Detail of alabaster relief from the palace of King Asurnasirpal at Nimrud; British Museum, London more carefully we discover a curious fact: there are plenty of dead and wounded in these gruesome wars – but not one of them is an Assyrian. The art of boasting and propaganda was well advanced in these early days. But perhaps we can take a slightly more charitable view of these Assyrians. Perhaps even they were still ruled by the old superstition which has come into this story so often: the superstition that there is more in a picture than a mere picture. Perhaps they did not want to represent wounded Assyrians for some such reason. In any case, the tradition which then began had a very long life. On all the monuments which glorify the warlords of the past, war is no trouble at all. You just appear, and the enemy is scattered like chaff in the wind.

An Egyptian craftsman at work on a golden sphinx, c. 1380 BC Copy of a wall-painting in a tomb at Thebes; British Museum, London

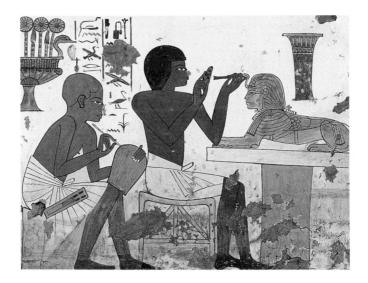

THE GREAT AWAKENING

Greece, seventh to fifth century BC

It was in the great oasis lands, where the sun burns mercilessly, and where only the land watered by the rivers provides food, that the earliest styles of art had been created under Oriental despots, and these styles remained almost unchanged for thousands of years. Conditions were very different in the milder climes of the sea which bordered these empires, on the many islands, large and small, of the eastern Mediterranean and the many-creeked coasts of the peninsulas of Greece and Asia Minor. These regions were not subject to one ruler. They were the hiding-places of adventurous seamen, or pirate-kings who travelled far and wide and piled up great wealth in their castles and harbour-towns by means of trade and sea-raiding. The main centre of these areas was originally the island of Crete, whose kings were at times sufficiently rich and powerful to send embassies to Egypt, and whose art created an impression even there, page 68.

No one knows exactly who the people were who ruled in Crete, and whose art was copied on the Greek mainland, particularly in Mycenae. Recent discoveries make it likely that they spoke an early form of Greek. Later, about 1000 BC, a fresh wave of warlike tribes from Europe penetrated to the rugged peninsula of Greece and to the shores of Asia Minor, and fought and defeated the former inhabitants. Only in the songs which tell of these battles does something survive of the splendour and beauty of the art which was destroyed in these protracted wars, for these songs are the Homeric poems, and among the new arrivals were the Greek tribes we know from history.

In the first few centuries of their domination of Greece the art of these tribes looked harsh and primitive enough. There is nothing of the gay movement of the Cretan style in these works; rather they seemed to outdo the Egyptians in rigidity. Their pottery was decorated with simple geometric patterns, and where a scene was to be represented it formed part of this strict design. *Figure 46*, for instance, represents the mourning for a dead man. He is lying on his bier, while wailing women right and left raise their hands to their heads in the ritual lament which is the custom in nearly all primitive societies.

The mourning of the dead, c. 700 BC Greek vase in the Geometric style; height 155 cm, 61 in; National Archaeological Museum, Athens

Something of this simplicity and clear arrangement seems to have gone into the style of building which the Greeks introduced in these early days, and which, strange to say, still lives on in our own towns and villages. Figure 50 shows a Greek temple of the old style which is called after the Doric tribe. This was the tribe to which the Spartans belonged, who were noted for their austerity. There is, indeed, nothing unnecessary in these buildings, nothing, at least, of which we do not see, or believe we see, the purpose. Probably the earliest of such temples were built of timber, and consisted of little else than a small walled cubicle to hold the image of the god, and around it, strong props to carry the weight of the roof. About the year 600 BC the Greeks began to imitate these simple structures in stone. The wooden props were turned into columns which supported strong crossbeams of stone. These crossbeams are called architraves, and the whole unit resting on the columns goes under the name of entablature. We can see traces of the timber structure in the upper part, which looks as if the ends of beams were showing. These ends were usually marked with three slits, and are therefore called by the Greek word triglyphs, which means 'three slits'. The space between these beams is called the metope. The astonishing thing in these early temples, which so clearly imitate wooden structures, is the simplicity and harmony of the whole. If the builders had used simple square pillars, or cylindrical columns, the temples might have looked heavy and clumsy. Instead, they took care to shape the columns so that there was a slight swelling towards the middle and a tapering off towards the top. The result is that they look almost as though they were elastic, and as though the weight of the roof was just slightly compressing them, without, however, squeezing them out of shape. It almost seems as if they were living beings who carried their loads with ease. Though some of these temples are large and imposing, they are not colossal like Egyptian buildings. One feels that they were built by human beings, and for human beings. In fact, there was no divine ruler over the Greeks who could or would have forced a whole people to slave for him. The Greek tribes had settled down in various small cities and harbourtowns. There was much rivalry and friction between these small communities, but none of them succeeded in lording it over all the others.

Of these Greek city-states, Athens in Attica became by far the most famous and the most important in the history of art. It was here, above all, that the greatest and most astonishing revolution in the whole history of art bore fruit. It is hard to tell when and where this revolution began — perhaps roughly at the time when the first temples of stone were being built in Greece, in the sixth century BC. We know that before that time the artists of the old Oriental empires had striven for a peculiar kind of perfection. They had tried to emulate the art of their forefathers as

faithfully as possible, and to adhere strictly to the sacred rules they had learned. When Greek artists began to make statues of stone, they started where the Egyptians and Assyrians had left off. Figure 47 shows that they studied and imitated Egyptian models, and that they learned from them how to make the figure of a standing young man, how to mark the divisions of the body and the muscles which hold it together. But it also shows that the artist who made these statues was not content to follow any formula, however good, and that he began experimenting for himself. He was obviously interested in finding out what knees really looked like. Perhaps he did not quite succeed; perhaps the knees of his statues are even less convincing than those of Egyptian examples; but the point was that he had decided to have a look for himself instead of following the old prescription. It was no longer a question of learning a ready-made formula for representing the human body. Every Greek sculptor wanted to know how he was to represent a particular body. The Egyptians had based their art on knowledge. The Greeks began to use their eyes. Once this revolution had begun, there was no stopping it. The sculptors in their workshops tried out new ideas and new ways of representing the human figure, and each innovation was eagerly taken up by others who added their own discoveries. One discovered how to chisel the trunk, another found out that a statue may look much more alive if the feet are not both placed firmly on the ground. Yet another would discover that he could make a face come alive by simply bending the mouth upwards so that it appeared to smile. Of course, the Egyptian method was in many ways safer. The experiments of the Greek artists sometimes misfired. The smile might look like an embarrassed grin, or the less rigid stance might give the impression of affectation. But the Greek artists were not easily frightened by these difficulties. They had set out on a road on which there was no turning back.

The painters followed suit. We know little of their work except what the Greek writers tell us, but it is important to realize that many Greek painters were even more famous in their time than the Greek sculptors. The only way in which we can form a vague idea of what early Greek painting was like is by looking at the pictures on pottery. These painted vessels are generally called vases, although they were intended more often to hold wine or oil than flowers. The painting of these vases developed into an important industry in Athens, and the humble craftsmen employed in these workshops were just as eager as the other artists to introduce the latest discoveries into their products. In the early vases, painted in the sixth century BC, we still see traces of the Egyptian methods, *figure 48*. We see the two heroes from Homer, Achilles and Ajax, playing draughts in their tent. Both figures are still shown strictly in profile. Their eyes still

47

Polymedes of Argos The brothers Cleobis and Biton, c. 615– 590 BC

Marble, height 218 and 216 cm, 86 and 85 in; Archaeological Museum, Delphi

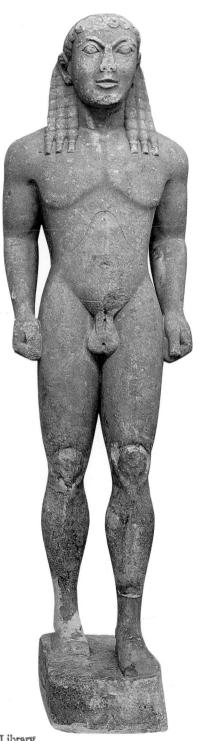

Victoria Public Library 302 N. Main Victoria, Tx. 77901

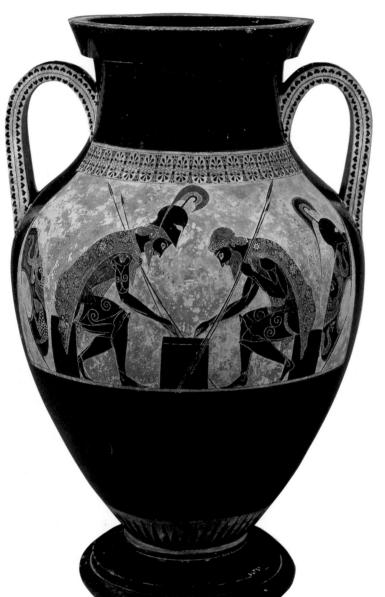

48

Achilles and Ajax playing draughts, c. 540 BC

Vase in the 'black-figured' style, signed by Exekias; height 61 cm, 24 in; Museo Etrusco, Vatican

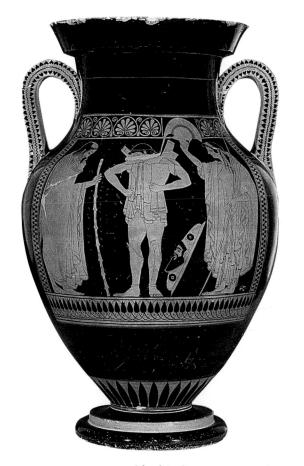

The warrior's leavetaking, c. 510–500 BC Vase in the 'red-figured' style, signed by Euthymedes; height 60 cm, 23½ in; Staatliche Antikensammlungen und Glyptothek, Munich

look as seen from the front. But their bodies are no longer drawn in the Egyptian fashion, nor are their arms and hands set out so clearly and so rigidly. The painter had obviously tried to imagine what it would really look like if two people were facing each other in that way. He was no longer afraid of showing only a small part of Achilles' left hand, the rest being hidden behind the shoulder. He no longer thought that everything he knew to be there must also be shown. Once this ancient rule was broken, once the artist began to rely on what he saw, a veritable landslide started. Painters made the greatest discovery of all, the discovery of foreshortening. It was a tremendous moment in the history of art when, perhaps a little before 500 BC, artists dared for the first time in all history to paint a foot as seen from in front. In all the thousands of Egyptian and Assyrian works which have come down to us. nothing of that kind had ever happened. A Greek vase, figure 49, shows with what

pride this discovery was taken up. We see a young warrior putting on his armour for battle. His parents on either side, who assist him and probably give him good advice, are still represented in rigid profile. The head of the youth in the middle is also shown in profile, and we can see that the painter did not find it too easy to fit his head on to the body, which we see from the front. The right foot, too, is still drawn in the 'safe' way, but the left foot is foreshortened – we see the five toes like a row of five little circles. It may seem exaggerated to dwell for long on such a small detail, but it really meant that the old art was dead and buried. It meant that the artist no longer aimed at including everything in the picture in its most clearly visible form, but took account of the angle from which he saw an object. And immediately beside the foot he showed what he meant. He drew the youth's shield, not in the shape in which we might see it in our imagination as a round, but seen from the side, leaning against a wall.

But as we look at this picture and the previous one, we also realize that the lessons of Egyptian art had not simply been discarded and thrown

overboard. Greek artists still tried to make their figures as clear in outline as possible, and to include as much of their knowledge of the human body as would go into the picture without doing violence to its appearance. They still loved firm outlines and balanced design. They were far from trying to copy any casual glimpse of nature as they saw it. The old formula, the type of human form as it had developed in all these centuries, was still their starting-point. Only they no longer considered it sacred in every detail.

The great revolution of Greek art, the discovery of natural forms and of foreshortening, happened at the time which is altogether the most amazing period of human history. It is the time when people in the Greek cities began to question the old traditions and legends about the gods, and inquired without prejudice into the nature of things. It is the time when science, as we understand the term today, and philosophy first awoke among men, and when the theatre first developed out of the ceremonies in honour of Dionysus. We must not imagine, however, that the artists in those days were among the intellectual classes of the city. The rich Greeks who managed the affairs of their city, and who spent their time in the market-place in endless arguments, perhaps even the poets and philosophers, mostly looked down on the sculptors and painters as inferior persons. Artists worked with their hands, and they worked for a living. They sat in their foundries, covered with sweat and grime, they toiled like ordinary navvies, and so they were not considered members of polite society. Nevertheless, their share in the life of the city was infinitely greater than that of an Egyptian or an Assyrian craftsman, because most Greek cities, Athens in particular, were democracies in which these humble workers who were despised by the well-to-do snobs were yet allowed to share to some extent in the business of government.

It was at the time when Athenian democracy had reached its highest level that Greek art came to the summit of its development. After Athens had defeated the Persian invasion, the people, under the leadership of Pericles, began to build again what the Persians had destroyed. In 480 BC the temples on the sacred rock of Athens, the Acropolis, had been burned down and sacked by the Persians. Now they were to be built in marble and with a splendour and nobility never known before, *figure 50*. Pericles was no snob. The ancient writers imply that he treated the artists of his time as his equals. The man he entrusted with the planning of the temples was the architect Iktinos, and the sculptor who was to fashion the figures of the gods and to supervise the decoration of the temples was Pheidias.

The fame of Pheidias is founded on works which no longer exist. But it is important to try to imagine what they were like, because we forget too easily what purpose Greek art still served at that time. We read in the Bible how the prophets inveighed against the worship of idols, but we do not

Iktinos
The Parthenon,
Acropolis, Athens,
c. 450 BC
A Doric temple

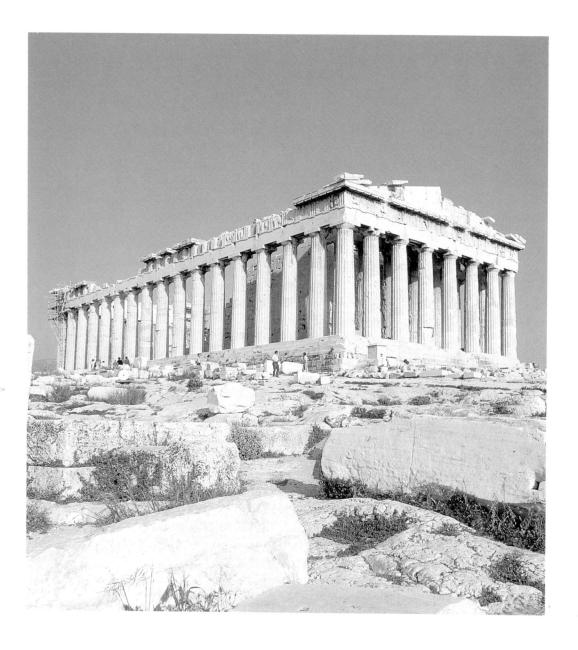

usually connect any very concrete ideas with these words. There are many passages like the following from Jeremiah (x. 3-5):

For the customs of the people are vain: for one cutteth a tree out of the forest, the work of the hands of the workman, with the axe. They deck it with silver and with gold; they fasten it with nails and with hammers, that it move not. They are upright as the palm tree, but speak not: they must needs be borne, because they cannot go. Be not afraid of them; for they cannot do evil, neither also is it in them to do good.

What Jeremiah had in mind were the idols of Mesopotamia, made of wood and precious metals. But his words would apply almost exactly to the works of Pheidias, made only a few centuries after the prophet's lifetime. As we walk along the rows of white marble statues from classical antiquity in the great museums, we too often forget that among them are these idols of which the Bible speaks; that people prayed before them, that sacrifices were brought to them amidst strange incantations, and that thousands and tens of thousands of worshippers may have approached them with hope and fear in their hearts - wondering, as the prophet says, whether these statues and graven images were not really at the same time gods themselves. In fact, the very reason why nearly all the famous statues of the ancient world perished was that after the victory of Christianity it was considered a pious duty to smash any statue of the heathen gods. The sculptures in our museums are, for the most part, only secondhand copies made in Roman times for travellers and collectors as souvenirs, and as decorations for gardens or public baths. We must be very grateful for these copies, because they give us at least a faint idea of the famous masterpieces of Greek art; but unless we use our imagination these weak imitations can also do much harm. They are largely responsible for the widespread idea that Greek art was lifeless, cold and insipid, and that Greek statues had that chalky appearance and vacant look which reminds one of old-fashioned drawing classes. The Roman copy of the great idol of Pallas Athene, for instance, which Pheidias made for her shrine in the Parthenon, floure 51, hardly looks very impressive. We must turn to old descriptions and try to picture what it was like: a gigantic wooden image, some 36 feet (11 metres) high, as high as a tree, covered all over with precious material the armour and garments of gold, the skin of ivory. There was also plenty of strong, shining colour on the shield and other parts of the armour, not forgetting the eyes, which were made of coloured stones. There were griffons on the golden helmet of the goddess, and the eyes of a huge snake which was coiled inside the shield were, no doubt, also marked by shining stones. It must have been an awe-inspiring and uncanny sight when one entered the temple and suddenly stood face to face with this gigantic

Athena Parthenos, c. 447–432 BC Roman marble copy after the wood, gold and ivory original by Pheidias, height 104 cm, 41 in; National Archaeological Museum, Athens

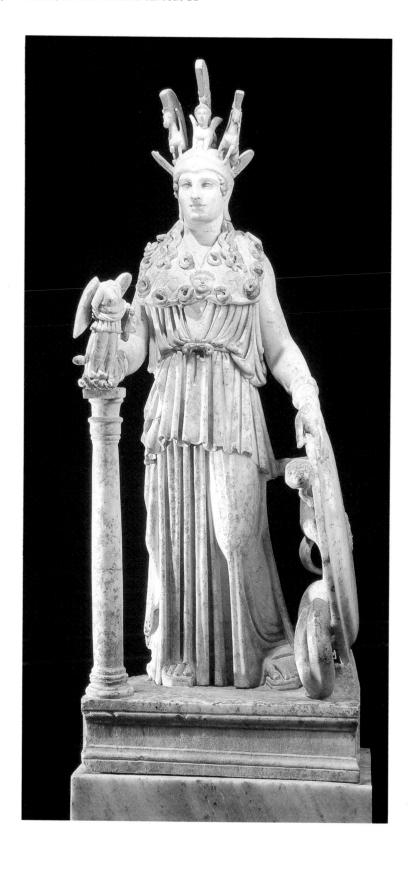

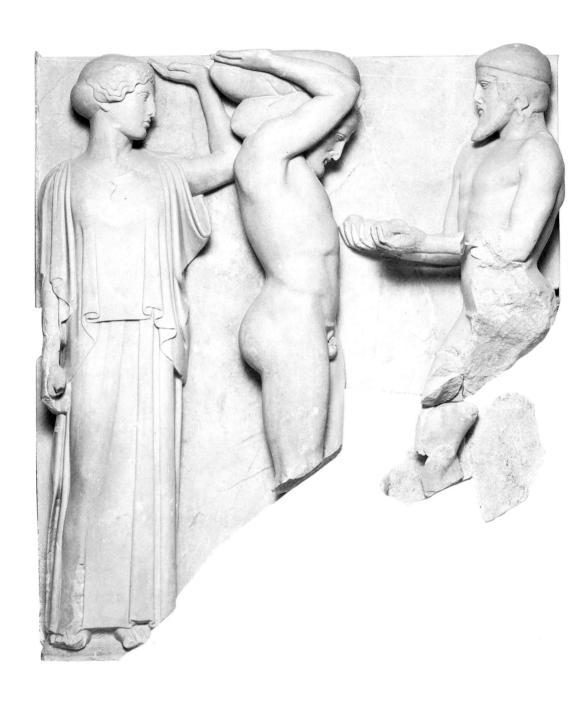

statue. There was no doubt something almost primitive and savage in some of its features, something which still linked an idol of this kind with the ancient superstitions against which the prophet Jeremiah had preached. But already these primitive ideas about the gods as formidable demons who dwelt in the statues had ceased to be the main thing. Pallas Athene, as Pheidias saw her and as he fashioned her statue, was more than the mere idol of a demon. From all accounts we know that his statue had a dignity which gave the people quite a different idea of the character and meaning of their gods. The Athene of Pheidias was like a great human being. Her power lay less in any magic spells than in her beauty. People realized at the time that the art of Pheidias had given the people of Greece a new conception of the divine.

The two great works of Pheidias, his Athene and his famous statue of Zeus in Olympia, have been irretrievably lost, but the temples in which they were placed still exist, and with them some of the decorations that were made at the time of Pheidias. The temple in Olympia is the older one; it was perhaps begun round about 470 BC and finished before 457 BC. In the squares (metopes) over the architrave the deeds of Hercules were represented. Figure 52 shows the episode when he was sent to fetch the apples of the Hesperides. That was a task which even Hercules could not, or would not, perform. He entreated Atlas, who bore the heavens on his shoulders, to do it for him and Atlas agreed on condition that Hercules would carry his burden in the meantime. On this relief Atlas is shown returning with the golden apples to Hercules, who stands taut beneath his huge load. Athene, his cunning helper in all his deeds, has put a cushion on his shoulder to make it easier for him. In her right hand she once held a metal spear. The whole story is told with a wonderful simplicity and clarity. We feel that the artist still preferred to show a figure in a straightforward attitude, from the front or side. Athene is shown squarely facing us, and only her head is turned sideways towards Hercules. It is not difficult to sense in the figures the lingering influence of the rules which governed Egyptian art. But we feel that the greatness, the majestic calm and strength which belong to Greek sculpture, are also due to this observance of ancient rules. For these rules had ceased to be a hindrance, cramping the artist's freedom. The old idea that it was important to show the structure of the body – its main hinges, as it were, which help us to realize how it all hangs together - spurred the artist on to explore the anatomy of the bones and muscles, and to build up a convincing picture of the human figure which remains visible even under the flow of the drapery. The way, in fact, in which Greek artists used the drapery to mark these main divisions of the body still shows what importance they attached to the knowledge of form. It is this balance

Hercules carrying the heavens, c. 470–460 BC

Marble fragment from the Temple of Zeus at Olympia, height 156 cm, 61½ in; Archaeological Museum, Olympia

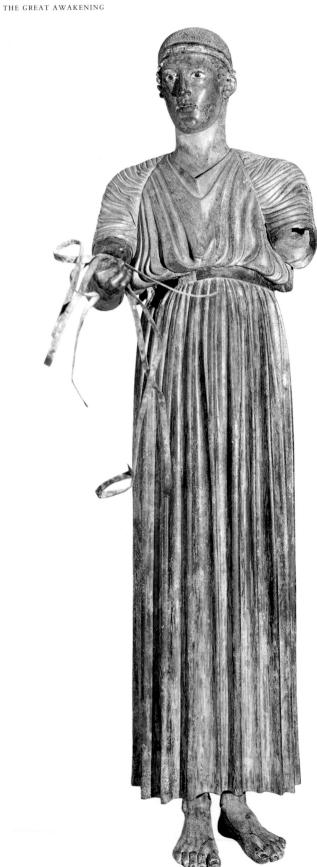

53 Charioteer, c. 475 BC Found at Delphi; bronze, height 180 cm, 71 in; Archaeological Museum, Delphi

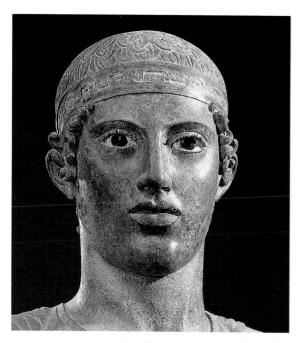

54 Detail of figure 53

between an adherence to rules and a freedom within the rules which has made Greek art so much admired in later centuries. It is for this that artists have returned again and again to the masterpieces of Greek art for guidance and for inspiration.

The type of work which Greek artists were frequently asked to do may have helped them to perfect their knowledge of the human body in action. A temple like that of Olympia was surrounded by statues of victorious athletes dedicated to the gods. To us this may seem a strange custom for, however popular our champions may be, we do not expect them to have their portraits made and presented to a church in thanksgiving for a victory achieved in the latest match.

But the great sports rallies of the Greeks, of which the Olympic Games were, of course, the most famous, were something very different from our modern contests. They were much more closely connected with the religious beliefs and rites of the people. Those who took part in them were not sportsmen – whether amateur or professional – but members of the leading families of Greece, and the victor in these games was looked upon with awe as a man whom the gods had favoured with the spell of invincibility. It was to find out on whom this blessing of victoriousness rested that the games were originally held, and it was to commemorate and perhaps to perpetuate these signs of divine grace that the winners commissioned their statues from the most renowned artists of their time.

Diggings in Olympia have unearthed a good many of the pedestals on which these famous statues rested, but the statues themselves have disappeared. They were mostly made of bronze and were probably melted down when metal became scarce in the Middle Ages. Only in Delphi has one of these statues been found, the figure of a charioteer, *figure 53*. His head, shown in *figure 54*, is amazingly different from the general idea one may easily form of Greek art when one only looks at copies. The eyes, which often look so blank and expressionless in marble statues or are empty in bronze heads, are marked in coloured stones – as they always were at that time. The hair, eyes and lips were slightly gilt, which gave an effect of richness and warmth to the whole face. And yet such a head never looked gaudy or vulgar. We can see that the artist was not out to imitate a

real face with all its imperfections but that he shaped it out of his knowledge of the human form. We do not know whether the charioteer is a good likeness – probably it is no 'likeness' at all in the sense in which we understand the word. But it is a convincing image of a human being, of wonderful simplicity and beauty.

Works like this which are not even mentioned by the classical Greek writers remind us what we must have lost in the most famous of these statues of athletes such as the 'Discobolos' (Discus thrower) by the Athenian sculptor Myron, who probably belonged to the same generation as Pheidias. Various copies of this work have been found which allow us at least to form a general idea of what it looked like, figure 55. The young athlete was represented at the moment when he is just about to hurl the heavy discus. He has bent down and swung his arm backwards so as to be able to throw with greater force. At the next moment he will spin round and let fly, supporting the throw with a turn of his body. The attitude looks so convincing that modern athletes have taken it for a model and have tried to learn from it the exact Greek style of throwing the discus. But this has proved less easy than they had hoped. They had forgotten that Myron's statue is not a 'still' from a sports film but a Greek work of art. In fact if we look at it more carefully we shall find that Myron has achieved his astonishing effect of movement mainly through a new adaptation of very ancient artistic methods. Standing in front of the statue and thinking only of its outlines, we become suddenly aware of its relation to the tradition of Egyptian art. Like the Egyptian painters, Myron has given us the trunk in front view, the legs and arms in side view; like them he has composed his picture of a man's body out of the most characteristic views of its parts. But under his hands this old and outworn formula has become something entirely different. Instead of fitting these views together into an unconvincing likeness of a rigid pose, he asked a real model to take up a similar attitude and so adapted it that it seems like a convincing representation of a body in motion. Whether or not this corresponds to the exact movement most suitable for throwing the discus is hardly relevant. What matters is that Myron conquered movement just as the painters of his time conquered space.

Of all Greek originals which have come down to us the sculptures from the Parthenon perhaps reflect this new freedom in the most wonderful way. The Parthenon, *figure 50*, was completed some twenty years after the temple of Olympia, and in that brief span of time artists had acquired an ever greater ease and facility in solving the problems of convincing representation. We do not know who the sculptors were who made these decorations of the temple, but as Pheidias made the statue of Athene in the shrine it seems likely that his workshop also provided the other sculptures.

Discobolos, c. 450 BC Roman marble copy after the bronze original by Myron, height 155 cm, 61 in; Museo Nazionale

Romano, Rome

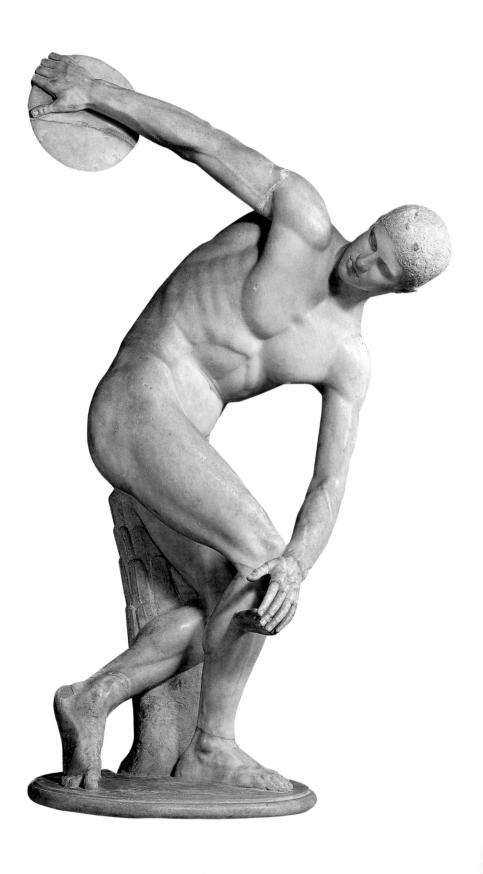

Charioteer, c. 440 BC
Detail from the marble frieze of the Parthenon;
British Museum, London

Figures 56 and 57 show fragments of the long band or frieze that ran high up round the inside of the building and represented the annual procession on the solemn festival of the goddess. There were always games and sports displays during these festivities, one of which consisted in the dangerous feat of driving a chariot and jumping on and off while the four horses galloped along. It is such a display that is shown in figure 56. At first it may be difficult to find one's way about on this fragment because the relief is very badly damaged. Not only is part of the surface broken off, but the whole of the colour has gone, which probably made the figures stand out brightly against an intensely coloured background. To us the colour and texture of fine marble is something so wonderful that we would never want to cover it with paint, but the Greeks even painted their temples with strong contrasting colours such as red and blue. But, however little may be left of the original work, it is always worth while with Greek sculptures to try to forget what is not there for the sheer joy of discovering what is left. The first we see in our fragment is the horses, four of them, one behind the other. Their heads and their legs are sufficiently well preserved to give us an idea of the mastery with which the artist contrived

Horse and horseman, c. 440 BC

Detail from the marble frieze of the Parthenon; British Museum, London

to show the structure of the bones and muscles without the whole looking stiff or dry. Soon we see that the same must also have been true of the human figures. We can imagine, from the traces that are left, how freely they moved and how clearly the muscles of their bodies stood out. Foreshortening no longer presented a great problem to the artist. The arm with the shield is drawn with perfect ease, and so is the fluttering crest of the helmet and the bulging cloak which is blown by the wind. But all these new discoveries do not 'run away' with the artist. However much he may have enjoyed this conquest of space and movement, we do not feel that he is eager to show off what he can do. Lively and spirited as the groups have become, they still fit well into the arrangement of the solemn procession which moves along the wall of the building. The artist has retained something of the wisdom of arrangement which Greek art derived from the Egyptians and from the training in geometrical patterns which had preceded the Great Awakening. It is this sureness of hand which makes every detail of the Parthenon frieze so lucid and 'right'.

Every Greek work from that great period shows this wisdom and skill in the distribution of figures, but what the Greeks of the time valued even more was something else: the new-found freedom to represent the human body in any position or movement could be used to reflect the inner life of the figures represented. We hear from one of his disciples that this is what the great philosopher Socrates, who had himself been trained as a sculptor, urged artists to do. They should represent the 'workings of the soul' by accurately observing the way 'feelings affect the body in action'.

Once more the craftsmen who painted vases tried to keep step with these discoveries of the great masters whose works are lost. Figure 58 represents the moving episode from the story of Ulysses when the hero has come home after nineteen years of absence, disguised as a beggar with crutch, bundle and bowl, and is recognized by his old nurse, who notices the familiar scar on his leg while washing his feet. The artist must have illustrated a slightly different version from the one we read in Homer (where the nurse has a different name from the one inscribed on the vase and where Eumaios the swineherd is not present); perhaps he had seen a play in which this scene was enacted, for we remember that it was in this century also that the Greek playwrights created the art of the drama. But we do not need the exact text to sense that something dramatic and moving is happening, for the glance exchanged between the nurse and the hero tells us almost more than words could. Greek artists had indeed mastered the means of conveying something of the unspoken feelings set up between people.

58

Ulysses recognized by his old nurse, 5th century BC Vase in the 'red-figured' style; height 20.5 cm, 8 in; Museo Archeologico

Nazionale, Chiusi

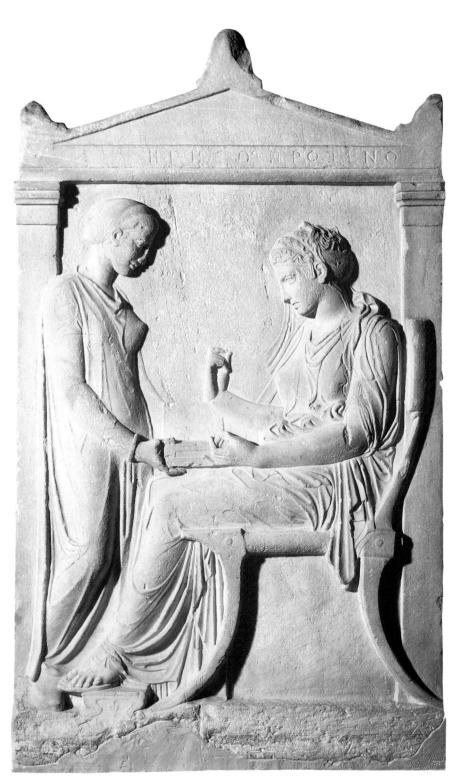

Tombstone of Hegeso, c. 400 BC Marble, height 147 cm, 58 in; National Archaeological Museum, Athens

It is this capacity to make us see the 'workings of the soul' in the poise of the body that turns a simple tombstone like figure 59 into a great work of art. The relief shows Hegeso, who is buried under the stone, as she was in life. A servant girl stands in front of her and offers her a casket, from which she seems to select a piece of jewellery. It is a quiet scene which we might compare to the Egyptian representation of Tutankhamun on his throne, with his wife adjusting his collar, page 69, figure 42. The Egyptian work, too, is wonderfully clear in its outline, but despite the fact that it dates from an exceptional period of Egyptian art it is rather stiff and unnatural. The Greek relief has shed all these awkward limitations, but it has retained the lucidity and beauty of the arrangement, which is no longer geometrical and angular but free and relaxed. The way the upper half is framed by the curve of the two women's arms, the way these lines are answered in the curves of the stool, the simple method by which Hegeso's beautiful hand becomes the centre of attention, the flow of the drapery round the forms of the body so expressive of calm - all combine to produce that simple harmony which only came into the world with Greek art of the fifth century.

Greek sculptor's workshop, c. 480 BC

Scene on the underside of a bowl in the 'red-figured' style; *left*: bronze foundry with sketches on the wall; *right*: man at work on a headless statue, the head lying on the ground; diameter 30.5 cm, 12 in; Antikensammlung, Staatliche Museen, Berlin

THE REALM OF BEAUTY

Greece and the Greek world, fourth century BC to first century AD

The great awakening of art to freedom had taken place in the hundred years between, roughly, 520 and 420 BC. Towards the end of the fifth century, artists had become fully conscious of their power and mastery, and so had the public. Though artists were still looked upon as craftsmen and, perhaps, despised by the snobs, an increasing number of people began to be interested in their work for its own sake, and not only for the sake of its religious or political functions. People compared the merits of the various 'schools' of art; that is to say, of the various methods, styles and traditions which distinguished the masters in different cities. There is no doubt that the comparison and competition between these schools stimulated the artist to ever greater efforts, and helped to create that variety which we admire in Greek art. In architecture, various styles began to be used side by side. The Parthenon had been built in the Doric style, page 83, figure 50, but in the later buildings on the Acropolis the forms of the so-called Ionic style were introduced. The principle of these temples is the same as that of the Doric ones, but the whole appearance and character are different. The building which shows it at its most perfect is the temple called the Erechtheion, figure 60. The columns of the Ionic temple are much less robust and strong. They are like slender shafts, and the capital or headpiece is no longer a simple unadorned cushion, but is richly decorated with volutes on the sides; these again seem to express the function of the part carrying the beam on which the roof rests. The whole impression of these buildings with their finely wrought details is one of infinite grace and ease.

The same character of grace and ease also marks the sculpture and painting of this period, which begins with the generation after Pheidias. Athens at this time was involved in a fearful war with Sparta, which ended her prosperity and that of Greece. In 408 BC, during a brief spell of peace, a carved balustrade was added to the small temple of the goddess of victory on the Acropolis, and its sculptures and ornaments show the change of taste towards delicacy and refinement which is also reflected in the Ionic style. The figures have been sadly mutilated, but I should like nevertheless to illustrate one of them, figure 61, to show how beautiful this broken figure still is, even without head or hands. It is the figure of a girl, one of

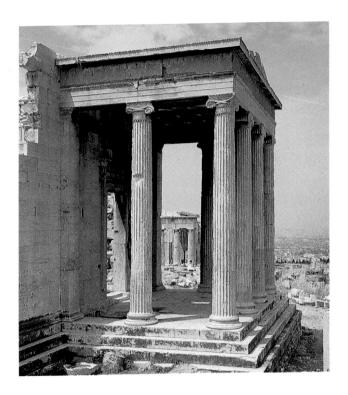

the goddesses of victory, stooping to fasten a loosened sandal as she walks. With what charm this sudden halt is portrayed, and how softly and richly the thin drapery falls over the beautiful body! We can see in these works that the artist could do whatever he wanted. He was no longer struggling with any difficulty in representing movement or foreshortening. This very ease and virtuosity made him perhaps a little self-conscious. The artist of the Parthenon frieze, pages 92-3, figures 56-7, did not seem to think overmuch about his art or what he was doing. He knew that his task was to represent a procession, and he took pains to represent it as clearly and well as he could. He was hardly conscious of the fact that he was a great master of whom old and young alike would still be talking thousands of years later. The frieze of the Victory temple shows, perhaps, the beginning of a change of attitude. This artist was proud of his immense power, as well he might be. And so, gradually, during the fourth century, the approach to art changed. Pheidias' statues of gods had been famous all over Greece as representations of gods. The great temple statues of the fourth century earned their reputation more by virtue of their beauty as works of art. The educated Greeks now discussed paintings and statues as they discussed poems and plays; they praised their beauty or criticized their form and conception.

The Erechtheion, Acropolis, Athens, c. 420–405 BC An Ionic temple

Goddess of victory, 408 BC From the balustrade round the Temple of Victory in Athens; marble, height 106 cm, 41½ in; Acropolis Museum, Athens

Praxiteles
Hermes with the young
Dionysus, c. 340 BC
Marble, height 213 cm,
84 in; Archaeological
Museum, Olympia

63 Detail of figure 62

The greatest artist of that century. Praxiteles, was above all famed for the charm of his work and for the sweet and insinuating character of his creations. His most celebrated work, whose praise was sung in many poems, represented the goddess of Love, the youthful Aphrodite, stepping into her bath. But this work has disappeared. One work which was found in Olympia in the nineteenth century is thought by many to be an original by his hands, figures 62-3. But we cannot be sure. It may only be an accurate marble copy after a bronze statue. It represents the god Hermes holding the young Dionysus on his arm and playing with him. If we look back at page 79, figure 47, we see what an enormous distance

Greek art had travelled in two hundred years. In the work of Praxiteles all traces of rigidity have gone. The god stands before us in a relaxed pose which does not impair his dignity. But if we think about the way in which Praxiteles has achieved his effect, we begin to realize that even then the lesson of ancient art had not been forgotten. Praxiteles, too, takes care to show us the hinges of the body, to make us understand its working as clearly as possible. But he can now do all that without keeping his statue stiff and lifeless. He can show the muscles and bones swelling and moving under the soft skin, and can give the impression of a living body in all its grace and beauty. Nevertheless, it is necessary to understand that Praxiteles and the other Greek artists achieved this beauty through knowledge. There is no living body quite as symmetrical, well-built and beautiful as those of the Greek statues. People often think that what the artists did was to look at many models and to leave out any feature they did not like; that they started by carefully copying the appearance of a real man, and then beautified it by omitting any irregularities or traits which did not conform to their idea of a perfect body. They say that Greek artists 'idealized' nature, and they think of it in terms of a photographer who touches up a portrait by deleting small blemishes. But a touched-up photograph and an idealized statue usually lack character and vigour. So much has been left out and deleted that little remains but a pale and insipid ghost of the

Apollo Belvedere, c. 350 BC Roman marble copy afte a Greek original, height

224 cm, 88¼ in; Museo Pio Clementino, Vatical

model. The Greek approach was really exactly the opposite. Through all these centuries, the artists we have been discussing were concerned with infusing more and more life into the ancient husks. In the time of Praxiteles their method bore its ripest fruits. The old types had begun to move and breathe under the hands of the skilful sculptor, and they stand before us like real human beings, and yet as beings from a different, better world. They are, in fact, beings from a different world, not because the Greeks were healthier or more beautiful than other men – there is no reason to think they were – but because art at that moment had reached a point at which the typical and the individual were poised in a new and delicate balance.

65

c. 200 BC

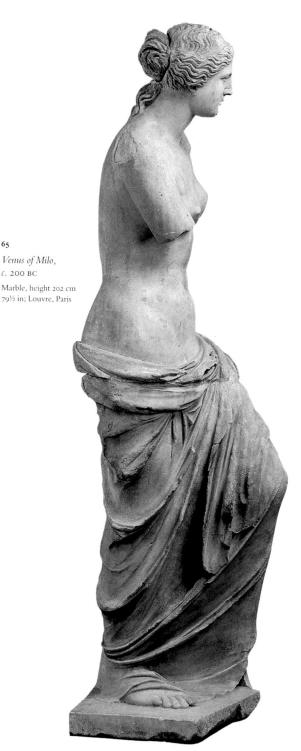

Many of the most famous works of classical art which were admired in later times as representing the most perfect types of human beings are copies or variants of statues which were created in this period, the middle of the fourth century BC. The Apollo Belvedere, figure 64, shows the ideal model of a man's body. As he stands before us in his impressive pose, holding up the bow in the extended arm and with his head turned sideways as if he were following the arrow with his eyes, we have no difficulty in recognizing the faint echo of the ancient scheme in which each part of the body was given its most characteristic view. Among the famous classical statues of Venus, the Venus of Milo (so called because it was found on the island of Melos) is perhaps the best known, figure 65. Probably it belonged to a group of Venus and Cupid which was made in a somewhat later period, but which used the achievements and the methods of Praxiteles. It was designed to be seen from the side (Venus was extending her arms towards Cupid), and again we can admire the clarity and simplicity with which the artist modelled the beautiful body, the way he marked its main divisions without ever becoming harsh or vague.

Of course, this method of creating beauty by making a general and schematic figure more and more lifelike until the marble's surface seems to live and breathe has one drawback. It was possible to create convincing human types by this means, but would this method ever lead to the

representation of real individual human beings? Strange as it may sound to us, the idea of a portrait, in the sense in which we use the word, did not occur to the Greeks until rather late in the fourth century. True, we hear of portraits made in earlier times, pages 89-90, figure 54, but these statues were probably not very good likenesses. A portrait of a general was little more than a picture of any good-looking soldier with a helmet and a staff. The artist never reproduced the shape of his nose, the furrows of his brow or his individual expression. It is a strange fact, which we have not yet discussed, that Greek artists in the works we have seen have avoided giving the heads a particular expression. This is really more astonishing than it seems at first sight, because we can hardly scribble any simple face on a scrap of paper without giving it some marked (usually a funny) expression. The heads of Greek statues or paintings of the fifth century, of course, are not expressionless in the sense of looking dull or blank, but their features never seem to express any strong emotion. It was the body and its movements which were used by these masters to express what Socrates had called 'the workings of the soul', pages 94-5, figure 58, because they sensed that the play of features would distort and destroy the simple regularity of the head.

In the generation after Praxiteles, towards the end of the fourth century, this restraint was gradually lifted and artists discovered means of animating the features without destroying their beauty. More than that: they learned how to seize the workings of the individual soul, the particular character of a physiognomy, and to make portraits in our sense of the word. It was in the time of Alexander that people started to discuss this new art of portraiture. A writer of that period, satirizing the irritating habits of flatterers and toadies, mentions that they always burst out in loud praise of the striking likeness of their patron's portrait. Alexander himself preferred to be portrayed by his court sculptor Lysippus, the most celebrated artist of the day, whose faithfulness to nature astonished his contemporaries. His portrait of Alexander is thought to be reflected in a free copy, figure 66, which shows how much art had changed since the time of the Delphic charioteer, or even since the time of Praxiteles, who was only a generation older than Lysippus. Of course, the trouble with all ancient portraits is that we really cannot pronounce on their likeness - much less, in fact, than the flatterer in the story. Perhaps if we could see a snapshot of Alexander we should find it quite unlike the bust. Possibly the statues of Lysippus resembled a god much more than they did the real conqueror of Asia. But so much we can say: a man such as Alexander, a restless spirit, immensely gifted but rather spoilt by success, might have looked like this bust with its upraised eyebrows and its lively expression.

The foundation of an empire by Alexander was an enormously

66

Head of Alexander the Great, c. 325–300 BC Marble copy after the original by Lysippus, height 41 cm, 161/2 in; Archaeological Museum, Istanbul Leaden

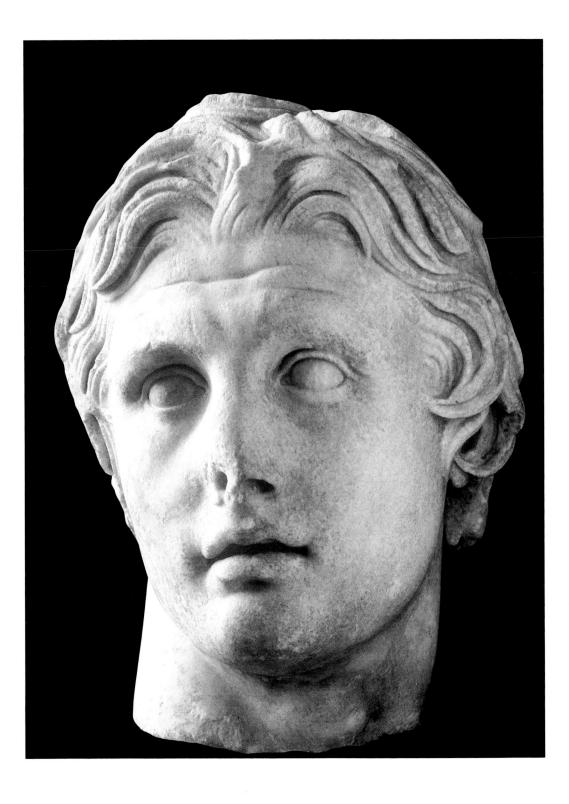

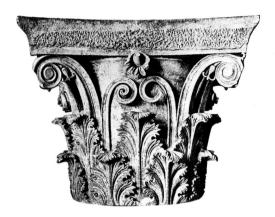

important event for Greek art, for thereby it developed from being the concern of a few small cities into the pictorial language of almost half the world. This change was bound to affect its character. We usually refer to this art of the later period not as Greek art, but as Hellenistic art, because that is the name commonly given

*'Corinthian' capital,*c. 300 BC
Archaeological Museum,
Epidaurus

to the empires founded by Alexander's successors on eastern soil. The rich capital cities of these empires, Alexandria in Egypt, Antioch in Syria and Pergamon in Asia Minor, made different demands on the artists from those to which they had been accustomed in Greece. Even in architecture the strong and simple forms of the Doric style and the easy grace of the Ionic style were not enough. A new form of column was preferred, which had been invented early in the fourth century and which was called after the wealthy merchant city of Corinth, *figure 67*. In the Corinthian style, foliage was added to the Ionic spiral volutes to decorate the capital, and there are generally more and richer ornaments all over the building. The luxurious mode suited the sumptuous buildings which were laid out on a vast scale in the newly founded cities of the East. Few of them have been preserved, but what remains from later periods gives us an impression of great magnificence and splendour. The styles and inventions of Greek art were applied on the scale, and to the traditions, of the Oriental kingdoms.

I have said that the whole of Greek art was bound to undergo a change in the Hellenistic period. This change can be noticed in some of the most famous sculptures of that age. One of them is an altar from the city of Pergamon which was erected around 160 BC, figure 68. The group on it represents the struggle between the gods and the Giants. It is a magnificent work, but we look in vain for the harmony and refinement of early Greek sculpture. The artist was obviously aiming at strong dramatic effects. The battle rages with terrible violence. The clumsy Giants are overwhelmed by the triumphant gods, and they look up in agony and frenzy. Everything is full of wild movement and fluttering drapery. To make the effect still more striking, the relief is no longer set flat on the wall but is composed of almost free-standing figures which, in their struggle, seem to overflow on to the steps of the altar as if they hardly troubled about where they belonged. Hellenistic art loved such wild and vehement works; it wished to be impressive, and impressive it certainly is.

68

The altar of Zeus from Pergamon, c. 164–156 BC

Marble; Pergamonmuseum, Staatliche Museen, Berlin

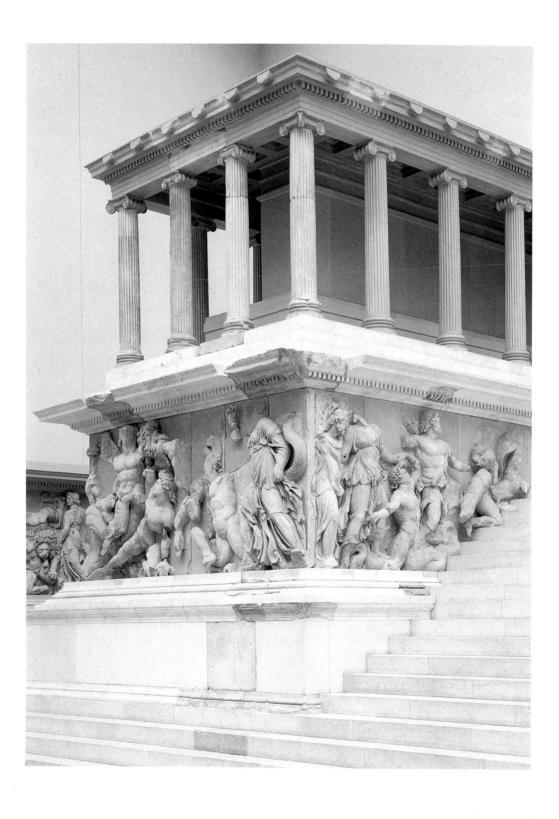

Hagesandros,
Athenodoros and
Polydoros of Rhodes
Laocoön and his sons,
c. 175–50 BC
Marble, height 242 cm,
95½ in; Museo Pio
Clementino, Vatican

Some of the works of classical sculpture which have enjoyed the greatest fame in later times were created in the Hellenistic period. When the group of the Laocoön, figure 69, came to light in 1506, artists and art-lovers were quite overwhelmed by the effect of this tragic group. It represents the terrible scene which is also described in Virgil's Aeneid: the Trojan priest Laocoön has warned his compatriots against accepting the wooden horse in which Greek soldiers were hiding. The gods who see their plans of destroying Troy thwarted send two gigantic snakes from the sea which catch the priest and his two unfortunate sons in their coils and suffocate them. It is one of the stories of senseless cruelty perpetrated by the Olympians against poor mortals which are quite frequent in Greek and Latin mythologies. One would like to know how the story struck the Greek artist who conceived this impressive group. Did he want us to feel the horror of a scene in which an innocent victim is made to suffer for having spoken the truth? Or did he mainly want to show off his own power of representing a terrifying and somewhat sensational fight between man and beast? He had every reason to be proud of his skill. The way in which the muscles of the trunk and the arms convey the effort and the suffering of the hopeless struggle, the expression of pain in the face of the priest, the helpless wriggling of the two boys and the way all this turmoil and movement are frozen into a permanent group have excited admiration ever since. But I cannot help suspecting sometimes that this was an art which was meant to appeal to a public which also enjoyed the horrible sights of the gladiatorial fights. Perhaps it is wrong to blame the artist for that. The fact is probably that by this time, the period of Hellenism, art had largely lost its old connection with magic and religion. Artists became interested in the problems of their craft for its own sake, and the problem of how to represent such a dramatic contest with all its movement, its expression and its tension, was just the type of task which would test an artist's skill. The rights or wrongs of Laocoön's fate may not have occurred to the sculptor at all.

It was in this time, and in this atmosphere, that rich people began to collect works of art, to have famous ones copied if they could not get hold of originals, and to pay fabulous prices for those which they could obtain. Writers began to be interested in art and wrote about the artists' lives, collected anecdotes about their oddities and composed guide-books for tourists. Many of the masters most famous among the ancients were painters rather than sculptors, and we know nothing about their works except what we find in those extracts from classical art books which have come down to us. We know that these painters, too, were interested in the special problems of their craft rather than in their art serving a religious purpose. We hear of masters who specialized in subjects from everyday life, who painted barbers' shops or scenes from the theatre, but all these paintings are lost to us. The

Maiden gathering flowers, 1st century AD Detail of a wall-painting from Stabiae; Museo Archeologico Nazionale, Naples

71

Head of a faun, 2nd century BC

Detail of a wall-painting from Herculaneum;

Museo Archeologico

Nazionale, Naples

only way in which we can form some idea of the character of ancient painting is by looking at the decorative wall-paintings and mosaics which have come to light in Pompeii and elsewhere. Pompeii was a well-to-do country town, and was buried beneath the ashes of Mount Vesuvius when it erupted in 79 AD. Almost every house and villa in that town had paintings on its walls, painted columns and vistas, imitations of framed pictures and of the stage. These paintings are, of course, not all masterpieces, though it is astonishing to see how much good work there was in such a small and rather unimportant town. We should hardly cut so good a figure if one of our seaside resorts were to be excavated by posterity. The interior decorators of Pompeii and neighbouring cities such as Herculaneum and Stabiae obviously drew freely on the stock of inventions made by the great Hellenistic artists. Among much that is humdrum we sometimes discover a figure of such exquisite beauty and grace as figure 70, which represents one of the Hours, picking a blossom as if in a dance. Or we find such details as the head of a faun, figure 71, from another painting, which gives us an idea of the mastery and freedom which these artists had acquired in the handling of expression.

Nearly every kind of thing that would go into a picture is to be found

in these decorative wall-paintings: pretty still lifes, for instance, such as two lemons with a glass of water, and pictures of animals. Even landscape paintings existed there. This was perhaps the greatest innovation of the Hellenistic period. Ancient Oriental art had no use for landscapes except as settings for their scenes of human life or of military campaigns. For Greek art at the time of Pheidias or Praxiteles, man remained the main subject of the artist's interest. In the Hellenistic period, the time when poets like Theocritus discovered the charm of simple life among shepherds, artists also tried to conjure up the pleasures of the countryside for sophisticated town-dwellers. These paintings are not actual views of particular country houses

or beauty-spots. They are rather collections of everything which makes up an idyllic scene: shepherds and cattle, simple shrines and distant villas and mountains, figure 72. Everything was charmingly arranged in these pictures, and all the set-pieces were looking their best. We really feel that we are looking at a peaceful scene. Nevertheless, even these works are much less realistic than we might think at first glance. If we were to start asking awkward questions, or try to draw a map of the locality, we should soon find out that it could not be done. We do not know how great the distance between the shrine and the villa is supposed to be, nor how near or how far the bridge from the shrine. The fact is that even Hellenistic artists did not know what we call the laws of perspective. The famous avenue of poplars, which recedes to a vanishing point and which so many of us drew at school, was not then a standard task. Artists drew distant things small, and near or important things large, but the law of regular diminution of objects as they become more distant, the fixed framework in which we can represent a view, was not adopted by classical antiquity. Indeed, it took more than another thousand years before it was applied. Thus even the latest, freest and most confident works of ancient art still preserve at

72

Landscape, 1st century

AD

Wall-painting; Villa

Albani, Rome

least a remnant of the principle which we discussed in our description of Egyptian painting. Even here, knowledge of the characteristic outline of individual objects counts for as much as the actual impression received through the eye. We have long recognized that this quality is not a fault in works of art, to be regretted and looked down upon, but that it is possible to achieve artistic perfection within any style. The Greeks broke through the rigid taboos of early Oriental art, and went out on a voyage of discovery to add more and more features from observation to the traditional images of the world. But their works never look like mirrors in which any odd corner of nature is reflected. They always bear the stamp of the intellect which made them.

Greek sculptor at work, 1st century BC Impression from a Hellenistic ringstone; 1.3 × 1.2 cm, ½ × ½ in; Metropolitan Museum of Art, New York

WORLD CONQUERORS

Romans, Buddhists, Jews and Christians, first to fourth century AD

We have seen that Pompeii, which was a Roman town, contained many reflections of Hellenistic art. For art remained more or less unchanged while the Romans conquered the world and founded their own empire on the ruins of the Hellenistic kingdoms. Most artists who worked in Rome were Greeks, and most Roman collectors bought works of the great Greek masters, or copies of them. Nevertheless art did change, to some extent, when Rome became mistress of the world. The artists were given new tasks and had to adapt their methods accordingly. The most outstanding achievement of the Romans was probably in civil engineering. We all know about their roads, their aqueducts, their public baths. Even the ruins of these buildings still look extremely impressive. One feels like an ant when walking in Rome between their enormous pillars. It was, in fact, these ruins which made it impossible for later centuries to forget 'the grandeur that was Rome'.

The most famous of these Roman buildings is, perhaps, the huge arena known as the Colosseum, *figure 73*. It is a characteristic Roman building, which excited much admiration in later days. On the whole it is a utilitarian structure, with three storeys of arches, one above the other, to support the seats of the vast amphitheatre inside. But in front of these arches the Roman architect has put a kind of screen of Greek forms. Indeed, he has applied all the three styles of building used for Greek temples. The ground floor is a variation on the Doric style – even the metopes and triglyphs are preserved; the second storey has Ionic, and the third and fourth Corinthian half-columns. This combination of Roman structures with Greek forms or 'orders' had an enormous influence on later architects. If we look round in our own towns we may easily see examples of this influence.

Perhaps none of their architectural creations made a more lasting impression than the triumphal arches the Romans set up all over their Empire in Italy, France, *figure 74*, North Africa and Asia. Greek architecture had generally been composed in identical units and the same is even true of the Colosseum; but the triumphal arches use the orders to frame and accent the large central gateway and to flank it by narrower

73The Colosseum, Rome, c. 80 ADA Roman amphitheatre

74 Triumphal arch of Tiberius, Orange, Southern France, c. 14–37 AD

openings. It was an arrangement that could be used for architectural composition much as a chord is used in music.

The most important feature in Roman architecture, however, is the use of arches. This invention had played little or no part in Greek buildings though it may have been known to Greek architects. To construct an arch out of separate wedge-formed stones is quite a difficult feat of engineering. Once this art is mastered the builder can use it for increasingly bold designs. He can span the pillars of a bridge or of an aqueduct, or he can even make use of this device for constructing a vaulted roof. The Romans became great experts in the art of vaulting by various technical devices.

75
Interior of the Pantheon,
Rome, c. 130 AD
Painting by G. P. Pannini;
Statens Museum for
Kunst, Copenhagen

76

Emperor Vespasian,
c. 70 AD

Marble, height 135 cm,
53¼ in; Museo
Archeologico Nazionale,
Naples

The most wonderful of these buildings is the Pantheon or temple of all the gods. It is the only temple of classical antiquity which always remained a place of worship – it was converted into a church in the early Christian era and was therefore never allowed to fall into ruin. Its interior, figure 75, is a huge round hall with a vaulted roof and a circular opening at the top through which one sees the open sky. There is no other window, but the whole room receives ample and even light from above. I know few buildings which convey a similar impression of serene harmony. There is no feeling of heaviness. The enormous dome seems to hover freely over you like a second dome of heaven.

It was typical of the Romans to take from Greek architecture what they liked, and to apply it to their own needs. They did the same in all fields. One of their principal needs was for good, lifelike portraits. Such portraits had played a part in the early religion of the Romans. It had been

customary to carry wax images of ancestors in funeral processions. There is little doubt that this usage had been connected with the belief that the likeness preserves the soul, which we know from ancient Egypt. Later, when Rome became an empire, the bust of the emperor was still looked upon with religious awe. We know that every Roman had to burn incense in front of this bust in token of his loyalty and allegiance, and we know that the persecution of Christians began because of their refusal to comply with this demand. The strange thing is that, despite this solemn significance of portraits, the Romans allowed their artists to make them more lifelike and uncomplimentary than anything the Greeks had attempted. Perhaps they sometimes used death-masks and thus acquired their astounding knowledge of the structure and features of the human head. At any rate, we know Pompey, Augustus, Titus, or Nero, almost as if we had seen their faces on the screen. There is no flattery in the bust of Vespasian, figure 76 – nothing to mark him out as a god. He might be any wealthy banker or owner of a shipping line. Nevertheless, there is nothing petty in these Roman portraits. Somehow the artists succeeded in being lifelike without being trivial.

77 Trajan's Column, Rome, c. 114 AD

78
Detail of figure 77; scenes showing the fall of a town (top), a battle against the Dacians (centre) and soldiers cutting corn outside a fort (bottom)

Another new task which the Romans set the artist revived a custom which we know from the ancient Orient, page 72, figure 45. They, too, wanted to proclaim their victories and to tell the story of their campaigns. Trajan, for instance, erected a huge column to show a whole picture chronicle of his wars and victories in Dacia (the modern Romania). There we see the Roman legionaries foraging, fighting and conquering, figure 78. All the skill and achievements of centuries of Greek art were used in these feats of war reporting. But the importance which the Romans attached to an accurate rendering of all details, and to a clear narrative which would impress the feats of the campaign on the stay-at-homes, rather changed the character of art. The main aim was no longer that of

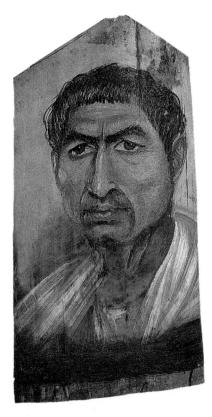

harmony, beauty or dramatic expression. The Romans were a matter-of-fact people, and cared less for fancy goods. Yet their pictorial methods of telling the deeds of a hero proved of great value to the religions which came into contact with their far-flung empire.

During the centuries after Christ, Hellenistic and Roman art completely displaced the arts of the Oriental kingdoms, even in their own former strongholds. Egyptians still buried their dead as mummies, but instead of adding their likenesses in the Egyptian style, they had them painted by artists who knew all the tricks of Greek portraiture, *figure 79*. These portraits, which were certainly made by humble craftsmen at a

low price, still astonish us by their vigour and realism. There are few works of ancient art which look so fresh and 'modern' as these.

The Egyptians were not the only ones to adapt the new methods of art to their religious needs. Even in far-distant India, the Roman way of telling a story, and of glorifying a hero, was adopted by artists who set themselves the task of illustrating the story of a peaceful conquest, the story of the Buddha.

The art of sculpture had flourished in India long before this Hellenistic influence reached the country; but it was in the frontier region of Gandhara that the figure of Buddha was first shown in the reliefs which became the model for later Buddhist art. *Figure 80* represents the episode from the Buddha legend of The Great Renunciation. The young Prince Gautama is leaving the palace of his parents to become a hermit in the wilderness. He thus addresses his favourite charger Kanthaka: 'My dear Kanthaka, please carry me once more for this one night. When I shall have become Buddha with your help, I shall bring salvation to the world of gods and men.' If Kanthaka had only so much as neighed or made a sound with his hoofs the city would have been roused and the prince's departure discovered. So the gods muffled his voice and placed their hands under his hooves wherever he stepped.

79

Portrait of a man, c. 100 AD

From a mummy found at Hawara, Egypt; painted on hot wax, 33×17.2 cm, $13 \times 6\%$ in; British Museum, London

80

Gautama (Buddha) leaving his home, c. 2nd century AD

Found at Loriyan Tangai, Pakistan (ancient Gandhara); black schist, 48 × 54 cm, 19 × 21½ in; Indian Museum, Calcutta

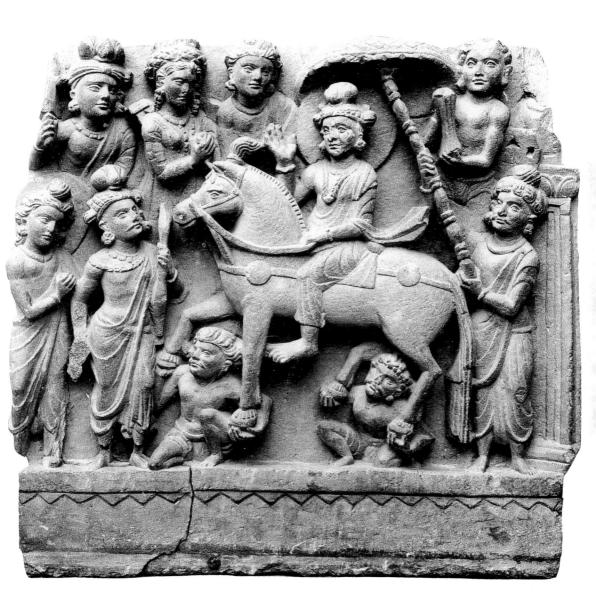

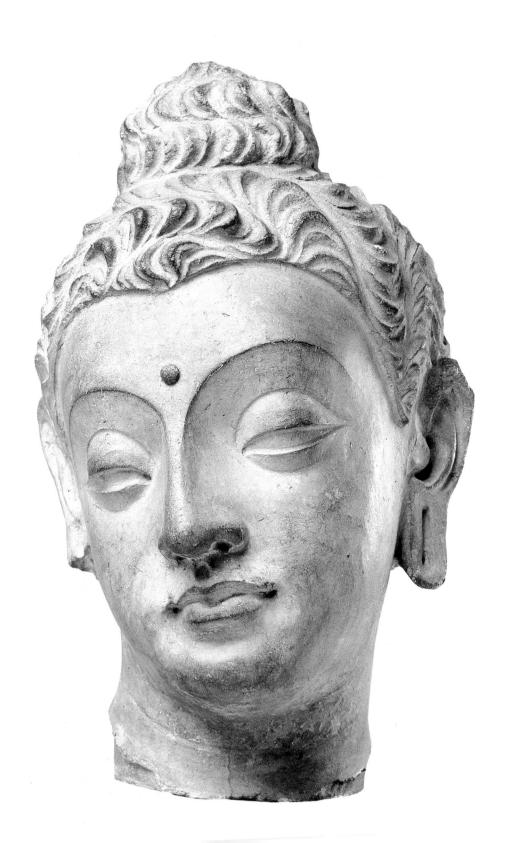

Greek and Roman art, which had taught men to visualize gods and heroes in beautiful form, also helped the Indians to create an image of their saviour. The beautiful head of the Buddha, with its expression of deep repose, was also made in this frontier region of Gandhara, figure 81.

Yet another Oriental religion that learned to represent its sacred stories for the instruction of believers was that of the Jews. Jewish Law actually forbade the making of images for fear of idolatry. Nevertheless, the Jewish colonies in eastern towns took to decorating the walls of their synagogues with stories from the Old Testament. One of these paintings was discovered in recent times in a small Roman garrison in Mesopotamia called Dura-Europos. It is not a great work of art by any means, but it is an interesting document from the third century AD. The very fact that the style seems clumsy and that the scene looks rather flat and primitive is not without interest, figure 82. It represents Moses striking water from the rock. But it is not so much an illustration of the biblical account as an explanation, in pictures, of its significance to the Jewish people. That may be the reason why Moses is represented as a tall figure standing in front of the Holy Tabernacle in which we can still discern the seven-branched candlestick. In order to signify that each tribe of Israel received its share of the miraculous water the artist has shown twelve rivulets, each flowing to a small figure standing before a tent. The artist was doubtless not very skilful, and that accounts for his simple methods. But perhaps he was not really much concerned with drawing lifelike figures. The more lifelike they were, the more they sinned against the Commandment forbidding images. His main intention was to remind the beholder of the occasions when God

4th-5th century AD Found at Hadda,

Afghanistan (ancient Gandhara); lime plaster with traces of pigment, height 20 cm, 111/2 in: Victoria and Albert Museum, London

Head of the Buddha,

from the rock, 245-56 AD Wall-painting; synagogue

Moses striking water

at Dura-Europos, Syria

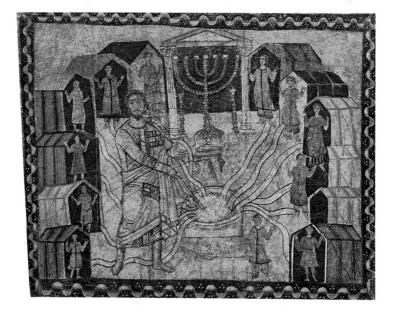

had manifested His power. The humble wall-painting from the Jewish synagogue is of interest to us, because similar considerations began to influence art when the Christian religion spread from the East and also took art into it service.

When Christian artists were first called upon to represent the Saviour and His apostles it was again the tradition of Greek art which came to their aid. Figure 83 shows one of the earliest representations of Christ, from the fourth century AD. Instead of the bearded figure to which we have become accustomed through later illustrations, we see Christ in youthful beauty, enthroned between St Peter and St Paul, who look like dignified Greek philosophers. There is one detail, in particular, which reminds us how closely such a representation is still linked with the methods of pagan Hellenistic art: to indicate that Christ is enthroned above the heavens the sculptor has made His feet rest on the canopy of the firmament, held aloft by the ancient god of the sky.

The origins of Christian art go even farther back than this example, but the earliest monuments never show Christ Himself. The Jews of Dura had painted scenes from the Old Testament in their synagogue, not so much to adorn it but rather to tell the sacred tale in visible form. The artists who

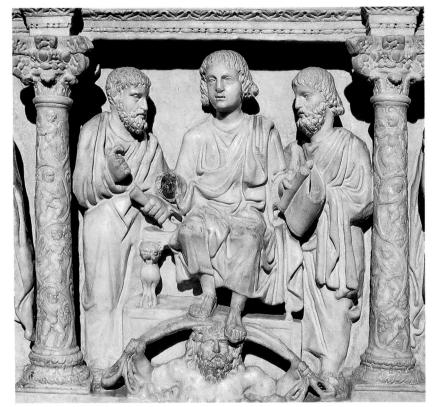

Christ with St Peter and St Paul, c. 389 AD Marble relief from the sarcophagus of Junius Bassus; crypt of St Peter's, Rome

84

The three men in the fiery furnace, 3rd century AD

Wall-painting; Priscilla Catacomb, Rome

were first called upon to paint images for Christian places of burial – the Roman catacombs – acted very much in the same spirit. Paintings such as that of the 'Three men in the fiery furnace', figure 84, probably from the third century AD, show that these artists were familiar with the methods of Hellenistic painting used in Pompeii. They were quite capable of conjuring up the idea of a human figure with a few rough strokes of the brush. But we also feel that these effects and tricks did not interest them very much. The picture no longer existed as a beautiful thing in its own right. Its main purpose was to remind the faithful of one of the examples of God's mercy and power. We read in the Bible (Daniel iii) of three high Jewish officials under King Nebuchadnezzar who refused to fall down and worship on a given signal when a gigantic golden image of the King was set up in the plain of Dura in the province of Babylon. Like so many Christians of the period when these paintings were made, they had to pay the penalty for their refusal. They were thrown into a fiery furnace 'in their coats, their hosen, and their hats'. But, lo, the fire had no power upon their bodies 'nor was an hair of their heads singed, neither were their coats changed'. The Lord 'sent His angel and delivered His servants'.

We need only imagine what the master of the Laocoön, *page 110*, *figure 69*, would have made of such a subject to realize the different direction art was taking. The painter in the catacombs did not want to represent a dramatic scene for its own sake. To present the consoling and inspiring example of fortitude and salvation it was quite sufficient if the three men in their Persian dress, the flames and the dove – a symbol of Divine help – were recognizable. Everything which was not strictly relevant was better left out. Once more ideas of clarity and simplicity began to outweigh ideals

85

Portrait of an official from Aphrodisias, c. 400 AD

Marble, height 176 cm
69¼ in; Archaeological Museum, Istanbul

of faithful imitation. Yet there is something touching in the very effort which the artist made to tell his story as clearly and simply as possible. These three men seen from the front, looking at the beholder, their hands raised in prayer, seem to show that mankind had begun to concern itself with other things besides earthly beauty.

It is not only in religious works of the period of the decline and fall of the Roman Empire that we can detect something of that shifting of interest. Few artists seemed to care much for what had been the glory of Greek art, its refinement and harmony. Sculptors no longer had the patience to work marble with a chisel, and to treat it with that delicacy and taste which had been the pride of the Greek craftsmen. Like the painter of the catacomb picture, they used more rough-and-ready methods, such as, for instance, a mechanical drill with which to mark the principal features of a face or a body. It has often been said that ancient art declined in these years, and it is certainly true that many secrets of the best period were lost in the general turmoil of wars, revolts and invasions. But we have seen that this loss in skill is not the whole story. The point is that artists at this time seemed no longer satisfied with the mere virtuosity of the Hellenistic period, and tried to achieve new effects. Some of the portraits of this period, the fourth and fifth centuries AD in particular, show perhaps most clearly what it was these artists aimed at, figure 85. To a Greek of the time of Praxiteles these works would have looked crude and barbaric. Indeed, the heads are not beautiful by any common standards. A Roman, used to the striking likenesses of portraits such as that of Vespasian, page 121, figure 76, might have dismissed them as of poor workmanship. And yet, to us, these figures seem to have a life of their own, and a very intense expression which is due to the firm marking of the features and the care bestowed on such traits as the part around the eyes and the furrows of the brow. They portray the people who witnessed, and finally accepted, the rise of Christianity, which meant the end of the ancient world.

A painter of 'funeral portraits' in his workshop, sitting beside his paintbox and easel, c. 100 AD From a painted sarcophagus found in

the Crimea

ADRONG MARINE

A PARTING OF WAYS

Rome and Byzantium, fifth to thirteenth century

When, in the year 311 AD, the Emperor Constantine established the Christian Church as a power in the State, the problems with which it saw itself confronted were enormous. During the periods of persecution there had been no need, and indeed no possibility, of building public places of worship. The churches and assembly halls that did exist were small and inconspicuous. But once the Church had become the greatest power in the realm, its whole relationship to art had to be reconsidered. The places of worship could not be modelled on the ancient temples, for their function was entirely different. The interior of the temple was usually only a small shrine for the statue of the god. Processions and sacrifices took place outside. The church, on the other hand, had to find room for the whole congregation that assembled for service when the priest read Mass at the high altar, or delivered his sermon. Thus it came about that churches were not modelled on pagan temples, but on the type of large assembly halls which had been known in classical times under the name of 'basilicas', which means roughly 'royal halls'. These buildings were used as covered market-halls and public law-courts, and mainly consisted of large, oblong halls with narrower, lower compartments on the longer sides, divided from the main hall by rows of columns. At the far end there was often room for a semicircular dais (or apse), where the chairman of the meeting, or the judge, could take his seat. The mother of the Emperor Constantine erected such a basilica to serve as a church, and so the term established itself for churches of this type. The semicircular niche or apse would be used for the high altar, towards which the eyes of the worshippers were directed. This part of the building, where the altar stood, came to be known as the choir. The main central hall, where the congregation assembled, was known later as the nave, which really means 'ship', while the lower compartments at the side were called side-aisles, which means 'wings'. In most of the basilicas, the lofty nave was simply roofed with timber, and the beams of the loft were visible. The side-aisles were often flat-roofed. The columns which separated the nave from the aisles were often sumptuously decorated. None of the earliest basilicas has remained quite unchanged, but despite the alterations and renovations made in the

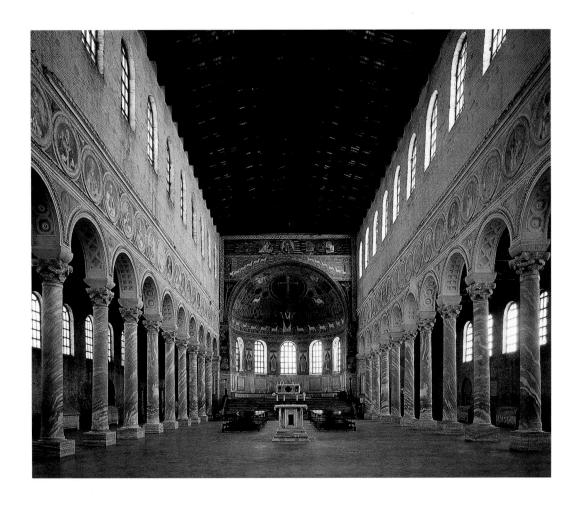

course of the 1,500 years since that time, we can still form an idea of what these buildings generally looked like, *figure 86*.

The question of how to decorate these basilicas was a much more difficult and serious one, because here the whole issue of the image and its use in religion came up again and caused very violent disputes. On one thing nearly all early Christians were agreed: there must be no statues in the House of God. Statues were too much like those graven images and heathen idols that were condemned in the Bible. To place a figure of God, or of one of His saints, on the altar seemed altogether out of the question. For how would the poor pagans who had just been converted to the new faith grasp the difference between their old beliefs and the new message, if they saw such statues in churches? They might too easily have thought that such a statue really 'represented' God, just as a statue by Pheidias was thought to represent Zeus. Thus they might have found it even more difficult to grasp the message of the one Almighty and Invisible God. in whose semblance we are made. But, although all devout Christians objected to large lifelike statues, their ideas about paintings differed a good deal. Some thought them useful because they helped to remind the congregation of the teachings they had received, and kept the memory of these sacred episodes alive. This view was mainly taken in the Latin, Western part of the Roman Empire. Pope Gregory the Great, who lived at the end of the sixth century AD, took this line. He reminded the people who were against all paintings that many members of the Church could neither read nor write, and that, for the purpose of teaching them, these images were as useful as the pictures in a picture-book are for children. 'Painting can do for the illiterate what writing does for those who can read,' he said.

It was of immense importance for the history of art that such a great authority had come out in favour of painting. His saying was to be quoted again and again whenever people attacked the use of images in churches. But it is clear that the type of art which was thus admitted was of a rather restricted kind. If Gregory's purpose was to be served, the story had to be told as clearly and simply as possible, and anything that might divert attention from this main and sacred aim should be omitted. At first, artists still used the methods of story-telling that had been developed by Roman art, but gradually they came to concentrate more and more on what was strictly essential. *Figure 87* shows a work in which these principles have been applied with the greatest consistency. It comes from a basilica in Ravenna, which was then, round about 500 AD, a great seaport and the capital city on Italy's east coast. It illustrates the story from the Gospels in which Christ fed five thousand people on five loaves and two fishes. A Hellenistic artist might have seized the opportunity to portray a large crowd of people in

Basilica of S. Apollinare in Classe, Ravenna, c. 530 AD An early Christian basilica a gay and dramatic scene. But this master chose a very different method. His work is not a painting done with deft strokes of the brush – it is a mosaic, laboriously put together, of stone or glass cubes which yield deep, full colours and give to the church interior, covered with such mosaics, an appearance of solemn splendour. The way in which the story is told shows the spectator that something miraculous and sacred is happening. The background is laid out with fragments of golden glass and on this gold background no natural or realistic scene is enacted. The still and calm figure of Christ occupies the centre of the picture. It is not the bearded Christ known to us, but the long-haired young man as He lived in the imagination of the early Christians. He wears a purple robe, and stretches out His arms in blessing on both sides, where stand two apostles offering Him the bread and fishes in order that the miracle may be accomplished. They carry the food with covered hands, as subjects bringing tribute for their rulers used to do at that time. Indeed, the scene looks like a solemn ceremony. We see that the artist attached a deep significance to what he represented. To him it was not only a strange miracle which had happened a few hundred years before in Palestine. It was the symbol and token of Christ's abiding power which was embodied in the Church. That explains, or helps to explain, the way in which Christ looks steadfastly at the beholder: it is he whom Christ will feed.

At first glance, such a picture looks rather stiff and rigid. There is nothing of the mastery of movement and expression which was the pride of Greek art, and which persisted until Roman times. The way in which the figures are planted in strict frontal view may almost remind us of certain children's drawings. And yet the artist must have been very well acquainted with Greek art. He knew exactly how to drape a cloak round a body so that the main joints should remain visible through the folds. He knew how to mix stones of differing shades in his mosaic to convey the colours of flesh or of the rocks. He marked the shadows on the ground, and had no difficulty in representing foreshortening. If the picture looks rather primitive to us, it must be because the artist wanted it to be simple. The Egyptian ideas about the importance of clarity in the representation of all objects had returned with great force because of the stress which the Church laid on clarity. But the forms which the artists used in this new attempt were not the simple forms of primitive art, but the developed forms of Greek painting. Thus Christian art of the Middle Ages became a curious mixture of primitive and sophisticated methods. The power of observation of nature, which we saw awakening in Greece about 500 BC, was put to sleep again about 500 AD. Artists no longer checked their formulae against reality. They no longer set out to make discoveries about how to represent a body, or how to create the illusion of depth. But

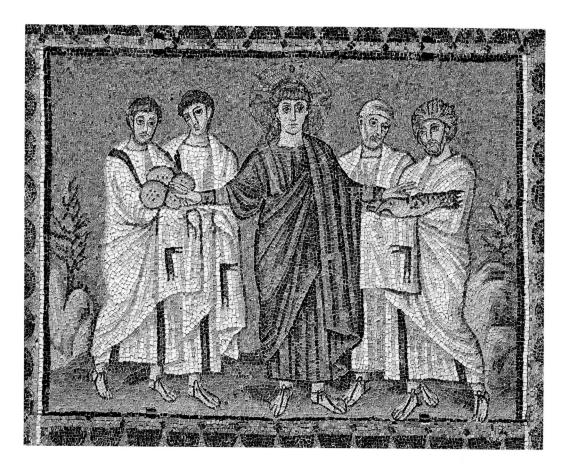

87

The Miracle of the Loaves and Fishes, c. 520 AD

Mosaic; basilica of S. Apollinare Nuovo, Ravenna

the discoveries which had been made were never lost. Greek and Roman art provided an immense stock of figures standing, sitting, bending down or falling. All these types could prove useful in the telling of a story, and so they were assiduously copied and adapted to ever-new contexts. But the purpose for which they were used was now so radically different that we cannot be surprised that, superficially, the pictures betray little of their classical origin.

This question of the proper purpose of art in churches proved of immense importance for the whole history of Europe. For it was one of the principal issues on which the Eastern, Greek-speaking parts of the Roman Empire, whose capital was Byzantium or Constantinople, refused to accept the lead of the Latin Pope. One party was against all images of

a religious nature. They were called iconoclasts or image-smashers. In 754 they gained the upper hand and all religious art was forbidden in the Eastern Church. But their opponents were even less in agreement with Pope Gregory's ideas. To them images were not just useful, they were holy. The arguments with which they tried to justify this point of view were as subtle as those used by the other party: 'If God in His mercy could decide to reveal Himself to mortal eyes in the human nature of Christ,' they argued, 'why should He not also be willing to manifest Himself in visible images? We do not worship these images themselves as the pagans did. We worship God and the Saints through or across their images.' Whatever we may think of the logic of this plea, its importance for the history of art was tremendous. For when this party had returned to power after a century of repression, the paintings in a church could no longer be regarded as mere illustrations for the use of those who could not read. They were looked upon as mysterious reflections of the supernatural world. The Eastern Church, therefore, could no longer allow the artist to follow his fancy in these works. Surely it was not any beautiful painting of a mother with her child that could be accepted as the true sacred image or 'icon' of the Mother of God, but only types hallowed by an age-old tradition.

Thus, the Byzantines came to insist almost as strictly as the Egyptians on the observance of traditions. But there were two sides to this question. By asking the artist who painted sacred images to keep strictly to the ancient models, the Byzantine Church helped to preserve the ideas and achievement of Greek art in the types used for drapery, faces or gestures. If we look at a Byzantine altar-painting of the Holy Virgin like figure 88, it may seem very remote from the achievements of Greek art. And yet, the way the folds are draped round the body and radiate round the elbows and knees, the method of modelling the face and hands by marking the shadows, and even the sweep of the Virgin's throne, would have been impossible without the conquests of Greek and Hellenistic painting. Despite a certain rigidity, Byzantine art therefore remained closer to nature than the art of the West in subsequent periods. On the other hand, the stress on tradition, and the necessity of keeping to certain permitted ways of representing Christ or the Holy Virgin, made it difficult for Byzantine artists to develop their personal gifts. But this conservatism developed only gradually, and it is wrong to imagine that the artists of the period had no scope whatever. It was they, in fact, who transformed the simple illustrations of early Christian art into the great cycles of large and solemn images that dominate the interior of Byzantine churches. As we look at the mosaics done by these Greek artists in the Balkans and in Italy in the Middle Ages, we see that this Oriental empire had in fact succeeded in

88

Madonna and Child on a curved throne, c. 1280

Altar-painting, possibly painted in Constantinople; tempera on wood, 81.5 × 49 cm, 32 × 19½ in; National Gallery of Art (Mellon Collection), Washington, DC

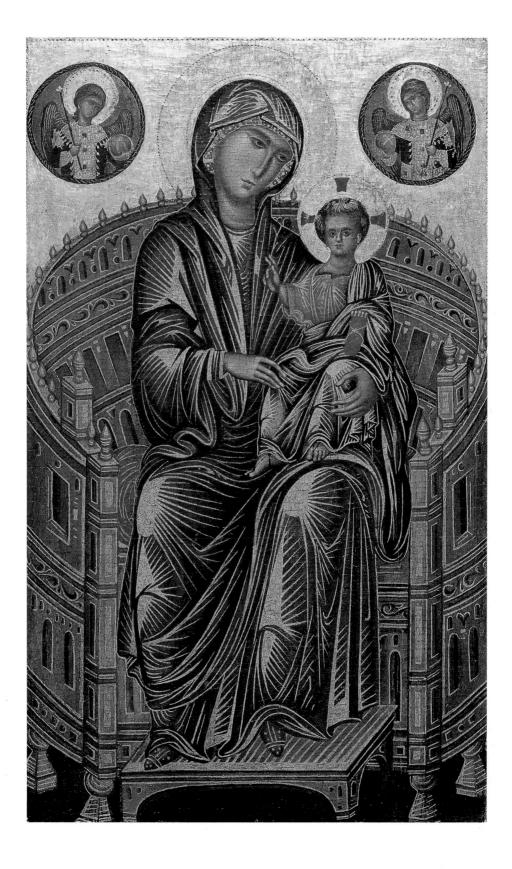

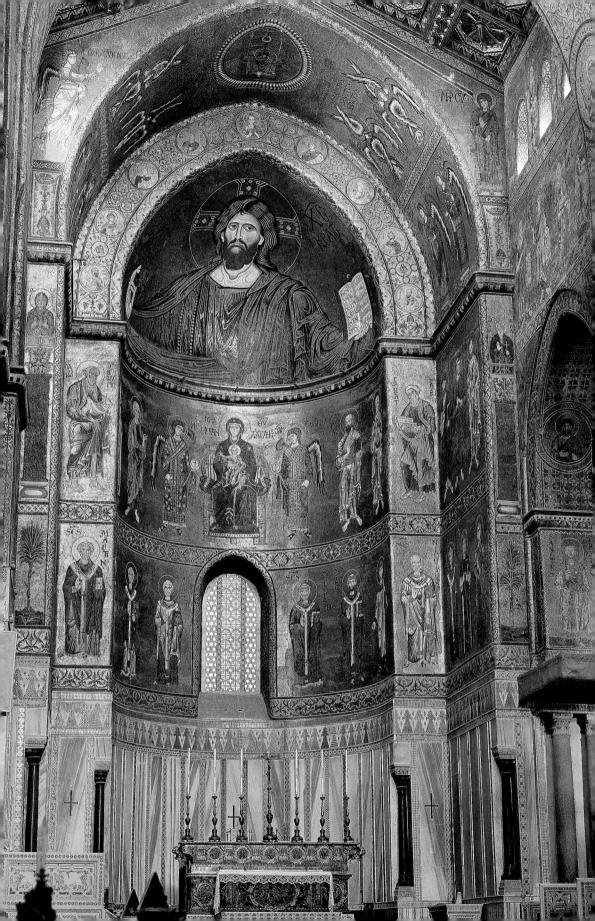

Christ as Ruler of the Universe, the Virgin and Child, and saints,

c. 1190

Mosaic; cathedral of

Monreale, Sicily

reviving something of the grandeur and majesty of ancient Oriental art, and in using it for the glorification of Christ and His power. Figure 89 gives an idea of how impressive this art could be. It shows the apse of the cathedral of Monreale, in Sicily, which was decorated by Byzantine craftsmen shortly before 1190. Sicily itself belonged to the Western or Latin Church, which accounts for the fact that among the Saints arrayed on each side of the window we find the earliest representation of St Thomas Becket, the news of whose murder some twenty years earlier had resounded throughout Europe. But apart from this choice of Saints the artists have kept close to their native Byzantine tradition. The faithful assembled in the cathedral would find themselves face to face with the majestic figure of Christ, represented as the Ruler of the Universe, His right hand raised in blessing. Below is the Holy Virgin, enthroned like an Empress, flanked by two archangels and the solemn row of Saints.

Images such as these, looking down on us from the golden, glimmering walls, seemed to be such perfect symbols of the Holy Truth that there appeared to be no need ever to depart from them. Thus they continued to hold their sway in all countries ruled by the Eastern Church. The holy images or 'icons' of the Russians still reflect these great creations of Byzantine artists.

Byzantine iconoclast whitewashing an image of Christ, c. 900 AD From a Byzantine

manuscript, the Chludow Psalter; State History Museum, Moscow

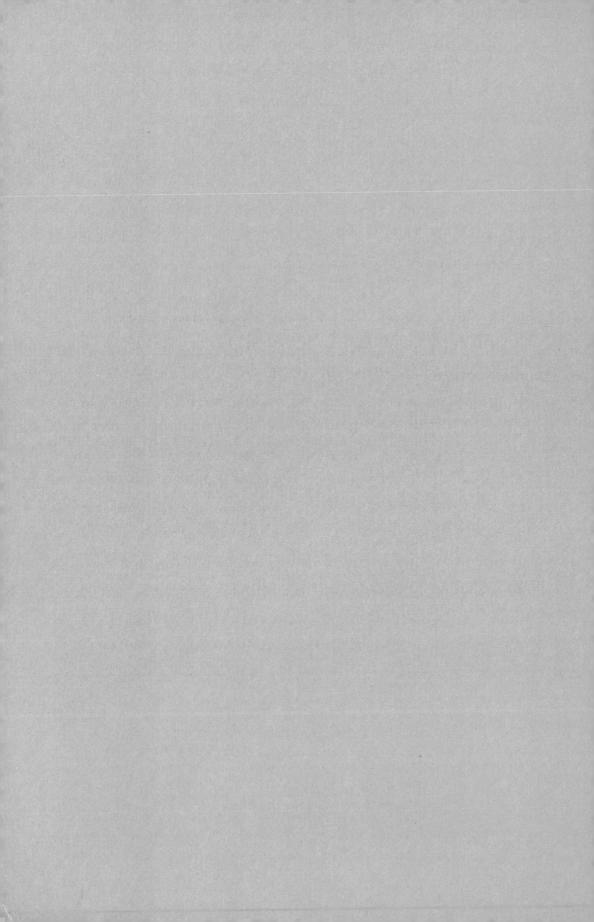

LOOKING EASTWARDS

Islam, China, second to thirteenth century

Before we return to the Western world and take up the story of art in Europe, we must at least cast a glance at what happened in other parts of the world during these centuries of turmoil. It is interesting to see how two other great religions reacted to the question of images, which so engaged the mind of the Western world. The religion of the Middle East, which swept everything before it in the seventh and eighth centuries AD, the religion of the Muslim conquerors of Persia, Mesopotamia, Egypt, North Africa and Spain, was even more rigorous in this matter than Christianity had been. The making of images was forbidden. But art as such cannot so easily be suppressed, and the craftsmen of the East, who were not permitted to represent human beings, let their imagination play with patterns and forms. They created the most subtle lacework ornamentation known as arabesques. It is an unforgettable experience to walk through the courtyards and halls of the Alhambra, figure 90, and to admire the inexhaustible variety of these decorative patterns. Even outside the Islamic dominions the world became familiar with these inventions through Oriental rugs, figure 91. Ultimately we may owe their subtle designs and rich colour schemes to Muhammad, who directed the mind of the artist away from the objects of the real world to this dream-world of lines and colours. Later sects among the Muslims were less strict in their interpretation of the ban on images. They did allow the painting of figures and illustrations as long as they had no connection with religion. The illustrating of romances, histories and fables done in Persia from the fourteenth century onwards, and later also in India under Muslim (Mogul) rulers, shows how much the artists of these lands had learned from the discipline which had confined them to the designing of patterns. The moonlight scene in a garden, figure 92, from a Persian romance of the fifteenth century is a perfect example of this wonderful skill. It looks like a carpet which has somehow come to life in a fairy-tale world. There is as little illusion of reality in it as in Byzantine art. Perhaps even less. There is no foreshortening, and no attempt to show light and shade or the structure of the body. The figures and plants look a little as if they had been cut out of coloured paper and distributed over the page to make a perfect pattern.

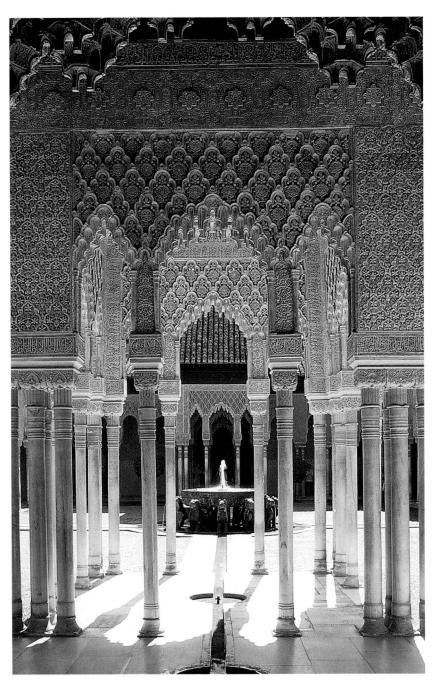

90 Court of Lions, Alhambra, Granada, Spain, 1377 An Islamic palace

Persian carpet, 17th century Victoria and Albert Museum, London

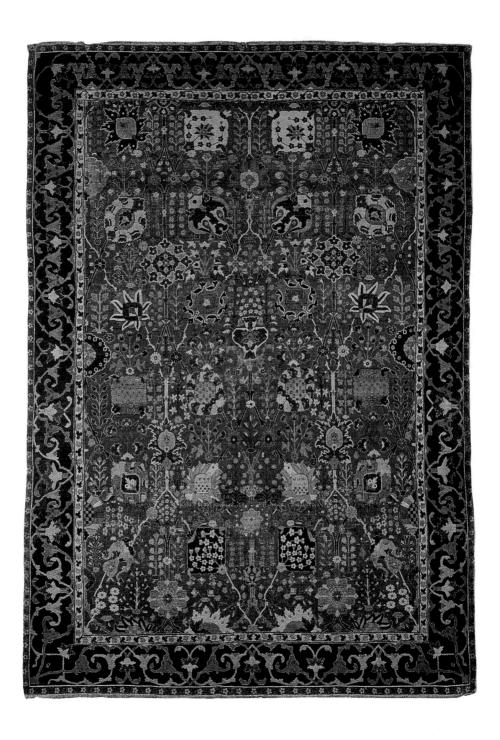

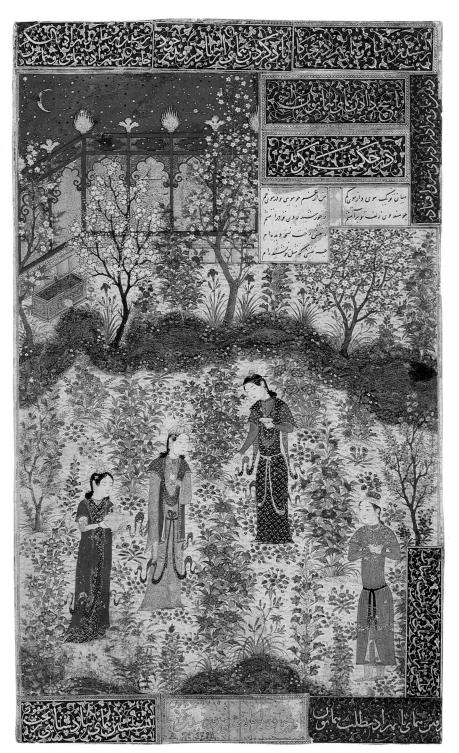

The Persian Prince Humay meets the Chinese Princess Humayun in her garden, c. 1430–40

92

Miniature from a Persian manuscript of a romance; Musée des Arts Décoratifs, Paris

A reception, c. 150 AD Impression from a relief on the tomb of Wu Liang-tse; province of Shantung, China

But, because of that, the illustration fits even better into the book than it might have done if the artist had wanted to create the illusion of a real scene. We can read such a page almost as we read a text. We can look from the hero, as he stands with his arms crossed in the right-hand corner, to the heroine, who approaches him, and we can let our imagination wander through the moonlit fairy garden without ever getting too much of it.

The impact of religion on art was even stronger in China. We know little about the beginnings of Chinese art, except the fact that the Chinese had been skilled in the art of casting bronze at a very early date, and that some of the bronze vessels used in the ancient temples go back to the first millennium before Christ – some say even earlier. Our records of Chinese painting and sculpture, however, are not so old. In the centuries immediately before and after Christ, the Chinese adopted burial customs somewhat reminiscent of the Egyptians, and in these burial chambers, as in the Egyptian ones, there are a number of vivid scenes which reflect the life and the habits of those long bygone days, *figure 93*. At that time, much of what we call typically Chinese in art had already developed. The artists were less fond of rigid angular forms than the Egyptians had been, and preferred swerving curves. When a Chinese artist had to represent a prancing horse, he seemed to fit it together out of a number of rounded

shapes. We can see the same in Chinese sculpture, which always seems to twist and turn without, however, losing its solidity and firmness, figure 94.

Some of the great teachers of China appear to have had a similar view of the value of art to that held by Pope Gregory the Great. They thought of art as a means of reminding people of the great examples of virtue in the golden ages of the past. One of the earliest illustrated Chinese book-scrolls to have been preserved is a collection of great examples of virtuous ladies, written in the spirit of Confucius. It is said to go back to the painter Ku K'ai-chi, who lived in the fourth century AD. The illustration, *figure 95*, shows a husband unjustly accusing his wife, and it has all the dignity and grace we connect with Chinese art. It is as clear in its gestures and arrangement as one might expect from a picture which also aims at driving home a lesson. It shows, moreover, that the Chinese artist had mastered the difficult art of representing movement. There is nothing rigid in this early Chinese work, because the predilection for undulating lines imparts a sense of movement to the whole picture.

Winged beast, c. 523 AD Tomb of Xiao Jing, near Nanjing, Jiangsu, China

95
Husband reproving his wife, c. 400 AD
Detail of a silk scroll; probably a copy after the original by Ku K'ai-chi; British Museum, London

However, the most important impulse to Chinese art probably came through yet another religious influence: that of Buddhism. The monks and ascetics of Buddha's circle were often represented in amazingly life-like statues, *figure 96*. Once more we see the curved outlines in the shape of the ears, the lips or the cheeks, but they do not distort the real forms; they only weld them together. We feel that such a work is not haphazard, but that everything is in its place and contributes to the effect of the whole. The old principle of the primitive masks, *page 51*, *figure 28*, serves its turn even in such a convincing representation of a face.

Buddhism influenced Chinese art not only by providing the artists with new tasks. It introduced an entirely new approach to pictures, a reverence for the artist's achievement such as did not exist either in ancient Greece or in Europe up to the time of the Renaissance. The Chinese were the first people who did not think of the making of pictures as a rather menial task, but who placed the painter on the same level as the inspired poet. The religions of the East taught that nothing was more important than the right kind of meditation. To meditate is to think and ponder about the same holy truth for many hours on end, to fix an idea in one's mind and to look at it from all sides without letting go of it. It is a kind of mental exercise for Orientals, to which they used to attach even greater importance than we attach to physical exercise or sport. Some monks meditated on single words, turning them over in their minds while they sat quite still for whole days and listened to the stillness which preceded and followed the holy syllable. Others meditated on things in nature, on water, for instance, and what we can learn from it, how humble it is, how it yields and yet wears away solid rock, how it is clear and cool and soothing and gives life to the thirsting field; or on mountains, how strong and lordly they are, and yet how good, for they allow the trees to grow on them. That is, perhaps, how religious art in China came to be employed less for telling the legends of the Buddha and the Chinese teachers, less for the teaching of a particular doctrine – as Christian art was to be employed in the Middle Ages – than as an aid to the practice of meditation. Devout artists began to paint water and mountains in a spirit of reverence, not in order to teach any particular lesson, nor merely as decorations, but to provide material for deep thought. Their pictures on silk scrolls were kept in precious containers and only unrolled in quiet moments, to be looked at and pondered over as one might open a book of poetry and read and reread a beautiful verse. That is the purpose behind the greatest of the Chinese landscape paintings of the twelfth and thirteenth centuries. It is not easy for us to recapture that mood, because we are fidgety Westerners with little patience and little knowledge of the technique of meditation – no more, I suppose, than the old Chinese had of the technique of physical training. But if we look long

96

Head of a Lohan,

Found in I-Chou, China; glazed terracotta, approximately lifesize; formerly Fuld Collection, Frankfurt

97 Ma Yüan Landscape in moonlight, c. 1200 Hanging scroll, ink and colour on silk, 149.7 × 78.2 cm, 59 × 30¾ in; National Palace Museum, Taipei

98 Attributed to Kao K'o-kung Landscape after rain, c. 1300

Hanging scroll, ink on paper, 122.1 × 81.1 cm, 48½ × 32 in; National Palace Museum, Taipei and carefully at a picture such as *figure 97*, we shall perhaps begin to feel something of the spirit in which it was painted and of the high purpose it was to serve. We must not, of course, expect any portraits of real landscapes, or picture-postcards of beauty spots. Chinese artists did not go out into the open, to sit down in front of some motif and sketch it. They even learned their art by a strange method of meditation and concentration in which they first acquired skill in 'how to paint pine trees', 'how to paint rocks', 'how to paint clouds', by studying not nature but the works of renowned masters. Only when they had thoroughly acquired this skill did they travel and contemplate the beauty of nature so as to capture the moods of the landscape. When they came home they would then try to recapture these moods by putting together their images of pine trees, rocks and clouds much in the way a poet might string together a number of

images which had come into his mind during a walk. It was the ambition of these Chinese masters to acquire such a facility in the handling of brush and ink that they could write down their vision while their inspiration was still fresh. Often they would write a few lines of poetry and paint a picture on the same scroll of silk. The Chinese, therefore, consider it childish to look for details in pictures and then to compare them with the real world. They want, rather, to find in them the visible traces of the artist's enthusiasm. It may not be easy for us to appreciate the boldest of these works, such as figure 98, which consists only of some vague forms of mountain peaks emerging out of clouds. But once we try to put ourselves in the place of the painter, and to experience something of the awe he must have felt for these majestic peaks, we may at least get an inkling of what the Chinese value most highly in art. For us it

99 Attributed to Liu Ts'ai Three fishes c. 1068–85 Leaf from an album; ink and colour on silk, 22.2

× 22.8 cm. 83/4 × 9 in:

Philadelphia Museum

of Art

is easier to admire the same skill and concentration in more familiar subjects. The painting of three fishes in a pond, *figure 99*, gives an idea of the patient observation that must have gone into the artist's study of his simple subject, and of the ease and mastery with which he handled it when he came to paint this picture. Again we see how fond the Chinese artists were of graceful curves, and how they could exploit their effects to suggest movement. The forms do not seem to make any clear symmetrical pattern. They are not evenly distributed as in the Persian miniature. Nevertheless we feel that the artist has balanced them with immense assurance. One can look at such a picture for a long stretch of time without getting bored. It is an experiment well worth trying.

There is something wonderful in this restraint of Chinese art, in its deliberate limitation to a few simple motifs of nature. But it almost goes without saying that this approach to painting also had its dangers. As time went on, nearly every type of brushstroke with which a stem of bamboo or a rugged rock could be painted was laid down and labelled by tradition, and so great was the general admiration for the works of the past that artists dared less and less to rely on their own inspiration. The standards of painting remained very high throughout the subsequent centuries both in China and in Japan (which adopted the Chinese conceptions) but art became more and more like a graceful and elaborate game which has lost much of its interest as so many of its moves are known. It was only after a new contact with the achievements of Western art in the eighteenth century that Japanese artists dared to apply the Eastern methods to new subjects. We shall see how fruitful these new experiments also became for the West when it first got to know them.

Japanese boy painting a branch of bamboo, early 19th century Woodblock print by Hidenobu, 13 × 18.1 cm, 5% × 7% in

WESTERN ART IN THE MELTING POT

Europe, sixth to eleventh century

We have taken the story of Western art up to the period of Constantine, and to the centuries in which it was to adapt itself to the precept of Pope Gregory the Great that images are useful for teaching laymen the sacred word. The period which followed this early Christian era, the period after the collapse of the Roman Empire, is generally known by the uncomplimentary title of the Dark Ages. We call these ages dark, partly to convey that the people who lived during these centuries of migrations, wars and upheavals were themselves plunged in darkness and had little knowledge to guide them, but also to imply that we ourselves know rather little about these confused and confusing centuries which followed upon the decline of the ancient world and preceded the emergence of the European countries in the shape, roughly, in which we know them now. There are, of course, no fixed limits to the period, but for our purpose we may say that it lasted almost five hundred years - approximately from 500 to 1000 AD. Five hundred years is a long time, in which much can change and much, in fact, did change. But what is most interesting to us is that these years did not see the emergence of any one clear and uniform style, but rather the conflict of a great number of different styles, which only began to fuse towards the end of that period. To those who know something of the history of the Dark Ages this is hardly surprising. It was not only a dark, it was a patchy period, with tremendous differences among various peoples and classes. Throughout these five centuries there existed men and women, particularly in the monasteries and convents, who loved learning and art, and who had a great admiration for those works of the ancient world which had been preserved in libraries and treasure-houses. Sometimes these learned and educated monks or clergy held positions of power and influence at the courts of the mighty, and tried to revive the arts which they most admired. But frequently their work came to naught because of new wars and invasions by armed raiders from the north, whose opinions about art were very different indeed. The various Teutonic tribes, the Goths, the Vandals, the Saxons, the Danes and the Vikings, who swept through Europe raiding and pillaging, were considered barbarians by those who valued Greek and Roman

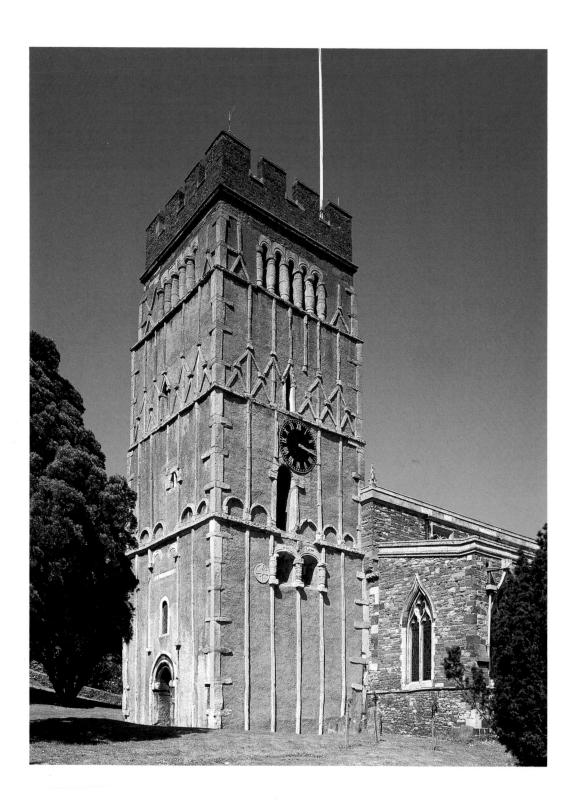

Dragon's head, c. 820 AD Woodcarving found at Oseberg, Norway, height 51 cm, 20 in; Universitetets Oldsaksamling, Oslo

Church of All Saints, Earls Barton, Northamptonshire.

c. 1000

A Saxon tower imitating a timber structure

achievements in literature and art. In a sense they certainly were barbarians, but this need not mean that they had no feeling for beauty, no art of their own. They had skilled craftsmen experienced in finely wrought metalwork, and excellent woodcarvers, comparable to those of the New Zealand Maoris, page 44, figure 22. They loved complicated patterns which included the twisted bodies of dragons or birds mysteriously interlaced. We do not know exactly where these patterns originated in the seventh century or what they signified, but it is not unlikely that the ideas of these Teutonic tribes about art resembled the ideas of primitive tribes elsewhere. There are reasons for believing that they, too, thought of such images as a means of working magic and exorcizing evil spirits. The carved figures of dragons from Viking sledges and ships give a good idea of the character of this art, figure 101. One can well imagine that these threatening heads of monsters were something more than just innocent decorations. In fact, we know that there were laws among the Norwegian Vikings which required the captain of a ship to remove these figures before entering his home port, 'so as not to frighten the spirits of the land'.

The monks and missionaries of Celtic Ireland and Saxon England tried to apply the traditions of these northern craftsmen to the tasks of Christian art. They built churches and steeples in stone imitating the timber structures used by local craftsmen, *figure 100*, but the most amazing monuments to their success are some of the manuscripts made in England and Ireland during the seventh and eighth centuries. *Figure 103* is a page

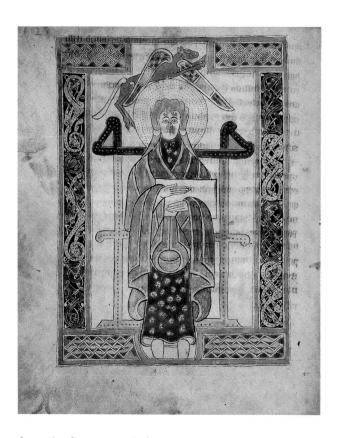

Stiftsbibliothek, St Gallen

St Luke, c. 750 AD From a gospel manuscript;

from the famous Lindisfarne Gospels, made in Northumbria shortly before 700 AD. It shows the Cross composed of an incredibly rich lacework of intertwined dragons and serpents, standing against a background of an even more complicated pattern. It is exciting to try to find one's way through this bewildering maze of twisted shapes, and to follow the coils of these interwoven bodies. It is even more astonishing to see that the result is not confusion, but that the various patterns strictly correspond to each other and form a complex harmony of design and colour. One can hardly imagine how anyone could have thought out such a scheme and had the patience and perseverance to finish it. It proves, if proof were needed, that the artists who took up this native tradition were certainly not lacking either in skill or in technique.

It is all the more surprising to look at the way in which human figures were represented by these artists in the illustrated manuscripts of England and Ireland. They do not look quite like human figures but rather like strange patterns made of human forms, figure 102. One can see that the artist used some example he had found in an old Bible, and transformed it to suit his taste. He changed the folds of the dress to something like interlacing ribbons, the locks of hair and even the ears into scrolls, and turned the whole face into a rigid mask. These figures of evangelists and saints look almost as stiff and quaint as primitive idols. They show that the artists who had grown up in the tradition of their native art found it

Page from the Lindisfarne Gospels, c. 698 AD British Library, London

difficult to adapt themselves to the new requirements of Christian books. Yet it would be wrong to look upon such pictures as being merely crude. The training of hand and eye which the artists had received, and which enabled them to make a beautiful pattern on the page, helped them to bring a new element into Western art. Without this influence, Western art might have developed on similar lines to those of the art of Byzantium. Thanks to the clash of the two traditions, the classical tradition and the taste of the native artists, something entirely new began to grow up in Western Europe.

For the knowledge of the earlier achievements of classical art was by no means lost altogether. At the court of Charlemagne, who regarded himself as the successor of the Roman Emperors, the tradition of Roman craftsmanship was eagerly revived. The church that Charlemagne had built about 800 AD at his residence in Aachen, *figure 104*, is a fairly close copy of a famous church that had been built in Ravenna some three hundred years earlier.

We have seen before that our modern notion that an artist must be 'original' was by no means shared by most peoples of the past. An Egyptian, a Chinese or a Byzantine master would have been greatly puzzled by such a demand. Nor would a medieval artist of Western Europe have understood why he should invent new ways of planning a church, of designing a chalice or of representing the sacred story when the old ones served their purpose so well. The pious donor who wanted to dedicate a new shrine for a holy relic of his patron saint not only tried to procure the most precious material he could afford, he would also seek to provide the master with an old and venerable example of how the legend of the saint should be correctly represented. Nor would the artist feel hampered by this type of commission. There remained enough scope for him to show whether he was a master or a bungler.

Perhaps we can best understand this attitude if we think of our own approach to music. If we ask a musician to perform at a wedding we do not expect him to compose something new for the occasion, any more than the medieval patron expected a new invention if he asked for a painting of the Nativity. We indicate the type of music we want and the size of the orchestra or choir we may be able to afford. It still is up to the musician to produce a wonderful performance of an ancient masterpiece or to make a mess of things. And just as two equally great musicians may interpret the same piece very differently, so two great medieval masters might make very different works of art on the same theme and even on the same ancient model. An example should make this clear:

Aachen Cathedral, consecrated in 805 AD

St Matthew, c. 800 AD From a gospel manuscript, probably painted at Aachen; Kunsthistorisches Museum, Vienna

Figure 105 shows a page from a gospel book produced at the court of Charlemagne. It represents the figure of St Matthew writing the gospel. It had been customary in Greek and Roman books to have the portrait of the author represented on the opening page and this picture of the writing evangelist must be an extraordinarily faithful copy of this type of portrait. The way the saint is draped in his toga in the best classical fashion, the way his head is modelled in many shades of light and colour, convinces us that the medieval artist had strained every nerve to give an accurate and worthy rendering of a venerated model.

The painter of another manuscript of the ninth century, figure 106, probably had before him the same or a very similar ancient example from early Christian times. We can compare the hands, the left hand holding an inkhorn and resting on the lectern, the right hand holding the pen; we can compare the feet and even the drapery round the knees. But while the artist of figure 105 had done his very best to copy the original as faithfully as possible, the artist of figure 106 must have aimed at a different interpretation. Perhaps he did not want to represent the evangelist like any serene old scholar, sitting quietly in his study. To him St Matthew was an inspired man, writing down the Word of God. It was an immensely important and immensely exciting event in the history of mankind that he wanted to portray, and he succeeded in conveying something of his own sense of awe and excitement in this figure of a writing man. It is not mere clumsiness and ignorance which made him draw the saint with wide open, protruding eyes and enormous hands. He intended to give him that expression of tense concentration. The very brushwork of the drapery and of the background looks as if it had been done in a mood of intense

106

St Matthew, c. 830 AD

From a gospel manuscript, probably painted at Reims; Bibliothèque municipale, Épernay

excitement. This impression, I think, is partly due to the evident enjoyment with which the artist seized on every opportunity to draw scrolly lines and zigzagging folds. There may have been something in the original to suggest such a treatment, but it probably appealed to the medieval artist because it reminded him of those interlaced ribbons and lines which had been the greatest achievement of northern art. In pictures like these we see the emergence of a new medieval style which made it possible for art to do something that neither ancient Oriental nor classical art had done: the Egyptians had largely drawn what they *knew* to exist, the Greeks what they *saw*; in the Middle Ages the artist also learned to express in his picture what he *felt*.

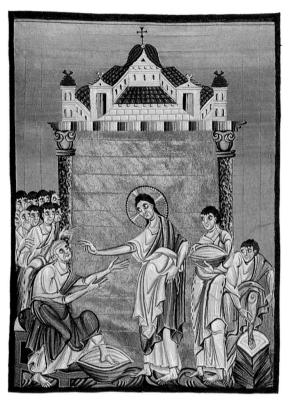

Christ washing the Apostles' feet, c. 1000 From the Gospel Book of Otto III; Bayerische Staatsbibliothek, Munich

One cannot do justice to any medieval work of art without keeping this purpose in mind. For these artists were not out to create a convincing likeness of nature or to make beautiful things – they wanted to convey to their brothers in the faith the content and the message of the sacred story. And in this they were perhaps more successful than most artists of earlier or later times. *Figure 107* is from a gospel book which was illustrated (or 'illuminated') in Germany more than a century later, around the year 1000. It represents the incident told in the Gospel of St John (xiii. 8–9) when Christ, after the Last Supper, washed the disciples' feet:

Peter saith unto him, 'Thou shalt never wash my feet.' Jesus answered him, 'If I wash thee not, thou hast no part with me.' Simon Peter saith unto him, 'Lord, not my feet only but my hands and my head.'

This exchange alone is what mattered to the artist. He saw no reason to represent the room in which the scene occurred; it might merely have diverted attention from the inner meaning of the event. He rather placed his principal figures before a flat, luminous golden ground, on which the gestures of the speakers stand out like a solemn inscription: the imploring movement of St Peter, the calm teaching gesture of Christ. A disciple on the right takes off his sandals, another brings a basin, the others crowd behind St Peter. All eyes are rigidly turned towards the centre of the scene and thus give us the feeling that something of infinite significance is happening here. What does it matter if the basin is not evenly rounded,

and if the painter has to wrench the leg of St Peter up, the knee somewhat forward, to get his foot clearly into the water? He was concerned with the message of divine humility, and this he conveyed.

It is interesting to glance back for a moment to another scene representing the washing of feet, the Greek vase painted in the fifth century BC, page 95, figure 58. It was in Greece that the art of showing the 'workings of the soul' was discovered, and however differently the medieval artist interpreted this aim, the Church could never have used pictures for its own ends without this heritage.

We remember the teaching of Pope Gregory the Great that 'painting can do for the illiterate what writing does for those who can read', *page 135*. This search for clarity comes out not only in the painted illustrations but also in works of sculpture such as the panel from a bronze door which was commissioned for the church of Hildesheim in Germany shortly after the year 1000, *figure 108*. It shows the Lord approaching Adam and Eve after the fall. Again there is nothing in this relief that does not strictly belong to the story. But this concentration on the things which matter makes the figures stand out all the more clearly against the plain background – and we can almost read off what their gestures say: God points to Adam, Adam to Eve, and Eve to the serpent on the ground. The shifting of guilt and the origin of evil are expressed with such forcefulness and clarity that we soon forget that the proportions of the figures are perhaps not strictly correct and the bodies of Adam and Eve not beautiful by our standards.

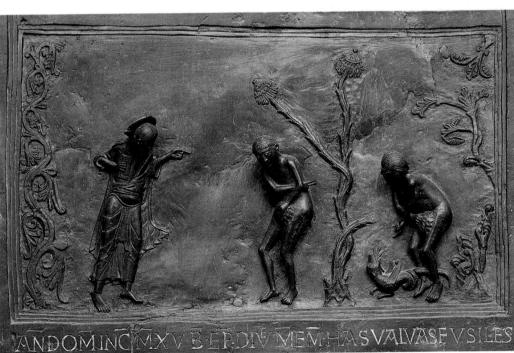

...

Adam and Eve after the Fall, c. 1015

From the bronze doors of

Hildesheim Cathedral

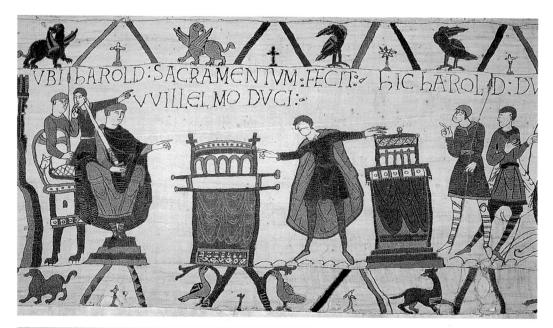

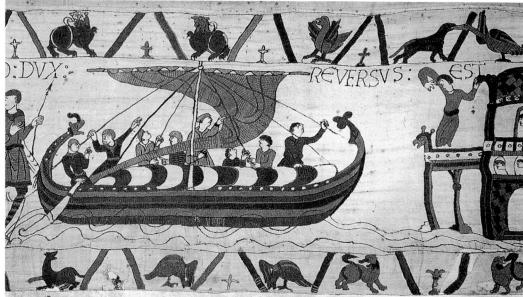

We need not imagine, though, that all art in this period existed exclusively to serve religious ideas. Not only churches were built in the Middle Ages, but castles as well, and the barons and feudal lords to whom the castles belonged also occasionally employed artists. The reason why we are inclined to forget these works when we speak of the art of the earlier Middle Ages is simple: castles were often destroyed when churches were spared. Religious art was, on the whole, treated with greater respect, and looked after more carefully, than mere decorations of private apartments. When these became old-fashioned they were removed or thrown away —

109, 110

The Bayeux Tapestry, c. 1080

King Harold swears an oath to Duke William of Normandy, and then returns to England; height of frieze 50 cm, 19½ in; Musée de la Tapisserie, Bayeux

just as happens nowadays. But, fortunately, one great example of this latter type of art has come down to us – and that because it was preserved in a church. It is the famous Bayeux Tapestry, which illustrates the story of the Norman Conquest. We do not know exactly when this tapestry was made, but most scholars agree that it was within living memory of the scenes it illustrates – perhaps round about the year 1080. The tapestry is a picture-chronicle of the kind we know from ancient Oriental and Roman art (Trajan's Column, for example, page 123, figure 78) - the story of a campaign and a victory. It tells its story with wonderful liveliness. In figure 109 we see, as the inscription tells, how Harold swears his oath to William and in figure 110 how he returns to England. Nothing could be clearer than the way in which the story is told – we see William on his throne watching Harold laying his hand on the sacred relics to swear allegiance – it was this oath which served William as pretext for his claims on England. I particularly like the man on the balcony in the next scene, who holds his hands above his eyes to espy Harold's ship as it arrives from afar. It is true that his arms and fingers look rather quaint and that all the figures in the story are strange little manikins which are not drawn with the assurance of the Assyrian or Roman chroniclers. When the medieval artist of this period had no model to copy, he drew rather like a child. It is easy to smile at him, but by no means so easy to do what he did. He tells the epic with such an economy of means, and with such concentration on what seemed important to him, that the final result remains more memorable than the realistic accounts in our newspapers and on television.

Brother Rufillus writing the letter R, 13th century Detail from an illuminated manuscript; Fondation

Martin Bodmer, Geneva

THE CHURCH MILITANT

The twelfth century

Dates are indispensable pegs on which to hang the tapestry of history, and since everybody knows the date 1066, that may serve us as a convenient peg. No complete buildings have survived in England from the Saxon period, and there are very few churches of the period before that date still existing anywhere in Europe. But the Normans who landed in England brought with them a developed style of building, which had taken shape within their generation in Normandy and elsewhere. The bishops and nobles who were the new feudal lords of England soon began to assert their power by founding abbeys and minsters. The style in which these buildings were erected is known as the Norman style in England, and as the Romanesque style on the Continent. It flourished for a hundred years and more after the Norman invasion.

Today it is not easy to imagine what a church meant to the people of that period. Only in some old villages in the countryside can we still get a glimpse of its importance. The church was often the only stone building anywhere in the neighbourhood; it was the only considerable structure for miles around, and its steeple was a landmark to all who approached from afar. On Sundays and during services all the inhabitants of the town might meet there, and the contrast between the lofty building and the primitive and humble dwellings in which these people spent their lives must have been overwhelming. Small wonder that the whole community was interested in the building of these churches and took pride in their decoration. Even from the economic point of view the building of a minster, which took years, must have transformed a whole town. The quarrying and transport of stone, the erection of suitable scaffolding, the employment of itinerant craftsmen, who brought tales from distant lands, all this was a real event in those far-off days.

The Dark Ages had by no means blotted out the memory of the first churches, the basilicas, and the forms which the Romans had used in their building. The ground-plan was usually the same – a central nave leading to an apse or choir, and two or four aisles at the side. Sometimes this simple plan was enriched by a number of additions. Some architects liked the idea of building churches in the form of a cross, and they thus added what is

III

Benedictine church of Murbach, Alsace, c. 1160

A Romanesque church

112

Tournai Cathedral, Belgium, 1171–1213 The church in the medieval city

called a transept between the choir and the nave. The general impression made by these Norman or Romanesque churches is nevertheless very different from that of the old basilicas. In the earliest basilicas classical columns carrying straight 'entablatures' had been used. In Romanesque and Norman churches we generally find round arches resting on massive piers. The whole impression which these churches make, both inside and outside, is one of massive strength. There are few decorations, even few windows, but firm unbroken walls and towers which remind one of medieval fastnesses, *figure 111*. These powerful and almost defiant piles of stone erected by the Church in lands of peasants and warriors who had only recently been converted from their heathen way of life seem to express the very idea of the Church Militant – the idea, that is, that here on earth it is the task of the Church to fight the powers of darkness till the hour of triumph dawns on doomsday, *figure 112*.

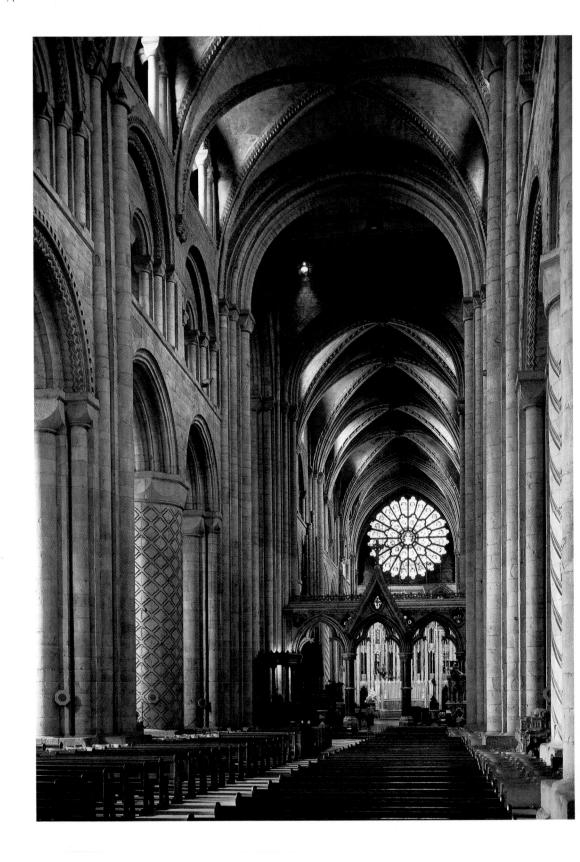

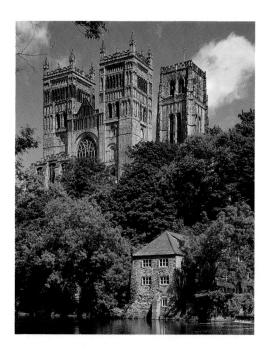

Nave and west front of Durham Cathedral, 1093–1128 A Norman cathedral

There was one problem in connection with the building of churches that engaged the minds of all good architects. It was the task of giving these impressive stone buildings a worthy roof of stone. The timber roofs which had been usual for basilicas lacked dignity, and were dangerous because they easily caught fire. The Roman art of vaulting such large buildings demanded a great amount of technical knowledge and calculation which had largely been lost. Thus the eleventh and twelfth centuries became a period of ceaseless experiment. It was no small matter to span the whole breadth of the main nave by a vault. The simplest solution, it would seem, was to bridge the distance as one throws a bridge across a river. Tremendous pillars were built up on both sides, which were to carry the arches of those bridges. But it soon became clear that a vault of this kind had to be very firmly joined if it was not to crash, and that the weight of the necessary stones was very great. To carry this enormous load the walls and pillars had to be made even stronger. Huge masses of stone were needed for these early 'tunnel'-vaults.

Norman architects therefore began to try out a different method. They saw that it was not really necessary to make the whole roof so heavy. It was sufficient to have a number of firm arches spanning the distance and to fill in the intervals with lighter material. It was found that the best method of doing this was by spanning the arches or 'ribs' crosswise between the pillars and then filling in the triangular sections between them. This idea, which was soon to revolutionize building methods, can be traced as far back as the Norman cathedral of Durham, *figure 114*, though the architect who, after the Conquest, designed the first 'rib-vault' for its mighty interior, *figure 113*, was hardly aware of its technical possibilities.

It was in France that Romanesque churches began to be decorated with sculptures, though here again the word 'decorate' is rather misleading. Everything that belonged to the church had its definite function and expressed a definite idea connected with the teaching of the Church. The porch of the late twelfth-century church of St-Trophime at Arles, in southern France, is one of the most complete examples of this style, *figure 115*. Its shape recalls the principle of the Roman triumphal arch, *page 119*, *figure 74*. In the field above the lintel – called the tympanum, *figure 116* – we see Christ in His glory, surrounded by the symbols of the four evangelists. These symbols, the lion for St Mark, the angel for St Matthew, the ox for St Luke and the eagle for St John, were derived from the Bible. In the Old Testament we read of the vision of Ezekiel (Ezek. i. 4–12), in which he describes the throne of the Lord, carried by four creatures with the heads of a lion, a man, an ox and an eagle.

Christian theologians thought the supporters of God's throne signified the four evangelists, and such a vision was a fitting subject for the entrance to the church. On the lintel below we see twelve seated figures, the twelve apostles, and we can discern, on Christ's left, a row of naked figures in chains – they are lost souls being dragged off to hell – while on Christ's right we see the blessed, their faces turned towards Him in eternal bliss. Below, we see the rigid figures of saints, each marked by his emblem,

Façade of the church of St-Trophime, Arles,

Christ in glory
Detail of figure 115

reminding the faithful of those who can intercede for them when their souls stand before the ultimate Judge. Thus the teachings of the Church about the final goal of our life here below were embodied in these sculptures on the portal of the church. These images lived on in the minds of the people even more powerfully than did the words of the preacher's sermon. A late medieval French poet, François Villon, has described this effect in the moving verses he wrote for his mother:

I am a woman, poor and old,
Quite ignorant, I cannot read.
They showed me at my village church
A painted Paradise with harps
And Hell where the damned souls are boiled,
One gives me joy, the other frightens me ...

We must not expect such sculptures to look as natural, graceful and light as classical works. They are all the more impressive because of their massive solemnity. It becomes much easier to see at a glance what is represented, and they fit in much better with the grandeur of the whole building.

Every detail inside the church was just as carefully thought out to fit its purpose and its message. *Figure 117* shows a candlestick made for

Gloucester Cathedral about the year 1110. The intertwined monsters and dragons of which it is formed remind us of the work of the Dark Ages, page 159, figure 101; page 161, figure 103. But now a more definite meaning is given to these uncanny shapes. A Latin inscription round its crown says roughly: 'This bearer of light is the work of virtue - with its shine it preaches the doctrine. so that man should not be darkened by vice.' And really, as we penetrate with our eyes into the jungle of strange creatures we not only find once more (round the knob in the middle) the symbols of the Evangelists, who stand for the doctrine, but also naked figures of men. Like Laocoön and his sons, page 110, figure 69, they are assailed by snakes and monsters; but theirs is not a hopeless struggle. 'The light that shineth in the darkness' can make them triumph over the power of evil.

The font of a church in Liège (Belgium), made about 1113, provides another example of the part taken by the theologians in advising the artists, figure 118. It is made of brass and shows in the middle a relief of the baptism of Christ – the most appropriate subject for a font. There are Latin inscriptions explaining the meaning of every figure; for instance, we read 'Angelis ministrantes' (ministering angels) over the two figures waiting at

The Gloucester
Candlestick,
c. 1104–13
Gilt bronze, height
58.4 cm, 23 in; Victoria
and Albert Museum,
London

Reiner van Huy Font, 1107–18 Brass, height 87 cm, 34½ in; church of St-Barthélemy, Liège

the side of the River Jordan to receive Christ. But it is not only these inscriptions that underline the importance attached to the meaning of every detail. Again, the whole font was given such a meaning. Even the figures of oxen on which it stands are not there merely for the sake of ornament or decoration. We read in the Bible (2 Chronicles iv) how King Solomon engaged a cunning workman from Tyre in Phoenicia who was an expert in brass foundry. Among the things he made for the temple in Jerusalem the Bible describes:

A molten sea of ten cubits from brim to brim, round in compass. . . . It stood upon twelve oxen, three looking towards the north, and three looking towards the west, and three looking towards the sea was set upon them, and all their hinder parts were inward.

It was this sacred model, then, which the artist of Liège, another expert in brass foundry, was asked to keep in mind two thousand years or more after the time of Solomon.

The forms which the artist uses for his images of Christ, of the angels and of St John, look more natural and at the same time more calm and majestic than those of the bronze doors of Hildesheim, page 167, figure 108. We remember that the twelfth century is the century of the Crusades. There was naturally more contact than formerly with the art of Byzantium, and many artists of the twelfth century tried to imitate and emulate the majestic sacred images of the Eastern Church, pages 139-40, figures 88, 89.

The Annunciation, c. 1150 From a Swabian gospel manuscript; Württembergische Landesbibliothek, Stuttgart

Saints Gereon,
Willimarus, Gall and
the martyrdom of
St Ursula with her
11,000 maidens,
1137–47
From a calendar
manuscript;
Württembergische
Landesbibliothek, Stuttgart

At no other time, in fact, did European art approach the ideals of this kind of Eastern art more closely than at the height of the Romanesque style. We have seen the rigid and solemn arrangement of the sculptures of Arles, figures 115–16, and we see the same spirit in many illuminated manuscripts of the twelfth century. Figure 119, for instance, represents the Annunciation. It looks almost as stiff and motionless as an Egyptian relief. The Virgin is seen from in front, her hands raised as in astonishment, while the dove of the Holy Spirit descends on her from on high. The Angel is seen half in profile, his right hand extended in a gesture which in medieval art signifies the act of speaking. If, looking at such a page, we expect a

vivid illustration of a real scene, we may well find it disappointing. But if we remember once more that the artist was not concerned with an imitation of natural forms, but rather with the arrangement of traditional sacred symbols, which were all he needed to illustrate the mystery of the Annunciation, we shall no longer feel the lack of what he never intended to give us.

For we must realize how great the possibilities were that opened up before the artists as soon as they finally discarded all ambition to represent things as we see them. Figure 120 shows a page from a calendar for the use of a German monastery. It marks the principal feasts of saints to be commemorated in the month of October, but, unlike our own calendars, it marks them not only in words but also by illustrations. In the middle, under the arches, we see St Willimarus the priest and St Gall with the bishop's crozier and a companion who carries the luggage of the wandering missionary. The curious pictures on top and below

illustrate the story of two martyrdoms which are remembered in October. In later times, when art had returned to the detailed representation of nature, such cruel scenes were often painted with a profusion of horrible detail. Our artist was able to avoid all this. To remind us of St Gereon and his companions, whose heads were cut off and thrown into a well, he arranged the beheaded trunks in a neat circle around the image of the well. St Ursula who, according to the legend, had been massacred with her eleven thousand maidens by the heathens, is seen enthroned, literally surrounded by her followers. An ugly savage with bow and arrows and a man brandishing his sword are placed outside the frame and aiming at the Saint. We are able to read the story off the page without being forced to

visualize it. And as the artist could dispense with any illusion of space or any dramatic action he could arrange his figures and forms on purely ornamental lines. Painting was indeed on the way to becoming a form of writing in pictures; but this return to more simplified methods of representation gave the artist of the Middle Ages a new freedom to experiment with more complex forms of composition (composition = putting together). Without these methods the teachings of the Church could never have been translated into visible shapes.

As with forms so with colours. As the artists no longer felt obliged to study and imitate the real gradations of shades that occur in nature they were free to choose any colour they liked for their illustrations. The bright gold and luminous blues of their goldsmiths' works, the intense colours of their book illuminations, the glowing red and deep greens of their stained-glass windows, *figure 121*, show that these masters put their independence of nature to good use. It was this freedom from the need to imitate the natural world that was to enable them to convey the idea of the supernatural.

The Annunciation, mid-12th century Stained-glass window; Chartres Cathedral

Artists at work on a manuscript and a panel painting, c. 1200
From the pattern book of Reun Monastery;
Österreichische
Nationalbibliothek,
Vienna

IO

THE CHURCH TRIUMPHANT

The thirteenth century

We have just compared the art of the Romanesque period with the art of Byzantium and even of the ancient Orient. But there is one respect in which Western Europe always differed profoundly from the East. In the East these styles lasted for thousands of years, and there seemed no reason why they should ever change. The West never knew this immobility. It was always restless, groping for new solutions and new ideas. The Romanesque style did not even outlast the twelfth century. Hardly had the artists succeeded in vaulting their churches and arranging their statues in the new and majestic manner, when a fresh idea made all these Norman and Romanesque churches look clumsy and obsolete. The new idea was born in northern France. It was the principle of the Gothic style. At first one might call it mainly a technical invention, but in its effect it became much more. It was the discovery that the method of vaulting a church by means of crosswise arches could be developed much more consistently and to much greater purpose than the Norman architects had dreamt of. If it was true that pillars were sufficient to carry the arches of the vaulting between which the other stones were held as mere filling, then all the massive walls between the pillars were really superfluous. It was possible to erect a kind of scaffolding of stone which held the whole building together. All that was needed were slim pillars and narrow 'ribs'. Anything in between could be left out without danger of the scaffolding collapsing. There was no need for heavy stone walls – instead one could put in large windows. It became the ideal of architects to build churches almost in the manner in which we build greenhouses. Only they had no steel frames or iron girders - they had to make them of stone, and that needed a great amount of careful calculation. Provided, however, that the calculation was correct, it was possible to build a church of an entirely new kind; a building of stone and glass such as the world had never seen before. This is the leading idea of the Gothic cathedrals, which was developed in northern France in the second half of the twelfth century.

Of course, the principle of crosswise 'ribs' alone was not sufficient for this revolutionary style of Gothic building. A number of other technical inventions were necessary to make the miracle possible. The round arches

of the Romanesque style, for instance, were unsuited to the aims of the Gothic builders. The reason is this: if I am given the task of bridging the gap between two pillars with a semicircular arch, there is only one way of doing it. The vaulting will always reach one particular height, no more and no less. If I wanted to reach higher I should have to make the arch steeper. The best thing, in this case, is not to have a

rounded arch at all, but to fit two segments together. That is the idea of the pointed arch. Its great advantage is that it can be varied at will, made flatter or more pointed according to the requirements of the structure.

There was one more thing to be considered. The heavy stones of the vaulting press not only downwards but also sideways, much like a bow which has been drawn. Here, too, the pointed arch was an improvement over the round one, but even so pillars alone were not sufficient to withstand this outward pressure. Strong frames were needed to keep the whole structure in shape. In the vaulted side-aisles this did not prove very difficult. Buttresses could be built outside. But what could be done with the high nave? This had to be kept in shape from outside, across the roofs of the aisles. To do that, the builders had to introduce their 'flying buttresses', which complete the scaffolding of the Gothic vault, figure 122. A Gothic church seems to be suspended between these slender structures of stone as a bicycle wheel, held in shape by its flimsy spokes, carries its load. In both cases it is the even distribution of weight that makes it possible to reduce the material needed for the construction more and more without endangering the firmness of the whole.

It would be wrong, however, to look at these churches mainly as feats of engineering. The artist saw to it that we feel and enjoy the boldness of their design. Looking at a Doric temple, page 83, figure 50, we sense the function of the row of columns which carry the load of the horizontal roof. Standing inside a Gothic interior, figure 123, we are made to understand the complex interplay of thrust and pull that holds the lofty vault in its place. There are no blank walls or massive pillars anywhere. The whole interior seems to be woven out of thin shafts and ribs; their network covers the vault, and runs down along the walls of the nave to be gathered up by the pillars, which are formed by a bundle of stone rods.

12

Cathedral of Notre-Dame of Paris, 1163–1250

Aerial view showing the cross form and the flying buttresses

123

Robert de Luzarches The nave of Amiens Cathedral, c. 1218–47 A Gothic interior

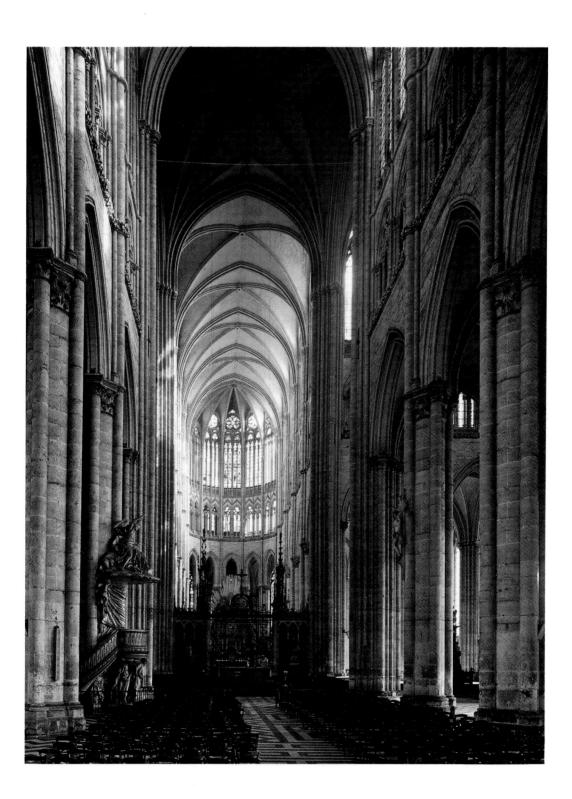

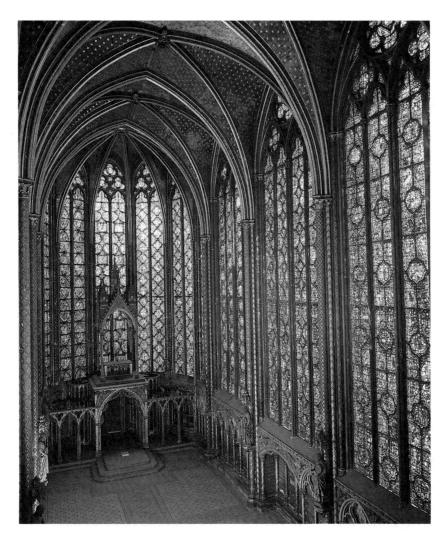

Sainte-Chapelle, Paris, 1248 Gothic church windows

Even the windows are overspread by these interlacing lines known as tracery, *figure 124*.

The great cathedrals, the bishops' own churches (cathedra = bishop's throne), of the late twelfth and early thirteenth century were mostly conceived on such a bold and magnificent scale that few, if any, were ever completed exactly as planned. But even so, and after the many alterations which they have undergone in the course of time, it remains an unforgettable experience to enter these vast interiors whose very dimensions seem to dwarf anything that is merely human and petty. We can hardly imagine the impression which these buildings must have made on those who had only known the heavy and grim structures of the Romanesque style. These older churches in their strength and power may have conveyed something of the 'Church Militant' that offered shelter against the onslaught of evil. The new cathedrals gave the faithful a glimpse of a different world. They would have heard in sermons and

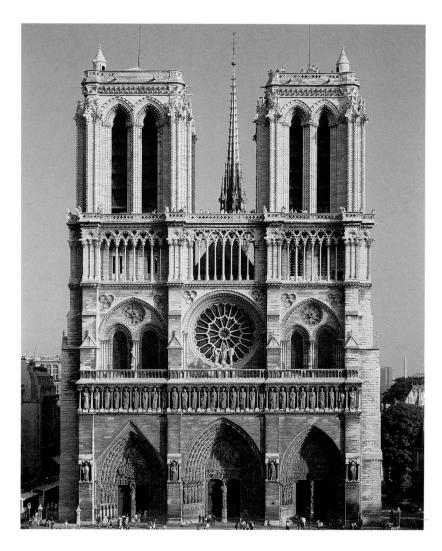

Cathedral of Notre-Dame of Paris, 1163–1250 A Gothic cathedral

hymns of the Heavenly Jerusalem with its gates of pearl, its priceless jewels, its streets of pure gold and transparent glass (Revelation xxi). Now this vision had descended from heaven to earth. The walls of these buildings were not cold and forbidding. They were formed of stained glass that shone like rubies and emeralds. The pillars, ribs and tracery were glistening with gold. Everything that was heavy, earthly or humdrum was eliminated. The faithful who surrendered themselves to the contemplation of all this beauty could feel that they had come nearer to understanding the mysteries of a realm beyond the reach of matter.

Even as seen from afar these miraculous buildings seemed to proclaim the glories of heaven. The façade of Notre-Dame in Paris is perhaps the most perfect of them all, *figure 125*. So lucid and effortless is the arrangement of the porches and windows, so lithe and graceful the tracery of the gallery, that we forget the weight of this pile of stone and the whole structure seems to rise up before us like a mirage.

There is a similar feeling of lightness and weightlessness in the sculptures that flank the porches like heavenly hosts. While the Romanesque master of Arles, page 176, figure 115, made his figures of saints look like solid pillars firmly fitted into the architectural framework, the master who worked on the northern porch of the Gothic cathedral of Chartres, figures 126, 127, made each of his figures come to life. They seem to move, and look at each other solemnly, and the flow of their drapery indicates once more that there is a body underneath. Each of

them is clearly marked, and should have been recognizable to anyone who knew his Old Testament. We have no difficulty in recognizing Abraham, the old man with his son Isaac held before him, ready to be sacrificed. We can also recognize Moses, because he holds the tablets on which the Ten Commandments were inscribed, and the column with the brazen serpent by which he cured the Israelites. The man on the other side of Abraham is Melchizedek, King of Salem, of whom we read in the Bible (Genesis xiv. 18) that he was 'a priest of the most high God' and that he 'brought forth bread and wine' to welcome Abraham after a successful battle. In medieval theology he was therefore considered the model of the priest who administers the sacraments, and that is why he is marked by the chalice and censer of the priest. In this way nearly every one of the figures that crowd the porches of the great Gothic cathedrals is clearly marked by an emblem so that its meaning and message could be understood and pondered by the faithful. Taken together they form as complete an embodiment of the teachings of the Church as the works discussed in the preceding chapter. And yet we feel that the Gothic sculptor has approached his task in a new spirit. To him these statues are not only sacred symbols, solemn reminders of a moral truth. Each of them must have been for him a figure in its own right, different from its neighbour in its attitude and type of beauty and each imbued with an individual dignity.

The cathedral of Chartres still largely belonged to the late twelfth century. After the year 1200 many new and magnificent cathedrals sprang up in France and also in the neighbouring countries, in England, in Spain and in the German Rhineland. Many of the masters busy on the new sites

126

Porch of the north transept of Chartres Cathedral, 1194

12/

Melchizedek, Abraham and Moses, 1194 Detail of figure 126

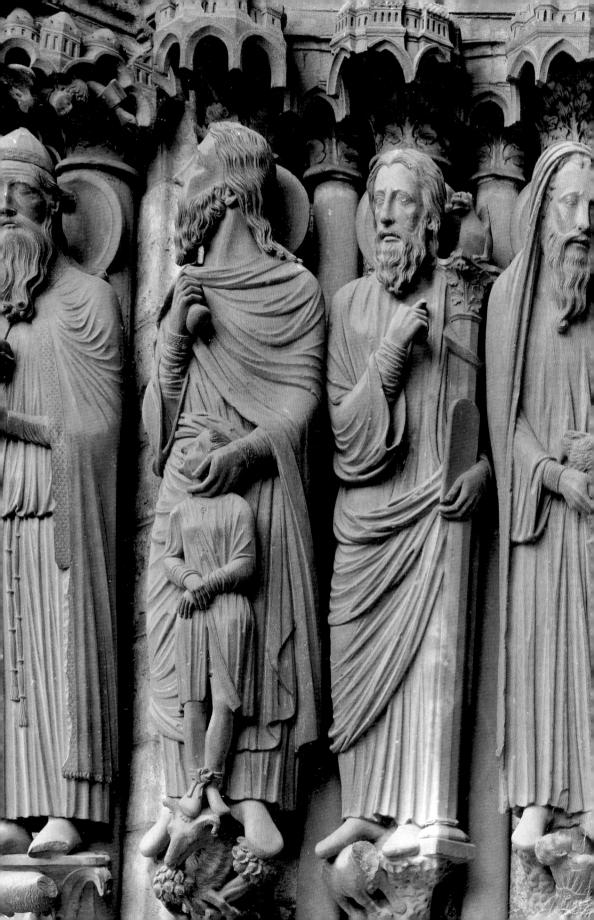

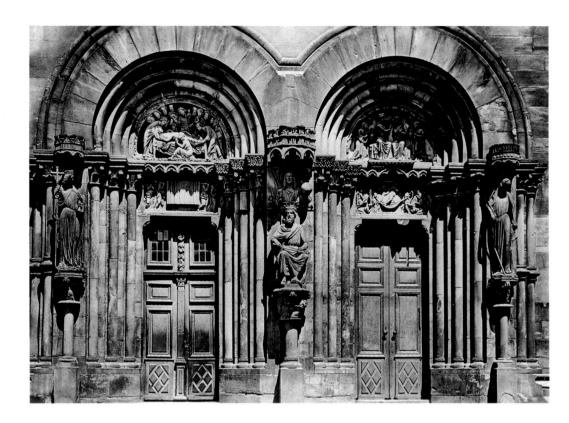

had learned their craft while working on the first buildings of this kind, but they all tried to add to the achievements of their elders.

Figure 129, from the early thirteenth-century Gothic cathedral of Strasbourg, shows the novel approach of these Gothic sculptors. It represents the Death of the Virgin. The twelve apostles surround her bed, St Mary Magdalene kneels before her. Christ, in the middle, is receiving the Virgin's soul into His arms. We see that the artist was still anxious to preserve something of the solemn symmetry of the early period. We can imagine that he sketched out the group beforehand to arrange the heads of the apostles around the arch, the two apostles at the bedside corresponding to each other, and the figure of Christ in the centre. But he was no longer content with a purely-symmetrical arrangement such as the twelfth-century master of page 181, figure 120, preferred. He clearly wanted to breathe life into his figures. We can see the expression of mourning in the beautiful faces of the apostles, with their raised eyebrows and their intent look. Three of them lift their hands to their faces in the traditional gesture of grief. Even more expressive are the face and figure of St Mary Magdalene, who cowers at the bedside and wrings her hands, and it is marvellous how the artist succeeded in contrasting her features with the serene and blissful look on the face of the Virgin. The draperies are no longer the empty husks and purely ornamental scrolls we see on early medieval work. The

Porch of the south transept of Strasbourg Cathedral, c. 1230

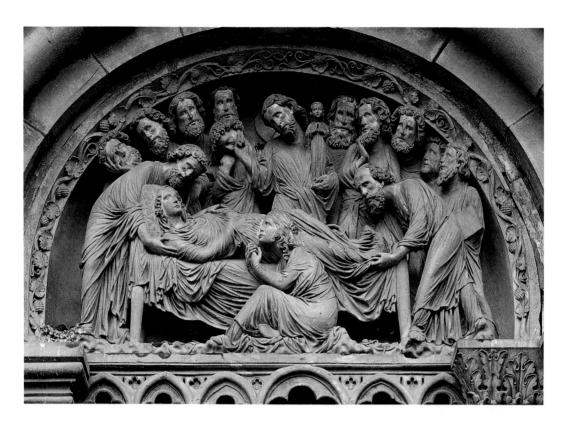

The Death of the Virgin
Detail of figure 128

Gothic artists wanted to understand the ancient formula for draped bodies, which had been handed down to them. Perhaps they turned for enlightenment to the remnants of pagan stonework, Roman tombstones and triumphal arches, of which several could be seen in France. Thus they regained the lost classical art of letting the structure of the body show under the folds of the drapery. Our artist, in fact, is proud of his ability to handle this difficult technique. The way in which the Virgin's feet and hands and Christ's hand appear under the cloth shows that these Gothic sculptors were no longer interested only in what they represented, but also in the problems of how to represent. Once more, as in the time of the great awakening in Greece, they began to look at nature, not so much to copy it as to learn from it how to make a figure look convincing. Yet there is a vast difference between Greek art and Gothic art, between the art of the temple and that of the cathedral. The Greek artists of the fifth century were mainly interested in how to build up the image of a beautiful body. To the Gothic artist all these methods and tricks were only a means to an end, which was to tell his sacred story more movingly and more convincingly. He does not tell it for its own sake, but for the sake of its message, and for the solace and edification the faithful could derive from it. The attitude of Christ as He looks at the dying Virgin was clearly more important to the artist than skilful rendering of muscles.

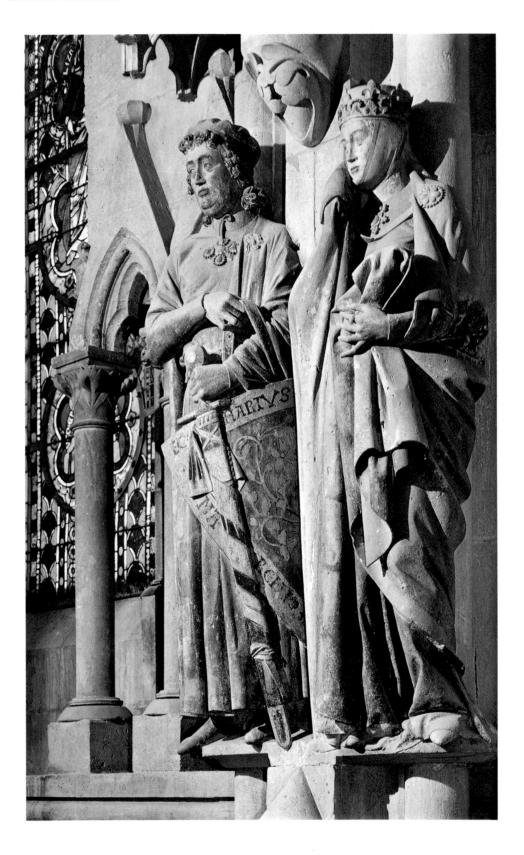

The Entombment
of Christ,
c. 1250–1300
From a Psalter manuscript
from Bonmont;

Bibliothèque municipale,

Besançon

Ekkehart and Uta, c. 1260

From the series of 'founders' in the choir of Naumburg Cathedral In the course of the thirteenth century, some artists went even further in their attempts to make the stone come to life. The sculptor who was given the task of representing the founders of Naumburg Cathedral in Germany, round about 1260, almost convinces us that he portrayed actual knights of his time, *figure 130*. It is not very likely that he really did – these founders had been dead for many years, and were nothing but a name to him. But his statues of men and women seem to be ready at any moment to step down from the pedestals and to join the company of those vigorous knights and gracious ladies whose deeds and suffering fill the pages of our history books.

To work for cathedrals was the main task of the northern sculptors of the thirteenth century. The most frequent task of the northern painters of that time was still the illumination of manuscripts, but the spirit of these illustrations was very different from that of the solemn Romanesque book pages. If we compare the Annunciation from the twelfth century, page 180, figure 119, with a page from a thirteenth-century Psalter, figure 131, we gain a measure of this change. It shows the entombment of Christ, similar in subject and in spirit to the relief from Strasbourg Cathedral, figure 129. Once more we see how important it has become to the artist to show us the feelings of his figures. The Virgin bends over the dead body of Christ and embraces it, while St John wrings his hands in grief. As in the relief,

we see what pains the artist took to fit his scene into a regular pattern: the angels in the top corners coming out of the clouds with censers in their hands, and the servants with their strange pointed hats – such as were worn by the Jews in the Middle Ages – supporting the body of Christ. This expression of intense feeling, and this regular distribution of the figures on the page, were obviously more important to the artist than any attempt to make his figures lifelike, or to represent a real scene. He does not mind that the servants are smaller than the holy personages, and he does not give us any indication of the place or the setting. We understand what is happening without any such external indications. Though it was not the artist's aim to represent things as we see them in reality, his knowledge of the human body, like that of the Strasbourg master, was nevertheless much greater than that of the painter of the twelfth-century miniature.

It was in the thirteenth century that artists occasionally abandoned their pattern books, in order to represent something because it interested them. We can hardly imagine today what this meant. We think of an artist as a person with a sketchbook who sits down and makes a drawing from life whenever he feels inclined. But we know that the whole training and upbringing of the medieval artist was very different. He started by being apprenticed to a master, whom he assisted at first by carrying out his instructions and filling in relatively unimportant parts of a picture. Gradually he would learn how to represent an apostle, and how to draw the Holy Virgin. He would learn to copy and rearrange scenes from old books, and fit them into different frames, and he would finally acquire enough facility in all this to be able even to illustrate a scene for which he knew no pattern. But never in his career would he be faced with the necessity of taking a sketchbook and drawing something from life. Even when he was asked to represent a particular person, the ruling king or a bishop, he would not make what we should call a likeness. There were no portraits as we understand them in the Middle Ages. All the artists did was to draw a conventional figure and to give it the insignia of office – a crown and sceptre for the king, a mitre and crozier for the bishop – and perhaps write the name underneath so that there would be no mistake. It may seem strange to us that artists who were able to make such lifelike figures as the Naumburg founders, figure 130, should have found it difficult to make a likeness of a particular person. But the whole idea of sitting down in front of a person or an object and copying it was alien to them. It is all the more remarkable that, on certain occasions, artists in the thirteenth century did in fact draw something from life. They did it when they had no conventional pattern on which they could rely. Figure 132 shows such an exception. It is the picture of an elephant drawn by the English historian Matthew Paris (died 1259) in the middle of the thirteenth

Matthew Paris
An elephant and
its keeper, c. 1255
Drawing from a
manuscript; Parker
Library, Corpus Christi

College, Cambridge

century. This elephant had been sent by St Louis, King of France, to Henry III in 1255. It was the first that had been seen in England. The figure of the servant by its side is not a very convincing likeness, though we are given his name, Henricus de Flor. But what is interesting is that in this case the artist was very anxious to get the right proportions. Between the legs of the elephant there is a Latin inscription saying: 'By the size of the man portrayed here you may imagine the size of the beast represented here.' To us this elephant may look a little odd, but it does show, I think, that medieval artists, at least in the thirteenth century, were very well aware of such things as proportions, and that, if they ignored them so often, they did so not out of ignorance but simply because they did not think they mattered.

In the thirteenth century, the time of the great cathedrals, France was the richest and most important country in Europe. The University of Paris was the intellectual centre of the Western World. In Italy, which was a land of warring cities, the ideas and methods of the great French cathedral builders, which had been so eagerly imitated in Germany and England, did not at first meet with much response.

It was only in the second half of the thirteenth century that an Italian sculptor began to emulate the example of the French masters and to study

the methods of classical sculpture in order to represent nature more convincingly. This artist was Nicola Pisano, who worked in the great seaport and trading centre of Pisa. Figure 133 shows one of the reliefs on a pulpit he completed in 1260. At first it is not too easy to see what subject is represented because Pisano followed the medieval practice of combining various stories within one frame. Thus the left corner of the relief is taken up with the group of the Annunciation and the middle with the Birth of Christ. The Virgin is lying on a bedstead, St Joseph is crouching in a corner, and two servants are engaged in bathing the Child. They seem to be jostled about by a herd of sheep, but these really belong to a third scene - the story of the Annunciation to the Shepherds, which is represented in the top right-hand corner, where the Christ Child appears once more in the manger. But if the scene appears a little crowded and confusing the sculptor has nevertheless contrived to give each episode its proper place and its vivid details. One can see how he enjoyed such touches of observation as the goat in the lower right-hand corner scratching its head with its hoof, and one realizes how much he owed to the study of classical and early Christian sculpture, page 128, figure 83, when one looks at his treatment of heads and garments. Like the master of Strasbourg who worked a generation before him, or like the master of Naumburg who may have been about his age, Nicola Pisano had learned the methods of the ancients to show the forms of the body under the drapery and to make his figures look both dignified and convincing.

Italian painters were even slower than Italian sculptors in responding to the new spirit of the Gothic masters. Italian cities such as Venice were in close contact with the Byzantine Empire and Italian craftsmen looked to Constantinople rather than to Paris for inspiration and guidance (see *page 23*, *figure 8*). In the thirteenth century Italian churches were still decorated with solemn mosaics in the 'Greek manner'.

It might have seemed as if this adherence to the conservative style of the East would prevent all change, and indeed the change was long delayed. But when it came towards the end of the thirteenth century, it was this firm grounding in the Byzantine tradition which enabled Italian art not only to catch up with the achievements of the northern cathedral sculptors but to revolutionize the whole art of painting.

We must not forget that the sculptor who aims at reproducing nature has an easier task than the painter who sets himself a similar aim. The sculptor need not worry about creating an illusion of depth through foreshortening or through modelling in light and shade. His statue stands in real space and in real light. Thus the sculptors of Strasbourg or Naumburg could reach a degree of lifelikeness which no thirteenth-century painting could match. For we remember that northern painting

Nicola Pisano
Annunciation, Nativity
and Shepherds, 1260
Marble relief from the
pulpit in the Baptistery

had given up all pretence of creating an illusion of reality. Its principles of arrangement and of story-telling were governed by quite different aims.

It was Byzantine art which ultimately allowed the Italians to leap the barrier that separates sculpture from painting. For all its rigidity, Byzantine art had preserved more of the discoveries of the Hellenistic painters than had survived the picture-writing of the Dark Ages in the West. We remember how many of these achievements still lay hidden, as it were, under the frozen solemnity of a Byzantine painting like page 139, figure 88; how the face is modelled in light and shade and how the throne and the footstool show a correct understanding of the principles of foreshortening. With methods of this kind a genius who broke the spell of Byzantine conservatism could venture out into a new world and translate the lifelike figures of Gothic sculpture into painting. This genius Italian art found in the Florentine painter Giotto di Bondone (c. 1267-1337).

It is usual to start a new chapter with Giotto; the Italians were convinced that an entirely new epoch of art had begun with the appearance of that great painter. We shall see that they were right. But for all that, it may be useful to remember that in real history there are no new chapters and no new beginnings, and that it detracts nothing from Giotto's greatness if we realize that his methods owe much to the Byzantine masters, and his aims and outlook to the great sculptors of the northern cathedrals.

Giotto's most famous works are wall-paintings or frescoes (so called because they must be painted on the wall while the plaster is still fresh, that is, wet). Between 1302 and 1305 he covered the wall of a small church in Padua in northern Italy with stories from the life of the Virgin and of Christ. Underneath he painted personifications of virtues and vices such as had sometimes been placed on the porches of northern cathedrals.

Figure 134 shows Giotto's figure of Faith, a matron with a cross in one hand, a scroll in the other. It is easy to see the similarity of this noble figure to the works of the Gothic sculptors. But this is no statue. It is a painting which gives the illusion of a statue in the round. We see the foreshortening of the arms, the modelling of the face and neck, the deep shadows in the flowing folds of the drapery. Nothing like this had been done for a thousand years. Giotto had rediscovered the art of creating the illusion of depth on a flat surface.

For Giotto this discovery was not only a trick to be displayed for its own sake. It enabled him to change the whole conception of painting. Instead of using the methods of picture-writing he could create the illusion that the sacred story was happening before our very eyes. For this it was no longer sufficient to look at older representations of the same scene and adapt these time-honoured models to a new use. He rather followed the

Giotto di Bondone, Faith, c. 1305 Detail of a fresco; Cappella dell'Arena, Padua

advice of the preaching friars who exhorted the people to visualize in their mind, when reading the Bible and the legends of the Saints, what it must have looked like when a carpenter's family fled to Egypt or when the Lord was nailed to the cross. He did not rest till he had thought it all out afresh: how would a man stand, how would he act, how would he move, if he took part in such an event? Moreover, how would such a gesture or movement present itself to our eyes?

We can best gauge the extent of this revolution if we compare one of Giotto's frescoes from Padua, figure 135, with a similar theme in the thirteenth-century miniature in figure 131. The subject is the mourning over the dead body of Christ, with the Virgin embracing her Son for the last time. In the miniature the artist was not interested in representing the scene as it might have happened. He varied the size of the figures so as to fit them well into the page, and if we try to imagine the space between the figures in the foreground and St John in the background - with Christ and the Virgin in between – we realize how everything is squeezed together, and how little the artist cared about space. It is the same indifference to the real place where the scene is happening which led Nicola Pisano to represent different episodes within one frame. Giotto's method is completely different. Painting, for him, is more than a substitute for the written word. We seem to witness the real event as if it were enacted on a stage. Compare the conventional gesture of the mourning St John in the miniature with the passionate movement of St John in Giotto's painting as he bends forward, his arms extended sideways. If we try here to imagine the distance between the cowering figures in the foreground and St John, we immediately feel that there is air and space between them, and that they can all move. These figures in the foreground show how entirely new Giotto's art was in every respect. We remember that early Christian art had reverted to the old Oriental idea that to tell a story clearly every figure had to be shown completely, almost as was done in Egyptian art. Giotto abandoned these ideas. He did not need such simple devices. He shows us so convincingly how each figure reflects the grief of the tragic scene that we sense the same grief in the cowering figures whose faces are hidden from us.

Giotto's fame spread far and wide. The people of Florence were proud of him. They were interested in his life, and told anecdotes about his wit and dexterity. This, too, was rather a new thing. Nothing quite like it had happened before. Of course, there had been masters who had enjoyed general esteem, and been recommended from monastery to monastery, or from bishop to bishop. But, on the whole, people did not think it necessary to preserve the names of these masters for posterity. They thought of them as we think of a good cabinet-maker or tailor. Even the

Giotto di Bondone, The Mourning of Christ, c. 1305

Fresco; Cappella dell'Arena, Padua

135

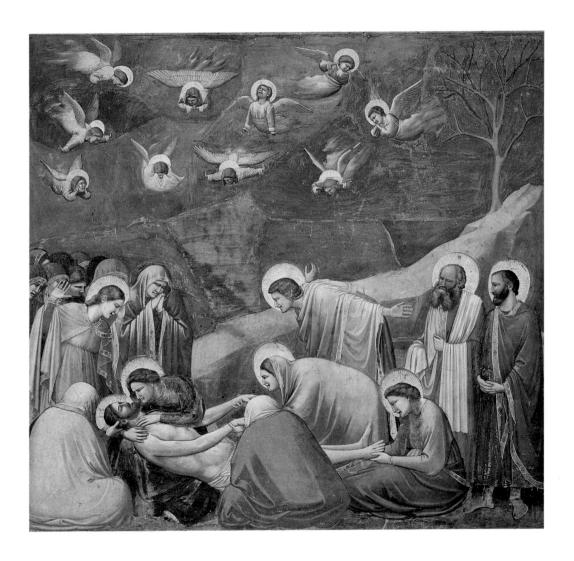

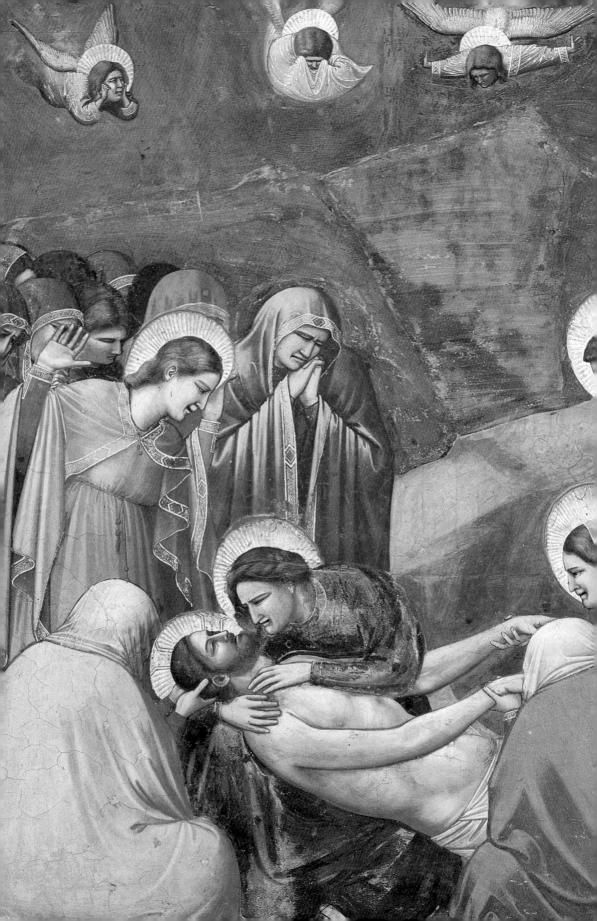

Detail of figure 135

artists themselves were not much interested in acquiring fame or notoriety Very often they did not even sign their work. We do not know the names of the masters who made the sculptures of Chartres, Strasbourg or Naumburg. No doubt they were appreciated in their time, but they gave the honour to the cathedral for which they worked. In this respect too, the Florentine painter Giotto begins an entirely new chapter in the history of art. From his day onwards the history of art, first in Italy and then in other countries also, is the history of the great artists.

The king and his architect (with compass and ruler) visiting the building site of a cathedral (King Offa at St Albans), c. 1240-50 Drawing by Matthew Paris

Abbey; Trinity College,

Dublin

II

COURTIERS AND BURGHERS

The fourteenth century

The thirteenth century had been the century of the great cathedrals, in which nearly all branches of art had their share. Work on these immense enterprises continued into the fourteenth century and even beyond, but they were no longer the main focus of art. We must remember that the world had changed a great deal during that period. In the middle of the twelfth century, when the Gothic style was first developed, Europe was still a thinly populated continent of peasants with monasteries and barons' castles as the main centres of power and learning. The ambition of the great bishops' sees to have mighty cathedrals of their own was the first indication of an awakening civic pride in the towns. But a hundred and fifty years later these towns had grown into teeming centres of trade whose burghers felt increasingly independent of the power of the Church and the feudal lords. Even the nobles no longer lived a life of grim seclusion in their fortified manors, but moved to the cities with their comfort and fashionable luxury, there to display their wealth at the courts of the mighty. We can get a very vivid idea of what life in the fourteenth century was like if we turn to the works of Chaucer, with his knights and squires, friars and artisans. This was no longer the world of the Crusades, and of those paragons of chivalry, which we remember when looking at the founders of Naumburg, page 194, figure 130. It is never safe to generalize too much about periods and styles. There are always exceptions and examples which would not fit any such generalization. But, with that reservation, we may say that the taste of the fourteenth century was rather for the refined than for the grand.

This is exemplified in the architecture of the period. In England we distinguish between the pure Gothic style of the early cathedrals, which is known as Early English, and the later development of these forms, known as the Decorated style. The name indicates the change of taste. The Gothic builders of the fourteenth century were no longer content with the clear majestic outline of the earlier cathedrals. They liked to show their skill in decoration and complicated tracery. The west window of Exeter Cathedral is a typical example of this style, *figure 137*.

Churches were no longer the main tasks of the architects. In the

growing and prosperous cities many secular buildings had to be designed – town halls, guild halls, colleges, palaces, bridges and city gates. One of the most celebrated and characteristic buildings of this kind is the Doges' Palace in Venice, *figure 138*, which was begun in the fourteenth century, when the power and prosperity of that city were at their height. It shows that this later development of the Gothic style, for all its delight in ornament and tracery, could yet achieve its own effect of grandeur.

The most characteristic works of sculpture in the fourteenth century are perhaps not those of stone, which were still made in great numbers for the churches of the period, but rather the smaller works of precious metal or

West front of Exeter Cathedral, c. 1350– 1400

The Decorated style

ivory, in which the craftsmen of the period excelled. Figure 139 shows a little silver-gilt statue of the Virgin made by a French goldsmith. Works of this kind were not intended for public worship. Rather, they were to be placed in a palace chapel for private prayer. They are not meant to proclaim a truth in solemn aloofness, like the statues of the great cathedrals, but to excite love and tenderness. The Paris goldsmith was thinking of the Virgin as a real mother, and of Christ as a real child, thrusting His hand at His mother's face. He took care to avoid any impression of rigidity. That is why he gave the figure a slight bend – she rests her arm on her hip to support the child, while her head is bent towards Him. Thus the whole body seems to sway slightly in a gentle curve, very much like an S, and Gothic artists of the period were very fond of this motif. In fact the artist who made this statue

probably did not invent either the peculiar posture of Our Lady, or the motif of the Child playing with her. In such things he was following the general trend of fashion. His own contribution lay in the exquisite finish of every detail, the beauty of the hands, the little creases in the baby's arms, the wonderful surface of gilded silver and enamel, and, last but not least, the exact proportion of the statue, with its small and graceful head on a long and slender body. There is nothing haphazard in these works by the great Gothic craftsmen. Such details as the drapery falling over the right arm show the infinite care the artist has taken to compose it into graceful and melodious lines. We can never do these works justice if we just pass them by in our museums, and devote no more than a quick glance to them. They were made to be appreciated by real connoisseurs, and treasured as pieces worthy of devotion.

The love of fourteenth-century painters for graceful and delicate details is seen in such famous illustrated manuscripts as the English Psalter known

139

Virgin and Child, c. 1324–39; dedicated by Joan of Evreux in 1339

Silver gilt, enamel and precious stones, height 69 cm, 27¼ in; Louvre, Paris

Christ in the Temple; a hawking party, c. 1310
Page from Queen Mary's
Psalter; British Library,
London

as 'Queen Mary's Psalter'. Figure 140 shows Christ in the Temple, conversing with the learned scribes. They have put Him on a high chair, and He is seen explaining some point of doctrine with the characteristic gesture used by medieval artists when they wanted to draw a teacher. The Jewish scribes raise their hands in attitudes of awe and astonishment, and so do Christ's parents, who are just coming on to the scene, looking at each other wonderingly. The method of telling the story is still rather unreal. The artist has evidently not yet heard of Giotto's discovery of the way in which to stage a scene so as to give it life. Christ, who was twelve at the time, as the Bible tells us, is minute in comparison with the grown-ups, and there is no attempt on the part of the artist to give us any idea of the space between the figures. Moreover, we can see that all the faces are more or less drawn according to one simple formula, with the curved eyebrows, the mouth drawn downwards and the curly hair and beard. It is all the more surprising to look down the same page and to see that another scene has been added, which has nothing

to do with the sacred text. It is a theme from the daily life of the time, the hunting of ducks with a hawk. Much to the delight of the man and women on horseback, and of the boy in front of them, the hawk has just got hold of a duck, while two others are flying away. The artist may not have looked at real twelve-year-old boys when he painted the scene above, but he had undoubtedly looked at real hawks and ducks when he painted the scene below. Perhaps he had too much reverence for the biblical narrative to bring his observation of actual life into it. He preferred to keep the two things apart: the clear symbolic way of telling a story with easily readable gestures and no distracting details, and, on the margin of the page, the slice of real life, which reminds us once more that this is Chaucer's century. It was only in the course of the fourteenth century that the two elements of this art, the graceful narrative and the faithful observation, were gradually fused. Perhaps this would not have happened so soon without the influence of Italian art.

In Italy, particularly in Florence, the art of Giotto had changed the whole idea of painting. The old Byzantine manner suddenly seemed stiff and outmoded. Nevertheless it would be wrong to imagine that Italian art was suddenly set apart from the remainder of Europe. On the contrary, Giotto's ideas gained influence in the countries north of the Alps, while the ideals of the Gothic painters of the north also began to have their effect on the southern masters. It was particularly in Siena, another Tuscan town and a great rival of Florence, that the taste and fashion of these northern artists made a very deep impression. The painters of Siena had not broken with the earlier Byzantine tradition in such an abrupt and revolutionary manner as Giotto in Florence. Their greatest master of Giotto's generation. Duccio (c. 1255/60-c. 1315/18), had tried – and tried successfully – to breathe new life into the old Byzantine forms instead of discarding them altogether. The altar panel of figure 141 was made by two younger masters of his school, Simone Martini (1285?-1344) and Lippo Memmi (died 1347?). It shows to what an extent the ideals and the general atmosphere of the fourteenth century had been absorbed by Sienese art. The painting represents the Annunciation – the moment when the Archangel Gabriel arrives from Heaven to greet the Virgin, and we can read his words coming out of his mouth: 'Ave gratia plena'. In his left hand he holds an olive branch, symbol of peace; his right hand is lifted as if he were about to speak. The Virgin has been reading. The appearance of the angel has taken her by surprise. She shrinks away in a movement of awe and humility, while looking back at the messenger from Heaven. Between the two there stands a vase with white lilies, symbols of virginity, and high up in the central pointed arch we see the dove, symbol of the Holy Ghost, surrounded by four-winged cherubim. These masters shared the predilection of the French and English artists of figures 139 and 140 for delicate forms and a lyrical mood. They enjoyed the gentle curves of the flowing drapery and the subtle grace of slender bodies. The whole painting, in fact, looks like some precious goldsmith's work, with its figures standing out from a golden background, so skilfully arranged that they form an admirable pattern. One can never cease to wonder at the way in which these figures are fitted into the complicated shape of the panel; the way in which the angel's wings are framed by the pointed arch to the left, and the Virgin's figure shrinks back into the shelter of the pointed arch to the right, while the empty space between them is filled by the vase and the dove over it. The painters had learned this art of fitting the figures into a pattern from the medieval tradition. We had occasion, earlier, to admire the way in which medieval artists arranged the symbols of the sacred stories so as to form a satisfying arrangement. But we know that they did so by ignoring the real shape and proportion of things, and by forgetting about

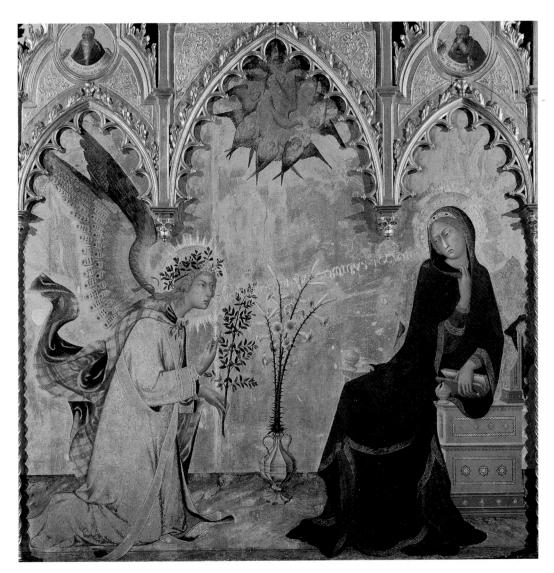

Simone Martini & Lippo Memmi The Annunciation, 1333

Part of an altarpiece made for Siena Cathedral; tempera on wood; Uffizi, Florence space altogether. That was no longer the way of the Sienese artists. Perhaps we may find their figures a little strange, with their slanting eyes and curved mouths. But we need only look at some details to see that the achievements of Giotto had by no means been lost on them. The vase is a real vase standing on a real stone floor, and we can tell exactly where it stands in relation to the angel and the Virgin. The bench on which the Virgin sits is a real bench, receding into the background, and the book she holds is not just the symbol of a book, but a real prayer book with light falling on it and with shade between the pages, which the artist must have studied from a prayer book in his studio.

Giotto was a contemporary of the great Florentine poet Dante, who mentions him in his *Divine Comedy*. Simone Martini, the master of *figure 141*, was a friend of Petrarch, the greatest Italian poet of the next generation. Petrarch's fame today rests mainly on the many love-sonnets he wrote for Laura. We know from them that Simone Martini painted a portrait of Laura which Petrarch treasured. We remember that portraits in our sense had not existed during the Middle Ages and that artists were content to use any conventional figure of a man or woman, and to write on it the name of the person it was intended to represent. Unfortunately, Simone Martini's portrait of Laura is lost, and we do not know how far it was a real likeness. We do know, however, that this artist and other masters in the fourteenth century painted likenesses from nature, and the art of portraiture developed during that period. Perhaps the way in which Simone Martini looked at nature and observed details had something to do with this, for the artists of Europe had ample opportunity of learning from

Peter Parler the Younger Self-portrait, 1379–86 Prague Cathedral

his achievements. Like Petrarch himself, Simone Martini spent many years at the court of the Pope, which was at that time not in Rome but at Avignon in southern France. France was still the centre of Europe, and French ideas and styles had a great influence everywhere. Germany was ruled by a family from Luxemburg who had their residence in Prague. There is a wonderful series of busts dating from this period (between 1379 and 1386) in the cathedral of Prague. They represent benefactors of the church and thus serve the same purpose as the figures of the Naumburg Founders, page 194, figure 130. But here we need no longer be in doubt. These are real portraits. For the series includes busts of contemporaries including one of the artist in charge, Peter Parler the Younger (1330–99), which is in all probability the first real self-portrait of an artist known to us, figure 142.

Bohemia became one of the centres through which this influence from Italy and France spread more widely. Its contacts reached as far as England, where Richard II married Anne of Bohemia. England traded with Burgundy. Europe, or at least the Europe of the Latin Church, was still one large unit. Artists and ideas travelled from one centre to another, and no one thought of rejecting an achievement because it was 'foreign'. The style which arose out of this mutual give-and-take towards the end of the fourteenth century is known among historians as the 'International style'. A wonderful example of it in England, possibly painted by a French master for an English king, is the so-called Wilton Diptych, figure 143. It is interesting to us for many reasons, including the fact that it, too, records the features of a real historical personage, and that of no other than Anne of Bohemia's unlucky husband - King Richard II. He is seen kneeling in prayer while St John the Baptist and two patron saints of the royal family commend him to the Holy Virgin, who seems to stand on the flowery meadow of Paradise, surrounded by angels of radiant beauty, all of whom wear the badge of the king, the white hart with golden antlers. The lively Christ Child is bending forward as if to bless or welcome the king and assure him that his prayers have been answered. Perhaps something of the ancient magical attitude towards the image still survives in the custom of 'donors' portraits' to remind us of the tenacity of these beliefs which we have found in the very cradle of art. Who can tell whether the donor did not feel somehow reassured in the rough and tumble of life, in which his own part was perhaps not always very saintly, to know that in some quiet church or chapel there was something of himself – a likeness fixed there through the artist's skill, which always kept company with the saints and angels and never ceased praying?

143 OVERLEAF

St John the Baptist,
St Edward the
Confessor and
St Edmund commend
Richard II to Christ
(the Wilton Diptych),
c. 1395
Tempera on wood; each

section 47.5 × 29.2 cm, 18 × 11½ in; National Gallery, London

It is easy to see how the art of the Wilton Diptych is linked with the works we have discussed before, how it shares with them the taste for

beautiful flowing lines and for dainty and delicate motifs. The way in which the Virgin touches the foot of the Christ Child and the gestures of the angels, with their long and slender hands, remind us of figures we have seen before. Once more we see how the artist showed his skill in foreshortening, for instance in the posture of the angel kneeling on the left side of the panel, and how he enjoyed making use of studies from nature in the many flowers which adorn the paradise of his imagination.

The artists of the International style applied the same power of observation, and the same delight in delicate and beautiful things, to their portrayal of the world around them. It had been customary in the Middle Ages to illustrate calendars with pictures of the changing occupations of the months, of sowing, hunting, harvesting. A calendar attached to a prayer book which a rich Burgundian duke had ordered from the workshop of the Limbourg brothers, figure 144, shows how these pictures from real life had gained in liveliness and observation, even since the time of Queen Mary's Psalter of figure 140. The miniature represents the annual spring festival of the courtiers. They are riding through a wood in gay attire, wreathed with branches and flowers. We can see how the painter enjoyed the spectacle of the pretty girls in their fashionable dresses, and how he took pleasure in bringing the whole colourful pageantry on to his page. Once more we may think of Chaucer and his pilgrims; for our artist, too, took pains to distinguish the different types, so skilfully that we almost seem to hear them talking. Such a picture was probably painted with a magnifying glass, and it should be studied with the same loving attention. All the choice details which the artist has crowded on to his page combine to build up a picture which looks nearly like a scene from real life. Nearly, but not quite; for when we notice that the artist has closed the background with a kind of curtain of trees, beyond which we see the roof-tops of a vast castle, we realize that what he gives us is not an actual scene from nature. His art seems so far removed from the symbolic way of telling a story which earlier painters had used, that it needs an effort to realize that even he cannot represent the space in which his figures move, and that he achieves the illusion of reality mainly through his close attention to detail. His trees are not real trees painted from nature, but rather a row of symbolic trees, one beside the other, and even his human faces are still developed more or less out of one charming formula. Nevertheless, his interest in all the splendour and gaiety of the real life around him shows that his ideas about the aims of painting were very different from those of the artists of the early Middle Ages. The interest had gradually shifted, from the best way of telling a sacred story as clearly and impressively as possible, to the methods of representing a piece of nature in the most faithful way. We have seen that the two ideals do not necessarily clash.

Paul and Jean de Limbourg May, c. 1410

144

Page from the 'Très Riches Heures', painted for the Duke of Berry; Musée Condé, Chantilly

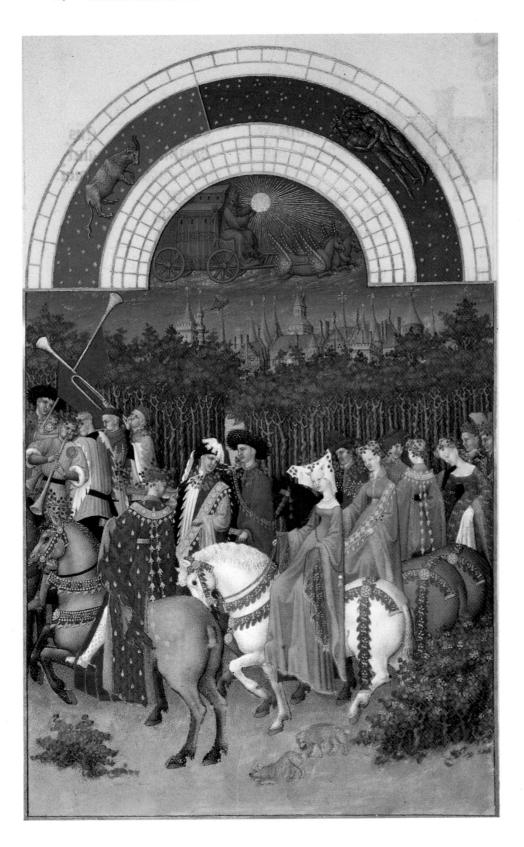

It was certainly possible to place this newly acquired knowledge of nature at the service of religious art, as the masters of the fourteenth century had done, and as other masters were to do after them; but, for the artist, the task had nevertheless changed. Formerly it was sufficient training to learn the ancient formulas for representing the main figures of the sacred story and to apply this knowledge in ever-new combinations. Now the artist's job included a different skill. He had to be able to make studies from nature and to transfer them to his pictures. He began to use a sketchbook, and to lay up a store of sketches of rare and beautiful plants and animals. What had been an exception in the case of Matthew Paris, page 197, figure

145

Antonio Pisanello
Studies of a monkey,
c. 1430
Leaf from a sketchbook;
silverpoint on paper, 20.6 ×
21.7 cm, 8 × 8½ in;
Louvre, Paris

132, was soon to be the rule. A drawing such as *figure 145*, made by the north Italian artist Antonio Pisanello (1397–1455?) only some twenty years after the Limbourg miniature, shows how this habit led artists to study a live animal with loving interest. The public which looked at the artist's works began to judge them by the skill with which nature was portrayed, and by the wealth of attractive details which the artist managed to bring into his pictures. The artists, however, wanted to go one better. They were no longer content with the newly acquired mastery of painting such details as flowers or animals from nature; they wanted to explore the laws of vision, and to acquire sufficient knowledge of the human body to build it up in their statues and pictures as the Greeks and Romans had done. Once their interest took this turn, medieval art was really at an end. We come to the period usually known as the Renaissance.

A sculptor at work, c. 1340 Marble relief by Andrea Pisano from the Florentine Campanile; height 100 cm, 39½ in; Museo dell'Opera del Duomo, Florence

THE CONQUEST OF REALITY

The early fifteenth century

The word renaissance means rebirth or revival, and the idea of such a rebirth had gained ground in Italy ever since the time of Giotto. When people of the period wanted to praise a poet or an artist, they said that his work was as good as that of the ancients. Giotto had been exalted in this way as a master who had led to a true revival of art; by this, people meant that his art was as good as that of the famous masters whose work they found praised in the ancient writers of Greece and Rome. It is not surprising that this idea became popular in Italy. The Italians were very much aware of the fact that in the distant past Italy, with Rome her capital, had been the centre of the civilized world, and that her power and glory had waned since the Germanic tribes, Goths and Vandals, had invaded the country and broken up the Roman Empire. The idea of a revival was closely connected in the minds of the Italians with the idea of a rebirth of 'the grandeur that was Rome'. The period between the classical age, to which they looked back with pride, and the new era of rebirth for which they hoped was merely a sad interlude, 'the time between'. Thus the idea of a rebirth or renaissance was responsible for the idea that the intervening period was a Middle Age - and we still use this terminology. Since the Italians blamed the Goths for the downfall of the Roman Empire, they began to speak of the art of this intervening period as Gothic, by which they meant barbaric - much as we speak of vandalism when we refer to the useless destruction of beautiful things.

We now know that these ideas of the Italians had little basis in fact. They were, at best, a crude and much simplified picture of the actual course of events. We have seen that some seven hundred years separated the Goths from the rise of the art that we now call Gothic. We also know that the revival of art, after the shock and turmoil of the Dark Ages, came gradually and that the Gothic period itself saw this revival getting into its full stride. Possibly we can understand the reason why the Italians were less aware of this gradual growth and unfolding of art than the people living farther north. We have seen that they lagged behind during part of the Middle Ages, so that the new achievements of Giotto came to them as a tremendous innovation, a rebirth of all that was noble and great in art.

The Italians of the fourteenth century believed that art, science and scholarship had flourished in the classical period, that all these things had been almost destroyed by the northern barbarians and that it was for them to help to revive the glorious past and thus bring about a new era.

In no city was this feeling of confidence and hope more intense than in the wealthy merchant city of Florence, the city of Dante and of Giotto. It was there, in the first decades of the fifteenth century, that a group of artists deliberately set out to create a new art and to break with the ideas of the past.

The leader of this group of young Florentine artists was an architect, Filippo Brunelleschi (1377–1446). Brunelleschi was employed on the completion of the cathedral of Florence. It was a Gothic cathedral, and Brunelleschi had fully mastered the technical inventions which formed part of the Gothic tradition. His fame, in fact, rests partly on an achievement in construction and design which would not have been possible without his knowledge of the Gothic methods of vaulting. The Florentines wished to have their cathedral crowned by a mighty dome, but no artist was able to span the immense space between the pillars on which the dome was to rest, till Brunelleschi devised a method of accomplishing this, figure 146. When Brunelleschi was called upon to design new churches or other buildings, he decided to discard the traditional style altogether, and to adopt the programme of those who longed for a revival of Roman grandeur. It is said that he travelled to Rome and measured the ruins of temples and palaces, and made sketches of their forms and ornaments. It was never his intention to copy these ancient buildings outright. They could hardly have been adapted to the needs of fifteenth-century Florence. What he aimed at was the creation of a new way of building, in which the forms of classical architecture were freely used to create new modes of harmony and beauty.

What remains most astonishing in Brunelleschi's achievement is the fact that he actually succeeded in making his programme come true. For nearly five hundred years the architects of Europe and America followed in his footsteps. Wherever we go in our cities and villages we find buildings in which classical forms, such as columns or pediments, are used. It was only in the present century that architects began to question Brunelleschi's programme and to revolt against the Renaissance tradition in building, just as he had revolted against the Gothic tradition. But many houses which are being built now, even those that have no columns or similar trimmings, still somewhere preserve remnants of classical form in the shape of mouldings on doors and window-frames, or in the measurements and proportions of the building. If Brunelleschi wanted to create the architecture of a new era, he certainly succeeded.

146
Filippo Brunelleschi
Dome of Florence
Cathedral, c. 1420–36

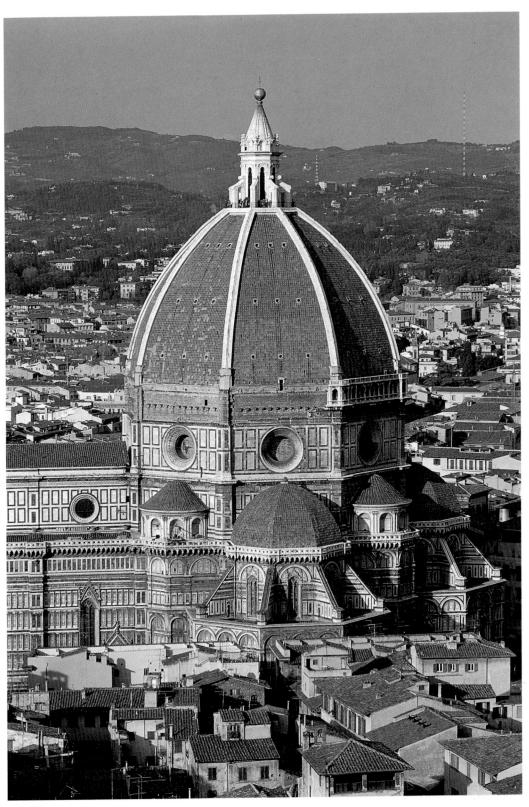

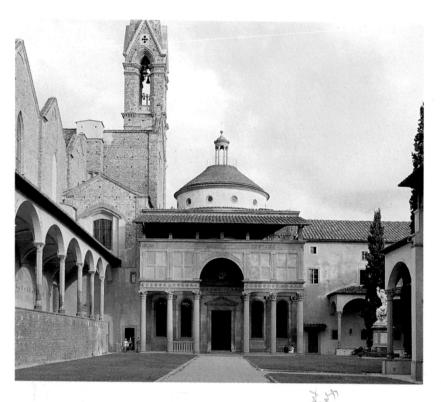

Filippo Brunelleschi Cappella Pazzi, Florence, c. 1430 An early Renaissance church

Figure 147 shows the façade of a little church which Brunelleschi built for the powerful family of the Pazzi in Florence. We see at once that it has little in common with any classical temple, but even less with the forms used by Gothic builders. Brunelleschi has combined columns, pilasters and arches in his own way to achieve an effect of lightness and grace which is different from anything that had gone before. Details such as the framing of the door, with its classical gable or pediment, show how carefully Brunelleschi had studied the ancient ruins, and buildings such as the Pantheon, page 120, figure 75. Compare how the arch is formed and how it cuts into the upper storey with its pilasters (flat half-columns). We see his study of Roman forms even more clearly as we enter the church, figure 148. Nothing in this bright and well-proportioned interior has any of the features which Gothic architects valued so highly. There are no high windows, no slim pillars. Instead, the blank white wall is subdivided by grey pilasters, which convey the idea of a classical 'order', although they serve no real function in the construction of the building. Brunelleschi only put them there to emphasize the shape and proportion of the interior.

Brunelleschi was not only the initiator of Renaissance architecture. To him, it seems, is due another momentous discovery in the field of art,

148 Filippo Bru

Filippo Brunelleschi Interior of the Cappella Pazzi, Florence, c. 1430

Chartres eathern

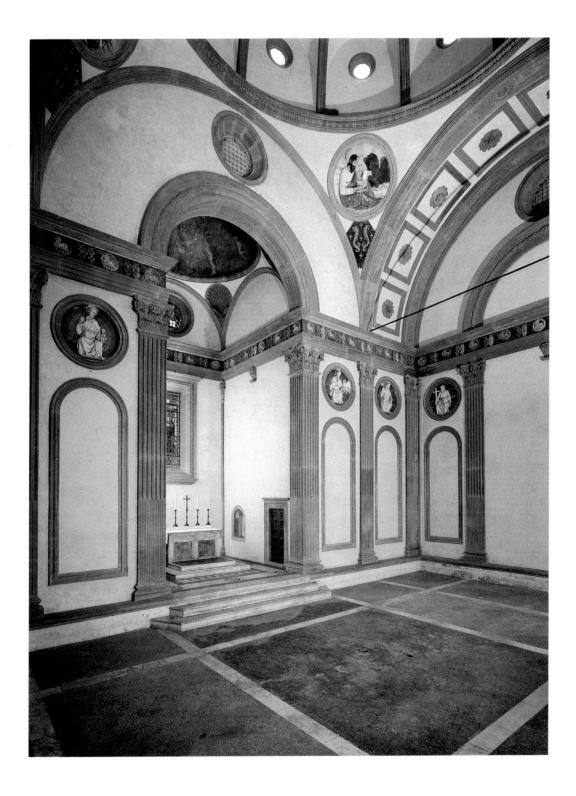

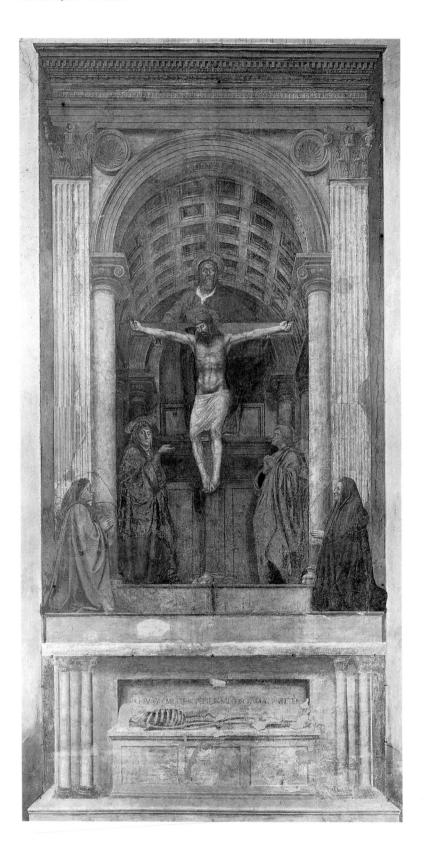

Masaccio
Holy Trinity with the
Virgin, St John and
donors, c. 1425–8
Fresco, 667 × 317 cm, 263
× 125 in; church of Sta

Maria Novella, Florence

which also dominated the art of subsequent centuries – that of perspective. We have seen that even the Greeks, who understood foreshortening, and the Hellenistic painters, who were skilled in creating the illusion of depth, page 114, figure 72, did not know the mathematical laws by which objects appear to diminish in size as they recede from us. We remember that no classical artist could have drawn the famous avenue of trees leading back into the picture until it vanishes on the horizon. It was Brunelleschi who gave artists the mathematical means of solving this problem; and the excitement which this caused among his painter-friends must have been immense. Figure 149 shows one of the first paintings which were made according to these mathematical rules. It is a wall-painting in a Florentine Church, and represents the Holy Trinity with the Virgin and St John under the cross, and the donors – an elderly merchant and his wife – kneeling outside. The artist who painted this was called Masaccio (1401) 28), which means 'clumsy Thomas'. He must have been an extraordinary genius, for we know that he died when hardly twenty-eight years of age, and that by then he had already brought about a complete revolution in painting. This revolution did not consist only in the technical trick of perspective painting, though that in itself must have been startling enough when it was new. We can imagine how amazed the Florentines must have been when this wall-painting was unveiled and seemed to have made a hole in the wall through which they could look into a new burial chapel in Brunelleschi's modern style. But perhaps they were even more amazed at the simplicity and grandeur of the figures which were framed by this new architecture. If the Florentines had expected something in the vein of the International style, which was as fashionable in Florence as elsewhere in Europe, they must have been disappointed. Instead of delicate grace, they saw massive heavy figures; instead of easy-flowing curves, solid angular forms; and, instead of dainty details such as flowers and precious stones, a stark tomb with a skeleton placed on it. But if Masaccio's art was less pleasing to the eye than the paintings they had been accustomed to, it was all the more sincere and moving. We can see that Masaccio admired the dramatic grandeur of Giotto, though he did not imitate him. The simple gesture with which the Holy Virgin points to her crucified Son is so eloquent and impressive because it is the only movement in the whole solemn painting. Its figures, in fact, look like statues. It is this effect, more than anything else, that Masaccio has heightened by the perspective frame in which he placed his figures. We feel we can almost touch them, and this feeling brings them and their message nearer to us. To the great masters of the Renaissance, the new devices and discoveries of art were never an end in themselves. They always used them to bring the meaning of their subject still nearer to our minds.

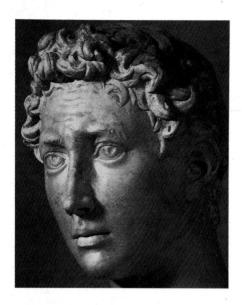

The greatest sculptor of Brunelleschi's circle was the Florentine master Donatello (1386?-1466). He was older than Masaccio by fifteen years, but he lived much longer. Figure 151 shows one of his earlier works. It was commissioned by the guild of the armourers, whose patron saint, St George, it represents, and was destined for a niche on the outside of a Florentine church (Or San Michele). If we think back to the Gothic statues outside the great cathedrals, page 191, figure 127, we realize how completely

Donatello broke with the past. These Gothic statues hovered at the side of the porches in calm and solemn rows, looking like beings from a different world. Donatello's St George stands firmly on the ground, his feet planted resolutely on the earth as if he were determined not to yield an inch. His face has none of the vague and serene beauty of medieval saints – it is all energy and concentration, figure 150. He seems to watch the approach of the enemy and to take its measure, his hands resting on his shield, his whole attitude tense with defiant determination. The statue has remained famous as an unrivalled picture of youthful dash and courage. But it is not only Donatello's imagination which we must admire, his faculty of visualizing the knightly saint in such a fresh and convincing manner; his whole approach to the art of sculpture shows a completely new conception. Despite the impression of life and movement which the statue conveys it remains clear in outline and solid as a rock. Like Masaccio's paintings, it shows us that Donatello wanted to replace the gentle refinement of his predecessors by a new and vigorous observation of nature. Such details as the hands or the brow of the saint show a complete independence from the traditional models. They prove a fresh and determined study of the real features of the human body. For these Florentine masters of the beginning of the fifteenth century were no longer content to repeat the old formulas handed down by medieval artists. Like the Greeks and Romans, whom they admired, they began to study the human body in their studios and workshops by asking models or fellow artists to pose for them in the required attitudes. It is this new method and this new interest which makes Donatello's work look so strikingly convincing.

Detail of figure 151

151 Donatello St George, c. 1415–16 Marble, height 209 cm, 82½ in; Museo Nazionale del Bargello, Florence

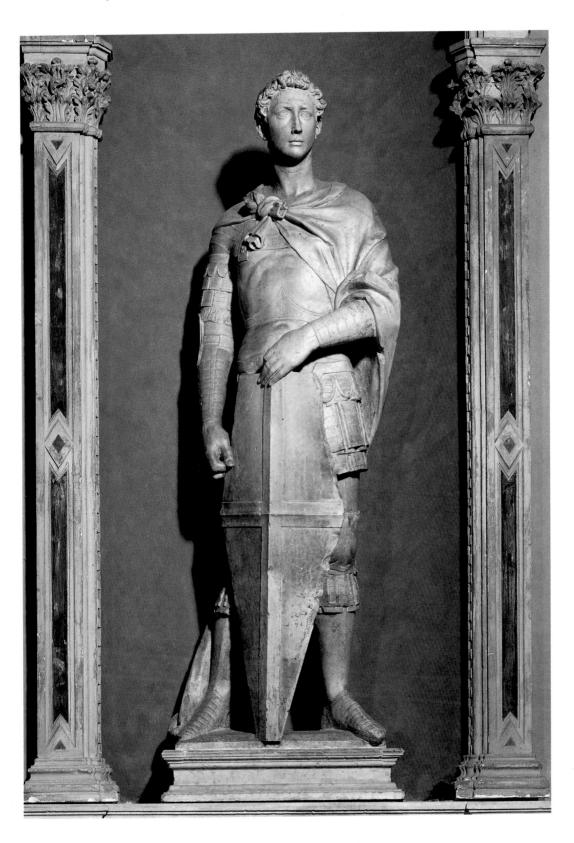

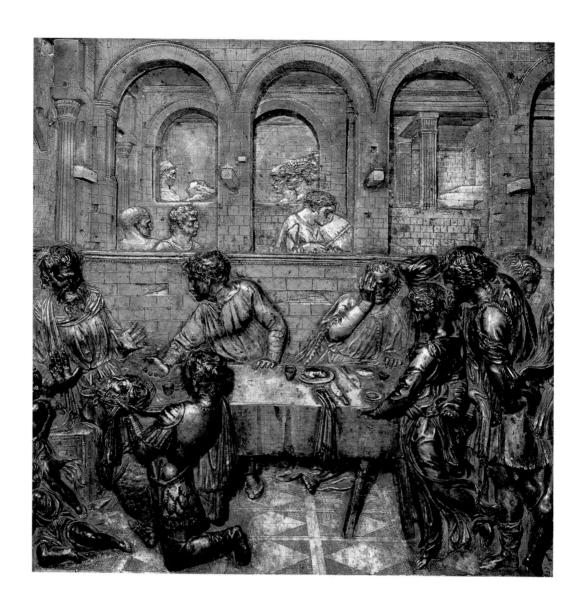

Donatello
The Feast of Herod,
1423-7
Gilt bronze, 60 × 60 cm,

Gilt bronze, 60×60 cm, $23\% \times 23\%$ in; relief on the font of the Baptistery, Siena Cathedral

153 Detail of figure 152

Donatello acquired great fame in his lifetime. Like Giotto a century earlier, he was frequently called to other Italian cities to add to their beauty and glory. Figure 152 shows a bronze relief he made for a font at Siena some ten years after the St George. Like the medieval font of page 179, figure 118, it illustrates a scene from the life of St John the Baptist. It shows the gruesome moment when the princess Salome had asked King Herod for the head of St John as a reward for her dancing, and got it. We look into the royal banqueting hall, and beyond it to the musicians' gallery and a sequence of rooms and stairs behind. The executioner has just entered and knelt down before the king carrying the head of the saint on a charger. The king shrinks back and raises his hands in horror, children cry and run away; Salome's mother, who instigated the crime, is seen talking to the king, trying to explain the deed. There is a great void around her as the guests recoil. One of them covers his eyes with his hand, others crowd round Salome, who seems just to have stopped in her dance. One need not explain at length what features were new in such a work of Donatello's. They all were. To people accustomed to the clear and graceful narratives of Gothic art, Donatello's way of telling a story must have come as a shock. Here there was no desire to form a neat and pleasing pattern, but rather to produce the effect of sudden chaos. Like Masaccio's figures, Donatello's are harsh and angular in their movements. Their gestures are violent, and there is no attempt to mitigate the horror of the story. To his contemporaries, the scene must have looked almost uncannily alive.

The new art of perspective further increases the illusion of reality. Donatello must have begun by asking himself: 'What must it have been

154

Claus Sluter
The prophets Daniel
and Isaiah, 1396–1404
From the Moses Fountain;
limestone, height
(excluding base) 360 cm,
142 in; Chartreuse de
Champmol, Dijon

like when the head of the saint was brought into the hall?' He did his best to represent a classical palace, such as the one in which the event might have taken place, and he chose Roman types for the figures in the background, figure 153. We can see clearly, in fact, that by this time Donatello, like his friend Brunelleschi, had begun a systematic study of Roman remains to help him bring about the rebirth of art. It is quite wrong, however, to imagine that this study of Greek and Roman art caused the rebirth or 'Renaissance'. Almost the opposite is true. The artists round Brunelleschi longed so passionately for a revival of art that they turned to nature, to science and to the remains of antiquity to realize their new aims.

The mastery of science and the knowledge of classical art remained for some time the exclusive possession of the Italian artists of the Renaissance. But the passionate will to create a new art, which should be more faithful to nature than anything that had ever been seen before, also inspired the artists of the same generation in the North.

Just as Donatello's generation in Florence became tired of the subtleties and refinements of the International Gothic style and longed to create more vigorous, austere figures, so a sculptor beyond the Alps strove for an art more lifelike and more forthright than the delicate works of his predecessors. This sculptor was Claus Sluter, who worked from about 1380 to 1405 at Dijon, at that time the capital of the rich and prosperous Duchy of Burgundy. His most famous work is a group of prophets which once formed the base of a large crucifix marking the fountain of a popular place of pilgrimage, figure 154. They are the men whose words were interpreted as the prediction of the Passion. Each of them holds in his hand a large book or scroll, on which these words were inscribed, and seems to be meditating on this coming tragedy. These are no longer the solemn and rigid figures that flanked the porches of Gothic cathedrals, page 191, figure 127. They differ from these earlier works just as much as does Donatello's St George. The man with the turban is Daniel, the bare-headed old prophet, Isaiah. As they stand before us, larger than life, still enlivened by gold and colour, they look less like statues than like impressive characters from one of the medieval mystery plays, just about to recite their parts. But with all this striking illusion of lifelikeness we should not forget the artistic sense with which Sluter has created these massive figures with the sweep of their drapery and the dignity of their bearing.

Yet it was not a sculptor who carried out the final conquest of reality in the North. For the artist whose revolutionary discoveries were felt from the beginning to represent something entirely new was the painter Jan van Eyck (1390?–1441). Like Sluter, he was connected with the court of the Dukes of Burgundy, but he mostly worked in the part of the Netherlands that is now Belgium. His most famous work is a huge altarpiece with many scenes

in the city of Ghent, *figures 155–6*. It is said to have been begun by Jan's elder brother Hubert, of whom little is known, and was completed by Jan in 1432. Thus it was painted during the very years that saw the completion of the great works of Masaccio and Donatello already described.

For all their obvious differences there are a number of similarities between Masaccio's fresco in Florence, figure 149, and this altarpiece painted for a church in distant Flanders. Both show the pious donor and his wife in prayer at the sides, figure 155, and both centre on a large symbolic image – that of the Holy Trinity in the fresco, and on the altar the mystic vision of the Adoration of the Lamb, the lamb, of course symbolizing Christ, figure 156. The composition is mainly based on a passage in the Revelations of St John (vii. 9), 'And I beheld ... a great multitude, which no man could number, of all nations and kindred and people and tongues [which] stood before the throne and before the lamb ...', a text that is related by the Church to the Feast of All Saints, to which there are further allusions in the painting. Above, we see God the Father, as majestic as Masaccio's but enthroned in splendour like a Pope, between the Holy Virgin and St John the Baptist, who first called Jesus the Lamb of God.

Like our fold-out, *figure 156*, the altar, with its many images, could be shown open, which happened on feast-days, when its glowing colours would be revealed, or shut (on week-days) when it presented a more sober appearance, *figure 155*. Here the artist represented St John the Baptist and St John the Evangelist as statues, much as Giotto had represented the figures of Virtues and Vices in the Arena Chapel, *page 200*, *figure 134*. Above, we are shown the familiar scene of the Annunciation, and we need only look back again at the wonderful panel by Simone Martini, painted a hundred years earlier, *page 213*, *figure 141*, to gain a first impression of van Eyck's wholly novel 'down to earth' approach to the sacred story.

His most striking demonstration of his new conception of art, however, he reserved for the inner wings: the figures of Adam and Eve after the Fall. The Bible tells us that it was only after having eaten from the Tree of Knowledge that they 'knew they were naked'. Stark naked indeed they look, despite the fig leaves they hold in their hands. Here there is really no parallel with the masters of the early Renaissance in Italy who never quite abandoned the traditions of Greek and Roman art. We remember that the ancients had 'idealized' the human figure in such works as the Venus of Milo or the Apollo Belvedere, pages 104–5, figures 64, 65. Jan van Eyck would have had none of this. He must have placed naked models in front of him and painted them so faithfully that later generations were somewhat shocked by so much honesty. Not that the artist had no eye for beauty. He clearly also enjoyed evoking the splendours of Heaven no less than the master of the Wilton Diptych, pages 216–17, figure 143, had done a generation earlier. But

155

Jan van Eyck

The Ghent altarpiece
with wings folded, 1432
Oil on panel, each panel
146.2 × 51.4 cm, 57½ ×
20¼ in; cathedral of
St Bavo, Ghent

The Ghent altarpiece with wings open

157 Details of figure 156 look again at the difference, at the patience and mastery with which he studied and painted the sheen of the precious brocades worn by the musicmaking angels and the sparkle of jewellery everywhere. In this respect the Van Eycks did not break as radically with the traditions of the International Style as Masaccio had done. They rather pursued the methods of such artists as the Limbourg brothers and brought them to such a pitch of perfection that they left the ideas of medieval art behind. They, like other Gothic masters of their period, had enjoyed crowding their pictures with charming and delicate details taken from observation. They were proud to show their skill in painting flowers and animals, buildings, gorgeous costumes and jewellery, and to present a delightful feast to the eye. We have seen that they did not concern themselves overmuch with the real appearance of the figures and landscapes, and that their drawing and perspective were therefore not very convincing. One cannot say the same thing of Van Eyck's pictures. His observation of nature is even more patient, his knowledge of details even more exact. The trees and the building in the background show this difference clearly. The trees of the Limbourg brothers, as we remember, were rather schematic and conventional, page 219, figure 144. Their landscape looked like a back-cloth or a tapestry rather than actual scenery. All this is quite different in Van Eyck's picture. In the details shown in figure 157, we have real trees and a real landscape leading back to the city and castle on the horizon. The infinite patience with which the grass on the rocks and the flowers growing in the crags are painted bears no comparison with the ornamental undergrowth in the Limbourg miniature. What is true of the landscape is true of the figures. Van Eyck seems to have been so intent on reproducing every minute detail on his picture that we almost seem able to count the hairs of the horses' manes. or on the fur trimmings of the riders' costumes. The white horse in the Limbourg miniature looks a little like a rocking-horse. Van Eyck's horse is very similar in shape and posture, but it is alive. We can see the light in its eye, and the creases in its skin, and, while the earlier horse looks almost flat, Van Eyck's horse has rounded limbs which are modelled in light and shade.

It may seem petty to look out for all these small details and to praise a great artist for the patience with which he observed and copied nature. It would certainly be wrong to think less highly of the work of the Limbourg brothers or, for that matter, of any other painting, because it lacked this faithful imitation of nature. But if we want to understand the way in which northern art developed we must appreciate this infinite care and patience of Jan van Eyck. The southern artists of his generation, the Florentine masters of Brunelleschi's circle, had developed a method by which nature could be represented in a picture with almost scientific accuracy. They began with the framework of perspective lines, and they built up the

human body through their knowledge of anatomy and of the laws of foreshortening. Van Eyck took the opposite way. He achieved the illusion of nature by patiently adding detail upon detail till his whole picture became like a mirror of the visible world. This difference between northern and Italian art remained important for many years. It is a fair guess to say that any work which excels in the representation of the beautiful surface of things, of flowers, jewels or fabric, will be by a northern artist, most probably by an artist from the Netherlands; while a painting with bold outlines, clear perspective and a sure mastery of the beautiful human body, will be Italian.

To carry out his intention of holding up a mirror to reality in all its details, Van Eyck had to improve the technique of painting. He was the inventor of oil-painting. There has been much discussion about the exact meaning and truth of this assertion, but the details matter comparatively little. His was not a discovery like that of perspective, which constituted something entirely new. What he achieved was a new prescription for the preparation of paints before they were put on the panel. Painters at that time did not buy ready-made colours in tubes or boxes. They had to prepare their own pigments, mostly from coloured plants and minerals. These they ground to powder between two stones – or let their apprentice grind them - and, before use, they added some liquid to bind the powder into a kind of paste. There were various methods of doing this, but all through the Middle Ages the main ingredient of the liquid had been made of an egg, which was quite suitable except that it dried rather quickly. The method of painting with this type of colour-preparation was called tempera. It seems that Jan van Eyck was dissatisfied with this formula, because it did not allow him to achieve smooth transitions by letting the colours shade off into each other. If he used oil instead of egg, he could work much more slowly and accurately. He could make glossy colours which could be applied in transparent layers or 'glazes', he could put on the glittering highlights with a pointed brush, and achieve those miracles of accuracy which astonished his contemporaries and soon led to a general acceptance of oil-painting as the most suitable medium.

Van Eyck's art reached perhaps its greatest triumph in the painting of portraits. One of his most famous portraits is *figure 158*, which represents an Italian merchant, Giovanni Arnolfini, who had come to the Netherlands on business, with his bride Jeanne de Chenany. In its own way it was as new and as revolutionary as Donatello's or Masaccio's work in Italy. A simple corner of the real world had suddenly been fixed on to a panel as if by magic. Here it all was – the carpet and the slippers, the rosary on the wall, the little brush beside the bed, and the fruit on the window-sill. It is as if we could pay a visit to the Arnolfini in their house. The picture

I58

Jan van Eyck

The betrothal of the

Arnolfini, 1434

Oil on wood, 81.8 × 59.7

cm, 32½ × 23½ in;

National Gallery, London

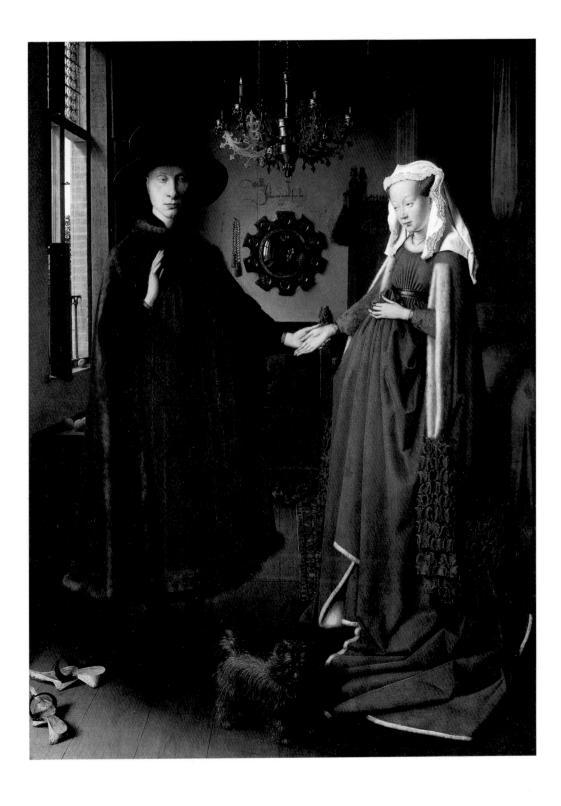

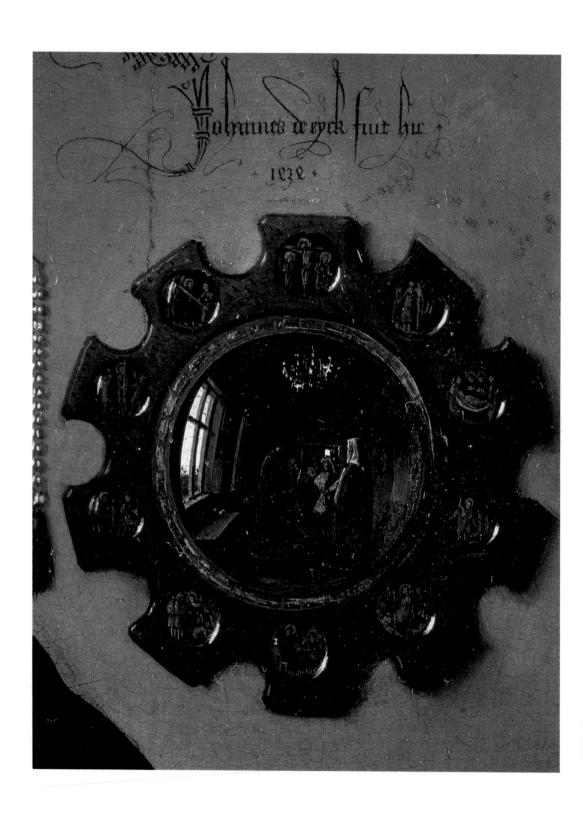

probably represents a solemn moment in their lives – their betrothal. The young woman has just put her right hand into Arnolfini's left and he is about to put his own right hand into hers as a solemn token of their union. Probably the painter was asked to record this important moment as a witness, just as a notary might be asked to declare that he has been present at a similar solemn act. This would explain why the master has put his name in a prominent position on the picture with the Latin words 'Johannes de eyck fuit hic' (Jan van Eyck was here). In the mirror at the back of the room we see the whole scene reflected from behind, and there, so it seems, we also see the image of the painter and witness, figure 150. We do not know whether it was the Italian merchant or the northern artist who conceived the idea of making this use of the new kind of painting, which may be compared to the legal use of a photograph, properly endorsed by a witness. But whoever it was that originated this idea, he had certainly been quick to understand the tremendous possibilities which lay in Van Eyck's new way of painting. For the first time in history the artist became the perfect eve-witness in the truest sense of the term.

In this attempt to render reality as it appeared to the eye, Van Eyck, like Masaccio, had to give up the pleasing patterns and flowing curves of the International Gothic style. To some, his figures may even look stiff and clumsy compared with the exquisite grace of such paintings as the Wilton Diptych, pages 216-17, figure 143. But everywhere in Europe artists of that generation, in their passionate search for truth, defied the older ideas of beauty and probably shocked many elderly people. One of the most radical

of these innovators was a Swiss painter called Konrad Witz (1400?–1446?). Figure 161 is from an altarpiece he painted for Geneva in 1444. It is dedicated to St Peter and represents the saint's encounter with Christ after the Resurrection as it is told in the Gospel of St John (Chapter xxi). Some apostles and their companions had gone to fish in the sea of Tiberias, but had caught nothing. When the morning came Jesus stood on the shore, but they did not recognize Him. He told them to cast the net on the right side of the ship and it was so full of fish that they were unable to pull it in. At that moment one of them said, 'It is the Lord', and when St Peter heard this, 'he girt his fisher's coat unto him (for he was naked) and did cast himself into the sea. And the other disciples came in a little ship', after which they partook of a meal with Jesus. A medieval painter who was

161

Konrad Witz The Miraculous Draught of Fishes, 1444

Panel from an altarpiece; oil on wood; 132 × 154 cm, 52 × 60¾ in; Musée d'Art et d'Histoire, Geneva

asked to illustrate this miraculous event would probably have been satisfied with a conventional row of wavy lines to mark the sea of Tiberias. But Witz desired to bring home to the burghers of Geneva what it must have looked like when Christ stood by the waters. Thus he painted not just any lake but a lake they all knew, the lake of Geneva with the massive Mont Salève rising in the background. It is a real landscape which everyone could see, which exists today, and still looks very much as it does in the painting. It is perhaps the first exact representation, the first 'portrait' of a real view ever attempted. On this real lake, Witz painted real fishermen: not the dignified apostles of older pictures, but uncouth men of the people, busy with their fishing tackle and struggling rather clumsily to keep the boat steady. St Peter looks somewhat helpless in the water, and so, surely, he ought. Only Christ Himself is standing quietly and firmly. His solid figure recalls those in Masaccio's great fresco, figure 149. It must have been a moving experience for the worshippers in Geneva when they looked at their new altar for the first time and saw the apostles as men like themselves, fishing on their own lake, with the risen Christ miraculously appearing to them on its familiar shore to give them help and comfort.

Stonemason and sculptors at work, c. 1408 Base of a marble sculpture by Nanni di Banco; Or San Michele, Florence

to find how simple and harmonious the ceiling looks if we regard it merely as a piece of superb decoration, and how clear the whole arrangement. Since it was cleaned of its many layers of candle-soot and dust in the 1980s the colours have been revealed as strong and luminous, a necessity if the ceiling was to be visible in a chapel with so few and narrow windows. (This is a point rarely considered by those who have admired these paintings in the strong electric light that is now thrown on to the ceiling.)

Figure 197 shows one sector of the work, vaulting across the ceiling, that exemplifies the way in which Michelangelo distributed the figures flanking the scenes of the Creation. On the one side there is the prophet Daniel holding a huge volume which he supports on his knees with the help of a little boy, and turning aside to take a note of what he has read. Next to him is the Cumaean Sibyl peering into her book. On the opposite side there is the 'Persian' Sibyl, an old woman in Oriental costume, holding a book close to her eyes - equally engrossed in her researches into the sacred texts - and the Old Testament prophet Ezekiel, turning violently as if in argument. The marble seats on which they sit are adorned with statues of playing children, and above them, one on each side, are two of the nudes gaily about to tie the medallion to the ceiling. In the triangular spandrels he represented ancestors of Christ as they are mentioned in the Bible, surmounted by more contorted bodies. The astonishing nude figures display all Michelangelo's mastery in drawing the human body in any position and from any angle. They are young athletes with wonderful muscles, twisting and turning in every conceivable direction, but always contriving to remain graceful. There are no fewer than twenty of them on the ceiling, each one more masterly than the last, and there is little doubt that many of the ideas which were to have come to life out of the marbles of Carrara now crowded upon Michelangelo's mind when he painted the Sistine ceiling. One can feel how he enjoyed his stupendous mastery and how his disappointment and his wrath at being prevented from continuing to work in the material he preferred spurred him on even more to show his enemies, real or suspected, that, if they forced him to paint - well, he would show them!

We know how minutely Michelangelo studied every detail, and how carefully he prepared each figure in his drawings. *Figure 199* shows a leaf from his sketch-book on which he studied the forms of a model for one of the Sibyls. We see the interplay of muscles as no one had observed and portrayed it since the Greek masters. But, if he proved himself an unsurpassed virtuoso in these famous 'nudes', he proved to be infinitely more than that in the illustrations of biblical themes which form the centre of the composition. There we see the Lord calling forth, with powerful

199

Michelangelo Study for the Libyan Sibyl on the Sistine Chapel ceiling, c. 1510 Red chalk on buff paper, 28.9 × 21.4 cm, 11% × 8% in; Metropolitan Museum

of Art. New York

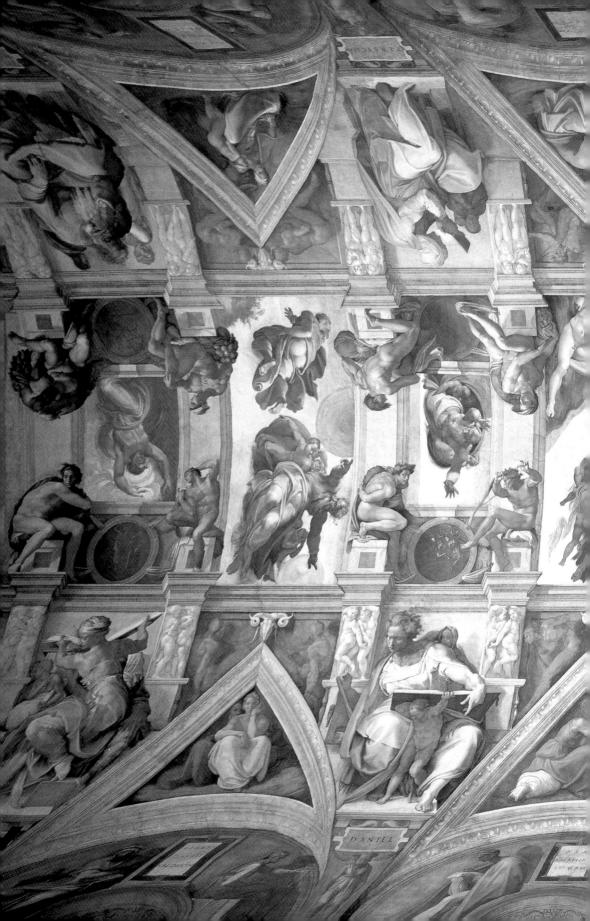

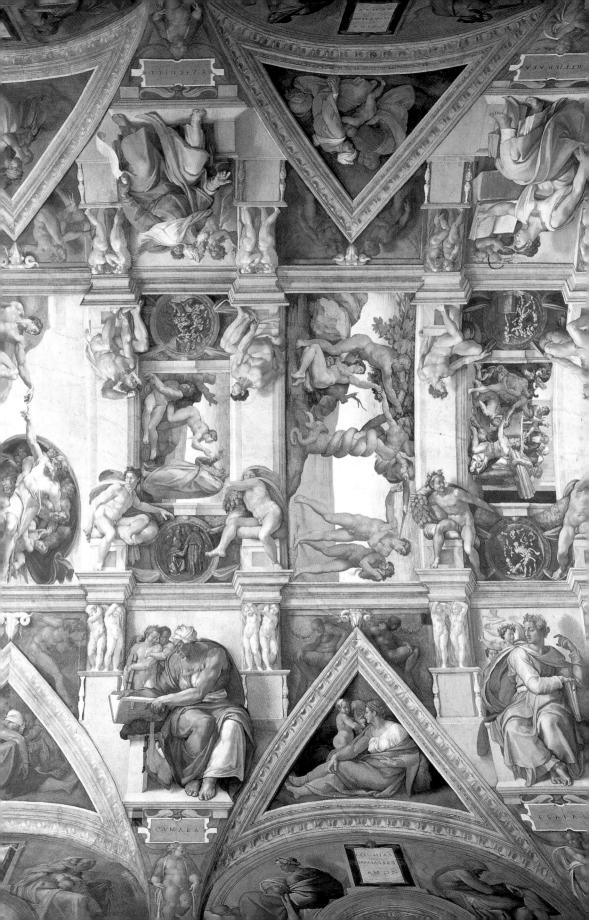

Victoria Public Library

302 N. Main

Victoria, Tx. 77901

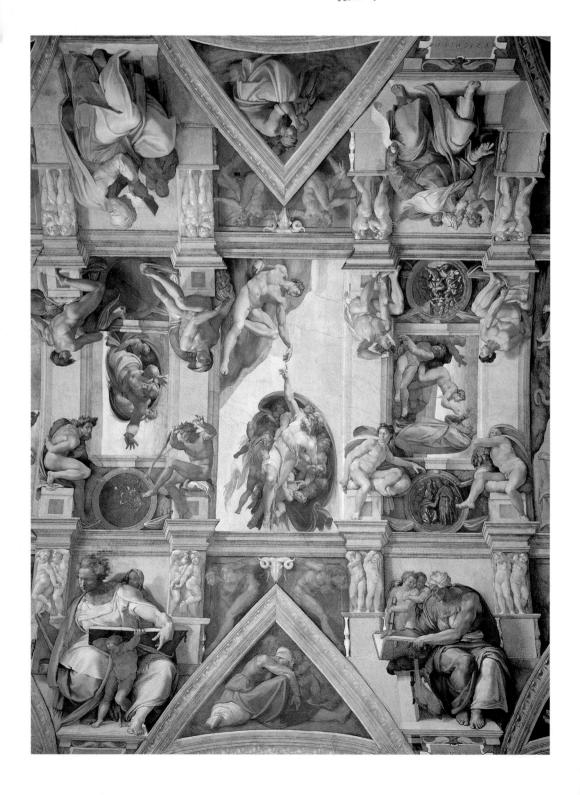

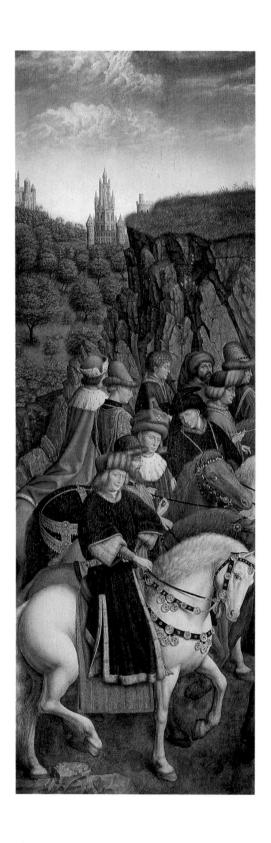

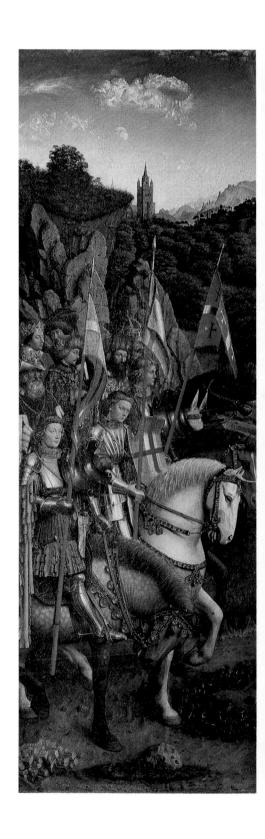

Gherardo di Giovanni The Annunciation and scenes from Dante's 'Divine Comedy', c. 1474–6

173

Page from a Missal; Museo Nazionale del Bargello, Florence

TRADITION AND INNOVATION: I

The later fifteenth century in Italy

The new discoveries which had been made by the artists of Italy and Flanders at the beginning of the fifteenth century created a stir all over Europe. Painters and patrons alike were fascinated by the idea that art could not only be used to tell the sacred story in a moving way, but might serve to mirror a fragment of the real world. Perhaps the most immediate result of this great revolution in art was that artists everywhere began to experiment and to search for new and startling effects. This spirit of adventure which took hold of art in the fifteenth century marks the real break with the Middle Ages.

There is one effect of this break which we must consider first. Until about 1400, art in different parts of Europe had developed on similar lines. We remember that the style of the Gothic painters and sculptors of that period is known as the International style, page 215, because the aims of the leading masters in France and Italy, in Germany and Burgundy, were all very similar. Of course, national differences had existed all through the Middle Ages – we remember the differences between France and Italy during the thirteenth century – but on the whole these were not very important. This applies not to the field of art alone, but also to the world of learning and even to politics. The learned men of the Middle Ages all spoke and wrote Latin and did not much mind whether they taught at the University of Paris, Padua or Oxford.

The noblemen of the period shared the ideas of chivalry; their loyalty to their king or their feudal overlord did not imply that they considered themselves the champions of any particular people or nation. All this had gradually changed towards the end of the Middle Ages, when the cities with their burghers and merchants became increasingly more important than the castles of the barons. The merchants spoke their native tongue and stood together against any foreign competitor or intruder. Each city was proud and jealous of its own position and privileges in trade and industry. In the Middle Ages a good master might travel from building site to building site, he might be recommended from one monastery to another, and few would trouble to ask what his nationality was. But as soon as the cities gained in importance, artists, like all artisans and

craftsmen, were organized into guilds. These guilds were in many respects similar to our trade unions. It was their task to watch over the rights and privileges of their members and to ensure a safe market for their produce. To be admitted into the guild the artist had to show that he was able to reach certain standards, that he was, in fact, a master of his craft. He was then allowed to open a workshop, to employ apprentices, and to accept commissions for altar-paintings, portraits, painted chests, banners and coats of arms, or any other work of the kind.

The guilds and corporations were usually wealthy companies who had a say in the government of the city and who not only helped to make it prosperous, but also did their best to make it beautiful. In Florence and elsewhere the guilds, the goldsmiths, the wool-workers, the armourers and others, devoted part of their funds to the foundation of churches, the building of guild halls and the dedication of altars and chapels. In this respect they did much for art. On the other hand they watched anxiously over the interests of their own members, and therefore made it difficult for any foreign artist to get employment or to settle among them. Only the most famous of artists sometimes managed to break down this resistance and to travel as freely as had been possible at the period when the great cathedrals were being built.

All this has a bearing on the history of art, because, thanks to the growth of the cities, the International style was perhaps the last international style Europe has seen – at least until the twentieth century. In the fifteenth century art broke up into a number of different 'schools' - nearly every city or small town in Italy, Flanders and Germany had its own 'school of painting'. 'School' is rather a misleading word. In those days there were no art schools where young students attended classes. If a boy decided that he would like to become a painter, his father apprenticed him at an early age to one of the leading masters of the town. He usually lived in, ran errands for the master's family, and had to make himself useful in every possible way. One of his first tasks might be to grind the colours, or to assist in the preparation of the wooden panels or the canvas which the master wanted to use. Gradually he might be given some minor piece of work like the painting of a flagstaff. Then, one day when the master was busy, he might ask the apprentice to help with the completion of some unimportant or inconspicuous part of a major work - to paint the background which the master had traced out on the canvas, to finish the costumes of the bystanders in a scene. If he showed talent and knew how to imitate his master's manner to perfection, the youth would gradually be given more important things to do – perhaps paint a whole picture from the master's sketch and under his supervision. These, then, were the 'schools of painting' of the fifteenth century. They were indeed excellent schools and

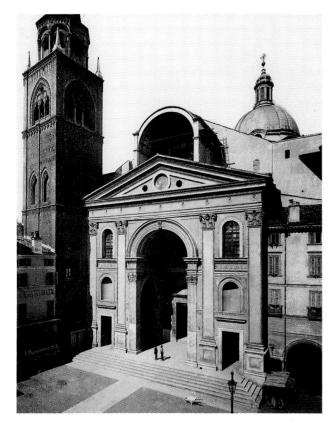

162 Leon Battista Alberti Church of S. Andrea, Mantua, c. 1460 A Renaissance church

there are many painters nowadays who wish they had received so thorough a training. The manner in which the masters of a town handed down their skill and experience to the young generation also explains why the 'school of painting' in these towns developed such a clear individuality of its own. One can recognize whether a fifteenth-century picture comes from Florence or Siena, Dijon or Bruges, Cologne or Vienna.

To gain a vantage point from which we can survey this immense variety of masters, 'schools' and experiments, we had best return to Florence, where the great revolution in art had begun. It is fascinating to watch how the generation which followed Brunelleschi, Donatello and Masaccio tried to make use of their discoveries and apply them

to all the tasks with which they were confronted. That was not always easy. The main tasks which the patrons commissioned had, after all, remained fundamentally unchanged since the earlier period. The new and revolutionary methods sometimes seemed to clash with the traditional commissions. Take the case of architecture: Brunelleschi's idea had been to introduce the forms of classical buildings, the columns, pediments and cornices which he had copied from Roman ruins. He had used these forms in his churches. His successors were eager to emulate him in this. Figure 162 shows a church planned by the Florentine architect Leon Battista Alberti (1404–72), who conceived its façade as a gigantic triumphal arch in the Roman manner, page 119, figure 74. But how was this new programme to be applied to an ordinary dwelling-house in a city street? Traditional houses and palaces could not be built in the manner of temples. No private houses had survived from Roman times, and even if they had, needs and customs had changed so much that they might have offered little guidance. The problem, then, was to find a compromise between the traditional house, with walls and windows, and the classical forms which Brunelleschi had taught the architects to use. It was again Alberti who found the

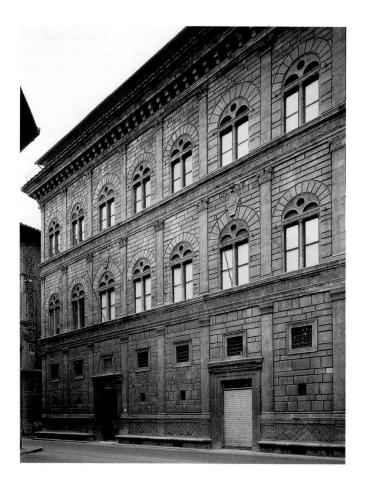

163 Leon Battista Alberti Palazzo Rucellai, Florence, c. 1460

solution that remained influential up to our own days. When he built a palace for the rich Florentine merchant family of Rucellai, figure 163, he designed an ordinary three-storeyed building. There is little similarity between this façade and any classical ruin. And yet Alberti stuck to Brunelleschi's programme and used classical forms for the decoration of the façade. Instead of building columns or half-columns, he covered the house with a network of flat pilasters and entablatures which suggested a classical order without changing the structure of the building. It is easy to see where Alberti had learned this principle. We remember the Roman Colosseum, page 118, figure 73, in which various Greek 'orders' were applied to the various storeys. Here, too, the lowest storey is an adaptation of the Doric order, and here, too, there are arches between the pilasters. But though Alberti had thus given the old city palace a modern look by reverting to Roman forms he did not quite break with Gothic traditions. We need only compare the palace windows with those on the façade of Notre-Dame in Paris, page 189, figure 125, to discover an unexpected similarity. Alberti has merely 'translated' a Gothic design into classical forms by smoothing out the 'barbaric' pointed arch and using the elements of the classical order in a traditional context.

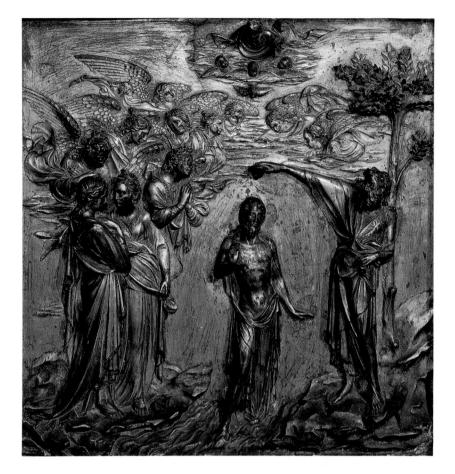

164 Lorenzo Ghiberti The Baptism of Christ, 1427 Gilt bronze, 60 × 60 cm,

23% × 23% in; relief on the font of the Baptistery, Siena Cathedral

This achievement of Alberti is typical. Painters and sculptors in fifteenth-century Florence also often found themselves in a situation in which they had to adapt the new programme to an old tradition. The mixture between new and old, between Gothic traditions and modern forms, is characteristic of many masters in the middle of the century.

The greatest of these Florentine masters who succeeded in reconciling the new achievements with the old tradition was a sculptor of Donatello's generation, Lorenzo Ghiberti (1378–1455). Figure 164 shows one of his reliefs for the same font in Siena for which Donatello made the 'Dance of Salome', page 232, figure 152. Of Donatello's work we could say that everything was new; Ghiberti's looks much less startling at first sight. We notice that the arrangement of the scene is not so very different from the one used by the famous brassfounder of Liège in the twelfth century, page 179, figure 118: Christ in the centre, flanked by St John the Baptist and the ministering angels with God the Father and the Dove appearing up in Heaven. Even in the treatment of details Ghiberti's work recalls that of his medieval forerunners – the loving care with which he arranges the folds of the drapery may remind us of such fourteenth-century

goldsmith's work as the Holy Virgin on page 210, figure 139. And yet Ghiberti's relief is in its own way as vigorous and as convincing as Donatello's companion piece. He, too, has learned to characterize each figure and to make us understand the part each plays: the beauty and humility of Christ, the Lamb of God; the solemn and energetic gesture of St John, the emaciated prophet from the wilderness; and the heavenly host of angels who silently look at each other in joy and wonder. And while Donatello's new dramatic way of representing the sacred scene somewhat upset the clear arrangement which had been the pride of earlier days, Ghiberti took care to remain lucid and restrained. He does not give us the idea of real space at which Donatello was aiming. He prefers to give us only a hint of depth and to let his principal figures stand out clearly against a neutral background.

Just as Ghiberti remained faithful to some of the ideas of Gothic art, without refusing to make use of the new discoveries of his century, the great painter Fra Angelico (brother Angelico) of Fiesole near Florence (1387–1455) applied the new methods of Masaccio mainly in order to express the traditional ideas of religious art. Fra Angelico was a friar of the Dominican order, and the frescoes he painted in his Florentine monastery of San Marco round about 1440 are among his most beautiful works. He painted a sacred scene in each monk's cell and at the end of every corridor, and as one walks from one to the other in the stillness of the old building one feels something of the spirit in which these works were conceived. Figure 165 shows a picture of the Annunciation which he painted in one of the cells. We see at once that the art of perspective presented no difficulty to him. The cloister where the Virgin kneels is represented as convincingly as the vault in Masaccio's famous fresco, page 228, figure 149. Yet it was clearly not Fra Angelico's main intention to 'break a hole into the wall'. Like Simone Martini in the fourteenth century, page 213. figure 141, he only wanted to represent the sacred story in all its beauty and simplicity. There is hardly any movement in Fra Angelico's painting and hardly any suggestion of real solid bodies. But I think it is all the more moving because of its humility, which is that of a great artist who deliberately renounced any display of modernity despite his profound understanding of the problems which Brunelleschi and Masaccio had introduced into art.

We can study the fascination of these problems and also their difficulty in the work of another Florentine, the painter Paolo Uccello (1397–1475), among whose best-preserved works is the

Fra Angelico
The Annunciation,
c. 1440
Fresco, 187 × 157 cm,
73% × 62 in; Museo di San

Marco, Florence

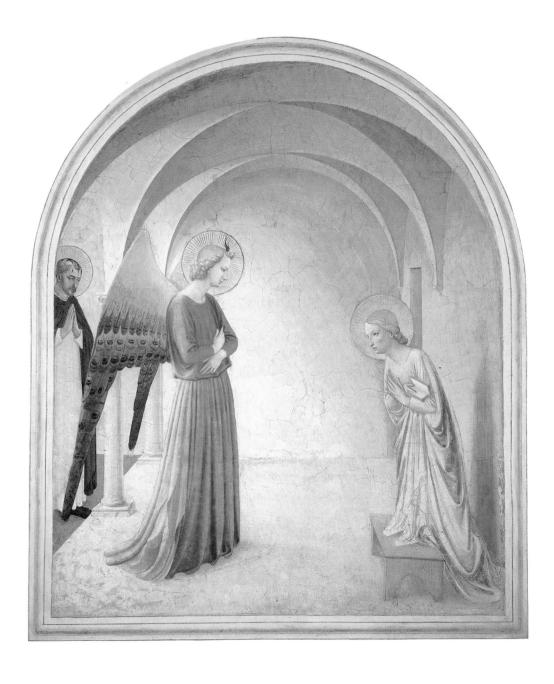

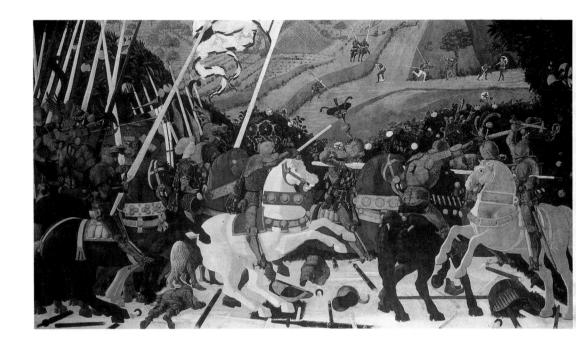

battle scene in the National Gallery, figure 166. The picture was probably intended to be placed above the wainscoting (panelling covering the lower part of the wall) of a room in the Palazzo Medici, the city palace of the most powerful and wealthy of the Florentine merchant families. It represents an episode from Florentine history, still topical when the picture was painted, the rout of San Romano in 1432, when Florentine troops defeated their enemies in one of the many battles between the Italian factions. Superficially the picture may look medieval enough. These knights in armour with their long and heavy lances, riding as if to a tournament, may remind us of a medieval romance of chivalry; nor does the way in which the scene is represented strike us at first as very modern. Both horses and men look a little wooden, almost like toys, and the whole gay picture seems very remote from the reality of war. But if we ask ourselves why it is that these horses look somewhat like rocking-horses and the whole scene reminds us a little of a puppet-show, we shall make a curious discovery. It is precisely because the painter was so fascinated by the new possibilities of his art that he did everything to make his figures stand out in space as if they were carved and not painted. It was said of Uccello that the discovery of perspective had so impressed him that he spent nights and days drawing objects in foreshortening, and setting

160

Paolo Uccello, The Battle of San Romano, c. 1450

Probably from a room in the Palazzo Medici, Florence; oil on wood, 181.6 × 320 cm, 71½ × 126 in; National Gallery, London

it Mony Mydalarby

himself ever new problems. His fellow artists used to tell that he was so engrossed in these studies that he would hardly look up when his wife called him to go to bed, and would exclaim: 'What a sweet thing perspective is!' We can see something of this fascination in the painting. Uccello obviously took great pains to represent the various pieces of armour which litter the ground in correct foreshortening. His greatest pride was probably the figure of the fallen warrior lying on the ground, the foreshortened representation of which must have been most difficult, figure 167. No such figure had been painted before and, though it looks rather too small in relation to the other figures, we can imagine what a stir it must have caused. We find traces all over the picture of the interest which Uccello took in perspective and of the spell it exerted over his mind. Even the broken lances lying on the ground are so arranged that they point towards their common 'vanishing point'. It is this neat mathematical arrangement which is partly responsible for the artificial appearance of the stage on which the battle seems to take place. If we turn back from this pageant of chivalry to Van Eyck's picture of knights, page 238, figure 157, and the Limbourg miniature, page 219, figure 144, with which we compared it, we may see more clearly what Uccello owed to the Gothic tradition,

and how he transformed it. Van Eyck, in the north, had changed the forms of the International style by adding more and more details from observation and trying to copy the surfaces of things down to the minutest shade. Uccello rather chose the opposite approach. By means of his beloved art of perspective, he tried to construct a convincing stage on which his figures would appear solid and real. Solid they undoubtedly look, but the effect is a little reminiscent of the stereoscopic pictures which one looks at through a pair of lenses. Uccello had not yet learned how to use the effects of light and shade and air to mellow the harsh outlines of a strictly perspective rendering. But if we stand in front of the actual painting in the National Gallery, we do not feel that anything is amiss, for, despite his preoccupation with applied geometry, Uccello was a real artist.

While painters such as Fra Angelico could make use of the new without changing the spirit of the old, while Uccello in his turn was completely captivated by the problems of the new, less devout and less ambitious artists applied the new methods gaily without worrying overmuch about their difficulty. The public probably liked these masters who gave them the best of both worlds. Thus the commission for painting the walls of the private chapel in the city palace of the Medici went to Benozzo Gozzoli (c.1421-97), a pupil of Fra Angelico, but apparently a man of very different outlook. He covered the walls of the chapel with a picture of the cavalcade of the three Magi and made them travel in truly royal state through a smiling landscape, figure 168. The biblical episode gives him the opportunity of displaying beautiful finery and gorgeous costumes, a fairy world of charm and gaiety. We have seen how this taste for representing the pageantry of noble pastimes developed in Burgundy, page 219, figure 144, with which the Medici entertained close trade relations. Gozzoli seems intent upon showing that the new achievements can be used to make these gay pictures of contemporary life even more vivid and enjoyable. We have no reason to quarrel with him for that. The life of the period was indeed so picturesque and colourful that we must be grateful to those minor masters who preserved a record of these delights in their works, and no one who goes to Florence should miss the joy of a visit to this small chapel, in which something of the zest and savour of a festive life seems still to linger.

Meanwhile, other painters in the cities north and south of Florence had absorbed the message of the new art of Donatello and Masaccio, and were perhaps even more eager to profit by it than the Florentines themselves. There was Andrea Mantegna (1431–1506), who worked first in the famous university town of Padua, and then at the court of the lords of Mantua, both in northern Italy. In a Paduan church, quite

168

Benozzo Gozzoli, The Journey of the Magi to Bethlehem, c. 1459–63 Detail of a fresco; chapel of the Palazzo Medici-Riccardi, Florence

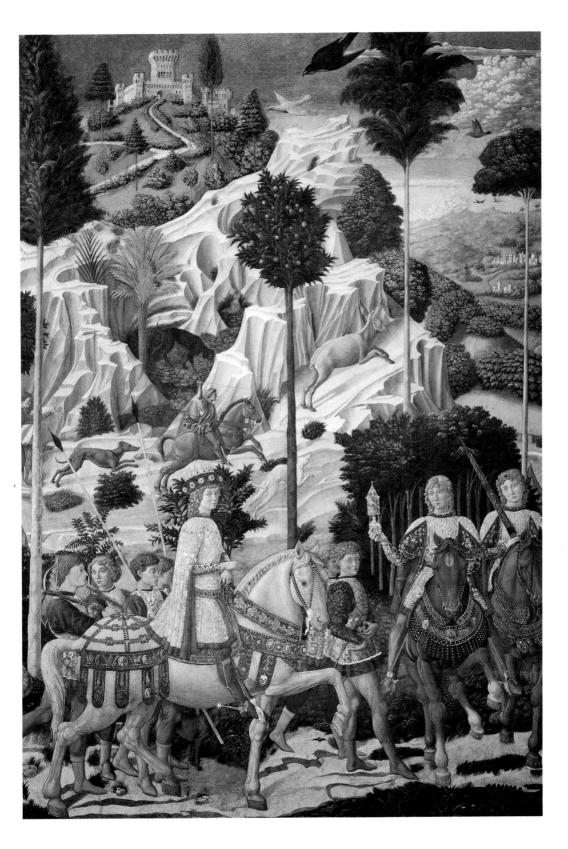

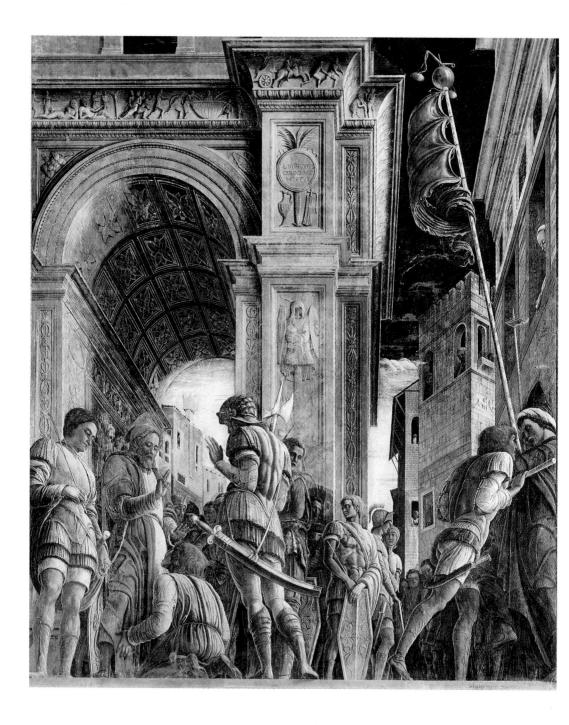

Andrea Mantegna
St James on the way to his execution, c. 1455
Fresco; destroyed; formerly church of the Eremitani, Padua

near the chapel where Giotto had painted his famous frescoes, Mantegna painted a series of wall-paintings illustrating the legend of St James. The church was heavily damaged by bombing during World War II, and most of these wonderful paintings by Mantegna were destroyed. It is a sad loss, because they were surely among the greatest works of art of all time. One of them, figure 169, showed St James being escorted to his place of execution. Like Giotto or Donatello, Mantegna tried to imagine quite clearly what the scene must have looked like in reality, but the standards of what he called reality had become much more exacting since Giotto's day. What had mattered to Giotto was the inner meaning of the story – how men and women would move and behave in a given situation. Mantegna was also interested in the outward circumstances. He knew that St James had lived in the period of the Roman Emperors, and he was anxious to reconstruct the scene just as it might have actually happened. He had made a special study of classical monuments for this purpose. The city gate through which St James has just been led is a Roman triumphal arch, and the soldiers of the escort all wear the dress and armour of Roman legionaries as we see them represented on authentic classical monuments. It is not only in these details of costume and ornament that the painting reminds us of ancient sculpture. The whole scene breathes the spirit of Roman art in its harsh simplicity and austere grandeur. The differences, indeed, between the Florentine frescoes of Benozzo Gozzoli and Mantegna's works which were painted approximately during the same years could hardly be more pronounced. In Gozzoli's gay pageantry we recognized a return to the taste of the International Gothic style. Mantegna, on the other hand, carries on where Masaccio had left off. His figures are as statuesque and impressive as Masaccio's. Like Masaccio, he uses the new art of perspective with eagerness, but he does not exploit it as Uccello did to show off the new effect which could be achieved by means of this magic. Mantegna rather uses perspective to create the stage on which his figures seem to stand and move like solid, tangible beings. He distributes them as a skilled theatrical producer might have done, so as to convey the significance of the moment and the course of the episode. We can see what is happening: the procession escorting St James has halted for a moment because one of the persecutors has repented and has thrown himself at the feet of the saint, to receive his blessing. The saint has turned round calmly to bless the man, while the Roman soldiers stand by and watch, one of them impassively, the other lifting his hand in an expressive gesture which seems to convey that he, too, is moved. The round of the arch frames this scene and separates it from the turmoil of the watching crowds pushed back by the guards.

While Mantegna was thus applying the new methods of art in northern Italy, another great painter, Piero della Francesca (1416?–92), did the same in the region south of Florence, in the towns of Arezzo and Urbino. Like Gozzoli's and Mantegna's frescoes, Piero della Francesca's were painted shortly after the middle of the fifteenth century, that is about a generation after Masaccio. The episode in figure 170 shows the famous legend of the dream which made the Emperor Constantine accept the Christian faith. Before a crucial battle with his rival, he dreamt that an angel showed him the Cross and said: 'Under this sign you will be victorious.' Piero's fresco represents the scene at night in the Emperor's camp before the battle. We look into the open tent, where the Emperor lies asleep on his camp bed. His bodyguard sits by his side, while two soldiers are also keeping guard. This quiet night scene is suddenly illuminated by a flash of light as an angel rushes down from Heaven holding the symbol of the Cross in his outstretched hand. As with Mantegna, we are somewhat reminded of a scene in a play. There is a stage quite clearly marked, and there is nothing to divert our attention from the essential action. Like Mantegna, Piero has taken pains over the dress of his Roman legionaries and, like him, he has avoided the gay and colourful details which Gozzoli crowded into his scenes. Piero, too, had mastered the art of perspective completely, and the way in which he shows the figure of the angel in foreshortening is so bold as to be almost confusing, especially in a small reproduction. But to these geometrical devices suggesting the space of the stage he has added a new one of equal importance: the treatment of light. Medieval artists had taken hardly any notice of light. Their flat figures cast no shadows. Masaccio had also been a pioneer in this respect - the round and solid figures of his paintings were forcefully modelled in light and shade, page 228, figure 149. But no one had seen the immense new possibilities of this means as clearly as Piero della Francesca. In this picture, light not only helps to model the forms of the figures, but is equal in importance to perspective in creating the illusion of depth. The soldier in front stands like a dark silhouette before the brightly lit opening of the tent. We thus feel the distance which separates the soldiers from the steps on which the bodyguard is sitting, whose figure, in turn, stands out in the flash of light that emanates from the angel. We are made to feel the roundness of the tent, and the hollow it encloses, just as much by means of this light as by foreshortening and perspective. But Piero lets light and shade perform an even greater miracle. They help him to create the mysterious atmosphere of the scene in the depth of night when the Emperor had a vision which was to change the course of history. This impressive simplicity and calm make Piero perhaps the greatest heir to Masaccio.

Piero della Francesca Constantine's dream, c. 1460

Detail of a fresco; church of S. Francesco, Arezzo

While these and other artists were applying the inventions of the great generation of Florentine masters, artists in Florence became increasingly aware of the new problems that these inventions had created. In the first flush of triumph, they may have thought that the discovery of perspective and the study of nature could solve all their difficulties. But we must not forget that art is altogether different from science. The artist's means, his technical devices, can be developed, but art itself can hardly be said to progress in the way in which science progresses. Each discovery in one direction creates a new difficulty somewhere else. We remember that medieval painters were unaware of the rules of correct draughtsmanship, but that this very shortcoming enabled them to distribute their figures over the picture in any way they liked in order to create the perfect pattern. The twelfth-century illustrated calendar, page 181, figure 120, or the thirteenth-century relief of the 'Death of the Virgin', page 193, figure 129, are examples of this skill. Even fourteenth-century painters like Simone Martini, page 213, figure 141, were still able to arrange their figures so that they formed a lucid design on the ground of gold. As soon as the new concept of making the picture a mirror of reality was adopted, this question of how to arrange the figures was no longer so easy to solve. In reality figures do not group themselves harmoniously, nor do they stand out clearly against a neutral background. In other words, there was a danger that the new power of the artist would ruin his most precious gift of creating a pleasing and satisfying whole. The problem was particularly serious where big altarpaintings and similar tasks confronted the artist. These paintings had to be seen from afar and had to fit into the architectural framework of the whole church. Moreover, they had to present the sacred story to the worshippers in a clear and impressive outline. Figure 171 shows the way in which a Florentine artist of the second half of the fifteenth century, Antonio Pollaiuolo (1432?-98), tried to solve this new problem of making a picture both accurate in draughtsmanship and harmonious in composition. It is one of the first attempts of its kind to solve this question, not by tact and instinct alone, but by the application of definite rules. It may not be an altogether successful attempt, nor is it a very attractive picture, but it clearly shows how deliberately the Florentine artists set about it. The picture represents the martyrdom of St Sebastian, who is tied to a stake while six executioners are grouped around him. This group forms a very regular pattern in the form of a steep triangle. Each executioner on one side is matched by a similar figure on the other side.

The arrangement, in fact, is so clear and symmetrical as to be almost too rigid. The painter was obviously aware of this drawback and tried to

introduce some variety. One of the executioners bending down to adjust his crossbow is seen from the front, the corresponding figure from behind, and the same with the shooting figures. In this simple way, the painter has endeavoured to relieve the rigid symmetry of the composition and to introduce a sense of movement and counter-movement very much as in a piece of music. In Pollaiuolo's picture this device is still used rather self-consciously and his composition looks somewhat like an exercise. We can imagine that he used the same model, seen from different sides, for the corresponding figures, and we feel that his pride in his mastery of muscles and movements has almost made him forget the true subject of his picture. Moreover, Pollaiuolo was not wholly successful in what he set out to do. It is true that he

Antonio Pollaiuolo
The martyrdom of Saint
Sebastian, c. 1475
Altar-painting; oil on
wood, 291.5 × 202.6 cm,
114½ × 70½ in; National

Gallery, London

applied the new art of perspective to a wonderful vista of the Tuscan landscape in the background, but the main theme and the background do not really blend. There is no path from the hill in the foreground on which the martyrdom is enacted to the scenery behind. One almost wonders whether Pollaiuolo would not have done better to place his composition against something like a neutral or golden background, but one soon realizes that this expedient was barred to him. Such vigorous and lifelike figures would look out of place on a golden background. Once art had chosen the path of vying with nature, there was no turning back. Pollaiuolo's picture shows the kind of problem that artists of the fifteenth century must have discussed in their studios. It was by finding a solution to this problem that Italian art reached its greatest heights a generation later.

Among the Florentine artists of the second half of the fifteenth century who strove for a solution to this question was the painter Sandro Botticelli (1446-1510). One of his most famous pictures represents not a Christian legend but a classical myth – the birth of Venus, figure 172. The classical poets had been known all through the Middle Ages, but only at the time of the Renaissance, when the Italians tried so passionately to recapture the former glory of Rome, did the classical myths become popular among -educated laymen. To these men, the mythology of the admired Greeks and Romans represented something more than gay and pretty fairy-tales. They were so convinced of the superior wisdom of the ancients that they believed these classical legends must contain some profound and mysterious truth. The patron who commissioned the Botticelli painting for his country villa was a member of the rich and powerful family of the Medici. Either he himself, or one of his learned friends, probably explained to the painter what was known of the way the ancients had represented Venus rising from the sea. To these scholars the story of her birth was the symbol of mystery through which the divine message of beauty came into the world. One can imagine that the painter set to work reverently to represent this myth in a worthy manner. The action of the picture is quickly understood. Venus has emerged from the sea on a shell which is driven to the shore by flying wind-gods amidst a shower of roses. As she is about to step on to the land, one of the Hours or Nymphs receives her with a purple cloak. Botticelli has succeeded where Pollaiuolo failed. His picture forms, in fact, a perfectly harmonious pattern. But Pollaiuolo might have said that Botticelli had done so by sacrificing some of the achievements he had tried so hard to preserve. Botticelli's figures look less solid. They are not so correctly drawn as Pollaiuolo's or Masaccio's. The graceful movements and melodious lines of his composition recall the Gothic tradition of Ghiberti and Fra Angelico, perhaps even the art of the fourteenth century - works such as Simone Martini's 'Annunciation' page 213, figure 141, or the French goldsmith's work, page 210, figure 139, in which we remarked on the gentle sway of the body and the exquisite fall of the drapery. Botticelli's Venus is so beautiful that we do not notice the unnatural length of her neck, the steep fall of her shoulders and the queer way her left arm is hinged to the body. Or, rather, we should say that these liberties which Botticelli took with nature in order to achieve a graceful outline add to the beauty and harmony of the design because they enhance the impression of an infinitely tender and delicate being, wafted to our shores as a gift from Heaven.

The rich merchant who commissioned this picture from Botticelli, Lorenzo di Pierfrancesco de' Medici, was also the employer of a Florentine Sandro Botticelli The birth of Venus, c. 1485
Tempera on canvas, 172.5×278.5 cm, $67\% \times 100\%$ in; Uffizi, Florence

who was destined to give his name to a continent. It was in the service of his firm that Amerigo Vespucci sailed to the New World. We have reached the period which later historians selected as the 'official' end of the Middle Ages. We remember that in Italian art there were various turning-points that might be described as the beginning of a new age - the discoveries of Giotto round about 1300, those of Brunelleschi round about 1400. But even more important, perhaps, than these revolutions in method was a gradual change that had come over art in the course of these two centuries. It is a change that is more easily sensed than described. A comparison of the medieval book illuminations discussed in the preceding chapters, page 195, figure 131 and page 211, figure 140, with a Florentine specimen of that art made about 1475, figure 173, might give an idea of the different spirit in which the same art can be employed. It is not that the Florentine master lacked reverence or devotion. But the very powers his art had gained made it impossible for him to think of it only as a means of conveying the meaning of the sacred story. Rather did he want to use this power to turn the page into a gay display of wealth and luxury. This function of art, to add to the beauty and graces of life, had never been entirely forgotten. In the period we call the Italian Renaissance it came increasingly to the fore.

Fresco painting and colour grinding, c. 1465
From a Florentine print showing the occupations of people born under

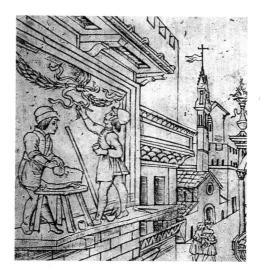

TRADITION AND INNOVATION: II

The fifteenth century in the North

We have seen that the fifteenth century brought a decisive change in the history of art because the discoveries and innovations of Brunelleschi's generation in Florence had lifted Italian art on to a new plane, and had separated it from the development of art in the rest of Europe. The aims of the northern artists of the fifteenth century did not, perhaps, differ so much from those of their Italian fellow artists as did their means and methods. The difference between the north and Italy is most clearly marked in architecture. Brunelleschi had put an end to the Gothic style in Florence by introducing the Renaissance method of using classical motifs for his buildings. It was nearly a century before the artists outside Italy followed his example. All through the fifteenth century they continued developing the Gothic style of the preceding century. But though the forms of these buildings still contained such typical elements of Gothic architecture as the pointed arch or the flying buttress, the taste of the times had greatly changed. We remember that in the fourteenth century architects liked to use graceful lacework and rich ornamentation. We remember the Decorated style, in which the window of Exeter Cathedral was designed, page 208, figure 137. In the fifteenth century this taste for complicated tracery and fantastic ornament went even further.

Figure 174, the Palace of Justice in Rouen, is an example of this last phase of French Gothic, sometimes referred to as the Flamboyant style. We see how the designers covered the whole building with an infinite variety of decorations, not, apparently, considering whether they performed any function in the structure. Some of these buildings have a fairy-tale quality of overwhelming wealth and invention; but one feels that in them the designers had exhausted the last possibility of Gothic building, and that a reaction was bound to set in sooner or later. There are, in fact, indications that even without the direct influence of Italy the architects of the North would have evolved a new style of greater simplicity.

It is particularly in England that we can see these tendencies at work in the last phase of the Gothic style which is known as the Perpendicular.

Courtyard of the Palace of Justice (formerly Treasury), Rouen, 1482 The Flambovant Gothic

The Flamboyant Gothic style

This name was invented to convey the character of later fourteenth- and fifteenth-century buildings in England because in their decorations straight lines are more frequent than the curves and arches of earlier 'decorated' tracery. The most famous example of this style is the wonderful chapel of King's College in Cambridge, *figure 175*, which was begun in 1446. The shape of this church is much more simple than those of earlier Gothic interiors – there are no side-aisles, and therefore no pillars and no steep arches. The whole makes the impression of a lofty hall rather than of a medieval church. But while the general structure is thus sober and perhaps more worldly than that of the great cathedrals, the imagination of the Gothic craftsmen is given free rein in the details, particularly in the form of the vault ('fan-vault'), with its fantastic lacework of curves and lines recalling the miracles of Celtic and Northumbrian manuscripts, *page 161*, *figure 103*.

The development of painting and sculpture in the countries outside Italy runs to a certain extent parallel with this development of architecture. In other words, while the Renaissance had been victorious in Italy along the whole front, the North in the fifteenth century remained still faithful to the Gothic tradition. Despite the great innovations of the Van Eyck

175

King's College Chapel, Cambridge, begun in 1446

The Perpendicular style

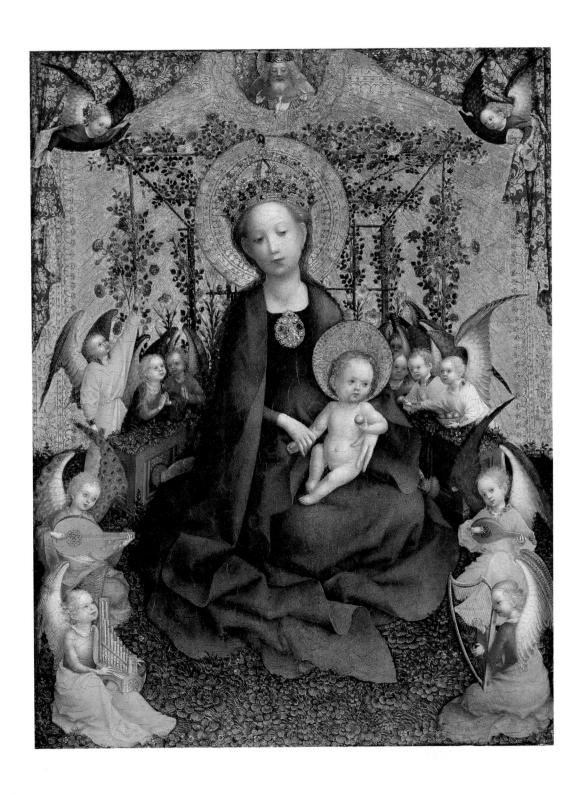

Stefan Lochner
The Virgin in the rose-

bower, c. 1440 Oil on wood, 51 × 40 cm, 20 × 15¾ in; Wallraf-Richartz-Museum, Cologne

brothers, the practice of art continued to be a matter of custom and usage rather than of science. The mathematical rules of perspective, the secrets of scientific anatomy, the study of Roman monuments did not yet trouble the peace of mind of the northern masters. For this reason we may say that they were still 'medieval artists', while their colleagues across the Alps already belonged to the 'modern era'. But the problems facing the artists on both sides of the Alps were nevertheless strikingly similar. Jan van Eyck had taught them how to make the picture a mirror of nature by carefully adding detail upon detail until the whole frame was filled with painstaking observation, page 238, figure 157, page 241, figure 158. But just as Fra Angelico and Benozzo Gozzoli in the south, page 253, figure 165, page 257, figure 168, had used Masaccio's innovations in the spirit of the fourteenth century, so there were artists in the north who applied Van Eyck's discoveries to more traditional themes. The German painter Stefan Lochner (1410?-51), for instance, who worked in Cologne in the middle of the fifteenth century, was somewhat like a northern Fra Angelico. His charming picture of the Virgin in a rose-bower, figure 176, surrounded by little angels who make music, scatter flowers, or offer fruit to the Christ Child, shows that the master was aware of the new methods of Van Eyck, just as Fra Angelico was aware of the discoveries of Masaccio. And yet his picture is nearer in spirit to the Gothic Wilton Diptych, pages 216–17, figure 143, than it is to Van Eyck. It may be interesting to look back at the earlier example and compare the two works. We see at once that the later master had learned one thing which had presented difficulties to the earlier painter. Lochner could suggest the space in which the Virgin is enthroned on the grass bank. Compared with his figures, those of the Wilton Diptych look a little flat. Lochner's Holy Virgin still sits enthroned before a background of gold, but in front of it there is a real stage. He has even added two charming angels holding back the curtain, which seems to hang from the frame. It was paintings like those by Lochner and Fra Angelico which first captured the imagination of the romantic critics of the nineteenth century, men such as Ruskin and the painters of the Pre-Raphaelite Brotherhood. They saw in them all the charm of simple devotion and a childlike heart. In a way they were right. These works are perhaps so fascinating because for us, used to real space in pictures, and more or less correct drawing, they are easier to understand than the works of the earlier medieval masters, whose spirit they nevertheless preserved.

Other painters in the North correspond rather to Benozzo Gozzoli, whose frescoes in the Palazzo Medici in Florence reflect the gay pageantry of the elegant world, in the traditional spirit of the International style. This applies particularly to the painters who designed tapestries, and to those who decorated the pages of precious manuscripts. The page

176

illustrated in figure 177 was painted about the middle of the fifteenth century, as were Gozzoli's frescoes. In the background is the traditional scene showing the author handing the finished book to his noble patron who had ordered it. But the painter found this theme rather dull by itself. He therefore gave it the setting of an entrance hall, and showed us the happenings all around. Behind the city gate there is a party apparently making ready for the chase – at least there is one rather dandyish figure carrying a falcon on his fist, while others stand around like pompous

burghers. We see the stalls and booths inside and in front of the city gate, with the merchants displaying their goods and the buyers inspecting them. It is a lifelike picture of a medieval city of the time. Nothing like it could have been done a hundred years earlier, or, indeed, at any earlier time. We have to go back to ancient Egyptian art to find pictures which portray the daily life of the people as faithfully as this; and even the Egyptians did not look at their own world with so much accuracy and humour. It is the spirit of the drollery of which we saw an example in 'Queen Mary's Psalter', page 211, figure 140, that came to fruition in these charming portrayals of daily life. Northern art, which was less preoccupied with attaining ideal harmony and beauty than Italian art, was to favour this type of representation to an increasing extent.

Nothing, however, would be more wrong than to imagine that these two 'schools' developed in watertight compartments. Of the leading French artist of the period, Jean Fouquet (1420?–80?), we know, in fact, that he visited Italy in his youth. He went to Rome, where he painted the Pope in 1447. Figure 178 shows a donor's portrait which he probably made a few years after his return. As in the Wilton Diptych, pages 216–17, figure 143, the saint protects the kneeling and praying figure of the donor. As the donor's name was Estienne (which is old French for Stephen), the saint by his side is his patron, St Stephen, who, as the first deacon of the Church, wears a deacon's robe. He carries a book and on it is a large sharp stone, for, according to the Bible, St Stephen was stoned. If we look back to the Wilton Diptych, we see once more what strides had been made by art in the representation of nature in half a century. The saints and donor

177

Jean le Tavernier

Dedication page to

'The Conquests of

Charlemagne', c. 1460

Bibliothèque Royale,

Brussels

178

Jean Fouquet
Estienne Chevalier,
Treasurer of Charles
VII of France, with
St Stephen, c. 1450
Panel from an altarpiece;
oil on wood, 96 × 88 cm,
374 × 34½ in;
Gemäldegalerie, Staatliche

Museen, Berlin

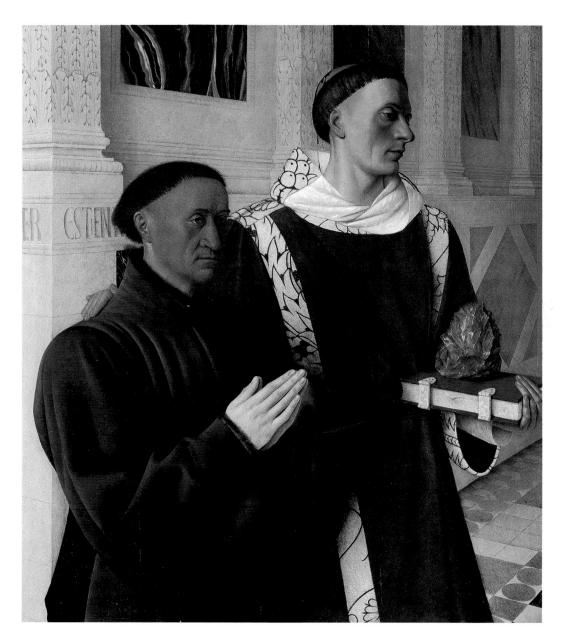

of the Wilton Diptych look as though they were cut out of paper and placed upon the picture; those of Jean Fouquet look as if they had been modelled. In the earlier picture there is no trace of light and shade; Fouquet uses light almost as Piero della Francesca did, page 261, figure 170. The way in which these calm and statuesque figures stand as in real space shows that Fouquet had been deeply impressed by what he had seen in Italy. And yet, his manner of painting is different from that of the Italians. The interest he takes in the texture and surface of things – the fur, the stone, the cloth and the marble – shows that his art remains indebted to the northern tradition of Jan van Eyck.

Another great northern artist who went to Rome (for a pilgrimage in 1450) was Rogier van der Weyden (1400?-64). Very little is known about this master except that he enjoyed great fame and lived in the southern Netherlands, where Jan van Evck had also worked. Figure 179 shows a large altar-painting which represents the Descent from the Cross. We see that Rogier, like Van Eyck, could faithfully reproduce every detail, every hair and every stitch. Nevertheless, his picture does not represent a real scene. He has placed his figures on a kind of shallow stage against a neutral background. Remembering Pollaiuolo's problems, page 263, figure 171, we can appreciate the wisdom of Rogier's decision. He, too, had to make a large altar-painting to be seen from afar, and had to display the sacred theme to the faithful in the church. It had to be clear in outline, and satisfying as a pattern. Rogier's picture fulfils these requirements without looking forced and self-conscious as does Pollaiuolo's. The body of Christ, which is turned full face towards the beholder, forms the centre of the composition. The weeping women frame it on both sides. St John, bending forward, like St Mary Magdalene on the other side, tries in vain to support the fainting Virgin, whose movement corresponds to that of Christ's descending body. The calm bearing of the old men forms an effective foil to the expressive gestures of the principal actors. For they really seem like actors in a mystery play or in a tableau vivant grouped or posed by an inspired producer who had studied the great works of the medieval past and wanted to imitate them in his own medium. In this way, by translating the main ideas of Gothic art into the new, lifelike style, Rogier did a great service to northern art. He saved much of the tradition of lucid design that might otherwise have been lost under the impact of Jan van Eyck's discoveries. Henceforward northern artists tried, each in his own way, to reconcile the new demands on art with its old religious purpose.

Rogier van der Weyden The Descent from the Cross, c. 1435 Altar-painting; oil on wood, 220 × 262 cm, 86% × 103% in; Prado,

We can study these efforts in a work of one of the greatest Flemish painters of the second half of the fifteenth century, Hugo van der Goes (died 1482). He is one of the few northern masters of this early period of whom we know some personal details. We hear that he spent the last years of his life in voluntary retirement in a monastery and that he was haunted by feelings of guilt and attacks of melancholy. There is indeed something tense and serious in his art that makes it very different from the placid moods of Jan van Eyck. Figure 180 shows his painting of the 'Death of the Virgin'. What strikes us first is the admirable way in which the artists has represented the varying reactions of the twelve apostles to the event they are witnessing – the range of expression from quiet brooding to passionate sympathy and almost indiscreet gaping. We can best gain a measure of Van der Goes's achievement if we turn back to the illustration of the same scene over the porch of Strasbourg Cathedral, page 193, figure 129. Compared to the painter's many types, the apostles of the sculpture look very much alike. And how easy it was for the earlier artist to arrange his figures in a clear design! He did not have to wrestle with foreshortening and the illusion of space as was expected of Van der Goes. We can feel the efforts of the painter to conjure up a real scene before our eyes and yet to leave no part of the panel's surface empty and meaningless. The two apostles in the foreground and the apparition over the bed show most clearly how he strove to spread his figures out and display them before us. But this visible strain which makes the movements look somewhat contorted also adds to the feeling of tense excitement that surrounds the calm figure of the dying Virgin who, alone in the crowded room, is granted the vision of her Son, who is opening His arms to receive her.

Hugo van der Goes The Death of the Virgin, c. 1480 Altar-painting; oil on wood, 146.7 × 121.1 cm, 573/4 × 475/8 in; Groeningemuseum,

181

Detail of figure 180

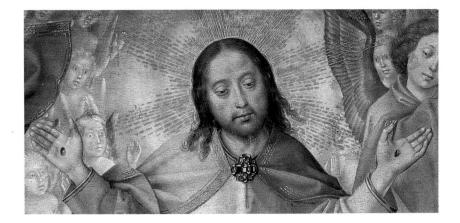

Veit Stoss
Head of an apostle
Detail of figure 182

Veit Stoss Altar of the church of

182

Our Lady, Cracow, 1477–89 Painted wood, height 43ft, 13.1m

For the sculptors and woodcarvers the survival of Gothic tradition in the new form which Rogier had given to it proved of particular importance. Figure 182 shows a carved altar which was commissioned for the Polish city of Cracow in 1477 (two years after Pollaiuolo's altar-painting, page 263, figure 171. Its master was Veit Stoss, who lived for the greater part of his life in Nuremberg in Germany and died there at a very advanced age in 1533. Even on the small illustration we can see the value of a lucid design. For like the members of the congregation who stood far away we are able to read off the meaning of the main scenes

without difficulty. The shrine in the centre shows again the death of the Virgin Mary, surrounded by the twelve apostles, though this time she is not represented lying on a bed but kneeling in prayer. Farther up we see her soul being received into a radiant Heaven by Christ, and at the top we watch her being crowned by God the Father and His Son. Both wings of the altar represent important moments in the life of the Virgin, which (together with her crowning) are known as the Seven Joys of Mary. The cycle begins in the left top square with the Annunciation; it continues farther down with the Nativity and the Adoration of the Magi. In the right-hand wing we find the remaining three joyous moments after so much sorrow - the Resurrection of Christ, His Ascension and the Outpouring of the Holy Ghost at Whitsun. All these stories the faithful could contemplate when they were assembled in church on a feast day of the Virgin (the other sides of the wings were adapted to other feast days). But only if they could approach close to the shrine could they admire the truthfulness and expressiveness of Veit Stoss's art in the wonderful heads and hands of his apostles, figure 183.

In the middle of the fifteenth century a decisive technical invention had been made in Germany, which had a tremendous effect on the future development of art, and not of art alone – the invention of printing. The printing of pictures had preceded the printing of books by several decades. Small leaflets, with images of saints and the text of prayers, had been printed for distribution among pilgrims and for private

devotion. The method of printing these images was simple enough. It was the same as was later developed for the printing of letters. You took a wood-block and cut away with a knife everything that should not appear on the print. In other words, everything that was to look white in the final product was to be cut hollow and everything that was to look black was left standing in narrow ridges. The result looked like any rubber stamp we use today, and the principle of printing it on to paper was practically the same: you covered the surface with printer's ink made of oil and soot and pressed it on to the leaflet. You could make a good many impressions from one block before it wore out. This simple technique of printing pictures is called woodcut. It was a very cheap method and soon became popular. Several wood-blocks together could be used for a little series of pictures printed together as a book; these books printed from whole blocks are called block-books. Woodcuts and block-books were soon on sale at popular fairs; playingcards were made in this way; there were humorous pictures and prints for devotional use. Figure 184 shows a page from one of these early blockbooks, which was used by the Church as a picture-sermon. Its purpose was to remind the faithful of the hour of death and to teach them - as the title says – 'The art of dying well'. The woodcut shows the pious man on his death-bed with the monk by his side putting a lighted candle into his hand. An angel is receiving his soul, which has come out of his mouth in the shape of a little praying figure. In the background we see Christ and His saints, towards whom the dying man should turn his mind. In the foreground we see a host of devils in the most ugly and fantastic shapes, and the inscriptions which come out of their mouths tell us what they say: 'I am raging', 'We are disgraced', 'I am dumbfounded', 'This is no comfort', 'We have lost his soul'. Their grotesque antics are in vain. The man who possesses the art of dying well need not fear the powers of hell.

When Gutenberg made his great invention of using movable letters held together by a frame, instead of whole wood-blocks, such block-books became obsolete. But methods were soon found of combining a printed text with a wood-block for illustration, and many books of the latter half of the fifteenth century were illustrated with woodcuts.

For all its usefulness, however, the woodcut was a rather crude way of printing pictures. It is true that this crudeness itself is sometimes effective. The quality of these popular prints of the late Middle Ages reminds one sometimes of our best posters – they are simple in outline and economical in their means. But the great artists of the period had rather different ambitions. They wanted to show their mastery of detail and their powers of observation, and for this the woodcut was not suitable.

he good man on his ath-bed, c. 1470 oodcut, 22.5 × 16.5 cm, i × 6½ in; illustration m 'The art of dying all', printed in Ulm

These masters, therefore, chose another medium, which gave more subtle effects. Instead of wood, they used copper. The principle of the copperplate engraving is a little different from that of the woodcut. In the woodcut you cut away everything except the lines you want to show. In the engraving you take a special tool, called a burin, and press it into the copper plate. The line which you thus engrave into the surface of the metal will hold any colour or printer's ink you spread over the surface. What you do, therefore, is to cover your engraved copper plate with printer's ink and then wipe the blank metal clean. If then you press the plate very hard against a piece of paper, the ink which has remained in the lines cut by the burin is squeezed on to the paper, and the print is ready. In other words, the copper-engraving is really a negative of the woodcut. The woodcut is made by leaving the lines standing, the engraving by cutting them into the plate. Now, however hard it may be to handle the burin firmly and to control the depth and strength of your lines, it is clear that, once you have mastered this craft, you can obtain much more detail and much more subtle effects from a copper-engraving than you can from a woodcut.

One of the greatest and most famous masters of engraving in the fifteenth century was Martin Schongauer (1453?–91), who lived on the upper Rhine at Colmar, in present-day Alsace. *Figure 185* shows Schongauer's engraving of the Holy Night. The scene is interpreted in the spirit of the great masters

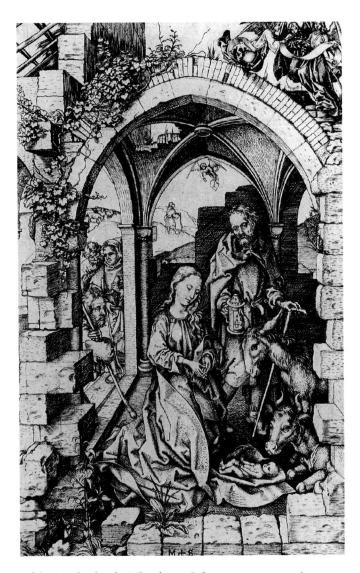

185 Martin Schongauer The Holy Night, c. 1470–3 Engraving, 25.8 × 17 cm, 10 × 6 in

of the Netherlands. Like them, Schongauer was anxious to convey every little homely detail of the scene, and to make us feel the very texture and surfaces of the objects he represents. That he should have succeeded in doing so without the help of brush and colour, and without the medium of oil, borders on the miraculous. One can look at his engravings through a magnifying glass and study the way he characterizes the broken stones and bricks, the flowers in the crags, the ivy creeping along the vault, the fur of the animals and the hair and beards of the shepherds. But it is not only his patience and craftsmanship we must admire. We can enjoy his tale of Christmas without any knowledge of the difficulties of working with the burin. There is the Virgin kneeling in the ruined chapel which is used as a stable. She kneels in adoration of the Child, whom she has carefully placed on the corner of her cloak, and St Joseph, lantern in hand, looks at her with a worried and fatherly expression. The ox and the ass are worshipping with

her. The humble shepherds are just about to cross the threshold; one of them, in the background, receives the message from the angel. Up in the right-hand corner we have a glimpse of the heavenly chorus singing 'Peace on Earth'. In themselves, these motifs are all deeply rooted in the tradition of Christian art, but the way in which they are combined and distributed over the page was Schongauer's own. The problems of composition for the printed page and for the altar-picture are in some respects similar. In both cases, the suggestion of space and the faithful imitation of reality must not be allowed to destroy the balance of the composition. It is only if we think of this problem that we can fully appreciate Schongauer's achievement. We now understand why he has chosen a ruin as setting – it allowed him to frame the scene solidly with the pieces of broken masonry that form the opening through which we look. It enabled him to place a black foil behind the principal figures and to leave no part of the engraving empty or without interest. We can see how carefully he planned his composition if we lay two diagonals across the page: they meet at the head of the Virgin, which is the true centre of the print.

The art of the woodcut and of engraving soon spread all over Europe. There are engravings in the manner of Mantegna and Botticelli in Italy, and others from the Netherlands and France. These prints became yet another means through which the artists of Europe learned of each other's ideas. At that time it was not yet considered dishonourable to take over an idea or a composition from another artist, and many of the humbler masters made use of engravings as pattern books from which they borrowed. Just as the invention of printing hastened the exchange of ideas without which the Reformation might never have come about, so the printing of images ensured the triumph of the art of the Italian Renaissance in the rest of Europe. It was one of the forces which put an end to the medieval art of the north, and brought about a crisis in the art of these countries which only the greatest masters could overcome.

Stonemasons and the king, c. 1464 From a manuscript of the story of Troy, illuminated by Jean Colombe; Kupferstichkabinett, Staatliche Museen, Berlin

HARMONY ATTAINED

Tuscany and Rome, early sixteenth century

We left Italian art at the time of Botticelli, that is, at the end of the fifteenth century, which the Italians by an awkward trick of language called the *Quattrocento*, that is to say, the 'four hundreds'. The beginning of the sixteenth century, the *Cinquecento*, is the most famous period of Italian art, one of the greatest periods of all time. This was the time of Leonardo da Vinci and Michelangelo, of Raphael and Titian, of Correggio and Giorgione, of Dürer and Holbein in the North, and of many other famous masters. One may well ask why it was that all these great masters were born in the same period, but such questions are more easily asked than answered. One cannot explain the existence of genius. It is better to enjoy it. What we have to say, therefore, can never be a full explanation of the great period which is called the High Renaissance, but we can try to see what the conditions were which made this sudden efflorescence of genius possible.

We have seen the beginning of these conditions far back in the period of Giotto. His fame was so great that the Commune of Florence was proud of him and anxious to have the bell-tower of their cathedral designed by that widely renowned master. This pride of the cities, which vied with each other in securing the services of the greatest artists to beautify their buildings and to create works of lasting fame, was a great incentive to the masters to outdo each other – an incentive which did not exist to the same extent in the feudal countries of the North, where cities had much less independence and local pride. Then came the period of the great discoveries, when Italian artists turned to mathematics to study the laws of perspective, and to anatomy to study the build of the human body. Through these discoveries, the artist's horizon widened. He was no longer a craftsman among craftsmen, ready to carry out commissions for shoes, or cupboards, or paintings, as the case might be. He was a master in his own right, who could not achieve fame and glory without exploring the mysteries of nature and probing into the secret laws of the universe. It was natural that the leading artists who had these ambitions felt aggrieved by their social status. This was still the same as it had been at the time of ancient Greece, when snobs might have accepted a poet who worked with his brain, but never an artist who worked with his hands. Here was another challenge for the artists to meet, another spur which urged them on towards yet greater achievements that would compel the surrounding world to accept them, not only as respectable heads of prosperous workshops, but as men of unique and precious gifts. It was a difficult struggle, which was not immediately successful. Social snobbery and prejudice are strong forces, and there were many who would gladly have invited to their tables a scholar who spoke Latin, and knew the right turn of phrase for every occasion, but would have hesitated to extend a similar privilege to a painter or a sculptor. It was again the love of fame on the part of the patrons which helped the artists to break down such prejudices. There were many small courts in Italy which were badly in need of honour and prestige. To erect magnificent buildings, to commission splendid tombs, to order great cycles of frescoes, or to dedicate a painting for the high altar of a famous church, was considered a sure way of perpetuating one's name and securing a worthy monument to one's earthly existence. As there were many centres competing for the services of the most renowned masters, the masters in turn could dictate their terms. In earlier times it was the prince who bestowed his favours on the artist. Now it almost came to pass that the roles were reversed, and that the artist granted a favour to a rich prince or potentate by accepting a commission from him. Thus it came about that the artists could frequently choose the kind of commission which they liked, and that they no longer needed to accommodate their works to the whims and fancies of their employers. Whether or not this new power was an unmixed blessing for art in the long run is difficult to decide. But at first, at any rate, it had the effect of a liberation which released a tremendous amount of pent-up energy. At last, the artist was free.

In no sphere was the effect of this change so marked as in architecture. Since the time of Brunelleschi, page 224, the architect had to have some of the knowledge of a classical scholar. He had to know the rules of the ancient 'orders', of the right proportions and measurements of the Doric, Ionic and Corinthian columns and entablatures. He had to measure ancient ruins, and pore over the manuscripts of classical writers like Vitruvius, who had codified the conventions of the Greek and Roman architects, and whose works contained many difficult and obscure passages, which challenged the ingenuity of Renaissance scholars. In no other field was the conflict between the requirements of the patrons and the ideals of the artists more apparent than in this field of architecture. What these learned masters really longed to do was to build temples and triumphal arches – what they were asked to do was to build city palaces and churches. We have seen how a compromise was reached in this

186

Caradosso Foundation medal for the new St Peter's, showing Bramante's scheme for a huge dome,

Bronze, diameter 5.6 cm, 21/4 in; British Museum, London

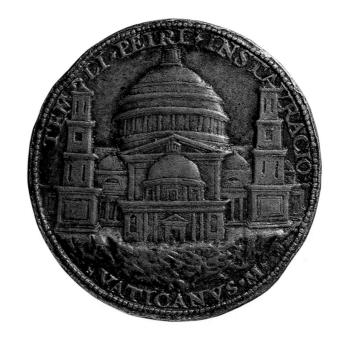

fundamental conflict by masters such as Alberti, page 250, figure 163, who wedded the ancient 'orders' to the modern city palace. But the true aspiration of the Renaissance architect was still to design a building irrespective of its use; simply for the beauty of its proportions, the spaciousness of its interior and the imposing grandeur of its ensemble. They craved for a perfect symmetry and regularity such as they could not achieve while concentrating on the practical requirements of an ordinary building. It was a memorable moment when one of them found a mighty patron willing to sacrifice tradition and expediency for the sake of the fame he would acquire by erecting a stately structure that would outshine the seven wonders of the world. Only in this way can we understand the decision of Pope Julius II in 1506 to pull down the venerable Basilica of St Peter, which stood at the place where, according to tradition, St Peter lay buried, and to have it built anew in a manner which defied the age-old traditions of church-building and the usages of divine service. The man to whom he entrusted this task was Donato Bramante (1444-1514), an ardent champion of the new style. One of the few of his buildings which have survived intact shows how far Bramante had gone in absorbing the ideas and standards of classical architecture without becoming a slavish imitator,

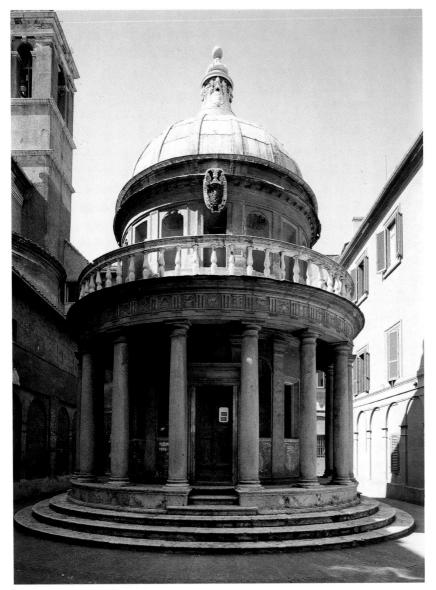

Donato Bramante, The Tempietto, church of S. Pietro in Montorio, Rome, 1502 A chapel of the High Renaissance

figure 187. It is a chapel, or 'Tempietto' (little temple) as he called it, which should have been surrounded by a cloister in the same style. It takes the form of a small pavilion, a round building on steps, crowned by a cupola and encircled by a colonnade of the Doric order. The balustrade on top of the cornice adds a light and graceful touch to the whole building, and the small structure of the actual chapel and the decorative colonnade are held in a harmony as perfect as that in any temple of classical antiquity.

To this master, then, the Pope had given the task of designing the new church of St Peter, and it was understood that this should become a true marvel of Christendom. Bramante was determined to disregard the Western tradition of a thousand years, according to which a church of this kind should be an oblong hall with the worshippers looking eastwards towards the main altar, where Mass is read.

In his craving for that regularity and harmony that alone could be worthy of the place, he designed a square church with chapels symmetrically arranged round a gigantic cross-shaped hall. This hall was to be crowned by a huge dome resting on colossal arches, which we know from the foundation medal, figure 186. Bramante hoped, it was said, to combine the effect of the largest ancient building, the Colosseum, page 118, figure 73, whose towering ruins still impressed the visitor to Rome, with that of the Pantheon, page 120, figure 75. For one brief moment, admiration for the art of the ancients and ambition to create something unheard of overruled considerations of expediency and time-honoured traditions. But Bramante's plan for St Peter's was not destined to be carried out. The enormous building swallowed up so much money that, in trying to raise sufficient funds, the Pope precipitated the crisis which led to the Reformation. It was the practice of selling indulgences against contributions for the building of the new church that led Luther in Germany to his first public protest. Even within the Catholic Church, opposition to Bramante's plan increased, and over the years the idea of an all-round symmetrical church was abandoned. St Peter's, as we know it today, has little in common with the original plan, except its gigantic dimensions.

The spirit of bold enterprise which made Bramante's plan for St Peter's possible is characteristic of the period of the High Renaissance, the period around 1500 which produced so many of the world's greatest artists. To these men nothing seemed impossible, and that may be the reason why they did sometimes achieve the apparently impossible. Once more, it was Florence which gave birth to some of the leading minds of that great epoch. Since the days of Giotto round about 1300, and of Masaccio in the early 1400s, Florentine artists had cultivated their tradition with special pride, and their excellence was recognized by all people of taste. We shall see that nearly all the greatest artists grew out of such a firmly established tradition, and that is why we should not forget the humbler masters in whose workshops they learned the elements of their craft.

Leonardo da Vinci (1452–1519), the oldest of these famous masters, was born in a Tuscan village. He was apprenticed to a leading Florentine workshop, that of the painter and sculptor Andrea del Verrocchio (1435–88). Verrocchio's fame was very great, so great indeed that the city of Venice commissioned from him the monument to Bartolommeo

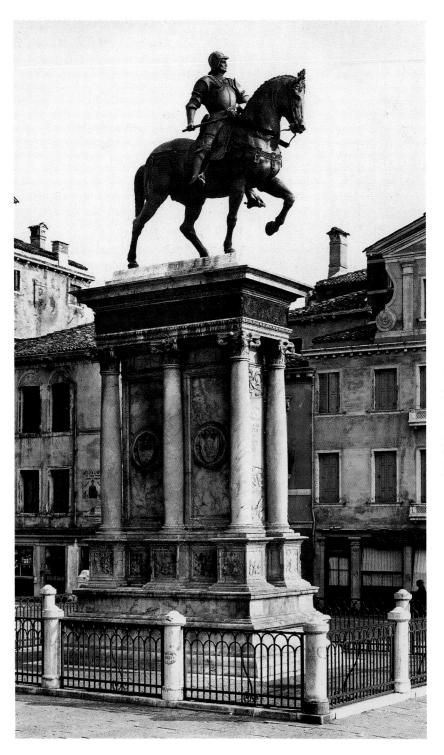

188
Andrea del
Verrocchio
Bartolommeo Colleoni,
1479
Bronze, height (horse and
rider) 395 cm, 155¾ in;
Campo di SS. Giovanni e
Paolo, Venice

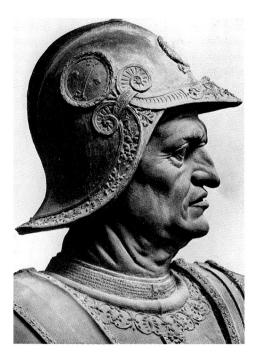

Detail of figure 188

Colleoni, one of their generals, to whom they owed gratitude for a number of charities he had founded rather than for any particular deed of military prowess. The equestrian statue which Verrocchio made, figures 188-9, shows that he was a worthy heir to the tradition of Donatello. He minutely studied the anatomy of the horse, and we see how clearly he observed the muscles of Colleoni's face and neck. But most admirable of all is the posture of the horseman, who seems to be riding ahead of his troops with an expression of bold defiance. Later times have made us so familiar with these riders of bronze that have come to people our towns and cities, representing more or less worthy emperors, kings, princes and generals, that it may take us some time to realize the greatness and simplicity of Verrocchio's work in the clear outline which his group presents from nearly all aspects, and the concentrated

energy which seems to animate the man in armour and his mount.

In a workshop capable of producing such masterpieces, the young Leonardo could certainly learn many things. He would be introduced into the technical secrets of foundry-work and other metalwork, he would learn to prepare pictures and statues carefully by making studies from the nude and from draped models. He would learn to study plants and curious animals for inclusion in his pictures, and he would receive a thorough grounding in the optics of perspective and in the use of colours. In the case of any other gifted boy, this training would have been sufficient to make a respectable artist, and many good painters and sculptors did in fact emerge from Verrocchio's prosperous workshop. But Leonardo was more than a gifted boy. He was a genius whose powerful mind will always remain an object of wonder and admiration to ordinary mortals. We know something of the range and productivity of Leonardo's mind because his pupils and admirers carefully preserved for us his sketches and notebooks, thousands of pages covered with writings and drawings, with excerpts from books Leonardo read, and drafts for books he intended to write. The more one reads of these papers, the less can one understand how one human being could have excelled in all these different fields of research and made important contributions to nearly all of them. Perhaps one of the reasons is that Leonardo was a Florentine artist and not a trained scholar. He thought that the artist's business was to explore the visible

world just as his predecessors had done, only more thoroughly and with greater intensity and accuracy. He was not interested in the bookish knowledge of the scholars. Like Shakespeare, he probably had 'little Latin and less Greek'. At a time when the learned men at the universities relied on the authority of the admired ancient writers, Leonardo, the painter, would never accept what he read without checking it with his own eyes. Whenever he came across a problem, he did not rely on authorities but tried an experiment to solve it. There was nothing in nature which did not arouse his curiosity and challenge his ingenuity. He explored the secrets of the human body by dissecting more than thirty corpses, figure 190. He was one of the first to probe into the mysteries of the growth of the child in the womb; he investigated the laws of waves and currents; he spent years in observing and analysing the flight of insects and birds, which was to help him to devise a flying machine which he was sure would one day become a reality. The forms of rocks and clouds, the effect of the atmosphere on the colour of distant objects, the laws governing the growth of trees and plants, the harmony of sounds, all these were the objects of his ceaseless research, which was to be the foundation of his art.

His contemporaries looked upon Leonardo as a strange and rather uncanny being. Princes and generals wanted to use this astonishing wizard as a military engineer for the building of fortifications and canals, of novel weapons and devices. In time of peace, he would entertain them with mechanical toys of his own invention, and with the designing of new effects for stage performances and pageantries. He was admired as a great artist, and sought after as a splendid musician, but, for all that, few people can have had an inkling of the importance of his ideas or the extent of his knowledge. The reason is that Leonardo never published his writings, and that very few can even have known of their existence. He was left-handed, and had taken to writing from right to left so that his notes can only be read in a mirror. It is possible that he was afraid of divulging his discoveries for fear that his opinions would be found heretical. Thus we find in his writings the five words 'The sun does not move', which shows that Leonardo anticipated the theories of Copernicus which were later to bring Galileo into trouble. But it is also possible that he undertook his researches and experiments simply because of his insatiable curiosity, and that, once he had solved a problem for himself, he was apt to lose interest because there were so many other mysteries still to be explored.

Most of all, it is likely that Leonardo himself had no ambition to be considered a scientist. All this exploration of nature was to him first and foremost a means of gaining knowledge of the visible world, such as he would need for his art. He thought that by placing it on scientific foundations he could transform his beloved art of painting from a humble

190

Leonardo da Vinci Anatomical studies (larynx and leg), 1510 Pen, brown ink and wash over black chalk on paper, 26 × 19.6 cm, 11 × 7 in; Royal Library, Windsor Castle

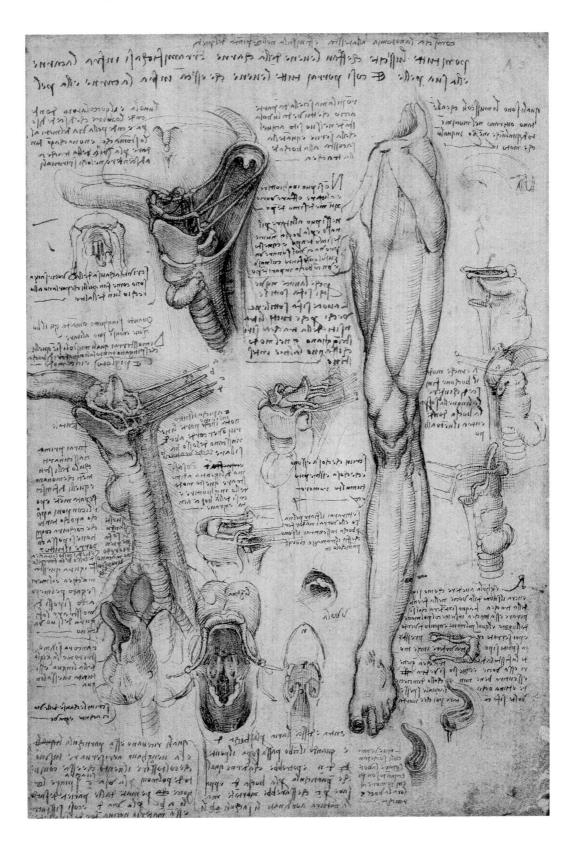

craft into an honoured and gentlemanly pursuit. To us, this preoccupation with the social rank of artists may be difficult to understand, but we have seen what importance it had for the men of the period. Perhaps if we remember Shakespeare's Midsummer Night's Dream and the roles he assigns to Snug the joiner, Bottom the weaver and Snout the tinker, we can understand the background of this struggle. Aristotle had codified the snobbishness of classical antiquity in distinguishing between certain arts that were compatible with a 'liberal education' (the so-called Liberal Arts such as grammar, logic, rhetoric, or geometry) and pursuits that involved working with the hands, which were 'manual' and therefore 'menial', and thus below the dignity of a gentleman. It was the ambition of such men as Leonardo to show that painting was a Liberal Art, and that the manual labour involved in it was no more essential than was the labour of writing in poetry. It is possible that this view often affected Leonardo's relationships with his patrons. Perhaps he did not want to be considered the owner of a shop where anyone could commission a picture. At any rate, we know that Leonardo often failed to carry out his commissions. He would start on a painting and leave it unfinished, despite the urgent requests of the patron. Moreover, he obviously insisted that it was he himself who had to decide when a work of his was considered finished. and he refused to let it go out of his hands unless he was satisfied with it. It is not surprising, therefore, that few of Leonardo's works were ever completed, and that his contemporaries regretted the way in which this outstanding genius seemed to fritter away his time, moving restlessly from Florence to Milan, from Milan to Florence, and to the service of the notorious adventurer Cesare Borgia, then to Rome, and finally to the court of King Francis I in France, where he died in the year 1519, more admired than understood.

By a singular misfortune, the few works which Leonardo did complete in his mature years have come down to us in a very bad state of preservation. Thus when we look at what remains of Leonardo's famous wall-painting of 'The Last Supper', *figures 191-2*, we must try to imagine how it may have appeared to the monks for whom it was painted. The painting covers one wall of an oblong hall that was used as a refectory by the monks of the monastery of Santa Maria delle Grazie in Milan. One must visualize what it was like when the painting was uncovered, and when, side by side with the long tables of the monks, there appeared the table of Christ and his apostles. Never before had the sacred episode appeared so close and so lifelike. It was as if another hall had been added to theirs, in which the Last Supper had assumed tangible form. How clear the light fell on to the table, and how it added roundness and solidity to the figures. Perhaps the monks were first struck by the truth to nature with

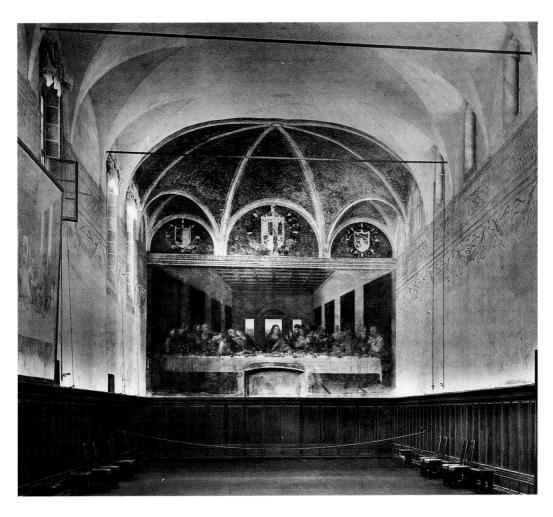

The refectory of the monastery of Sta Maria delle Grazie, Milan, with Leonardo da Vinci's 'Last Supper' on the end wall

which all details were portrayed, the dishes on the tablecloth, and the folds of the draperies. Then, as now, works of art were often judged by laymen according to their degree of lifelikeness. But that can only have been the first reaction. Once they had sufficiently admired this extraordinary illusion of reality, the monks would turn to the way in which Leonardo had presented the biblical story. There was nothing in this work that resembled older representations of the same theme. In these traditional versions, the apostles were seen sitting quietly at the table in a row – only Judas being segregated from the rest – while Christ was calmly dispensing the Sacrament. The new picture was very different from any of these paintings. There was drama in it, and excitement. Leonardo, like Giotto before him, had gone back to the text of the Scriptures, and had striven to visualize what it must have been like when Christ said, "Verily I say unto

you, that one of you shall betray me", and they were exceeding sorrowful and began every one of them to say unto him "Lord, is it I?" (Matthew xxvi. 21-2). The gospel of St John adds that 'Now there was leaning on Jesus' bosom one of his disciples, whom Jesus loved. Simon Peter therefore beckoned to him, that he should ask who it should be of whom he spake' (John xiii. 23-4). It is this questioning and beckoning that bring movement into the scene. Christ has just spoken the tragic words, and those on His side shrink back in terror as they hear the revelation. Some seem to protest their love and innocence, others gravely to dispute whom the Lord may have meant, others again seem to look to Him for an explanation of what He has said. St Peter, most impetuous of all, rushes towards St John, who sits to the right of Jesus. As he whispers something into St John's ear, he inadvertently pushes Judas forward. Judas is not segregated from the rest, and yet he seems isolated. He alone does not gesticulate and question. He bends forward and looks up in suspicion or anger, a dramatic contrast to the figure of Christ sitting calm and resigned amidst this surging turmoil. One wonders how long it took the first spectators to realize the consummate art by which all this dramatic movement was controlled. Despite the excitement which Christ's words have caused, there is nothing chaotic in the picture. The twelve apostles seem to fall quite naturally into four groups of three, linked to each other by gestures and movements. There is so much order in this variety, and so much variety in this order, that one can never quite exhaust the harmonious interplay of movement and answering movement. Perhaps we can only fully appreciate Leonardo's achievement in this composition if we think back to the problem we discussed in the description of Pollaiuolo's 'St Sebastian', page 263, figure 171. We remember how the artists of that generation had struggled to combine the demands of realism with those of design. We remember how rigid and artificial Pollaiuolo's solution of this problem looked to us. Leonardo, who was only a little younger than Pollaiuolo, had solved it with apparent ease. If one forgets for a moment what the scene represents, one can still enjoy the beautiful pattern formed by the figures. The composition seems to have the effortless balance and harmony which it had in Gothic paintings, and which artists like Rogier van der Weyden and Botticelli, each in his own way, had tried to recapture for art. But Leonardo did not find it necessary to sacrifice correctness of drawing, or accuracy of observation, to the demands of a satisfying outline. If one forgets the beauty of the composition, one suddenly feels confronted with a piece of reality as convincing and striking as any we saw in the works of Masaccio or Donatello. And even this achievement hardly touches upon the true greatness of the work. For, beyond such technical matters as composition

192

Leonardo da Vinci The Last Supper, 1495–8

Tempera on plaster, 460×880 cm, $181 \times 346\%$ in; refectory of the monastery of Sta Maria delle Grazie, Milan

Victoria Public Library 302 N. Main Victoria, Tx. 77901 and draughtsmanship, we must admire Leonardo's deep insight into the behaviour and reactions of men, and the power of imagination which enabled him to put the scene before our eyes. An eye-witness tells us that he often saw Leonardo at work on 'The Last Supper'. He would get on to the scaffolding and stand there for whole days with folded arms just looking critically at what he had done before painting another stroke. It is the result of this thought that he has bequeathed to us, and, even in its ruined state, 'The Last Supper' remains one of the great miracles wrought by human genius.

There is another work of Leonardo's which is perhaps even more famous than 'The Last Supper'. It is the portrait of a Florentine lady whose name was Lisa, 'Mona Lisa', figure 193. A fame as great as that of Leonardo's 'Mona Lisa' is not an unmixed blessing for a work of art. We become so used to seeing it on picture postcards, and even advertisements, that we find it difficult to see it with fresh eyes as the painting by a real man portraying a real woman of flesh and blood. But it is worth while to forget what we know, or believe we know, about the picture, and to look at it as if we were the first people ever to set eyes on it. What strikes us first is the amazing degree to which Lisa looks alive. She really seems to look at us and to have a mind of her own. Like a living being, she seems to change before our eyes and to look a little different every time we come back to her. Even in photographs of the picture we experience this strange effect, but in front of the original in the Louvre it is almost uncanny. Sometimes she seems to mock at us, and then again we seem to catch something like sadness in her smile. All this sounds rather mysterious, and so it is; that is so often the effect of a great work of art. Nevertheless, Leonardo certainly knew how he achieved this effect, and by what means. That great observer of nature knew more about the way we use our eyes than anybody who had ever lived before him. He had clearly seen a problem which the conquest of nature had posed to artists – a problem no less intricate than the one of combining correct drawing with a harmonious composition. The great works of the Italian Quattrocento masters who followed the lead given by Masaccio have one thing in common: their figures look somewhat hard and harsh, almost wooden. The strange thing is that it clearly is not lack of patience or lack of knowledge that is responsible for this effect. No one could be more patient in his imitation of nature than Van Eyck, page 241, figure 158; no one could know more about correct drawing and perspective than Mantegna, page 258, figure 169. And yet, for all the grandeur and impressiveness of their representations of nature, their figures look more like statues than living beings. The reason may be that the more conscientiously we copy a figure line by line and detail by detail, the less

fame: dullian dontiens

Leonardo da Vinci Mona Lisa, c. 1502 Oil on wood, 77 × 53 cm, 30 × 20% in: Louvre, Paris

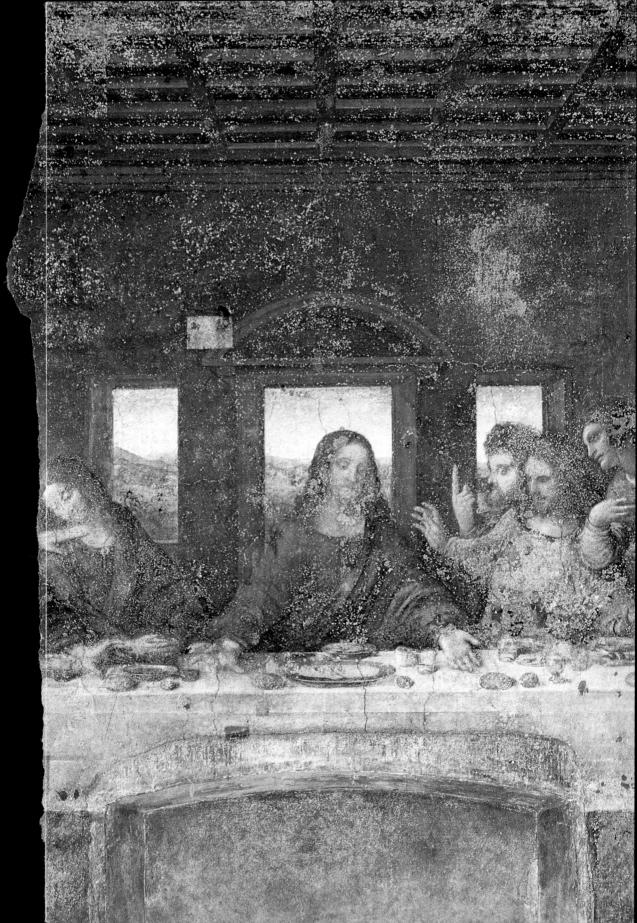

Detail of figure 193

we can imagine that it ever really moved and breathed. It looks as if the painter had suddenly cast a spell over it, and forced it to stand stock-still for evermore, like the people in 'The Sleeping Beauty'. Artists had tried various ways out of this difficulty. Botticelli, for instance, page 265, figure 172, had tried to emphasize in his pictures the waving hair and the fluttering garments of his figures, to make them look less rigid in outline. But only Leonardo found the true solution to the problem. The painter must leave the beholder something to guess. If the outlines are not quite so firmly drawn, if the form is left a little vague, as though disappearing into a shadow, this impression of dryness and stiffness will be avoided. This is

net nyrav, his dons

nhoe

Leonardo's famous invention which the Italians call 'sfumato' – the blurred outline and mellowed colours that allow one form to merge with another and always leave something to our imagination.

If we now return to the 'Mona Lisa', figure 194, we may understand something of its mysterious effect. We see that Leonardo has used the means of his 'sfumato' with the utmost deliberation. Everyone who has ever tried to draw or scribble a face knows that what we call its expression rests mainly in two features: the corners of the mouth, and the corners of the eyes. Now it is precisely these parts which Leonardo has left deliberately indistinct, by letting them merge into a soft shadow. That is why we are never quite certain in what mood Mona Lisa is really looking at us. Her expression always seems just to elude us. It is not only vagueness, of course, which produces this effect. There is much more behind it. Leonardo has done a very daring thing, which perhaps only a painter of his consummate mastery could risk. If we look carefully at the picture, we see that the two sides do not quite match. This is most obvious in the fantastic dream landscape in the background. The horizon on the left side seems to lie much lower than the one on the right. Consequently, when we focus on the left side of the picture, the woman looks somehow taller or more erect than if we focus on the right side. And her face, too, seems to change with this change of position, because, even here, the two sides do not quite match. But with all these sophisticated tricks, Leonardo might have produced a clever piece of jugglery rather than a great work of art, had he not known exactly how far he could go, and had he not counterbalanced his daring deviation from nature by an almost miraculous rendering of the living flesh. Look at the way in which he modelled the hand, or the sleeves with their minute folds. Leonardo could be as painstaking as any of his forerunners in the patient observation of nature. Lauxep Only he was no longer merely the faithful servant of nature. Long ago, in the distant past, people had looked at portraits with awe, because they had thought that in preserving the likeness the artist could somehow preserve the soul of the person he portrayed. Now the great scientist, Leonardo, had made some of the dreams and fears of these first image-makers come true. He knew the spell which would infuse life into the colours spread by his magic brush. I willow soy me, site quiye no

The second great Florentine whose work makes Italian art of the *Cinquecento* so famous was Michelangelo Buonarroti (1475–1564). Michelangelo was twenty-three years younger than Leonardo and survived him by forty-five years. In his long lifetime he witnessed a complete change in the position of the artist. To some degree it was he himself who brought about this change. In his youth Michelangelo was trained like any other craftsman. As a boy of thirteen he was apprenticed for three years to

intentional intentional

consummedo

consummedo

foração purpor não.

So plus i catal:

So plus i catal:

Howard has held

Tondering home

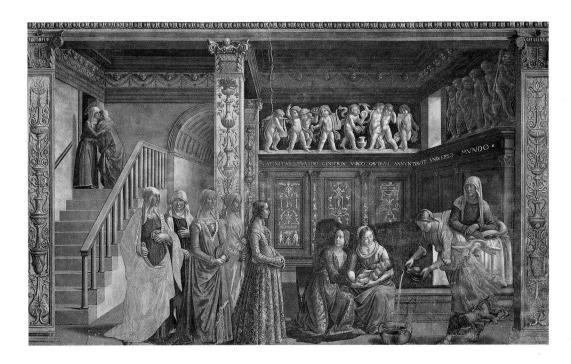

the busy workshop of one of the leading masters of late *Quattrocento* Florence, the painter Domenico Ghirlandaio (1449–94). Ghirlandaio was one of those masters whose works we enjoy rather for the way in which they mirror the colourful life of the period than for the greatness of their genius. He knew how to tell the sacred story pleasantly, as if it had just happened among the rich Florentine citizens of the Medici circle who were his patrons. *Figure 195* represents the birth of the Virgin Mary, and we see the relatives of her mother, St Anne, coming to visit and congratulate her. We look into a fashionable apartment of the late fifteenth century, and witness the formal visit of well-to-do ladies of society. Ghirlandaio proved that he knew how to arrange his groups effectively and how to give pleasure to the eye. He showed that he shared the taste of his contemporaries for the themes of ancient art, for he took care to depict a relief of dancing children, in the classical manner, in the background of the room.

In his workshop the young Michelangelo could certainly learn all the technical tricks of the trade, a solid technique in painting frescoes, and a thorough grounding in draughtsmanship. But, as far as we know, Michelangelo did not enjoy his days in this successful painter's firm. His ideas about art were different. Instead of acquiring the facile manner of Ghirlandaio, he went out to study the work of the great masters of the past, of Giotto, Masaccio, Donatello, and of the Greek and Roman

Domenico
Ghirlandaio
Birth of the Virgin,
1491

Fresco; church of Sta Maria Novella, Florence sculptors whose works he could see in the Medici collection. He tried to penetrate into the secrets of the ancient sculptors, who knew how to represent the beautiful human body in motion, with all its muscles and sinews. Like Leonardo, he was not content with learning the laws of anatomy secondhand, as it were, from antique sculpture. He made his own research into human anatomy, dissected bodies, and drew from models, till the human figure did not seem to hold any secrets for him. But, unlike Leonardo, for whom man was only one of the many fascinating riddles of nature, Michelangelo strove with an incredible singleness of purpose to master this one problem, but to master it fully. His power of concentration and his retentive memory must have been so outstanding that soon there was no posture and no movement which he found difficult to draw. In fact, difficulties only seemed to attract him. Attitudes and angles which many a great Quattrocento artist might have hesitated to introduce into his pictures, for fear of failing to represent them convincingly, only stimulated his artistic ambition, and soon it was rumoured that this young artist not only equalled the renowned masters of classical antiquity but actually surpassed them. The time was to come when young artists spent several years at art schools studying anatomy, the nude, perspective, and all the tricks of draughtsmanship. And today many an unambitious commercial artist may have acquired facility in drawing human figures from all angles. Thus it may not be easy for us to grasp the tremendous admiration which Michelangelo's sheer skill and knowledge aroused in his day. By the time he was thirty, he was generally acknowledged to be one of the outstanding masters of the age, equal in his way to the genius of Leonardo. The city of Florence honoured him by commissioning him and Leonardo each to paint an episode from Florentine history on a wall of their council chamber. It was a dramatic moment in the history of art when these two giants competed for the palm, and all Florence watched with excitement the progress of their preparations. Unfortunately, the works were never completed. In 1506 Leonardo returned to Milan and Michelangelo received a call which kindled his enthusiasm even more. Pope Julius II wanted his presence in Rome to erect a tomb for him that should be worthy of the overlord of Christendom. We have heard of the ambitious plans of this great-minded but ruthless ruler of the Church, and it is not difficult to imagine how fascinated Michelangelo must have been to work for a man who possessed the means and the will to carry out the boldest plans. With the Pope's permission, he immediately travelled to the famous marble quarries at Carrara, there to select the blocks from which to carve a gigantic mausoleum. The young artist was overwhelmed by the sight of all these marble rocks, which seemed to be waiting for his chisel to turn

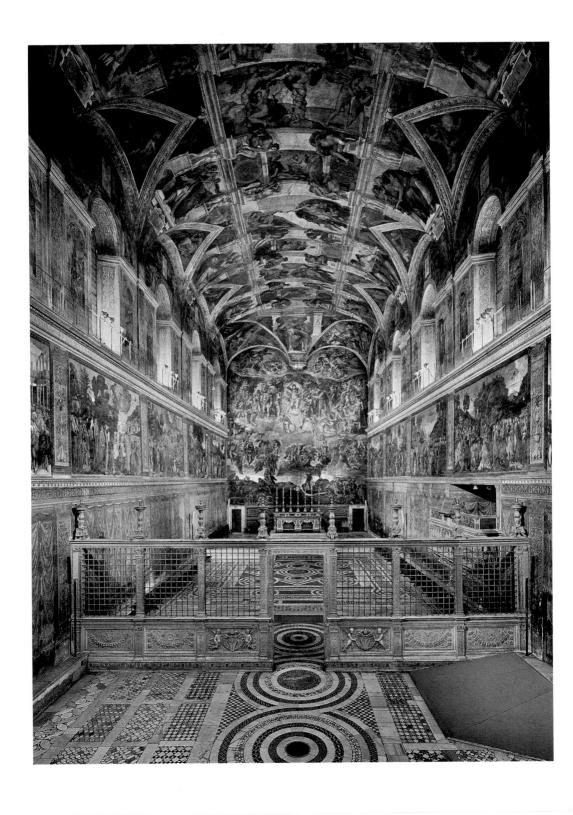

six months at the quarries, buying, selecting and rejecting, his mind seething with images. He wanted to release the figures from the stones in which they were slumbering. But when he returned and started to work he soon discovered that the Pope's enthusiasm for the great enterprise had markedly cooled. We know, today, that one of the main reasons for the Pope's embarrassment was that his plan for a tomb had come into conflict with that plan of his which was even dearer to his heart: the plan for a new St Peter's. For the tomb had originally been destined to stand in the old building, and if that was to be pulled down, where was the mausoleum to be housed? Michelangelo, in his boundless disappointment, suspected different reasons. He smelt intrigue, and even feared that his rivals, above all Bramante, the architect of the new St Peter's, wanted to poison him. In a fit of fear and fury he left Rome for Florence, and wrote a rude letter to the Pope saying that if he wanted him, he could come and look for him. What was so remarkable in this incident was that the Pope did not lose

his temper, but started formal negotiations with the head of the city of

them into statues such as the world had never seen. He stayed more than

Florence to persuade the young sculptor to return. All concerned seemed to agree that the movements and plans of this young artist were as important as any delicate matter of State. The Florentines even feared that the Pope might turn against them if they continued to give him shelter. The head of the city of Florence therefore persuaded Michelangelo to return to the service of Julius II, and gave him a letter of recommendation in which he said that his art was unequalled throughout Italy, perhaps even throughout the world, and that if only he met with kindness 'he would achieve things which would amaze the whole world'. For once a diplomatic note had uttered the truth. When Michelangelo returned to Rome, the Pope made him accept another commission. There was a chapel in the Vatican which had been built by Pope Sixtus IV, and was therefore called the Sistine Chapel, figure 196. The walls of this chapel had been decorated by the most famous painters of the former generation, by Botticelli, Ghirlandaio and others. But the vault was still blank. The Pope suggested that Michelangelo should paint it. Michelangelo did all he could to evade this commission. He said that he was not really a painter, but a sculptor. He was convinced that this thankless commission had been palmed off on him through the intrigues of his enemies. When the Pope remained firm, he started to work out a modest scheme of twelve apostles

in niches, and to engage assistants from Florence to help him with the painting. But suddenly he shut himself up in the chapel, let no one come near him, and started to work alone on a plan which has indeed continued

to 'amaze the whole world' from the moment it was revealed.

Sistine Chapel, Vatican General view of the interior, before cleaning It is very difficult for any ordinary mortal to imagine how it could be possible for one human being to achieve what Michelangelo achieved in four years of lonely work on the scaffolding of the papal chapel, figure 198. The mere physical exertion of painting this huge fresco on the ceiling of the chapel, of preparing and sketching the scenes in detail and transferring them to the wall, is fantastic enough. Michelangelo had to lie on his back and paint looking upwards. In fact, he became so used to this cramped position that even when he received a letter during this period he had to hold it over his head and bend backwards to read it. But the physical performance of one man covering this vast space unaided is as nothing compared to the intellectual and artistic achievement. The wealth of ever-new inventions, the unfailing mastery of execution in every detail, and, above all, the grandeur of the visions which Michelangelo revealed to those who came after him, have given mankind a quite new idea of the power of genius.

One often sees illustrations of details of this gigantic work, and one can never look at them enough. But the impression given by the whole, when one steps into the chapel, is still very different from the sum of all the photographs one may ever see. The chapel resembles a very large and high assembly hall, with a shallow vault. High up on the walls, we see a row of paintings of the stories of Moses and of Christ in the traditional manner of Michelangelo's forerunners. But, as we look upwards, we seem to look into a different world. It is a world of more than human dimensions. In the vaultings that rise between the five windows on either side of the chapel, Michelangelo placed gigantic images of the Old Testament prophets who spoke to the Jews of the coming Messiah, alternating with images of Sibyls, who, according to an old tradition, predicted the coming of Christ to the pagans. He painted them as mighty men and women, sitting deep in thought, reading, writing, arguing, or as though they were listening to an inner voice. Between these rows of over life-size figures, on the ceiling proper, he painted the story of the Creation and of Noah. But, as though this immense task had not satisfied his urge for creating ever-new images, he filled the framework between these pictures with an overwhelming host of figures, some of them like statues, others like living youths of supernatural beauty, holding festoons and medallions with yet more stories. And even this is only the centrepiece. Beyond that, in the vaultings and directly below them, he painted an endless succession of men and women in infinite variation – the ancestors of Christ as they are enumerated in the Bible.

When we see all this wealth of figures in a photographic reproduction, we may suspect that the whole <u>ceiling may look crow</u>ded and unbalanced. It is one of the great surprises, when one comes into the Sistine Chapel,

Michelangelo
Detail of the Sistine
Chapel ceiling

198 FOLD-OUT
Michelangelo
Sistine Chapel ceiling,
1508–12
Fresco, 13.7 × 39 m, 45 ×
138 ft; Vatican

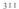

gestures, the plants, the heavenly bodies, animal life, and man. It is hardly an exaggeration to say that the picture of God the Father - as it has lived in the minds of generation after generation, not only of artists but of humble people, who perhaps have never heard the name of Michelangelo – was shaped and moulded through the direct and indirect influence of these great visions in which Michelangelo illustrated the act of creation. Perhaps the most famous and most striking of them is the creation of Adam on one of the large fields, figure 200. Artists before Michelangelo had already painted Adam lying on the ground and being called to life by a mere touch of the hand of God, but none of them had even come near to expressing the greatness of the mystery of creation with such simplicity and force. There is nothing in the picture to divert attention from the main subject. Adam is lying on the ground in all the vigour and beauty that befit the first man; from the other side God the Father is approaching, carried and supported by His angels, wrapped in a wide and majestic mantle blown out by the wind like a sail, and suggesting the ease and speed with which He floats through the void. As He stretches out His hand, not even touching Adam's finger, we almost see the first man waking, as from a profound sleep, and gazing into the fatherly face of his Maker. It is one of the greatest miracles in art how Michelangelo has contrived thus to make the touch of the Divine hand the centre and focus of the picture, and how he has made us see the idea of omnipotence by the ease and power of this gesture of creation.

Michelangelo had hardly finished his great work on the Sistine ceiling, in 1512, when he eagerly returned to his marble blocks to go on with the tomb of Julius II. He had intended to adorn it with a number of statues of prisoners, such as he had seen on Roman monuments – although it is

Michelangelo
The creation of Adam
Detail of figure 198

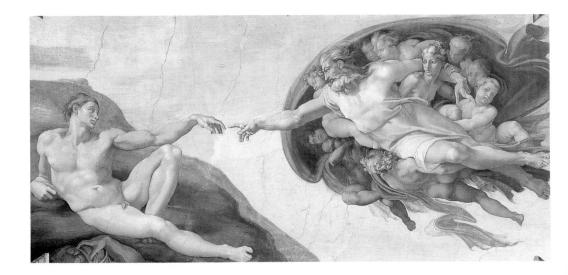

Michelangelo

The dying slave, c. 1513

Marble, height 229 cm,
90% in; Louvre, Paris

likely he planned to give to these figures a symbolic meaning. One of these is the 'Dying slave', figure 201.

If anyone had thought that after the tremendous exertion in the chapel Michelangelo's imagination had run dry, he was soon proved wrong. For when he returned to his beloved material, his powers seemed greater than ever. While in the 'Adam' Michelangelo had depicted the moment when life entered the beautiful body of a vigorous youth, he now, in the 'Dying slave', chose the moment when life was just fading, and the body was giving way to the laws of dead matter. There is unspeakable beauty in this last moment of final relaxation and release from the struggle of life – this gesture of lassitude and resignation. It is difficult to think of this work as being a statue of cold and lifeless stone, as we stand before it in the Louvre. It seems to move before our eyes, and yet to remain at rest. This is probably the effect Michelangelo aimed at. It is one of the secrets of his art that has been admired ever since, that, however much he lets the bodies of his figures twist and turn in violent movement, their outline always remains firm, simple and restful. The reason for this is that, from the very beginning, Michelangelo always tried to conceive his figures as lying hidden in the block of marble on which he was working; the task he set himself as a sculptor was merely to remove the stone which covered them. Thus the simple shape of a block was always reflected in the outline of the statues, and held it together in one lucid design, however much movement there was in the figure.

If Michelangelo had been famous when Julius II called him to Rome, his fame after the completion of these works was something no artist had ever enjoyed before. But this tremendous fame began to be something like a curse to him: for he was never allowed

to complete the dream of his youth – the tomb of Julius II. When Julius died, another pope required the services of the most famous artist of his time, and each successive pope seemed more eager than his predecessor to have his name linked with that of Michelangelo. Yet, while princes and popes were outbidding each other to secure the services of the ageing master, he seemed to retire more and more into himself and to become more exacting in his standards. The poems he wrote show that he was troubled by doubts as to whether his art had been sinful, while his

letters make it clear that the higher he rose in the esteem of the world, the more bitter and difficult he became. He was not only admired, but feared for his temper, and he spared neither high nor low. There is no doubt he was very conscious of his social position, which was so different from anything he remembered from the days of his youth. Indeed, when he was seventy-seven, he once rebuffed a compatriot for having addressed a letter to 'the Sculptor Michelangelo'. 'Tell him', he wrote, 'not to address

202

Perugino
The Virgin appearing to
St Bernard, c. 1490–4
Altar-painting; oil on
wood, 173 × 170 cm, 68%
× 67 in; Alte Pinakothek,
Munich

his letters to the sculptor Michelangelo, for here I am known only as Michelangelo Buonarroti ... I have never been a painter or sculptor, in the sense of having kept a shop ... although I have served the popes; but this I did under compulsion.'

How sincere he was in this feeling of proud independence is best shown by the fact that he refused payment for his last great work, which occupied him in his old age: the completion of the work of his one-time enemy Bramante – the crowning cupola of St Peter's. This work on the principal church of Christendom the aged master regarded as a service to the greater glory of God, which should not be sullied by worldly profit. As it rises over the city of Rome, supported, it seems, by a ring of twin columns and soaring up with its clean majestic outline, it serves as a fitting monument to the spirit of this singular artist whom his contemporaries called 'divine'.

At the time when Michelangelo and Leonardo were competing with each other in Florence in 1504, a young painter arrived there from the small city of Urbino, in the province of Umbria. He was Raffaello Santi, whom we know as Raphael (1483-1520), who had shown great promise in the workshop of the leader of the 'Umbrian' school, Perugino (1446–1523). Like Michelangelo's master, Ghirlandaio, and Leonardo's master, Verrocchio, Raphael's teacher, Perugino, belonged to the generation of highly successful artists who needed a large staff of skilled apprentices to help them carry out the many commissions they received. Perugino was one of those masters whose sweet and devout manner in painting altar-pieces commanded general respect. The problems with which earlier Quattrocento artists had wrestled with such zeal no longer presented much difficulty to him. Some of his most successful works, at any rate, show that he knew how to achieve a sense of depth without upsetting the balance of the design, and he had learned to handle Leonardo's 'sfumato' so as to avoid giving his figures a harsh and rigid appearance. Figure 202 is an altar-painting dedicated to St Bernard. The saint looks up from his book to see the Holy Virgin standing in front of him. The arrangement could hardly be simpler – and yet there is nothing stiff or forced in this almost symmetrical lay-out. The figures are distributed to form a harmonious composition, and each of them moves with calm and ease. It is quite true that Perugino achieved this beautiful harmony at the expense of something else. He sacrificed the faithful portrayal of nature which the great masters of the Quattrocento had striven for with such passionate devotion. If we look at Perugino's angels, we see that they all follow, more or less, the same type. It is a type of beauty which Perugino invented and applied in his pictures in ever-new variations. When we see too much of his work, we may

tire of his devices, but then his paintings were not meant to be seen, side by side, in picture galleries. Taken singly, some of his best works give us a glimpse into a world more serene and more harmonious than our own.

It was in this atmosphere that the young Raphael grew up, and he had soon mastered and absorbed the manner of his teacher. When he arrived in Florence he was confronted with a stirring challenge. Leonardo and Michelangelo, the one his senior by thirty-one years, the other by eight years, were setting up new standards in art of which nobody had ever dreamed. Other young artists might have become discouraged by the reputations of these giants. Not so Raphael. He was determined to learn. He must have known that he was at a disadvantage in some respects. He had neither the immense range of knowledge of Leonardo, nor the power of Michelangelo. But while these two geniuses were difficult to get on with, unpredictable and elusive to ordinary mortals, Raphael was of a sweetness of temper which would commend him to influential patrons. Moreover he could work, and work he would until he had caught up with the older masters.

Raphael's greatest paintings seem so effortless that one does not usually connect them with the idea of hard and relentless work. To many he is simply the painter of sweet Madonnas which have become so well known as hardly to be appreciated as paintings any more. For Raphael's vision of the Holy Virgin has been adopted by subsequent generations in the same way as Michelangelo's conception of God the Father. We see cheap reproductions of these works in humble dwellings, and we are apt to conclude that paintings with such a general appeal must surely be a little 'obvious'. In fact, their apparent simplicity is the fruit of deep thought, careful planning and immense artistic wisdom, pages 34-5, figures 17-18. A painting like Raphael's 'Madonna del Granduca', figure 203, is truly 'classical' in the sense that it has served countless generations as a standard of perfection in the same way as the works of Pheidias and Praxiteles. It needs no explanation. In this respect it is indeed 'obvious'. But, if we compare it with the countless representations of the same theme which preceded it, we feel that they have all been groping for the very simplicity that Raphael has attained. We can see what Raphael did owe to the calm beauty of Perugino's types, but what a difference there is between the rather empty regularity of the master and the fullness of life in the pupil! The way the Virgin's face is modelled and recedes into the shade, the way Raphael makes us feel the volume of the body wrapped in the freely flowing mantle, the firm and tender way in which she holds and supports the Christ Child – all this contributes to the effect of perfect poise. We feel that to change

203
Raphael
Madonna del
Granduca, c.1505
Oil on wood, 84 × 55 cm,
33 × 21½ in; Palazzo Pitti,
Florence

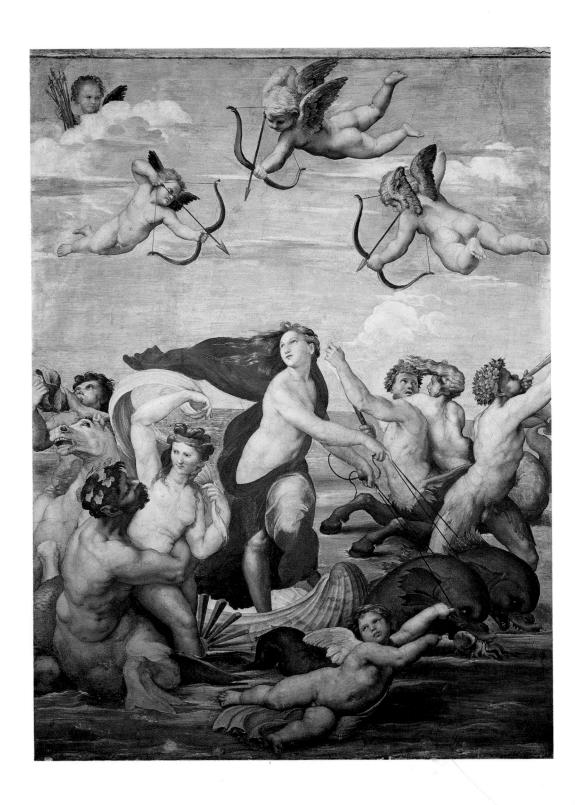

so slightly would upset the whole harmony. Yet there ed or sophisticated in the composition. It looks as if otherwise, and as if it had so existed from the beginning

ears in Florence, Raphael went to Rome. He arrived n 1508, at the time when Michelangelo was just starting ine ceiling. Julius II soon found work for this young t also. He asked him to decorate the walls of various ican which have come to be known by the name of is). Raphael proved his mastery of perfect design and sition in a series of frescoes on the walls and ceilings of appreciate the full beauty of these works, one must in the rooms and feel the harmony and diversity of e in which movement answers to movement, and moved from their setting and reduced in size they 1, for the individual figures, which stand before us face the frescoes, are too readily absorbed by the ly, when taken out of their context as illustrations of res lose one of their principal functions – that of e graceful melody of the whole design. s to a smaller fresco, figure 204, which Raphael painted alled the Farnesina) of a rich banker, Agostino Chigi. e a verse from a poem by the Florentine Angelo ad also helped to inspire Botticelli's 'Birth of Venus'. e how the clumsy giant Polyphemus sings a love -nymph Galatea and how she rides across the waves by two dolphins, laughing at his uncouth song, bany of other sea-gods and nymphs is milling round o shows Galatea with her gay companions; the was to appear elsewhere in the hall. However long rely and cheerful picture, one will always discover ich and intricate composition. Every figure seems ne other figure, every movement to answer a . We have observed this method in Pollaiuolo's figure 171. But how rigid and dull his solution with Raphael's! To start with the small boys with rows who aim at the heart of the nymph: not only left echo each other's movements, but the boy

swimming beside the chariot corresponds to the one flying at the top of the picture. It is the same with the group of sea-gods which seems to be 'wheeling' round the nymph. There are two on the margins, who blow on their sea-shells, and two pairs in front and behind, who

are making love to each other. But what is more admirable is that all these diverse movements are somehow reflected and taken up in the figure of Galatea herself. Her chariot had been driving from left to right with her veil blowing backwards, but, hearing the strange love song, she turns round and smiles, and all the lines in the picture, from the love-gods' arrows to the reins she holds, converge on her beautiful face in the very centre of the picture. By these artistic means Raphael has achieved constant movement throughout the picture, without letting it become restless or unbalanced. It is for this supreme mastery of arranging his figures, this consummate skill in composition, that artists have admired Raphael ever since. Just as Michelangelo was found to have reached the highest peak in the mastery of the human body, Raphael was seen to have accomplished what the older generation had striven so hard to achieve: the perfect and harmonious composition of freely moving figures.

There was another quality in Raphael's work that was admired by his contemporaries and by subsequent generations – the sheer beauty of his figures. When he had finished the 'Galatea', Raphael was asked by a courtier where in all the world he had found a model of such beauty. He replied that he did not copy any specific model but rather followed 'a certain idea' he had formed in his mind. To some extent, then, Raphael, like his teacher Perugino, had abandoned the faithful portrayal of nature which had been the ambition of so many Quattrocento artists. He deliberately used an imagined type of regular beauty. If we look back to the time of Praxiteles, page 102, figure 62, we remember how what we call an 'ideal' beauty grew out of a slow approximation of schematic forms to nature. Now the process was reversed. Artists tried to modify nature according to the idea of beauty they had formed when looking at classical statues - they 'idealized' the model. It was a tendency not without its dangers, for, if the artist deliberately 'improves on' nature, his work may easily look mannered or insipid. But if we look once more at Raphael's work, we see that he, at any rate, could idealize without any loss of vitality and sincerity in the result. There is nothing schematic or calculated in Galatea's loveliness. She is an inmate of a brighter world of love and beauty - the world of the classics as it appeared to its admirers in sixteenthcentury Italy.

It was for this achievement that Raphael has remained famous throughout the centuries. Perhaps those who connect his name only with beautiful Madonnas and idealized figures from the classical world may even be surprised to see Raphael's portrait of his great

Detail of figure 204

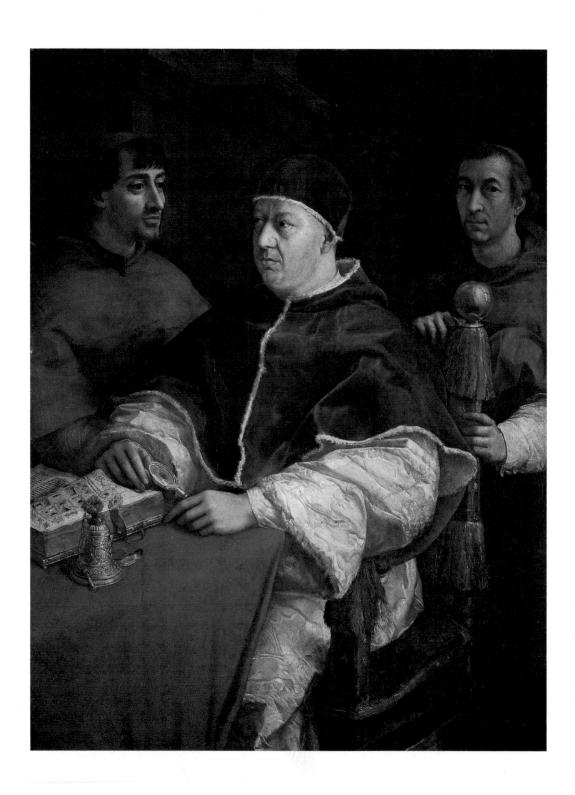

patron Pope Leo X of the Medici family, in the company of two cardinals, figure 206. There is nothing idealized in the slightly puffed head of the nearsighted Pope, who has just examined an old manuscript (somewhat similar in style and period to the Queen Mary's Psalter, page 211, figure 140). The velvets and damasks in their various rich tones add to the atmosphere of pomp and power, but one can well imagine that these men are not at ease. These were troubled times, for we remember that at the very period when this portrait was painted Luther had attacked the Pope for the way he raised money for the new St Peter's. It so happens that it was Raphael himself whom Leo X had put in charge of this building enterprise after Bramante had died in 1514, and thus he had also become an architect. designing churches, villas and palaces and studying the ruins of ancient Rome. Unlike his great rival Michelangelo, though, he got on well with people and could keep a busy workshop going. Thanks to his sociable qualities the scholars and dignitaries of the papal court made him their companion. There was even talk of his being made a cardinal when he died on his thirty-seventh birthday, almost as young as Mozart, having crammed into his brief life an astonishing diversity of artistic achievements. One of the most famous scholars of his age, Cardinal Bembo, wrote the epitaph for his tomb in the Pantheon of Rome:

Raphael
Pope Leo X with two
cardinals, 1518
Oil on wood, 154 × 119
cm, 60% × 46% in; Uffizi,
Florence

This is Raphael's tomb, while he lived he made Mother Nature Fear to be vanquished by him and, as he died, to die too.

Members of Raphael's workshop plastering, painting and decorating the Loggie, c. 1518 Stucco relief; Loggie, Vatican

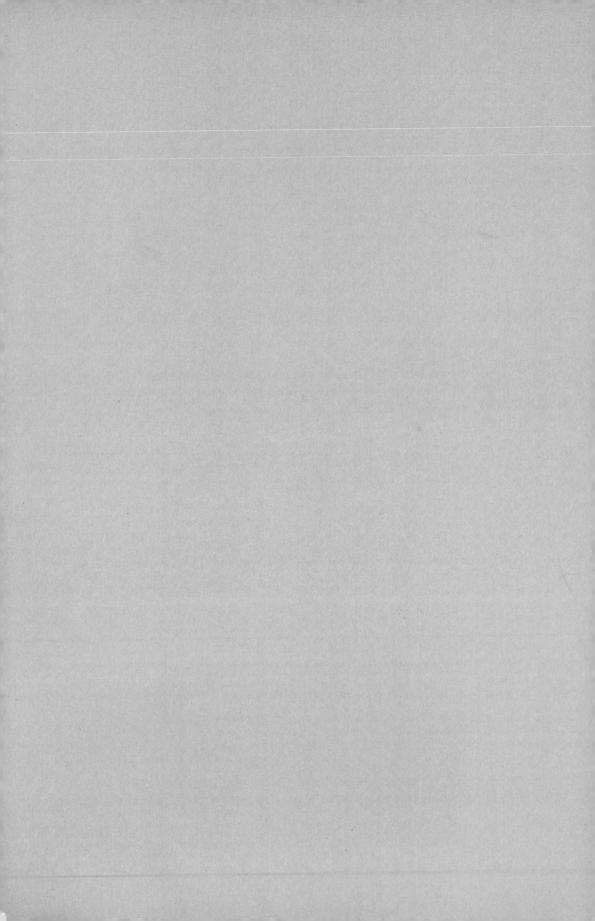

LIGHT AND COLOUR

Venice and northern Italy, early sixteenth century

We must now turn to another great centre of Italian art, second in importance only to Florence itself – the proud and prosperous city of Venice. Venice, whose trade linked it closely with the East, had been slower than other Italian cities in accepting the style of the Renaissance, Brunelleschi's application of classical form to buildings. But when it did, the style there acquired a new gaiety, splendour and warmth which evoke, perhaps more closely than any other buildings in modern times, the grandeur of the great merchant cities of the Hellenistic period, of Alexandria or Antioch. One of the most characteristic buildings of this style is the Library of San Marco, figure 207. Its architect was a Florentine, Jacopo Sansovino (1486–1570), but he had completely adapted his style and manner to the genius of the place, the brilliant light of Venice, which is reflected by the lagoons, and dazzles the eye by its splendour. It may seem a little pedantic to anatomize such a festive and simple building, but to look at it carefully may help us to see how skilled these masters were in weaving a few simple elements into ever-new patterns. The lower storey, then, with its vigorous Doric order of columns, is in the most orthodox classical manner. Sansovino has closely followed the rules of building which the Colosseum, page 118, figure 73, exemplified. He adhered to the same tradition when he arranged the upper storey in the Ionic order, carrying a so-called 'attic' crowned with a balustrade and topped by a row of statues. But instead of letting the arched openings between the orders rest on pillars, as had been the case with the Colosseum, Sansovino supported them by another set of small Ionic columns, and thus achieved a rich effect of interlocked orders. With his balustrades, garlands and sculptures he gave the building something of the appearance of tracery such as had been used on the Gothic façades of Venice, page 209, figure 138.

This building is characteristic of the taste for which Venetian art in the *Cinquecento* became famous. The atmosphere of the lagoons, which seems to blur the sharp outlines of objects and to blend their colours in a radiant light, may have taught the painters of this city to use colour in a more deliberate and observant way than other painters in Italy had done so far. Maybe, also, the links with Constantinople and its craftsmen in mosaic had

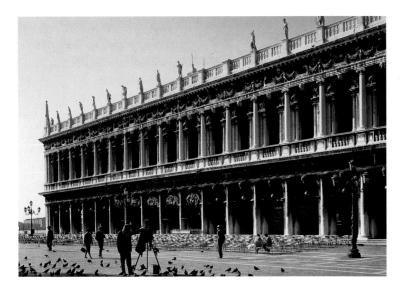

something to do with this bias. It is difficult to talk or write about colours, and no illustration, much reduced in scale, gives an adequate idea of the real appearance of a masterpiece of colour. But so much seems to be clear: the painters of the Middle Ages were no more concerned about the 'real' colours of things than they were about their real shapes. In their miniatures, enamel work and panel paintings, they loved to spread out the purest and most precious colours they could get - with shining gold and flawless ultramarine blue as a favourite combination. The great reformers of Florence were less interested in colour than in drawing. That does not mean, of course, that their pictures were not exquisite in colour – the contrary is true – but few of them regarded colour as one of the principal means of welding the various figures and forms of a picture into one unified pattern. They preferred to do this by means of perspective and composition before they even dipped their brushes into paint. The Venetian painters, it seems, did not think of colour as an additional adornment for the picture after it had been drawn on the panel. When one enters the little church of San Zaccaria in Venice and stands before the picture, figure 208, which the great Venetian painter Giovanni Bellini (1431?-1516) painted over the altar there in 1505 - in his old age - one immediately notices that his approach to colour was very different. Not that the picture is particularly bright or shining. It is rather the mellowness and richness of the colours that impress one before one even begins to look at what the picture represents. I think that even the photograph conveys something of the warm and gilded atmosphere which fills the niche in which the Virgin sits enthroned, with the infant Jesus lifting His little hands to bless the worshippers before the altar. An angel at the foot of the altar softly plays the violin, while the saints stand quietly at either side of the throne: St Peter with his key and book, St Catherine with the palm of martyrdom and the broken wheel, St Lucy and St Jerome, the

207

Jacopo Sansovino
Library of San Marco,
Venice, 1536
A building of the High
Renaissance

208

Giovanni Bellini Madonna with saints, 1505 Altar-painting; oil on wood, transferred to canvas, 402 × 273 cm,

1581/2 × 1021/2 in; church of

S. Zaccaria, Venice

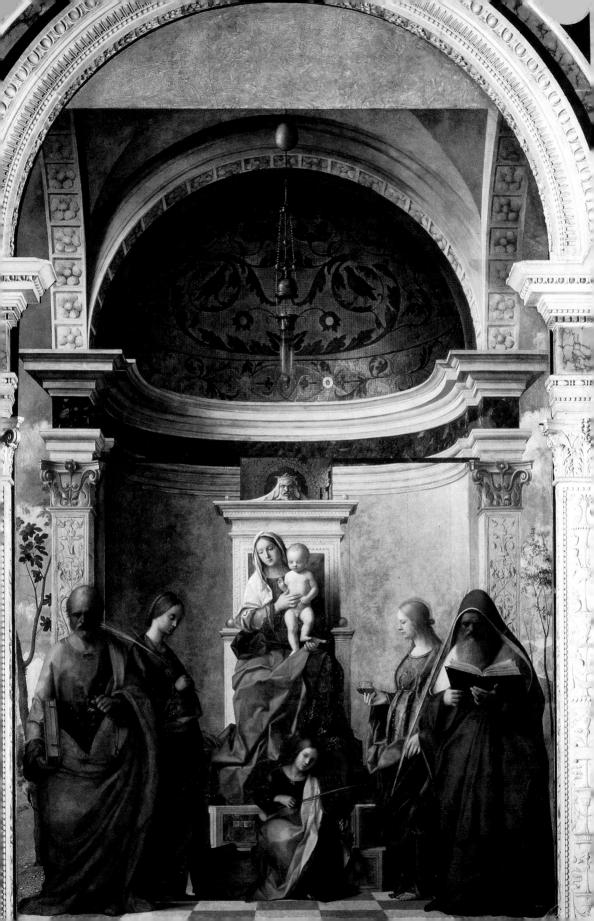

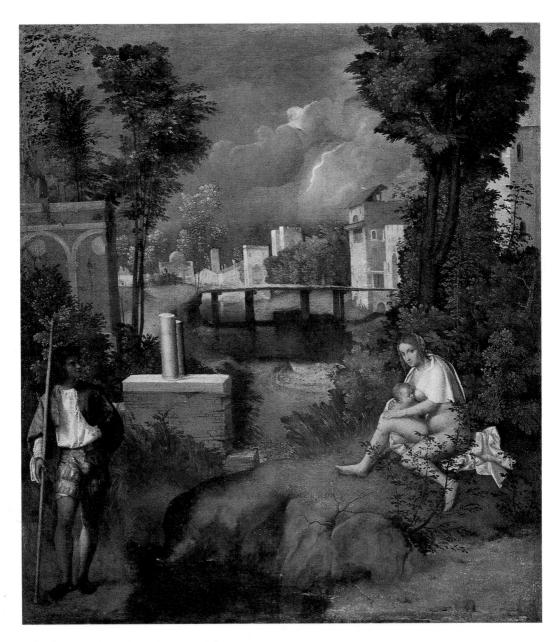

scholar who translated the Bible into Latin, and whom Bellini therefore represented as reading a book. Many Madonnas with saints have been painted before and after, in Italy and elsewhere, but few were ever conceived with such dignity and repose. In the Byzantine tradition, the picture of the Virgin used to be rigidly flanked by images of the saints, page 140, figure 89. Bellini knew how to bring life into this simple

symmetrical arrangement without upsetting its order. He also knew how to turn the traditional figures of the Virgin and saints into real and living beings without divesting them of their holy character and dignity. He did not even sacrifice the variety and individuality of real life – as Perugino had done to some extent, *page 314*, *figure 202*. St Catherine with her dreamy smile, and St Jerome, the old scholar engrossed in his book, are real enough in their own ways, although they, too, no less than Perugino's figures, seem to belong to another more serene and beautiful world, a world transfused with that warm and supernatural light that fills the picture.

Giovanni Bellini belonged to the same generation as Verrocchio,

Ghirlandaio and Perugino – the generation whose pupils and followers were the famous Cinquecento masters. He, too, was the head of an exceedingly busy workshop out of whose orbit there emerged the famous painters of the Venetian Cinquecento, Giorgione and Titian. If the classical painters of central Italy had achieved the new complete harmony within their pictures by means of perfect design and balanced arrangement, it was only natural that the painters of Venice should follow the lead of Giovanni Bellini, who had made such happy use of colour and light to unify his pictures. It was in this sphere that the painter Giorgione (1478?-1510) achieved the most revolutionary results. Very little is known of this artist; scarcely five paintings can be ascribed with absolute certainty to his hand. Yet these suffice to secure him a fame nearly as great as that of the great leaders of the new movement. Strangely enough, even these pictures contain something of a puzzle. We are not quite sure what the most accomplished one, 'The tempest', figure 200, represents; it may be a scene from some classical writer or an imitator of the classics. For Venetian artists of the period had awakened to the charm of the Greek poets and what they stood for. They liked to illustrate the idyllic stories of pastoral love and to portray the beauty of Venus and the nymphs. One day the episode here illustrated may be identified – the story, perhaps, of a mother of some future hero, who was cast out of the city into the wilderness with her child and was there discovered by a friendly young shepherd. For this, it seems, is what Giorgione wanted to represent. But it is not due to its content that the picture is one of the most wonderful things in art. That this is so may be difficult to see in a small-scale illustration, but even such an illustration conveys a shadow, at least, of his revolutionary achievement. Though the figures are not particularly carefully drawn, and though the composition is somewhat artless, the picture is clearly blended into a whole simply by the light and air that permeate it all. It is the weird light

of a thunderstorm, and for the first time, it seems, the landscape before which the actors of the picture move is not just a background. It is there,

Giorgione
The tempest, c. 1508
Oil on canvas, 82 × 73 cm,
32¹/₄ × 28¹/₄ in; Accademia,
Venice

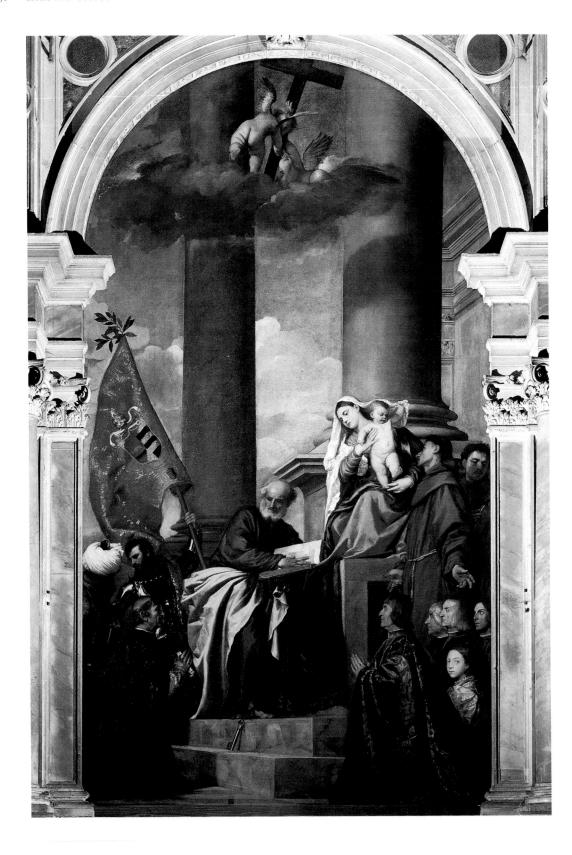

by its own right, as the real subject of the painting. We look from the figures to the scenery which fills the major part of the small panel, and then back again, and we feel somehow that, unlike his predecessors and contemporaries, Giorgione has not drawn things and persons to arrange them afterwards in space, but that he really thought of nature, the earth, the trees, the light, air and clouds and the human beings with their cities and bridges as one. In a way, this was almost as big a step forward into a new realm as the invention of perspective had been. From now on, painting was more than drawing plus colouring. It was an art with its own secret laws and devices.

Giorgione died too young to gather all the fruits of this great discovery. This was done by the most famous of all Venetian painters, Titian (c. 1485?–1576). Titian was born in Cadore, in the southern Alps, and was rumoured to be ninety-nine when he died of the plague. During his long life he rose to a fame which nearly matched that of Michelangelo. His early biographers tell us with awe that even the great Emperor Charles V had done him honour by picking up a brush he had dropped. We may not find this very remarkable, but if we consider the strict rules of the court of those times, we realize that the greatest embodiment of worldly power was believed to have humbled himself symbolically before the majesty of genius. Seen in this light, the little anecdote, whether true or not, represented to later ages a triumph for art. All the more so since Titian was neither such a universal scholar as Leonardo, nor such an outstanding personality as Michelangelo, nor such a versatile and attractive man as Raphael. He was principally a painter, but a painter whose handling of paint equalled Michelangelo's mastery of draughtsmanship. This supreme skill enabled him to disregard all the time-honoured rules of composition, and to rely on colour to restore the unity which he apparently broke up. We need but look at figure 210 (which was begun only some fifteen years after Giovanni Bellini's 'Madonna with saints') to realize the effect which his art must have had on contemporaries. It was almost unheard of to move the Holy Virgin out of the centre of the picture, and to place the two administering saints - St Francis, who is recognizable by the Stigmata (the wounds of the Cross), and St Peter, who has deposited the key (emblem of his dignity) on the steps of the Virgin's throne – not symmetrically on each side, as Giovanni Bellini had done, but as active participants of a scene. In this altar-painting, Titian had to revive the tradition of donors' portraits, pages 216-17, figure 143, but did it in an entirely novel way. The picture was intended as a token of thanksgiving for a victory over the Turks by the Venetian nobleman Jacopo Pesaro, and Titian portrayed him kneeling before the Virgin while an armoured standard-bearer drags a Turkish

Titian

Madonna with saints and members of the Pesaro family, 1519–26 Altar-painting; oil on canvas, 478 × 266 cm, 188% × 104½ in; church of Sta Maria dei Frari, Venice

Detail of figure 210

Titian
Portrait of a man,
the so-called 'Young
Englishman',
c. 1540-5
Oil on canvas, 111 × 93
cm, 43½ × 36% in; Palazzo
Pitti, Florence

prisoner behind him. St Peter and the Virgin look down on him benignly while St Francis, on the other side, draws the attention of the Christ Child to the other members of the Pesaro family, who are kneeling in the corner of the picture, figure 211. The whole scene seems to take place in an open courtyard, with two giant columns which rise into the clouds where two little angels are playfully engaged in raising the Cross. Titian's contemporaries may well have been amazed at the audacity with which he had dared to upset the old-established rules of composition. They must have expected, at first, to find such a picture lopsided and unbalanced. Actually it is the opposite. The unexpected composition only serves to make it gay and lively without upsetting the harmony of it all. The main reason is the way in which Titian contrived to let light, air and colours unify the scene. The idea of making a mere flag counterbalance the figure of the Holy Virgin would probably have shocked an earlier generation, but this flag, in its rich, warm colour, is such a stupendous piece of painting that the venture was a complete success.

Titian's greatest fame with his contemporaries rested on portraits. We need only look at a head like *figure 212*, usually called a 'Young Englishman', to understand this fascination. We might try in vain to analyse wherein it consists. Compared with earlier portraits it all looks so simple and effortless.

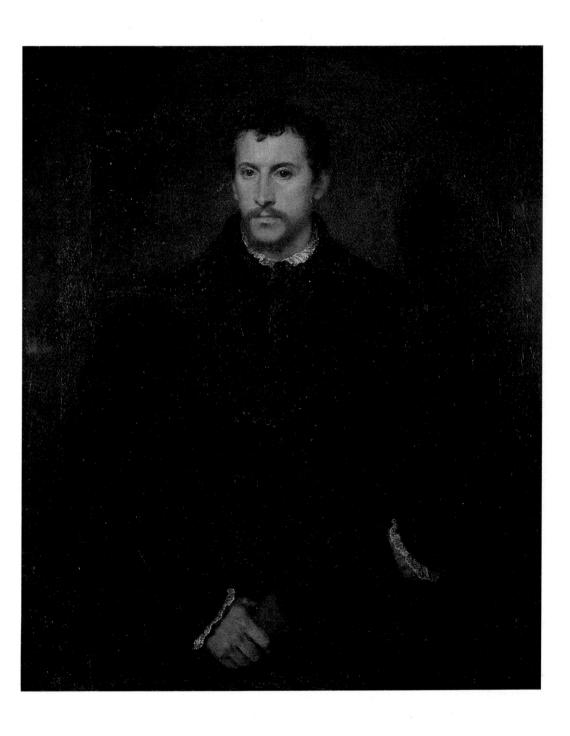

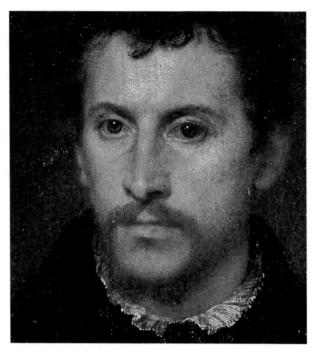

Detail of figure 212

Titian

Pope Paul III with

Alessandro and Ottavio

Farnese, 1546
Oil on canvas, 200 × 173
cm, 78½ × 68½ in;

Museo di Capodimonte,

Naples

There is nothing of the minute modelling of Leonardo's 'Mona Lisa' in it – and yet this unknown young man seems as mysteriously alive as she does. He seems to gaze at us with such an intense and soulful look that it is almost impossible to believe that these dreamy eyes are only a bit of coloured earth spread on a rough piece of canvas, *figure 213*.

No wonder that the mighty of this world competed with each other for the honour of being painted by this master. Not that Titian was inclined to produce a specially flattering likeness, but he gave them the conviction that through his art they would go on living. They did, or so we feel when we stand in front of his portrait of Pope Paul III in Naples, figure 214. It shows the aged ruler of the Church turning towards a young relative, Alessandro Farnese, who is about to pay homage while his brother, Ottavio, calmly looks at us. Clearly Titian knew and admired Raphael's portrait of Pope Leo X with his cardinals painted some twentyeight years earlier, page 322, figure 206, but he must also have aimed at surpassing it in lively characterization. The encounter of these personalities is so convincing and so dramatic that we cannot help speculating about their thoughts and emotions. Are the cardinals plotting? Does the Pope see through their schemes? These are probably idle questions, but they may also have obtruded themselves on contemporaries. The painting remained unfinished when the master left Rome to obey a summons to Germany to paint the Emperor Charles V.

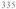

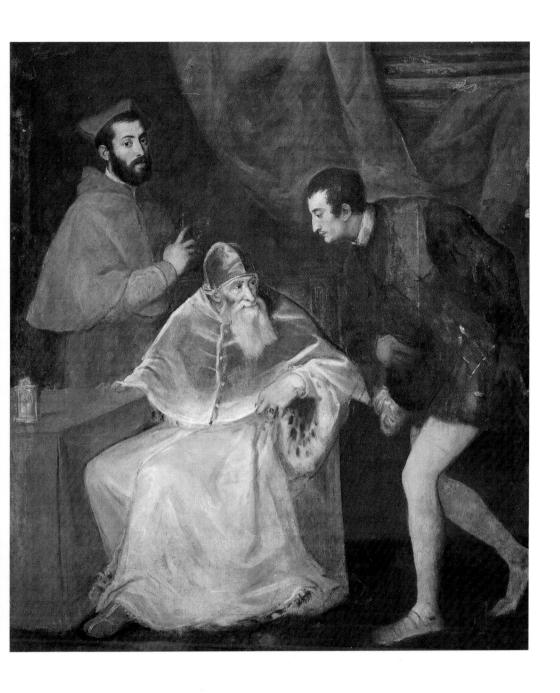

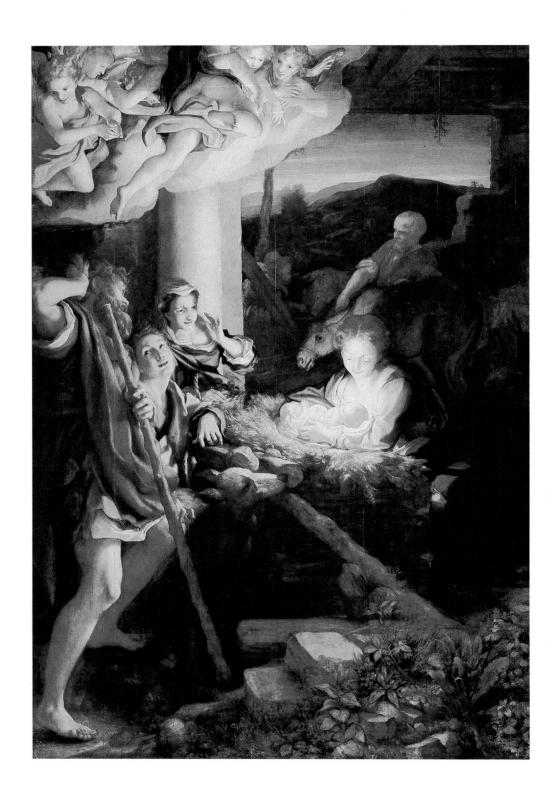

Correggio The Holy Night, c. 1530

Oil on wood, 256 × 188 cm, 1003/4 × 74 in; Gemäldegalerie Alte Meister, Dresden

216

Correggio The Assumption of the Virgin: study for the cupola of Parma Cathedral, c. 1526 Red chalk on paper, 27.8 × 23.8 cm, 12 × 7% in; British Museum, London

It was not only in the great centres like Venice that artists advanced to the discovery of new possibilities and new methods. The painter who was looked upon by later generations as the most 'progressive' and most daring innovator of the whole period led a lonely life in the small northern Italian town of Parma. He was Antonio Allegri, called Correggio (1489?-1534). Leonardo and Raphael had died and Titian had already risen to fame when Correggio painted his more important works, but we do not know how much he knew of the art of his time. He probably had an opportunity in the neighbouring cities of northern Italy to study the works of some of Leonardo's pupils and to learn about his treatment of light and shade. It was in this field that he worked out entirely new effects which greatly influenced later schools of painters.

Figure 215 shows one of his most famous paintings - 'The Holy Night'. The tall shepherd has just had the vision of the open heavens in which the angels sing their 'Glory to God on High'; we see them whirling gaily about in the cloud and looking down on the scene to which the shepherd has rushed with his long staff. In the dark ruins of the stable he sees the miracle - the new-born Child that radiates light all round, lighting up the beautiful face of the happy mother. The shepherd arrests his movement and fumbles for his cap, ready to kneel down and worship. There are two servant girls - one is dazzled by the light from the manger, one looks happily at the shepherd. St Joseph in the murky dark outside busies himself with the ass.

At first sight the arrangement looks quite artless and casual. The crowded scene on the left does not seem to be balanced by any corresponding group on the right. It is only balanced through the emphasis which the light

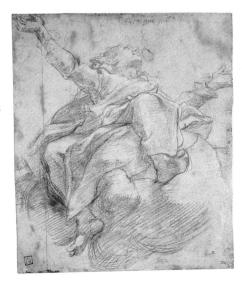

gives to the group of the Virgin and the Child. Correggio even more than Titian exploited the discovery that colour and light can be used to balance forms and to direct our eyes along certain lines. It is we who rush to the scene with the shepherd and who are made to see what he sees - the miracle of the Light that shone in darkness of which the Gospel of St John speaks.

There is one feature of Correggio's works which was imitated throughout the subsequent centuries; it is the

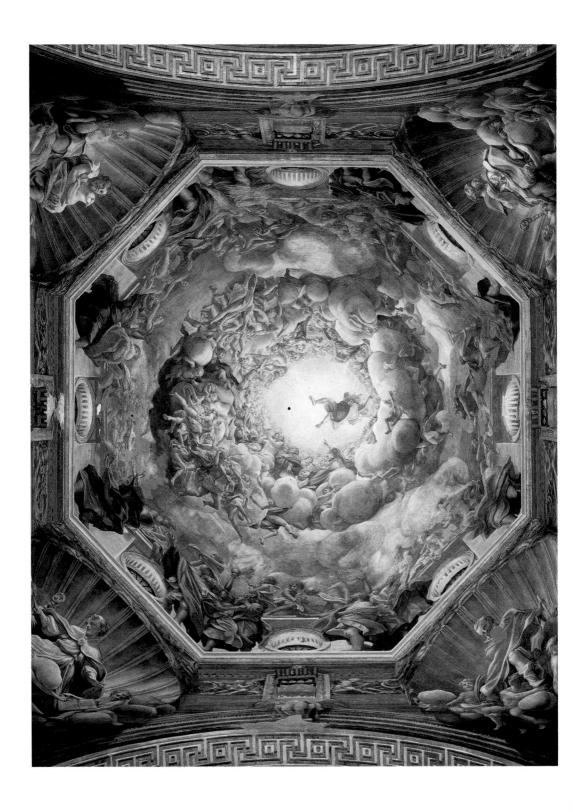

give the worshippers in the nave below the illusion that the ceiling had opened and that they were looking straight into the glory of Heaven. His mastery of light effects enabled him to fill the ceiling with sunlit clouds between which the heavenly hosts seem to hover with their legs dangling downwards. This may not sound very dignified and actually there were people at the time who objected, but when you stand in the dark and gloomy medieval cathedral of Parma and look up towards its dome the impression is nevertheless very great, figure 217. Unfortunately this type of effect cannot easily be reproduced in an illustration. It is fortunate, therefore, that we still have some of his drawings which he made in preparation. Figure 216 shows his first idea for the figure of the Virgin ascending on a cloud and gazing towards the radiance of heaven that awaits her. The drawing is certainly easier to make out than the figure in the fresco, which is even more contorted. Moreover, we are able to see with what simple means Correggio could suggest such a flood of light with a few strokes of his chalk.

way in which he painted the ceilings and cupolas of churches. He tried to

Correggio
The Assumption of
the Virgin
Fresco; cupola of Parma

Cathedral

An orchestra of Venetian painters: detail from Paolo Veronese's 'The Wedding Feast at Cana', 1562–3

Oil on canvas; from left to right, Paolo Veronese (with tenor viol), Jacopo Bassano (with treble cornett), Tintoretto (with lira da braccio or violin), and Titian (with bass viol); Louvre, Paris

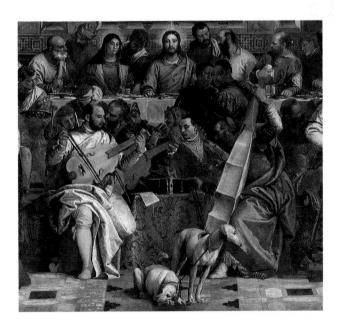

THE NEW LEARNING SPREADS

Germany and the Netherlands, early sixteenth century

The great achievements and inventions of the Italian masters of the Renaissance made a deep impression on the peoples north of the Alps. Everyone who was interested in the revival of learning had become accustomed to looking towards Italy, where the wisdom and the treasures of classical antiquity were being discovered. We know very well that in art we cannot speak of progress in the sense in which we speak of progress in learning. A Gothic work of art may be just as great as a work of the Renaissance. Nevertheless, it is perhaps natural that to the people at that time, who came into contact with the masterpieces from the south, their own art seemed suddenly to be old-fashioned and uncouth. There were three tangible achievements of the Italian masters to which they could point. One was the discovery of scientific perspective, the second the knowledge of anatomy – and with it the perfect rendering of the beautiful human body - and thirdly the knowledge of the classical forms of building, which seemed to the period to stand for everything that was dignified and beautiful.

It is a fascinating spectacle to watch the reactions of various artists and traditions to the impact of this new knowledge, and to see how they asserted themselves – or as sometimes happened, how they succumbed – according to the strength of their character and the breadth of their vision. Architects were perhaps in the most difficult position. Both the Gothic system, to which they were accustomed, and the new revival of ancient buildings are, at least in theory, utterly logical and consistent, but as different from each other in aim and spirit as two styles could possibly be. It took a long time, therefore, before the new fashion in building was adopted north of the Alps. When this did come about, it was frequently on the insistence of princes and noblemen who had visited Italy and wanted to be up to date. Even so, architects often complied only very superficially with the requirements of the new style. They demonstrated their acquaintance with the new ideas by putting a column here and a frieze there - in other words, by adding some of the classical forms to their wealth of decorative motifs. More often than not, the body of the building remained entirely untouched. There are churches in France, England and

Pierre Sohier
Choir of the church of
St-Pierre, Caen,
1518–45
Gothic transformed

Germany where the pillars supporting the vault are superficially turned into columns by having capitals affixed to them, or where the Gothic windows are complete with tracery, but the pointed arch has given way to a rounded one, *figure 218*. There are regular cloisters supported by fantastic bottle-shaped columns, castles bristling with turrets and buttresses, but adorned with classical details, gabled town houses with classical friezes and busts, *figure 219*. An Italian artist, convinced of the perfection of the classical rules, would probably have turned away from these things in horror, but if we do not measure them by any pedantic academic standard we may often admire the ingenuity and wit with which these incongruous styles were blended.

Things were rather different in the case of painters and sculptors, because for them it was not a matter of taking over certain definite forms such as columns, or arches, piecemeal. Only minor painters could be content with borrowing a figure or a gesture from an Italian engraving which had come their way. Any real artist was bound to feel the urge thoroughly to understand the new principles of art and to make up his mind about their usefulness. We can study this dramatic process in the work of the greatest German artist, Albrecht Dürer (1471–1528), who was throughout his life fully conscious of their vital importance for the future of art.

Albrecht Dürer was the son of a distinguished master-goldsmith who had come from Hungary and settled in the flourishing city of Nuremberg. Even as a boy, the young Dürer showed an astonishing gift for drawing – some of his works of that time have been preserved – and he was apprenticed with the largest workshop for altars and woodcut illustrations. This belonged to the Nuremberg master, Michel Wolgemut. Having

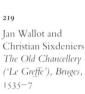

A Northern Renaissance building

completed his apprenticeship, he followed the custom of all young medieval craftsmen and travelled about as a journeyman to broaden his views and to look for a place in which to settle. Dürer's intention had been to visit the workshop of the greatest copper-engraver of this period, Martin Schongauer, pages 283-4, but when he arrived at Colmar he found that the master had died some months earlier. However, he stayed with Schongauer's brothers, who had taken charge of the workshop, and then turned to Basle in Switzerland, at that time a centre of learning and of the book trade. Here he made woodcuts for books, and then travelled on, across the Alps into northern Italy, keeping an open eye throughout his journeys and making watercolours of the picturesque places in the Alpine valleys, and studying the works of Mantegna, pages 256-9. When he returned to Nuremberg to marry and open his own workshop, he possessed all the technical accomplishments a northern artist could expect to acquire in the South. He soon showed that he had more than mere technical knowledge of his difficult craft, that he possessed that intense feeling and imagination which alone make the great artist. One of his first great works was a series of large woodcuts illustrating the Revelation of St

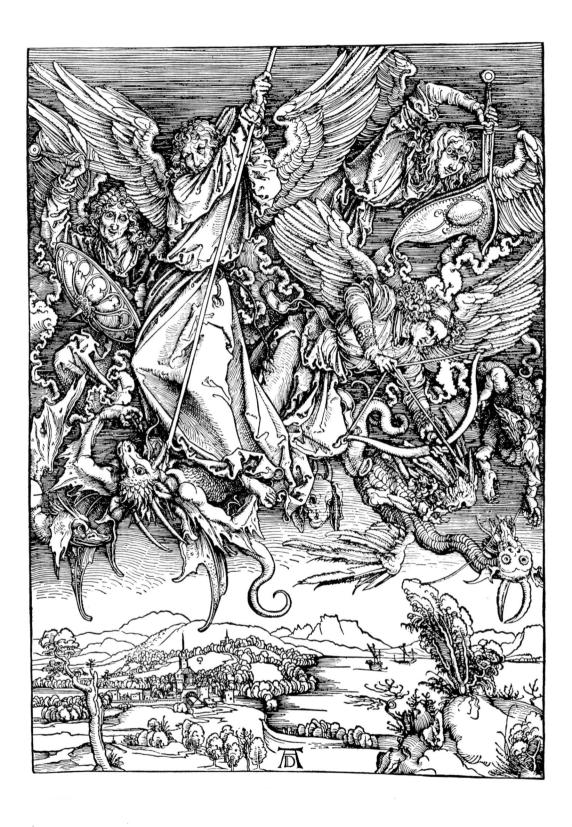

220

Albrecht Dürer St Michael's fight against the dragon, 1498

Woodcut, 39.2 \times 28.3 cm, 15 \times 11½ in

221

Albrecht Dürer Great piece of turf, 1503 Watercolour, pen and ink, pencil and wash on paper, 40.3×31.1 cm, $15\% \times$ 12% in; Albertina, Vienna John. It was an immediate success. The terrifying visions of the horrors of doomsday, and of the signs and portents preceding it, had never before been visualized with such force and power. There is little doubt that Dürer's imagination, and the interest of the public, fed on the general discontent with the institutions of the Church which was rife in Germany towards the end of the Middle Ages, and was finally to break out in Luther's Reformation. To Dürer and his public, the weird visions of the apocalyptic events had acquired something like topical interest, for there were many who expected these prophecies to come true within their lifetime. *Figure 220* shows an illustration of Revelation xii.7:

And there was war in heaven: Michael and his angels fought against the dragon; and the dragon fought and his angels, and prevailed not; neither was their place found any more in heaven.

To represent this great moment, Dürer discarded all the traditional poses that had been used time and again to represent, with a show of elegance and ease, a hero's fight against a mortal enemy. Dürer's St Michael does not strike any pose. He is in deadly earnest. He uses both hands in a mighty effort to thrust his huge spear into the dragon's throat, and this powerful gesture dominates the whole scene. Round him there are the hosts of other warring angels fighting as swordsmen and archers against

But though Dürer had proved himself a master of the fantastic and the visionary, a true heir of those Gothic artists who had created the porches of the great cathedrals, he did not rest content with this achievement. His studies and sketches show that it was also his aim to contemplate the beauty of nature, and to copy it as patiently and as faithfully as any artist had ever done, since Jan van Eyck had shown the artists of the North that their task was to mirror nature. Some of these studies of Dürer have become famous: his hare, page 24, figure 9, for instance, or his watercolour of a piece of turf, figure 221. It seems that Dürer strove for his perfect mastery in the imitation of nature,

not so much as an aim in itself but as a better way of presenting a convincing vision of the sacred stories which he was to illustrate in his paintings, engravings, and woodcuts. For the same patience which enabled him to draw these sketches also made him the born engraver, who never tired of adding detail upon detail to build up a true little world within the compass of his copper plate. In his 'Nativity', figure 222, which he made in 1504 (that is, about the time when Michelangelo amazed the Florentines by his display of knowledge of the human body), Dürer took up the theme which Schongauer, page 284, figure 185, had represented in his lovely engraving. The older artist had already used the opportunity to depict the rugged walls of dilapidated stables with special love. It would seem. at first glance, that for Dürer this was the main subject. The old farmyard with its cracked mortar and loose tiles, its broken wall from which trees are growing, its ramshackle boards in place of a roof, on which birds are nesting, is thought out and rendered with such quiet and contemplative patience that one feels how much the artist enjoyed the idea of the picturesque old building. Compared with it, the figures seem, indeed, small and almost insignificant: Mary, who has sought shelter in the old shed and is kneeling in front of her Child, and Joseph, who busies himself hauling water from the well and pouring it carefully into a narrow pitcher. One must look carefully to discover one of the adoring shepherds in the background, and one almost needs a magnifying glass to detect the traditional angel in the sky who announces the glad tidings to the world. And yet no one would seriously suggest that Dürer was merely trying to display his skill in rendering old and broken walls. This old, disused farmyard, with its humble visitors, conveys such an atmosphere of idyllic peace that it calls on us to ponder the miracle of the Holy Night in the same mood of devout meditation as went into the making of the engraving. In engravings like this, Dürer seemed to have summed up and brought to perfection the development of Gothic art, since it had turned towards the imitation of nature. But, at the same time, his mind was busy grappling with the new aims given to art by the Italian artists.

There was one aim which Gothic art had almost excluded and which now stood in the foreground of interest: the representation of the human body in that ideal beauty with which classical art had endowed it.

Here Dürer was soon to find out that any mere imitation of real nature, even when done as diligently and devotedly as Van Eyck's Adam and Eve, page 237, figure 156, would never be sufficient to produce the elusive quality of beauty that distinguished southern works of art. Raphael, when confronted with this question, referred to the 'certain idea' of beauty that he found in his mind, page 320, the idea that he had absorbed during years of studying classical sculpture and beautiful models. To Dürer, this was no

Albrecht Dürer
The Nativity, 1504
Engraving, 18.5 × 12 cm,
7½ × 4½ in

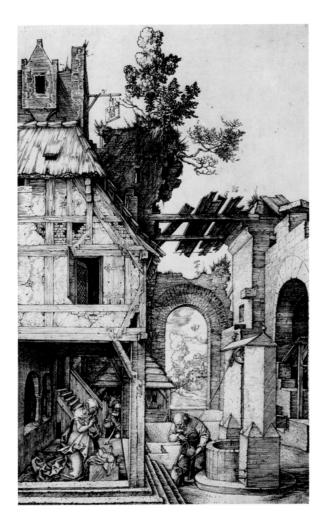

simple proposition. Not only were his opportunities for study less wide, but he had no firm tradition or sure instinct to guide him in such matters. That is why he went in search of a reliable recipe, as it were, a teachable rule which would explain what makes for beauty in the human form; and he believed that he had found such a rule in the teachings of the classical writers on the proportions of the human body. Their expressions and measurements were rather obscure, but Dürer was not to be deterred by such difficulties. He intended, as he said, to give the vague practice of his forefathers (who had created vigorous works without clear knowledge of the rules of art) a proper teachable foundation. It is thrilling to watch Dürer experimenting with various rules of proportion, to see him deliberately distorting the human frame by drawing overlong, or overbroad, bodies in order to find the right balance and the right harmony.

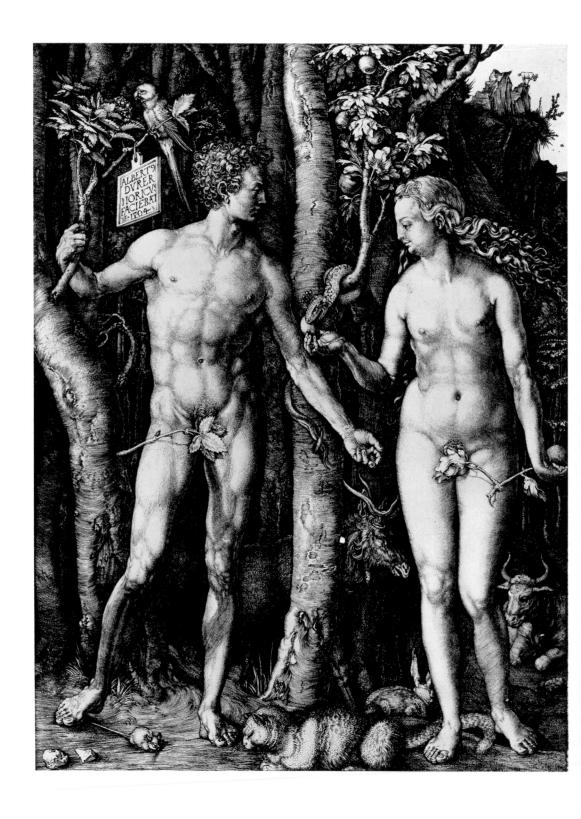

Albrecht Dürer

Adam and Eve, 1504

Engraving, 24.8 × 19.2 cm,

 $9\frac{3}{4} \times 7\frac{1}{2}$ in

Among the first results of these studies, which were to engage him throughout his life, was the engraving of Adam and Eve, in which he embodied all his new ideas of beauty and harmony, and which he proudly signed with his full name in Latin, ALBERTUS DURER NORICUS FACIEBAT 1504 ('Albrecht Dürer of Nuremberg made [this engraving] in 1504'), figure 223.

It may not be easy for us to see immediately the achievement which lay in this engraving. For the artist is speaking a language which is less familiar to him than that which he used in our preceding example. The harmonious forms at which he arrived by diligent measuring and balancing with compass and ruler are not as convincing and beautiful as their Italian and classical models. There is some slight suggestion of artificiality, not only in their form and posture, but also in the symmetrical composition. But this first feeling of awkwardness soon disappears when one realizes that Dürer has not abandoned his real self to worship new idols, as lesser artists did. As we let him guide us into the Garden of Eden, where the mouse lies quietly beside the cat, where the elk, the cow, the rabbit and the parrot do not fear the tread of human feet, as we look deep into the grove where the tree of knowledge grows, and watch the serpent giving Eve the fatal fruit while Adam stretches out his hand to receive it, and as we notice how Dürer has contrived to let the clear outline of their white and delicately modelled bodies show up against the dark shade of the forest with its rugged trees, we come to admire the first serious attempt to transplant the ideals of the South into northern soil.

Dürer himself, however, was not easily satisfied. A year after he had published this engraving, he travelled to Venice to broaden his horizon and to learn more about the secrets of southern art. The arrival of so eminent a competitor was not altogether welcome to the minor Venetian artists, and Dürer wrote to a friend:

I have many friends among the Italians who warn me not to eat and drink with their painters. Many of them are my enemies; they copy my works in the churches and wherever they can find them; and then they decry my work and say it was not in the manner of the classics and therefore it was no good. But Giovanni Bellini has praised me very highly to many noblemen. He wanted to have something I have done, and he himself came to me and asked me to make something for him — he would pay well. Everyone tells me how devout a man he is, which makes me like him. He is very old, and still the best in painting.

It is in one of these letters from Venice that Dürer wrote the touching sentence which shows how keenly he felt the contrast of his position as an artist in the rigid order of the Nuremberg guilds compared with the freedom of his Italian colleagues: 'How I shall shiver for the sun,' he

wrote, 'here I am a lord, at home a parasite.' But Dürer's later life does not quite bear out these apprehensions. True, at first he had to bargain and argue with the rich burghers of Nuremberg and Frankfurt like any artisan. He had to promise them to use only the best-quality paint for his panels and to apply it in many layers. But gradually his fame spread, and the Emperor Maximilian, who believed in the importance of art as an instrument of glorification, secured Dürer's services for a number of ambitious schemes. When, at the age of fifty, Dürer visited the Netherlands, he was, indeed, received like a lord. He himself, deeply moved, described how the painters of Antwerp honoured him in their guild hall with a solemn banquet, 'and when I was led to the table, the people stood, on both sides, as if they were introducing a great lord, and among them were many persons of excellence who all bowed their heads in the most humble manner'. Even in the northern countries the great artists had broken down the snobbery which led people to despise men who worked with their hands.

It is a strange and puzzling fact that the only German painter who can be compared with Dürer for greatness and artistic power has been forgotten to such an extent that we are not even quite sure of his name. A writer of the seventeenth century makes rather confused mention of one Matthias Grünewald of Aschaffenburg. He gives a glowing description of some paintings of this 'German Correggio', as he calls him, and thenceforward these paintings and others which must have been painted by the same great artist are usually labelled 'Grünewald'. No record or document of the period, however, mentions any painter of the name of Grünewald, and we must consider it likely that the author had mixed up his facts. Since some of the paintings ascribed to the master bear the initials M.G.N., and since a painter Mathis Gothardt Nithardt is known to have lived and worked near Aschaffenburg in Germany as an approximate contemporary of Albrecht Dürer, it is now believed that this, and not Grünewald, was the true name of the great master. But this theory does not help us much, since we do not know very much about that master Mathis. In short, while Dürer stands before us like a living human being whose habits, beliefs, tastes and mannerisms are intimately known to us, Grünewald is as great a mystery to us as Shakespeare. It is unlikely that this is entirely due to mere coincidence. The reason why we know so much about Dürer is precisely that he saw himself as a reformer and innovator of the art of his country. He reflected on what he was doing and why he did it, he kept records of his journeys and researches, and he wrote books to teach his own generation. There is no indication that the painter of the 'Grünewald' masterpieces saw himself in a similar light. On the contrary. The few paintings we have of his are altar-panels of the traditional type in major

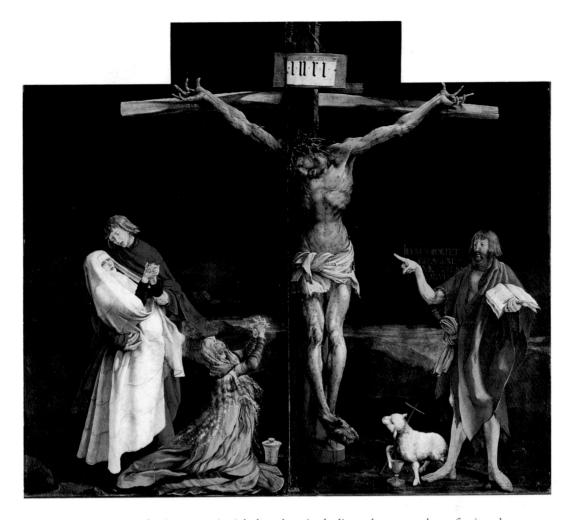

Grünewald
The Crucifixion, 1515
Panel from the Isenheim
altarpiece; oil on wood,
269 × 307 cm, 103% ×
120% in; Musée
d'Unterlinden, Colmar

and minor provincial churches, including a large number of painted 'wings' for a great altar at the Alsatian village of Isenheim (the so-called Isenheim altarpiece). His works afford no indication that he strove like Dürer to become something different from a mere craftsman or that he was hampered by the fixed traditions of religious art as it had developed in the late Gothic period. Though he was certainly familiar with some of the great discoveries of Italian art, he made use of them only as far as they suited his ideas of what art should do. On this score, he does not seem to have felt any doubts. Art for him did not consist in the search for the hidden laws of beauty – for him it could have only one aim, the aim of all religious art in the Middle Ages - that of providing a sermon in pictures, of proclaiming the sacred truths as taught by the Church. The central panel of the Isenheim altarpiece, figure 224, shows that he sacrificed all other considerations to this one overriding aim. Of beauty, as the Italian artists saw it, there is none in the stark and cruel picture of the crucified Saviour. Like a preacher at Passiontide, Grünewald left nothing undone to bring home to us the horrors of this scene of suffering: Christ's dying body

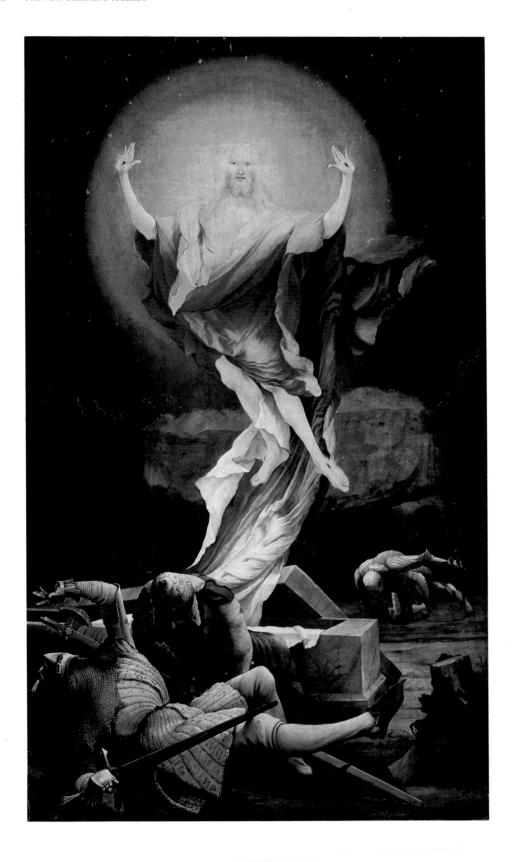

Grünewald

The Resurrection, 1515

Panel from the Isenheim altarpiece; oil on wood,

269 × 143 cm, 105% ×

56¼ in; Musée d'Unterlinden, Colmar

225

is distorted by the torture of the Cross; the thorns of the scourges stick in the festering wounds which cover the whole figure. The dark red blood forms a glaring contrast to the sickly green of the flesh. By His features and the impressive gesture of His hands, the Man of Sorrows speaks to us of the meaning of His Calvary. His suffering is reflected in the traditional group of Mary, in the garb of a widow, fainting in the arms of St John the Evangelist, to whose care the Lord has commended her, and in the smaller figure of St Mary Magdalene with her vessel of ointments, wringing her hands in sorrow. On the other side of the Cross, there stands the powerful figure of St John the Baptist with the ancient symbol of the lamb carrying the cross and pouring out its blood into the chalice of the Holy Communion. With a stern and commanding gesture he points towards the Saviour, and over him are written the words that he speaks (according to the gospel of St John iii. 30): 'He must increase, but I must decrease.'

There is little doubt that the artist wanted the beholder of the altar to meditate on these words, which he emphasized so strongly by the pointing hand of St John the Baptist. Perhaps he even wanted us to *see* how Christ must grow and we diminish. For in this picture, in which reality seems to be depicted in all its unmitigated horror, there is one unreal and fantastic trait: the figures differ greatly in size. We need only compare the hands of St Mary Magdalene under the Cross with those of Christ to become fully aware of the astonishing difference in their dimensions. It is clear that in these matters Grünewald rejected the rules of modern art as it had developed since the Renaissance, and that he deliberately returned to the principles of medieval and primitive painters, who varied the size of their figures according to their importance in the picture. Just as he had sacrificed the pleasing kind of beauty for the sake of the spiritual message of the altar, he also disregarded the new demand for correct proportions, since this helped him to express the mystic truth of the words of St John.

Grünewald's work may thus remind us once more that an artist can be very great indeed without being 'progressive', because the greatness of art does not lie in new discoveries. That Grünewald was familiar with these discoveries he showed plainly enough whenever they helped him to express what he wanted to convey. And just as he used his brush to depict the dead and tormented body of Christ, he used it on another panel to convey its transfiguration at the Resurrection into an unearthly apparition of heavenly light, *figure 225*. It is difficult to describe this picture because, once more, so much depends on its colours. It seems as if Christ has just soared out of the grave, leaving a trail of radiant light – the shroud in which the body has been swathed reflecting the coloured rays of the halo. There is a poignant contrast between the risen Christ, who is hovering over the scene, and the helpless gestures of the soldiers on the ground,

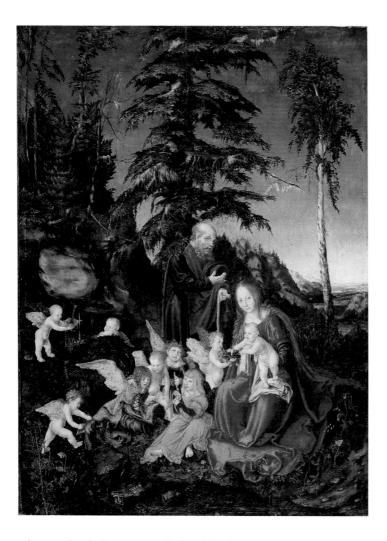

Lucas Cranach
The rest on the Flight
into Egypt, 1504
Oil on wood, 70.7 × 53
cm, 28 × 20% in;
Gemäldegalerie, Staatliche
Museen, Berlin

who are dazzled and overwhelmed by this sudden apparition of light. We feel the violence of the shock in the way in which they writhe in their armour. As we cannot assess the distance between foreground and background, the two soldiers behind the grave look like puppets who have tumbled over, and their distorted shapes only serve to throw into relief the serene and majestic calm of the transfigured body of Christ.

A third famous German of Dürer's generation, Lucas Cranach (1472–1553), began as a most promising painter. In his youth he spent several years in southern Germany and Austria. At the time when Giorgione, who came from the southern foothills of the Alps, discovered the beauty of mountain scenery, page 328, figure 209, this young painter was fascinated by the northern foothills with their old forests and romantic vistas. In a painting dated 1504 – the year when Dürer published his prints, figures 222, 223 – Cranach represented the Holy Family on the Flight into Egypt, figure 226. They are resting near a spring in a wooded mountain region. It is a charming place in the wilderness with shaggy trees and a wide view down

Albrecht Altdorfer Landscape, c.1526–8 Oil on parchment, mounted on wood, 30 × 22 cm, 12 × 8% in; Alte Pinakothek, Munich

a lovely green valley. Crowds of little angels have gathered round the Virgin; one is offering berries to the Christ Child, another is fetching water in a shell while others have settled down to refresh the spirit of the tired refugees with a concert of pipes and flutes. This poetic invention has preserved something of the spirit of Lochner's lyrical art, *page 272*, *figure 176*.

In his later years Cranach became a rather slick and fashionable court painter in Saxony, who owed his fame mainly to his friendship with Martin Luther. But it seems that his brief stay in the Danube region had been sufficient to open the eyes of the people who lived in the Alpine districts to the beauty of their surroundings. The painter Albrecht Altdorfer, of Regensburg (1480?–1538), went out into the woods and mountains to study the shape of weather-beaten pines and rocks. Many of his watercolours and etchings, and at least one of his oil-paintings, figure 227, tell no story and contain no human being. This is quite a momentous change. Even the Greeks with all their love of nature had

painted landscapes only as settings for their pastoral scenes, *page 114*, *figure 72*. In the Middle Ages a painting which did not clearly illustrate a theme, sacred or profane, was almost inconceivable. Only when the painter's skill as such began to interest people was it possible for him to sell a painting which served no other purpose but that of recording his enjoyment of a beautiful piece of scenery.

The Netherlands, at this great time of the first decades of the sixteenth century, produced not as many outstanding masters as they had done during the fifteenth century, when masters like Jan van Eyck, pages 235-6, Rogier van der Weyden, page 276 and Hugo van der Goes, page 279, were famous throughout Europe. Those artists, at least, who strove to absorb the New Learning as Dürer had done in Germany were often torn between their loyalties to old methods and their love for the new. Figure 228 shows a characteristic example by the painter Jan Gossaert, called Mabuse (1478?-1532). According to the legend, St Luke the Evangelist was a painter by profession, and thus he is represented here making a portrait of the Virgin and her Child. The way in which Mabuse painted these figures is quite in accordance with the traditions of Jan van Eyck and his followers, but the setting is quite different. It seems that he wanted to show off his knowledge of the Italian achievements, his skill in scientific perspective, his familiarity with classical architecture, and his mastery of light and shade. The result is a picture which certainly has great charm but which lacks the simple harmony of both its northern and Italian models. One wonders why St Luke found no more suitable place in which to draw the Madonna than this ostentatious but presumably draughty palace courtyard.

Thus it came about that the greatest Netherlandish artist of the period is not found among the adherents of the New Style but among those who, like Grünewald in Germany, refused to be drawn into the modern movement from the South. In the Dutch town of 's Hertogenbosch there lived such a painter, who was called Hieronymus Bosch. Very little is known about him. We do not know how old he was when he died in 1516, but he must have been active for a considerable time since he became an independent master in 1488. Like Grünewald, Bosch showed that the traditions and achievements of painting which had been developed to represent reality most convincingly could be turned round, as it were, to give us an equally plausible picture of things no human eye had seen. He became famous for his terrifying representations of the powers of evil. Perhaps it is no accident that the gloomy King Philip II of Spain, later in the century, had a special predilection for this artist, who was so

Mabuse
St Luke painting the
Virgin, c. 1515
Oil on wood, 230 × 205
cm, 90½ x 80½ in;
Národní Galerie, Prague

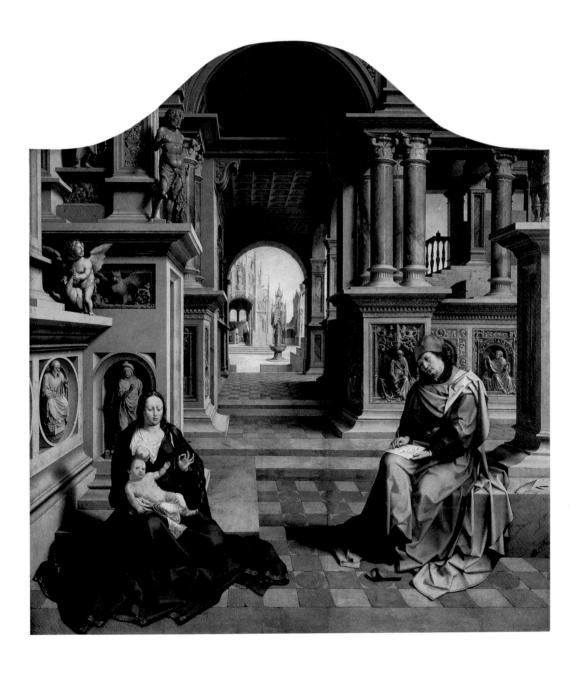

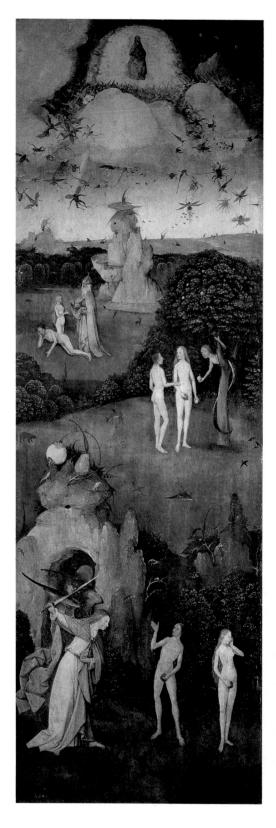

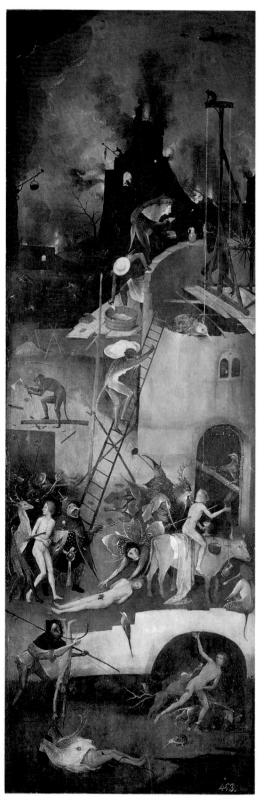

much concerned with man's wickedness. Figures 229-30 show two wings from one of Bosch's triptychs he bought and which is therefore still in Spain. On the left we watch evil invading the world. The creation of Eve is followed by the temptation of Adam and both are driven out of Paradise, while high above in the sky we see the fall of the rebellious angels, who are hurled from heaven as a swarm of repulsive insects. On the other wing we are shown a vision of hell. There we see horror piled upon horror, fires and torments and all manner of fearful demons, half animal, half human or half machine, who plague and punish the poor sinful souls for all eternity. For the first and perhaps for the only time, an artist had succeeded in giving concrete and tangible shape to the fears that had haunted the minds of man in the Middle Ages. It was an achievement which was perhaps only possible at this very moment, when the old ideas were still vigorous and yet the modern spirit had provided the artist with methods of representing what he saw. Perhaps Hieronymus Bosch could have written on one of his paintings of hell what Jan van Eyck wrote on his peaceful scene of the Arnolfinis' betrothal: 'I was there'.

229, 230
Hieronymus Bosch
Paradise and Hell,
c. 1510
Left and right panels of
a triptych; oil on wood,
each panel 135 × 45 cm,
53½ × 17½ in; Prado,

Madrid

The painter studying the laws of foreshortening, 1525 Woodcut by Albrecht Dürer; 13.6 × 18.2 cm, 5% × 7½ in; from Dürer's textbook on perspective and proportion, Underweysung der Messung

mit dem Zirckel und Richtscheyt

18

A CRISIS OF ART

Europe, later sixteenth century

Round about 1520 all lovers of art in the Italian cities seemed to agree that painting had reached the peak of perfection. Men such as Michelangelo and Raphael, Titian and Leonardo had actually done everything that former generations had tried to do. No problem of draughtsmanship seemed too difficult for them, no subject-matter too complicated. They had shown how to combine beauty and harmony with correctness, and had even surpassed – so it was said – the most renowned statues of Greek and Roman antiquity. For a boy who wanted one day to become a great painter himself, this general opinion was perhaps not altogether pleasant to listen to. However much he may have admired the works of the great living masters, he must have wondered whether it was true that nothing remained to be done because everything art could possibly do had been achieved. Some appeared to accept this idea as inevitable, and studied hard to learn what Michelangelo had learned, and to imitate his manner as best they could. Michelangelo had loved to draw nudes in complicated attitudes – well, if that was the right thing to do, they would copy his nudes, and put them into their pictures whether they fitted or not. The results were sometimes slightly ludicrous – the sacred scenes from the Bible were crowded out by what appeared to be a training team of young athletes. Later critics, who saw that these young painters had gone wrong since they merely imitated the manner of Michelangelo because it was in fashion, have called this the period of Mannerism. But not all young artists of this period were so foolish as to believe that all that was asked of art was a collection of nudes in difficult postures. Many, indeed, doubted whether art could ever come to a standstill, whether it was not possible, after all, to surpass the famous masters of the former generation, if not in their handling of human forms, then, perhaps, in some other respect. Some wanted to outdo them in the matter of invention. They wanted to paint pictures full of significance and wisdom - such wisdom, indeed, that it should remain obscure, save to the most learned scholars. Their works almost resemble picture puzzles which cannot be solved save by those who know what the scholars of the time believed to be the true meaning of Egyptian hieroglyphs, and of many

half-forgotten ancient writers. Others, again, wanted to attract attention by making their works less natural, less obvious, less simple and harmonious than the works of the great masters. These works, they seem to have argued, are indeed perfect – but perfection is not for ever interesting. Once you are familiar with it, it ceases to excite you. We will aim at the startling, the unexpected, the unheard-of. Of course, there was something slightly unsound in this obsession of the young artists with the task of outdoing the classical

Ederico Zuccaro
Window of the Palazzo
Zuccari, Rome, 1592

masters – it led even the best among them to strange, sophisticated experiments. But in a way, these frantic efforts to go one better were the greatest tribute they could pay to the older artists. Had not Leonardo himself said: 'It is a wretched pupil who does not surpass his master'? To some extent, the great 'classical' artists had themselves begun and encouraged new and unfamiliar experiments; their very fame, and the credit they enjoyed in their later years, had enabled them to try out novel, unorthodox effects in arrangement or colouring, and to explore new possibilities of art. Michelangelo in particular had occasionally shown a bold disregard for all conventions – nowhere more than in architecture, where he sometimes abandoned the sacrosanct rules of classical tradition to follow his own moods and whims. It was he himself who accustomed the public to admire an artist's 'caprices' and 'inventions', and who set the example of a genius not satisfied with the matchless perfection of his own early masterpieces, but constantly and restlessly searching for new methods and modes of expression.

It was only natural that young artists should regard this as a licence to startle the public with their own 'original' inventions. Their efforts resulted in some amusing pieces of design. The window in the form of a face, *figure 231*, designed by an architect and painter, Federico Zuccaro (1543?–1609), gives a good idea of this type of caprice.

Other architects, again, were more intent on displaying their great learning and their knowledge of classical authors in which they did, in fact, surpass the masters of Bramante's generation. The greatest and most learned of these was the architect Andrea Palladio (1508–80). *Figure 232* shows his famous Villa Rotonda, or round villa, near Vicenza. In a way,

it, too, is a 'caprice', for it has four identical sides, each with a porch in the form of a temple façade, grouped round a central hall which recalls the Roman Pantheon, *page 120*, *figure 75*. However beautiful the combination may be, it is hardly a building which one would like to live in. The search for novelty and effect has interfered with the ordinary purpose of architecture.

A typical artist of this period was the Florentine sculptor and goldsmith Benvenuto Cellini (1500–71). Cellini has described his own life in a famous book, which gives an immensely colourful and vivid picture of his age. He was boastful, ruthless and vain, but it is hard to be cross with him because he tells the story of his adventures and exploits with such gusto that you think you are reading a novel by Dumas. In his vanity and conceit and in his restlessness, which drove him from town to town and from court to court, picking quarrels and earning laurels, Cellini is a real product of his time. For him, to be an artist was no longer to be a respectable and sedate owner of a workshop: it was to be a 'virtuoso' for whose favour princes and cardinals should compete. One of the few works by his hand which have come down to us is a golden salt-cellar, made for

Andrea Palladio Villa Rotonda, near Vicenza, 1550 An Italian sixteenthcentury villa

234
Parmigianino
Madonna with the long
neck, 1534-40
Left unfinished at the

artist's death; oil on wood, 216×132 cm, 85×52 in;

Uffizi, Florence

Benvenuto Cellini Salt-cellar, 1543 Chased gold and enamel on ebony base, length 33.5 cm, 13¹/₄ in;

the King of France in 1543, figure 233. Cellini tells us the story in great detail. We hear how he snubbed two famous scholars who ventured to suggest a subject to him, how he made a model in wax of his own invention representing the Earth and the Sea. To show how the Earth and the Sea interpenetrate he made the legs of the two figures interlock: 'The Sea, fashioned as a man, held a finely wrought ship which could hold enough salt, beneath I had put four sea-horses and I had given the figure a trident. The Earth I fashioned as a fair woman, as graceful as I could do it. Beside here I placed a richly decorated temple to hold the pepper.' But all this subtle invention makes less interesting reading than the story of how Cellini carried the gold from the King's treasurer and was attacked by four bandits, all of whom he put to flight single-handed. To some of us the smooth elegance of Cellini's figures may look a little over-elaborate and affected. Perhaps it is a consolation to know that their master had enough of that healthy robustness which his work seems to lack.

Cellini's outlook is typical of the restless and hectic attempts of the period to create something more interesting and unusual than former generations had done. We find the same spirit in the paintings of one of Correggio's followers, Parmigianino (1503–40). I can well imagine that some may find his Madonna, figure 234, almost offensive because of the affectation and sophistication with which a sacred subject is treated. There is nothing in it of the ease and simplicity with which Raphael had treated that ancient theme. The picture is called the 'Madonna with the long neck' because the painter, in his eagerness to make the Holy Virgin look graceful and elegant, has given her a neck like that of a swan. He has

Giambologna Mercury, 1580 Bronze, height 187 cm, 67 in; Museo Nazionale del Bargello, Florence stretched and lengthened the proportions of the human body in a strangely capricious way. The hand of the Virgin with its long delicate fingers, the long leg of the angel in the foreground, the lean, haggard prophet with a scroll of parchment – we see them all as through a distorting mirror. And yet there can be no doubt that the artist achieved this effect through neither ignorance nor indifference. He has taken care to show us that he liked these unnaturally elongated forms, for, to make doubly sure of his effect, he placed an oddly shaped high column of equally unusual proportions in the background of the painting. As for the arrangement of the picture, he also showed us that he did not believe in conventional harmonies. Instead of distributing his figures in equal pairs on both sides of the Madonna, he crammed a jostling crowd of angels into a narrow corner, and left the other side wide open to show the tall figure of the prophet, so reduced in size through the distance that he hardly reaches the Madonna's knee. There can be no doubt, then, that if this be madness there is method in it. The painter wanted to be unorthodox. He wanted to show that the classical solution of perfect harmony is not the only solution conceivable; that natural simplicity is one way of achieving beauty, but that there are less direct ways of getting interesting effects for sophisticated lovers of art. Whether we like or dislike the road he took, we must admit that he was consistent. Indeed, Parmigianino and all the artists of his time who deliberately sought to create something new and unexpected, even at the expense of the 'natural' beauty established by the great masters, were perhaps the first 'modern' artists. We shall see, indeed, that what is now called 'modern' art may have had its roots in a similar urge to avoid the obvious and achieve effects which differ from conventional natural beauty.

Other artists of this strange period, in the shadow of the giants of art, were less despairing of surpassing them by ordinary standards of skill and virtuosity. We may not agree with all they did, but here, too, we are forced to admit that some of their efforts are startling enough. A typical example is the statue of Mercury, the messenger of the gods, by a Flemish sculptor, Jean de Boulogne (1529–1608), whom the Italians called Giovanni da Bologna or Giambologna, figure 235. He had set himself the task of achieving the impossible – a statue which overcomes the weight of dead matter and which creates the sensation of a rapid flight through the air. And to a certain extent he was successful. Only with a tip of his toe does his famous Mercury touch the ground – rather, not the ground, but a gush of air which comes out of the mouth of a mask representing the South Wind. The whole statue is so carefully balanced that it really seems to hover in the air – almost to speed through it, with swiftness and grace. Perhaps a classical sculptor, or even Michelangelo, might have found such an effect unbecoming to a

statue which should remind one of the heavy block of matter out of which it was shaped – but Giambologna, no less than Parmigianino, preferred to defy these well-established rules and to show what surprising effects could be achieved.

Perhaps the greatest of all these masters of the latter part of the sixteenth century lived in Venice. He was called Jacopo Robusti, but nicknamed Tintoretto (1518–94). He too had tired of the simple beauty in forms and colours which Titian had shown to the Venetians – but his discontent must have been more than a mere desire to accomplish the unusual. He seems to have felt that, however incomparable Titian was as a painter of beauty, his pictures tended to be more pleasing than moving; that they were not sufficiently exciting to make the great stories of the Bible and the sacred legends live for us. Whether he was right in this or not, he must, at any rate, have been resolved to tell these stories in a different way, to make the spectator feel the thrill and tense drama of the events he painted. Figure 236 shows that he did indeed succeed in making his pictures unusual and captivating. At first glance this painting looks confused and confusing. Instead of a clear arrangement of the main figures in the plane of the picture, such as Raphael had achieved, we look into the depths of a strange vault. There is a tall man with a halo at the left corner, raising his arm as if to stop something that is happening – and if we follow his gesture we can see that he is concerned with what is going on high under the roof of the vault on the other side of the picture. There are two men about to lower a dead body from a tomb - they have lifted its lid - and a third man in a turban is helping them, while a nobleman in the background with a torch is trying to read the inscription on another tomb. These men are evidently plundering a catacomb. One of the bodies is stretched out on a carpet in strange foreshortening, while a dignified old man in a gorgeous costume kneels beside it and looks at it. In the right corner there is a group of gesticulating men and women, looking with astonishment at the saint – for a saint the figure with the halo must be. If we look more closely we see that he carries a book – he is St Mark the Evangelist, the patron saint of Venice. What is happening? The picture represents the story of how the relics of St Mark were brought from Alexandria (the town of the 'infidel' Muslims) to Venice, where the famous shrine of the church of St Mark was built to house them. The story goes that St Mark had been bishop at Alexandria and had been buried in one of the catacombs there. When the Venetian party had broken into the catacomb on the pious errand of finding the body of the saint, they did not know which of the many tombs contained the treasured relic. But when they came upon the right one, St Mark suddenly appeared and revealed the remains of his earthly existence. That is the moment which Tintoretto selected. The saint commands the men not to continue

236 Tintoretto The finding of St Mark's remains, c. 1562 Oil on canvas, 405 × 405

and already its presence is working miracles. The writhing man on the right is freed from a demon who had possessed him and who is seen escaping from his mouth like a wisp of smoke. The nobleman who kneels down in gratitude and adoration is the Donor, a member of the religious cm, 1595/8 × 1595/8 in; confraternity who had commissioned the painting. No doubt the whole Pinacoteca di Brera, Milan picture must have struck contemporaries as eccentric. They may have been rather shocked by the clashing contrasts of light and shade, of closeness and distance, by the lack of harmony in gestures and movement. Yet they must soon have understood that with more ordinary methods Tintoretto could

Tintoretto
St George and the dragon, c. 1555-8

dragon, *c*. 1555–8 Oil on canvas, 157.5 × 100.3 cm, 62 × 39½ in; National Gallery, London not have created the impression of a tremendous mystery unfolding before our eyes. To achieve this purpose Tintoretto even sacrificed that mellow beauty of colour that had been the proudest achievement of Venetian painting, of Giorgione and Titian. His painting of St George's fight with the dragon, in London, *figure 237*, shows how the weird light and the broken tones add to the feeling of tension and excitement. We feel the drama has just reached its climax. The princess seems to be rushing right out of the picture towards us while the hero is removed, against all rules, far into the background of the scene.

Giorgio Vasari (1511-74), the great Florentine critic and biographer of the period, wrote of Tintoretto that 'had he not abandoned the beaten track but rather followed the beautiful style of his predecessors, he would have become one of the greatest painters seen in Venice'. As it was, Vasari thought his work was marred by careless execution and eccentric taste. He was puzzled by the lack of 'finish' Tintoretto gave his work. 'His sketches', he says, 'are so crude that his pencil strokes show more force than judgement and seem to have been made by chance.' It is a reproach which from that time onwards has often been made against modern artists. Perhaps this is not altogether surprising, for these great innovators in art have often concentrated on the essential things and refused to worry about technical perfection in the usual sense. In periods like that of Tintoretto, technical excellence had reached such a high standard that anyone with some mechanical aptitude could master some of its tricks. A man like Tintoretto wanted to show things in a new light, he wanted to explore new ways of representing the legends and myths of the past. He considered his painting complete when he had conveyed his vision of the legendary scene. A smooth and careful finish did not interest him, for it did not serve his purpose. On the contrary – it might have distracted our attention from the dramatic happenings of the picture. So he left it at that, and left people wondering.

No one in the sixteenth century took these methods further than a painter from the Greek island of Crete, Domenikos Theotokopoulos (1541?–1614), who was called El Greco ('the Greek') for short. He had come to Venice from an isolated part of the world which had not developed any new kind of art since the Middle Ages. In his homeland, he must have been used to seeing the images of saints in the ancient Byzantine manner – solemn, rigid and remote from any semblance of natural appearance. Not being trained to look at pictures for their correct design, he found nothing shocking in Tintoretto's art, but much that was fascinating. For he too, it seems, was a passionate and devout man, and he felt an urge to tell the sacred stories in a new and stirring manner. After his stay in Venice he settled in a distant part of Europe – in Toledo, Spain,

where again he was not likely to be disturbed and harried by critics asking for correct and natural design – for in Spain, too, the medieval ideas on art still lingered on. This may explain why El Greco's art surpasses even Tintoretto's in its bold disregard of natural forms and colours, and in its stirring and dramatic vision. *Figure 238* is one of his most startling and

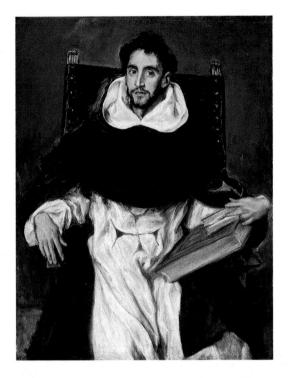

El Greco
Brother Hortensio Felix
Paravicino, 1609
Oil on canvas, 113 × 86
cm, 44½ × 33¾ in;
Museum of Fine Arts,

238

Boston

El Greco The opening of the Fifth Seal of the Apocalypse, c. 1608–14

Oil on canvas, 224.5 × 192.8 cm, 88½ × 76 in; Metropolitan Museum of Art, New York exciting pictures. It represents a passage from the Revelation of St John, and it is St John himself whom we see on one side of the picture in visionary rapture, looking towards Heaven and raising his arms in a prophetic gesture.

The passage is the one in which the Lamb summons St John to 'Come and see' the opening of the seven seals. 'And when he had opened the fifth seal, I saw under the altar the souls of them that were slain for the word of God, and for the testimony which they held: And they cried with a loud voice, saying "How long, O Lord, holy and true, dost thou not judge and avenge our blood on them that dwell on the earth?" And white robes were given unto every one of them' (Rev. vi. 9–11). The nude figures, with their excited gestures, are therefore the martyrs who rise to receive the heavenly gift of white robes. Surely no exact and

accurate drawing could ever have expressed with such an uncanny and convincing force that terrible vision of doomsday, when the very saints call for the destruction of this world. It is not difficult to see that El Greco had learned much from Tintoretto's unorthodox method of lopsided composition, and that he had also adopted the mannerism of over-long figures like that of Parmigianino's sophisticated Madonna, figure 234. But we also realize that El Greco employed this artistic method with a new purpose. He lived in Spain, where religion had a mystic fervour found hardly anywhere else. In this atmosphere, the sophisticated art of Mannerism lost much of its character of an art for connoisseurs. Though his work strikes us as incredibly 'modern', his contemporaries in Spain do not seem to have raised any objections such as Vasari did to Tintoretto's works. His greatest portraits, figure 239, can indeed stand beside those of Titian, page 333, figure 212. His studio was always fully employed. He seems to have engaged a number of assistants to cope with the many orders he received, and that may explain why not all the works that bear his name are equally good. It was only a generation later that people began to criticize his unnatural forms and colours, and to regard his pictures as something like a bad joke; and only after the First World War, when modern artists had taught us not to apply the same standards of 'correctness' to all works of art, was El Greco's art rediscovered and understood.

In the northern countries, in Germany, Holland and England, artists were confronted with a much more real crisis than their colleagues in Italy and Spain. For these southerners had only to deal with the problem of how to paint in a new and startling manner. In the North the question soon faced them whether painting could and should continue at all. This great crisis was brought about by the Reformation. Many Protestants objected to pictures or statues of saints in churches and regarded them as a sign of Popish idolatry. Thus the painters in Protestant regions lost their best source of income, the painting of altar-panels. The stricter among the Calvinists even objected to other kinds of luxury such as gay decorations of houses, and even where these were permitted in theory, the climate and the style of buildings were usually unsuited to large fresco decorations such as Italian nobles commissioned for their palaces. All that remained as a regular source of income for artists was book illustration and portrait painting, and it was doubtful whether these would suffice to make a living.

We can witness the effect of this crisis in the career of the greatest German painter of this generation, in the life of Hans Holbein the Younger (1497–1543). Holbein was twenty-six years younger than Dürer and only three years older than Cellini. He was born in Augsburg, a rich merchant city with close trading relations with Italy; he soon moved to Basle, a renowned centre of the New Learning.

The knowledge which Dürer strove for so passionately throughout his life thus came more naturally to Holbein. Coming from a painter's family (his father was a respected master) and being exceedingly alert, he soon absorbed the achievements of both the northern and the Italian artists. He was hardly over thirty when he painted the wonderful altar-painting of the Virgin with the family of the burgomaster of Basle as donors, figure 240. The form was traditional in all countries, and we have seen it applied in the Wilton Diptych, pages 216-17, figure 143, and Titian's 'Pesaro Madonna', page 330, figure 210. But Holbein's painting is still one of the most perfect examples of its kind. The way in which the donors are arranged in seemingly effortless groups on both sides of the Virgin, whose calm and majestic figure is framed by a niche of classical forms. reminds us of the most harmonious compositions of the Italian Renaissance, of Giovanni Bellini, page 327, figure 208, and Raphael, page 317, figure 203. The careful attention to detail, on the other hand, and a certain indifference to conventional beauty, show that Holbein had learned his trade in the North. He was on his way to becoming the leading master of the German-speaking countries when the turmoil of the Reformation put an end to all such hopes. In 1526 he left Switzerland for England with a letter of recommendation from the great scholar, Erasmus

240

Hans Holbein the Younger The Virgin and Child with the family of Burgomaster Meyer, 1528

Altar-painting; oil on wood, 146.5 × 102 cm, 57% × 40% in; Schlossmuseum,

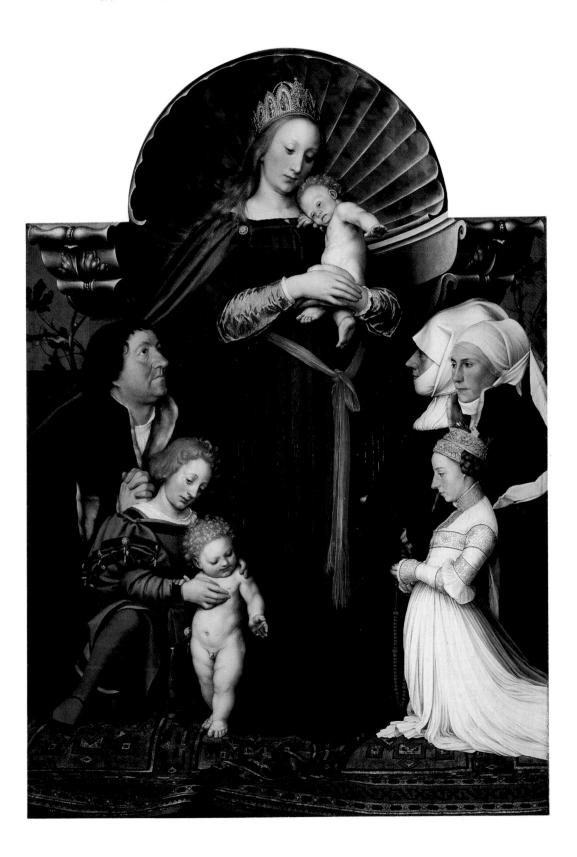

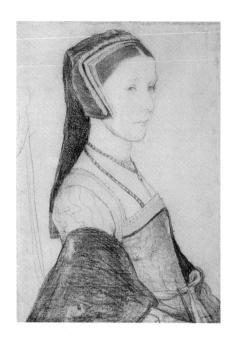

of Rotterdam. 'The arts here are freezing,' Erasmus wrote commending the painter to his friends, among whom was Sir Thomas More. One of Holbein's first jobs in England was to prepare a large portrait of that other great scholar's family, and some detailed studies for this work are still preserved at Windsor Castle, figure 241. If Holbein had hoped to get away from the turmoil of the Reformation he must have been disappointed by later events, but when he finally settled in England for good and was given the official title of Court Painter by Henry VIII he had at least found a sphere of activity which allowed him to live and work. He could no longer paint Madonnas, but the tasks of a Court Painter were exceedingly manifold. He designed jewellery and furniture, costumes for pageantries and decorations for halls, weapons and goblets. His main job, however, was to paint portraits of the royal household, and it is due to Holbein's unfailing eye that we still have such a vivid picture of the men and women of Henry VIII's period. Figure 242 shows his portrait of Sir Richard Southwell, a courtier and official who took part in the dissolution of the monasteries. There is nothing dramatic in these portraits of Holbein, nothing to catch the eye, but the longer we look at them the more they seem to reveal of the sitter's mind and personality. We do not doubt for a moment that they are in fact faithful records of what Holbein saw, drawn without fear or favour. The way in which Holbein has placed the figure in the picture shows the sure touch of the master. Nothing seems left to chance; the whole composition is so perfectly balanced that it may easily

Hans Holbein the Younger Anne Cresacre, Sir Thomas More's daughter-in-law, 1528 Black and coloured chalks on paper, 37.9 × 26.9 cm, 14% × 10½ in; Royal

Library, Windsor Castle

Hans Holbein the Younger Sir Richard Southwell, 1536

Oil on wood, 47.5×38 cm, 18×15 in; Uffizi, Florence

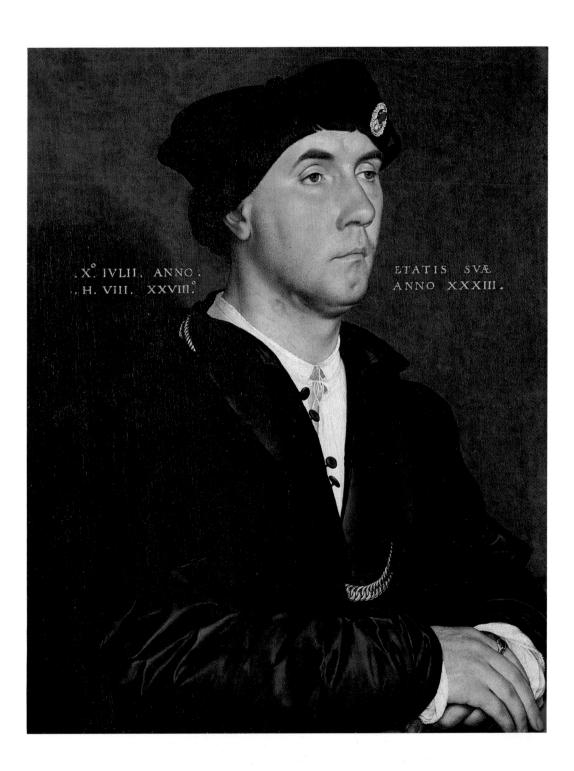

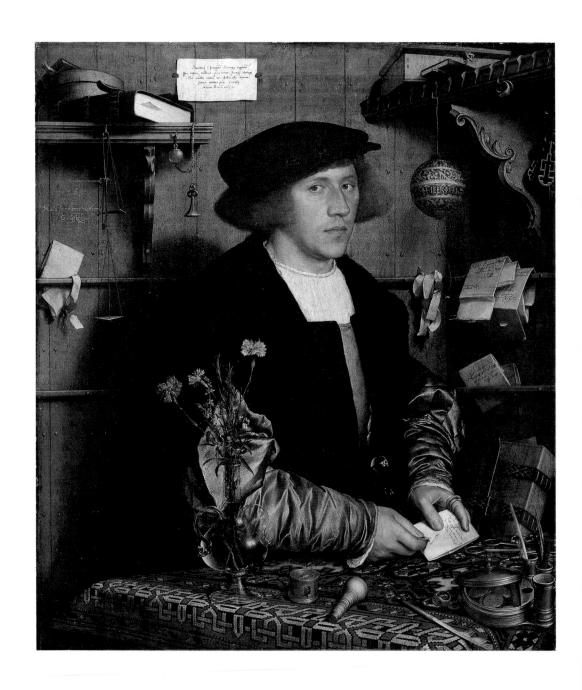

Nicholas Hilliard Young man among roses, c. 1587

Watercolour and gouache on vellum, 13.6 × 7.3 cm, 5% × 2% in; Victoria and Albert Museum, London

243
Hans Holbein
the Younger
Georg Gisze, a
German merchant in
London, 1532

Oil on wood, 96.3 × 85.7 cm, 38 × 33¾ in; Gemäldegalerie, Staatliche Museen, Berlin seem 'obvious' to us. But this was Holbein's intention. In his earlier portraits he had still sought to display his wonderful skill in the rendering of details, to characterize a sitter through his setting, through the things among which he spent his life, *figure 243*. The older he grew and the more mature his art became, the less did he seem in need of any such tricks. He did not want to obtrude himself and to divert attention from the sitter. And it is precisely for this masterly restraint that we admire him most.

When Holbein had left the German-speaking countries, painting there began to decline to a frightening extent, and when Holbein died the arts were in a similar plight in England. In fact, the only branch of painting there that survived the Reformation was that of portrait painting, which Holbein had so firmly established. Even in this branch the fashions of southern Mannerism made themselves increasingly felt, and ideals of courtly refinement and elegance replaced the simpler style of Holbein.

The portrait of a young Elizabethan nobleman, *figure 244*, gives an idea of this new type of portraiture at its best. It is a 'miniature' by the famous English master

Nicholas Hilliard (1547–1619), a contemporary of Sir Philip Sidney and William Shakespeare. We may indeed think of Sidney's pastorals or Shakespeare's comedies when looking at this dainty youth who leans languidly against a tree, surrounded by thorny wild roses, his right hand pressed against his heart. Perhaps the miniature was intended as the young man's gift to the lady he was wooing, for it bears the Latin inscription 'Dat poenas laudata fides', which means roughly, 'my praised faith procures my pain'. We ought not to ask whether these pains were any more real than the painted thorns on the miniature. A young gallant in those days was expected to make a show of grief and unrequited love. These sighs and these sonnets were all part of a graceful and elaborate game, which nobody took too seriously but in which everybody wanted to shine by inventing new variations and new refinements.

If we look at Hilliard's miniature as an object designed for this game, it may no longer strike us as affected and artificial. Let us hope that when the maiden received this token of affection in a precious case and saw the pitiful pose of her elegant and noble wooer, his 'praised faith' had at last its reward.

There was only one Protestant country in Europe where art fully survived the crisis of the Reformation – that was the Netherlands. There,

Pieter Bruegel the Elder The painter and the buyer, c. 1565 Pen and black ink on brown paper, 25 × 21.6 cm, 9% × 8½ in; Albertina, Vienna

where painting had flourished for so long, artists found a way out of their predicament: instead of concentrating on portrait painting alone they specialized in all those types of subject-matter to which the Protestant Church could raise no objections. Since the early days of Van Eyck, the artists of the Netherlands had been recognized as perfect masters in the imitation of nature. While the Italians prided themselves on being unrivalled in the representation of the beautiful human figure in motion, they were ready to recognize that, for sheer patience and accuracy in depicting a flower, a tree, a barn or a flock of sheep, the 'Flemings' were apt to outstrip them. It was therefore quite natural that

the northern artists, who were no longer needed for the painting of altarpanels and other devotional pictures, tried to find a market for their recognized specialities and to paint pictures the main object of which was to display their stupendous skill in representing the surface of things. Specialization was not even quite new to the artists of these lands. We remember that Hieronymus Bosch, page 358, figures 229–30, had made a speciality of pictures of hell and of demons even before the crisis of art. Now, when the scope of painting had become more restricted, the painters went further along this road. They tried to develop the traditions of northern art which reach back to the time of the drôleries on the margins of medieval manuscripts, page 211, figure 140, and to the scenes of real life represented in fifteenth-century art, page 274, figure 177. Pictures in which the painters deliberately cultivated a certain branch or kind of subject, particularly scenes from daily life, later became known as 'genre pictures' (genre being the French word for branch or kind).

The greatest of the Flemish sixteenth-century masters of genre was Pieter Bruegel the Elder (1525?–69). We know little of his life except that he had been to Italy, like so many northern artists of his time, and that he lived and worked in Antwerp and Brussels, where he painted most of his pictures in the 1560s, the decade in which the stern Duke of Alva arrived in the Netherlands. The dignity of art and of artists was probably as important to him as it was to Dürer or Cellini, for in one of his splendid drawings he is clearly out to point a contrast between the proud painter and the stupid-looking bespectacled man who fumbles in his purse as he peers over the artist's shoulder, figure 245.

The 'kind' of painting on which Bruegel concentrated was scenes from peasant life. He painted peasants merrymaking, feasting and working, and so people have come to think of him as one of the Flemish peasants. This is a common mistake which we are apt to make about artists. We are often inclined to confuse their work with their person. We think of Dickens as a member of Mr Pickwick's jolly circle, or of Jules Verne as a daring inventor and traveller. If Bruegel had been a peasant himself he could not have painted them as he did. He certainly was a townsman and his attitude towards the rustic life of the village was very likely similar to that of Shakespeare, for whom Quince the Carpenter and Bottom the Weaver were a species of 'clown'. It was the custom at that time to regard the country vokel as a figure of fun. I do not think that either Shakespeare or Bruegel accepted this custom out of snobbery, but in rustic life human nature was less disguised and covered up with a veneer of artificiality and convention than in the life and manners of the gentlemen Hilliard portrayed. Thus, when they wanted to show up the folly of humankind, playwrights and artists often took low life as their subject.

One of the most perfect of Bruegel's human comedies is his famous picture of a country wedding, figure 246. Like most pictures, it loses a great deal in reproduction: all details become much smaller, and we must therefore look at it with double care. The feast takes place in a barn, with straw stacked up high in the background. The bride sits in front of a piece of blue cloth, with a kind of crown suspended over her head. She sits quietly, with folded hands and a grin of utter contentment on her stupid face, figure 247. The old man in the chair and the woman beside her are probably her parents, while the man farther back, who is so busy gobbling his food with his spoon, may be the bridegroom. Most of the people at the table concentrate on eating and drinking, and we notice this is only the beginning. In the left-hand corner a man pours out beer -agood number of empty jugs are still in the basket – while two men with white aprons are carrying ten more platefuls of pie or porridge on an improvised tray. One of the guests passes the plates to the table. But much more is going on. There is the crowd in the background trying to get in; there are the musicians, one of them with a pathetic, forlorn and hungry look in his eyes, as he watches the food being carried past; there are the two outsiders at the corner of the table, the friar and the magistrate,

Pieter Bruegel the Elder Peasant wedding, c. 1568 Oil on wood, 114 × 164 cm, 45 × 64½ in; Kunsthistorisches Museum, Vienna

engrossed in their own conversation; and there is the child in the foreground, who has got hold of a plate, and a feathered cap much too large for its little head, and who is completely absorbed in licking the delicious food – a picture of innocent greed. But what is even more admirable than all this wealth of anecdote, wit and observation, is the way in which Bruegel has organized his picture so that it does not look crowded or confusing. Tintoretto himself could not have produced a more convincing picture of a crowded space than did Bruegel with his device of the table receding into the background and the movement of people starting with the crowd at the barn door, leading up to the foreground and the scene of the food carriers, and back again through the gesture of the man serving the table who leads our eyes directly to the small but central figure of the grinning bride.

In these gay, but by no means simple, pictures, Bruegel had discovered a new kingdom for art which the generations of Netherlandish painters after him were to explore to the full.

In France the crisis of art took again a different turn. Situated between Italy and the northern countries, it was influenced by both. The vigorous tradition of French medieval art was at first threatened by the inrush of the Italianate fashion, which French painters found as difficult to adapt as did their colleagues in the Netherlands, page 357, figure 228. The form in which

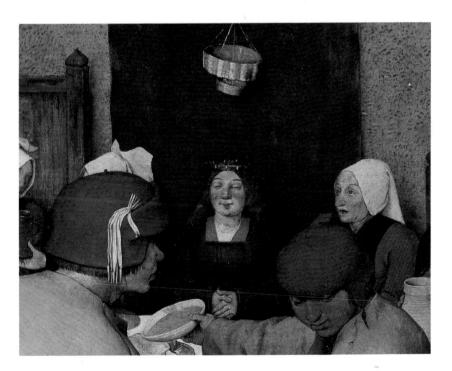

247 Detail of figure 246

248
Jean Goujon
Nymphs from the
Fontaine des Innocents,
1547–9
Marble; each panel 240 ×
63 cm, 94½ × 24¾ in;
Musée National des
Monuments Français, Paris

Italian art was finally accepted by high society was that of the elegant and refined Italian Mannerists of Cellini's type, *figure 233*. We can see its influence in the lively reliefs from a fountain by the French sculptor, Jean Goujon (died 1566?), *figure 248*. There is something both of Parmigianino's fastidious elegance and Giambologna's virtuosity in these exquisitely graceful figures and the way they are fitted into the narrow strips reserved for them.

A generation later an artist arose in France in whose etchings the bizarre inventions of the Italian Mannerists were represented in the spirit of Pieter Bruegel: the Lorrainian, Jacques Callot (1592–1635). Like Tintoretto or

Jacques Callot
Two Italian clowns,
c. 1622
Detail of etching from the
series 'Balli di Sfessania'

even El Greco, he loved to show the most surprising combinations, of tall, gaunt figures and wide unexpected vistas; but, like Bruegel, he used these devices to portray the follies of mankind through scenes from the life of its outcasts, soldiers, cripples, beggars and strolling players, *figure 249*. But by the time Callot popularized these extravaganzas in his etchings most painters of his day had turned their attention to new problems, which filled the talk of the studios in Rome, Antwerp and Madrid.

Taddeo Zuccaro at work on the scaffolding of a palace. He is watched with admiration by the aged Michelangelo, while the goddess of Fame trumpets his triumph all over the world, c. 1590 Drawing by Federico

Zuccaro; pen and ink on paper, 26.2 × 41 cm, 10¼ × 16½ in; Albertina,

19

VISION AND VISIONS

Catholic Europe, first half of the seventeenth century

The history of art is sometimes described as the story of a succession of various styles. We hear how the Romanesque or Norman style of the twelfth century with its round arches was succeeded by the Gothic style with the pointed arch; how the Gothic style was supplanted by the Renaissance, which had its beginnings in Italy in the early fifteenth century and slowly gained ground in all the countries of Europe. The style which followed the Renaissance is usually called Baroque. But, while it is easy to identify the earlier styles by definite marks of recognition, this is not so simple in the case of Baroque. The fact is that from the Renaissance onwards, almost up to our own time, architects have used the same basic forms - columns, pilasters, cornices, entablatures and mouldings, all of which were originally borrowed from classical ruins. In a sense, therefore, it is true to say that the Renaissance style of building has continued from Brunelleschi's days to our own, and many books on architecture speak of this whole period as Renaissance. On the other hand, it is natural that within such a long period tastes and fashions in building should have varied considerably, and it is convenient to have different labels by which to distinguish these changing styles. It is a strange fact that many of these labels which to us are simply names of styles were originally words of abuse or derision. The word 'Gothic' was first used by the Italian art critics of the Renaissance to denote the style which they considered barbarous, and which they thought had been brought into Italy by the Goths who destroyed the Roman Empire and sacked its cities. The word 'Mannerism' still retains for many people its original connotation of affectation and shallow imitation, of which critics of the seventeenth century had accused the artists of the late sixteenth century. The word 'Baroque' was a term employed by critics of a later period who fought against the tendencies of the seventeenth century, and wanted to hold them up to ridicule. Baroque really means absurd or grotesque, and it was used by men who insisted that the forms of classical buildings should never have been used or combined except in the ways adopted by the Greeks and Romans. To disregard the strict rules of ancient architecture seemed to these critics a deplorable lapse of taste - whence they labelled the style Baroque. It is not altogether easy

for us to appreciate these distinctions. We have become too accustomed to seeing buildings in our cities which defy the rules of classical architecture or misunderstand them altogether. So we have become insensitive in these matters and the old quarrels seem very remote from the architectural questions which interest us. To us a church façade like that in figure 250 may not seem very exciting, because we have seen so many good and bad imitations of this type of building that we hardly turn our heads to look at them; but when it was first built in Rome, in 1575, it was a most revolutionary building. It was not just one more church in Rome, where there are many churches. It was the church of the newly founded Order of the Jesuits, on which high hopes were set for combating the Reformation all over Europe. Its very shape was to be on a new and unusual plan; the Renaissance idea of round and symmetrical church building had been rejected as unsuited to divine service, and a new, simple and ingenious plan had been worked out which was to be accepted all over Europe. The church was to be in the form of a cross, topped by a high and stately cupola. In the one large, oblong space, known as the nave, the congregation could assemble without hindrance, and look towards the main altar. This stood at the end of the oblong, and behind it was the apse, which was similar in form to that of the early basilicas. To suit the requirements of private devotion and adoration of individual saints, a row of small chapels was distributed on either side of the nave each of which had an altar of its own, and there were two larger chapels at the ends of the arms of the cross. It is a simple and ingenious way of planning a church and has since been widely used. It combines the main features of medieval churches – their oblong shape, emphasizing the main altar – with the achievements of Renaissance planning, in which so much stress is laid on large and roomy interiors into which the light would stream through a majestic dome.

Looking closely at the façade of Il Gesù, which was built by the celebrated architect Giacomo della Porta (1541?–1602), we soon realize why it must have impressed contemporaries as being no less new and ingenious than the interior of the church. We see at once that it is composed of the elements of classical architecture – we find all the set pieces together: columns (or rather, half-columns and pilasters) carrying an 'architrave' crowned by a high 'attic' which, in turn, carries the upper storey. Even the distribution of these set pieces employs some features of classical architecture: the large middle entrance, framed by columns and flanked by two smaller entrances, recalls the scheme of triumphal arches, *page 119*, *figure 74*, which (to repeat) became as firmly implanted in the architects' mind as the major chord in the mind of musicians. There is nothing in this simple and majestic façade to suggest deliberate defiance of the classical

Giacomo della Porta Church of Il Gesù, Rome, c. 1575–7 An early Baroque church

rules for the sake of sophisticated caprice. But the way in which the classical elements are fused into a pattern shows that Roman and Greek and even Renaissance rules have been left behind. The most striking feature in this façade is the doubling of each column or pilaster, as if to give the whole structure greater richness, variety and solemnity. The second trait we notice is the care which the artist has taken to avoid repetition and monotony and to arrange the parts so as to form a climax in the centre, where the main entrance is emphasized by a double frame. If we turn back to earlier buildings composed of similar elements, we immediately see the great change in character. Brunelleschi's Cappella Pazzi, page 226, figure 147, looks infinitely light and graceful by comparison, in its wonderful simplicity, and Bramante's Tempietto, page 290, figure 187, almost austere in its clear and straightforward arrangement. Even the rich complexities of Sansovino's Library, page 326, figure 207, appear simple by comparison, because there the same pattern is repeated again and again. If you have seen a part of it, you have seen it all. In Della Porta's façade of the first Jesuit church everything depends on the effect given by the whole. It is all fused together into one large and complex pattern. Perhaps the most characteristic trait in this respect is the care the architect has taken to connect the upper and lower storeys. He uses a form of volute which has no place at all in classical architecture. We need only imagine a form of this kind somewhere on a Greek temple or a Roman theatre to realize how utterly out of place it would seem. In fact, it is these curves and scrolls that have been responsible for much of the censure showered on Baroque

builders by the upholders of pure classical tradition. But if we cover the offending ornaments with a piece of paper and try to visualize the building without them, we must admit that they are not merely ornamental. Without them the building would 'fall apart'. They help to give it that essential coherence and unity which was the aim of the artist. In the course of time, Baroque architects had to use ever more bold and unusual devices to achieve the essential unity of a large pattern. Seen in isolation these devices often look puzzling enough, but in all good buildings they are essential to the architect's purpose.

The development of painting out of the deadlock of Mannerism, into a style far richer in possibilities than that of the earlier great masters, was in some respects similar to that of Baroque architecture. In the great paintings of Tintoretto and of El Greco we have seen the growth of some ideas which gained increasing importance in the art of the seventeenth century: the emphasis on light and colour, the disregard of simple balance, and the preference for more complicated compositions. Nevertheless, seventeenth-century painting is not just a continuation of the Mannerist style. At least people at the time did not feel it to be so. They felt that art had got into a dangerous rut, and must be got out of it. People liked talking about art in those days. In Rome, in particular, there were cultured gentlemen who enjoyed discussions on the various 'movements' among the artists of their time, who liked to compare them with older masters, and to take sides in their quarrels and intrigues. Such discussions were in themselves something new in the world of art. They had begun in the sixteenth century with such questions as whether painting was better than sculpture, or whether design was more important than colour or vice versa (the Florentines backing design, the Venetians colour). Now their topic was different: they talked about two artists who had come to Rome from northern Italy and whose methods seemed to them utterly opposed. One was Annibale Carracci (1560–1609) from Bologna, the other Michelangelo da Caravaggio (1573–1610) from a little place near Milan. Both these artists seemed tired of Mannerism. But the ways in which they overcame its sophistications were very different. Annibale Carracci was a member of a family of painters who had studied the art of Venice and of Correggio. On his arrival in Rome, he fell under the spell of Raphael's works, which he greatly admired. He aimed at recapturing something of their simplicity and beauty instead of deliberately contradicting them, as the Mannerists had done. Later critics have attributed to him the intention of imitating the best in all the great painters of the past. It is unlikely that he ever formulated a programme of this kind (which is called 'eclectic'). That was done later, in the academies or art schools which took his work as a model. Carracci himself was too much of a real artist to adopt such a

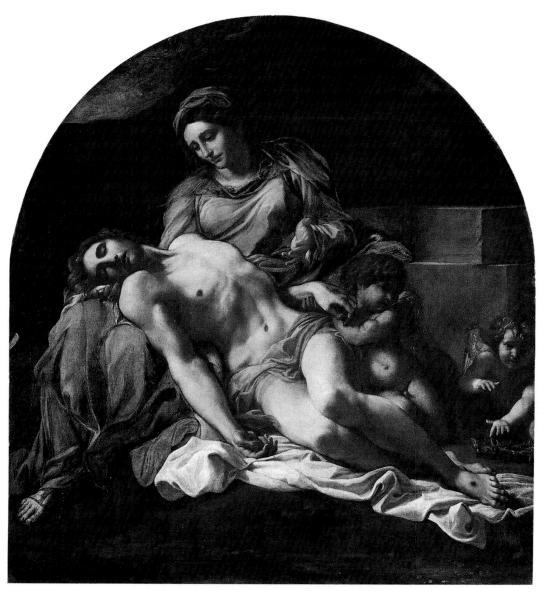

Annibale Carracci
The Virgin mourning
Christ, 1599—1600
Altar-painting; oil
on canvas, 156 × 149 cm,
61% × 58% in; Museo di
Capodimonte, Naples

foolish idea. But the battle-cry of his party among the cliques of Rome was the cultivation of classical beauty. We can see his intention in the altarpicture of the Holy Virgin mourning over the dead body of Christ, figure 251. We need only think back to Grünewald's tormented body of Christ, page 351, figure 224, to realize how careful Annibale Carracci was not to remind us of the horrors of death and the agonies of pain. The picture itself is as simple and harmonious in arrangement as that of an early Renaissance painter. Nevertheless, we would not easily mistake it for a Renaissance painting. The way in which the light is made to play over the body of the Saviour, the whole appeal to our emotions, is quite different, is Baroque. It is easy to dismiss such a picture as sentimental, but we must not forget the purpose for which it was made. It is an altar-painting, meant to be contemplated in prayer and devotion with candles burning before it.

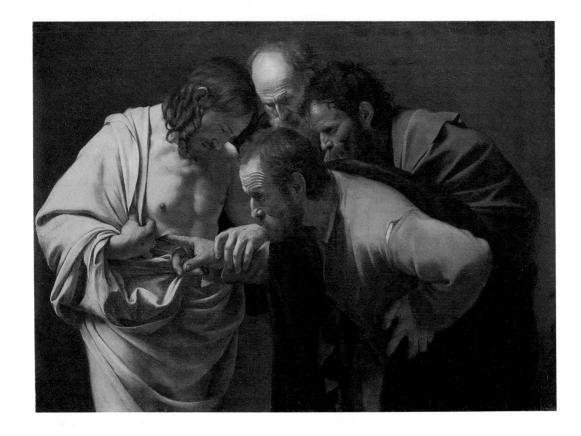

Whatever we may feel about Carracci's methods, Caravaggio and his partisans certainly did not think highly of them. The two painters, it is true, were on the best of terms - which was no easy matter in the case of Caravaggio, for he was of a wild and irascible temper, quick to take offence, and even to run a dagger through a man. But his work was on different lines from Carracci's. To be afraid of ugliness seemed to Caravaggio a contemptible weakness. What he wanted was truth. Truth as he saw it. He had no liking for classical models, nor any respect for 'ideal beauty'. He wanted to do away with convention and to think about art afresh, pages 30–1, figures 15, 16. Some people thought he was mainly out to shock the public; that he had no respect for any kind of beauty or tradition. He was one of the first painters at whom these accusations were levelled and the first whose outlook was summed up by his critics in a slogan: he was condemned as a 'naturalist'. In point of fact, Caravaggio was far too great and serious an artist to fritter away his time in trying to cause a sensation. While the critics argued, he was busy at work. And his work has lost nothing of its boldness in the three centuries and more since he did it. Consider his painting of

Caravaggio
Doubting Thomas,
c. 1602–3
Oil on canvas, 107 × 146
cm, 42½ × 57½ in;
Stiftung Schlösser und
Gärten, Sanssouci.

252

Potsdam

St Thomas, *figure 252*: the three apostles staring at Jesus, one of them poking his finger into the wound in His side, look unconventional enough. One can imagine that such a painting struck devout people as being irreverent and even outrageous. They were accustomed to seeing the apostles as dignified figures draped in beautiful folds – here they looked like common labourers, with weathered faces and wrinkled brows. But, Caravaggio would have answered, they *were* old labourers, common people – and as to the unseemly gesture of Doubting Thomas, the Bible is quite explicit about it. Jesus says to him: 'Reach hither thy hand, and thrust it into my side: and be not faithless, but believing' (St John xx. 27).

Caravaggio's 'naturalism', that is, his intention to copy nature faithfully, whether we think it ugly or beautiful, was perhaps more devout than Carracci's emphasis on beauty. Caravaggio must have read the Bible again and again, and pondered its words. He was one of the great artists, like Giotto and Dürer before him, who wanted to see the holy events before his own eyes as if they had been happening in his neighbour's house. And he did everything possible to make the figures of the ancient texts look more real and tangible. Even his way of handling light and shade helps to this end. His light does not make the body look graceful and soft: it is harsh and almost glaring in its contrast to the deep shadows. But it makes the whole strange scene stand out with an uncompromising honesty which few of his contemporaries could appreciate, but which had a decisive effect on later artists.

Annibale Carracci and Caravaggio fell out of fashion in the nineteenth century, but have come into their own again. But the impulse they both gave to the art of painting can hardly be imagined. Both of them worked in Rome, and Rome, at the time, was the centre of the civilized world. Artists from all parts of Europe came there, took part in the discussions on painting, took sides in the quarrels of the cliques, studied the old masters, and returned to their native countries with tales of the latest 'movements' much as modern artists used to do with regard to Paris. According to their national traditions and temperaments, artists preferred one or other of the rival schools in Rome, and the greatest of them developed their own personal idiom from what they had learned of these foreign movements. Rome still remains the best vantage point from which to glance at the splendid panorama of painting in the countries adhering to Roman Catholicism. Of the many Italian masters who developed their style in Rome, the most famous was probably Guido Reni (1575-1642), a painter from Bologna who after a brief period of hesitation threw in his lot with the school of the Carracci. His fame, like that of his master, once stood immeasurably higher than it happens to stand just now, page 22, figure 7. There was a time when his name ranked with that of Raphael, and if we

look at figure 253 we may realize why. Reni painted this fresco on the ceiling of a palace in Rome in 1614. It represents Aurora (the Dawn) and the youthful sun-god Apollo in his chariot, round which the fair maidens of the Hours (the Horae) dance their joyful measure preceded by a torch-bearing child, the Morning Star. Such are the grace and beauty of this picture of the radiant rising day that one can understand how it reminded people of Raphael and his frescoes in the Farnesina, page 318, figure 204. Indeed Reni wanted them to think of this great painter, whom he had set out to emulate. If modern critics have often thought less highly of Reni's achievement, this may be the reason. They feel, or fear, that this very emulation of another master has made Reni's work too self-conscious, too deliberate in its striving for pure beauty. We need not quarrel over these distinctions. It is no doubt true that Reni differed from Raphael in his whole approach. With Raphael, we feel that the sense of beauty and serenity flowed naturally from his whole nature and art; with Reni we feel that he chose to paint like this as a matter of principle, and that if perchance Caravaggio's disciples had convinced him that he was wrong, he could have adopted a different style. But it was not Reni's fault that these matters of principle had been brought up and had permeated the minds and the conversation of painters. In fact, it was no one's fault. Art had been developed to such a point that artists were inevitably conscious of the choice of methods before them. And once we accept this, we are free to admire the way in which Reni carried out his programme of beauty, how he deliberately discarded anything in nature that he considered low and ugly or unsuitable for his lofty ideas, and how his quest for forms more perfect and more ideal than reality was rewarded with success. It was Annibale Carracci, Reni and their followers who formulated the programme of idealizing, of 'beautifying' nature, according to the standards set by the classical statues. We call it the neo-classical or 'academic'

Guido Reni Aurora, 1614 Fresco, c. 280 × 700 cm, 110 × 276 in; Palazzo Pallavicini-Rospigliosi, Rome

253

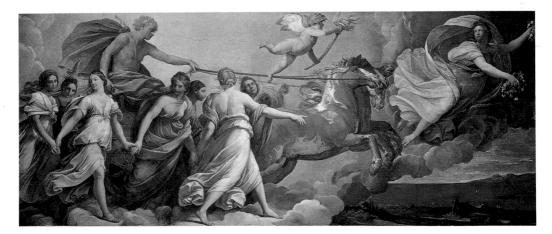

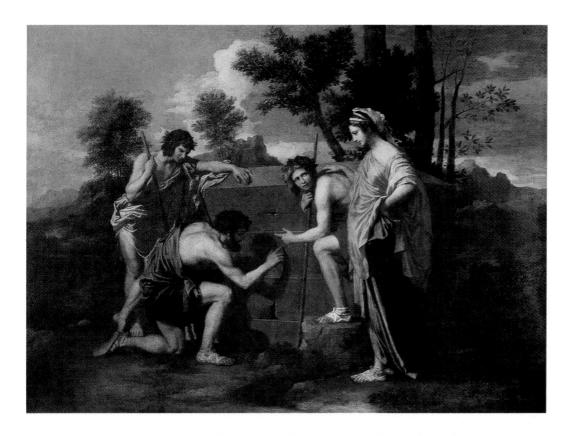

254
Nicolas Poussin
'Et in Arcadia ego',
1638–9
Oil on canvas, 85 × 121
cm, 33½ × 47% in;
Louvre, Paris

programme as distinct from classical art, which is not bound up with any programme at all. The disputes over it are not likely to cease soon, but no one denies that among its champions have been great masters who gave us a glimpse of a world of purity and beauty without which we would be the poorer.

The greatest of the 'academic' masters was the Frenchman Nicolas Poussin (1504–1665), who made Pome his adopted home town. Powering studied the

(1594–1665), who made Rome his adopted home town. Poussin studied the classical statues with passionate zeal, because he wanted their beauty to help him convey his vision of bygone lands of innocence and dignity. Figure 254 represents one of the most famous results of these unremitting studies. It shows a calm, sunny southern landscape. Beautiful young men and a fair and dignified young woman have gathered round a large tomb of stone. One of the shepherds – for shepherds they are, as we see by their wreaths and their shepherds' staffs - has knelt down to try to decipher the inscription on the tomb, and a second one points towards it while he looks at the fair shepherdess who, like her companion opposite, stands in silent melancholy. It is inscribed in Latin et in Arcadia ego (Even in Arcady I am): I, Death, reign even in the idyllic dreamland of the pastorals, in Arcady. Now we understand the wonderful gesture of awe and contemplation with which the framing figures gaze at the tomb, and we admire even more the beauty with which the reading figures answer each other's movements. The arrangement seems simple enough but it is simplicity born of immense artistic knowledge.

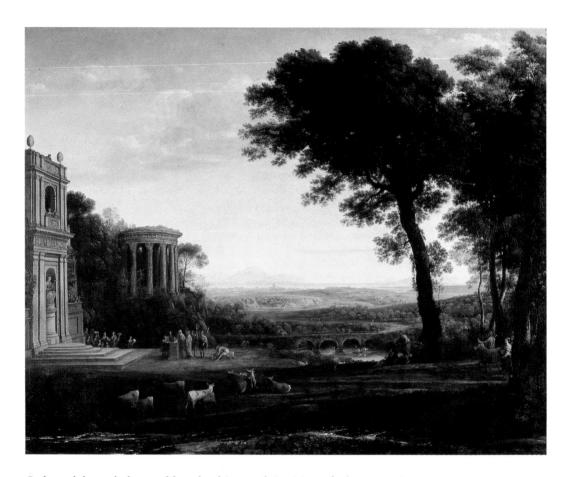

Only such knowledge could evoke this nostalgic vision of calm repose in which death has lost its terror.

It is for the same mood of nostalgic beauty that the works of another Italianized Frenchman became famous. He was Claude Lorrain (1600–82), some six years younger than Poussin. Claude studied the landscape of the Roman Campagna, the plains and hills round Rome with their lovely southern hues and their majestic reminders of a great past. Like Poussin, he showed in his sketches that he was a perfect master of the realistic representation of nature, and his studies of trees are a joy to look at. But for his finished pictures and etchings he selected only such motifs as he considered worthy of a place in a dreamlike vision of the past, and he dipped it all in a golden light or a silvery air which appear to transfigure the whole scene, figure 255. It was Claude who first opened people's eyes to the sublime beauty of nature, and for nearly a century after his death travellers used to judge a piece of real scenery according to his standards. If it reminded them of his visions, they called it lovely and sat down to

Claude Lorrain

Landscape with sacrifice
to Apollo, 1662–3
Oil on canvas, 174 ×
220 cm, 68½ × 86½ in;
Anglesey Abbey,
Cambridgeshire

picnic there. Rich Englishmen went even further and decided to model the pieces of nature they called their own, the gardens on their estates, on Claude's dreams of beauty. In this way, many a tract of the lovely English countryside should really bear the signature of the French painter who settled in Italy and made the programme of the Carracci his own.

The one northern artist to come most directly into contact with the Roman atmosphere of Carracci's and Caravaggio's days was a generation older than Poussin and Claude, and about as old as Guido Reni. He was the Fleming Peter Paul Rubens (1577–1640), who came to Rome in 1600 when he was twenty-three years old – perhaps the most impressionable age. He must have listened to many heated discussions on art, and studied a great number of new and older works, not only in Rome, but also in Genoa and Mantua (where he staved for some time). He listened and learned with keen interest, but does not seem to have joined any of the 'movements' or groups. In his heart he remained a Flemish artist – an artist from the country where Van Eyck and Rogier van der Weyden and Bruegel had worked. These painters from the Netherlands had always been most interested in the variegated surfaces of things: they had tried to use all artistic means known to them to express the texture of cloth and living flesh, in short to paint as faithfully as possible everything the eye could see. They had not troubled about the standards of beauty so sacred to their Italian colleagues, and they had not even always shown much concern for dignified subjects. It was in this tradition that Rubens had grown up, and all his admiration for the new art that was developing in Italy does not seem to have shaken his fundamental belief that a painter's business was to paint the world around him; to paint what he liked, to make us feel that he enjoyed the manifold living beauty of things. To such an approach there was nothing contradictory in Caravaggio's and Carracci's art. Rubens admired the way in which Carracci and his school revived the painting of classical stories and myths and arranged impressive altar-panels for the edification of the faithful; but he also admired the uncompromising sincerity with which Caravaggio studied nature.

When Rubens returned to Antwerp in 1608 he was a man of thirty-one, who had learned everything there was to be learned; he had acquired such facility in handling brush and paint, in representing nudes and drapery, armour and jewels, animals and landscapes, that he had no rival north of the Alps. His predecessors in Flanders had mostly painted on a small scale. He had brought from Italy the predilection for huge canvases to decorate churches and palaces, and this suited the taste of the dignitaries and princes. He had learned the art of arranging the figures on a vast scale, and of using light and colours to increase the general effect.

Figure 256, a sketch for the painting over the high altar of an Antwerp church, shows how well he had studied his Italian predecessors, and how boldly he developed their ideas. It is again the old, time-honoured theme of the Holy Virgin surrounded by saints, with which artists had grappled at the time of the Wilton Diptych, pages 216-17, figure 143, Bellini's 'Madonna', page 327, figure 208, or Titian's 'Pesaro Madonna', page 330, figure 210, and it may be worth while to turn to these illustrations once more to see the freedom and ease with which Rubens handled the ancient task. One thing is clear at the first glance: there is more movement, more light, more space, and there are more figures in this painting than in any of the earlier ones. The saints are crowding to the lofty throne of the Virgin in a festive throng. In the foreground the Bishop St Augustine, the Martyr St Lawrence with the grill on which he suffered, and the monk St Nicholas of Tolentino lead the spectator on to their object of worship. St George with the Dragon, and St Sebastian with a guiver and arrows, look into each other's eyes in fervent emotion, while a warrior – the palm of martyrdom in his hand – is about to kneel before the throne. A group of women, among them a nun, are looking up enraptured to the main scene, in which a young girl, assisted by a little angel, is falling on her knees to receive a ring from the little Christ Child, who is bending towards her from His mother's lap. It is the legend of the betrothal of St Catherine, who saw such a scene in a vision and considered herself the Bride of Christ. St Joseph watches benevolently from behind the throne, and St Peter and St Paul - one recognizable by the key, the other by the sword – stand in deep contemplation. They make an effective contrast to the imposing figure of St John on the other side, standing alone, bathed in light, throwing up his arms in ecstatic admiration while two charming little angels drag his reluctant lamb up the steps of the throne. From the sky another pair of little angels come rushing down to hold a wreath of laurels over the Virgin's head.

Having looked at the details, we must once more consider the whole, and admire the grand sweep with which Rubens has contrived to hold all the figures together, and to impart to it all an atmosphere of joyful and festive solemnity. Small wonder that a master who could plan such vast pictures with such sureness of hand and eye soon had more orders for paintings than he could cope with alone. But this did not worry him. Rubens was a man of great organizing ability and great personal charm; many gifted painters in Flanders were proud to work under his direction and thereby to learn from him. If an order for a new picture came from one of the churches, or from one of the kings or princes of Europe, he would sometimes paint only a small coloured sketch. (*Figure 256* is such a colour sketch for a large composition.) It would be the task of his pupils or assistants to transfer these ideas on to the large canvas, and only when they

256

Peter Paul Rubens Virgin and Child enthroned with saints, c. 1627–8

Sketch for a large altarpainting; oil on wood, 80.2 × 55.5 cm, 31½ × 21¼in; Gemäldegalerie, Staatliche Museen, Berlin

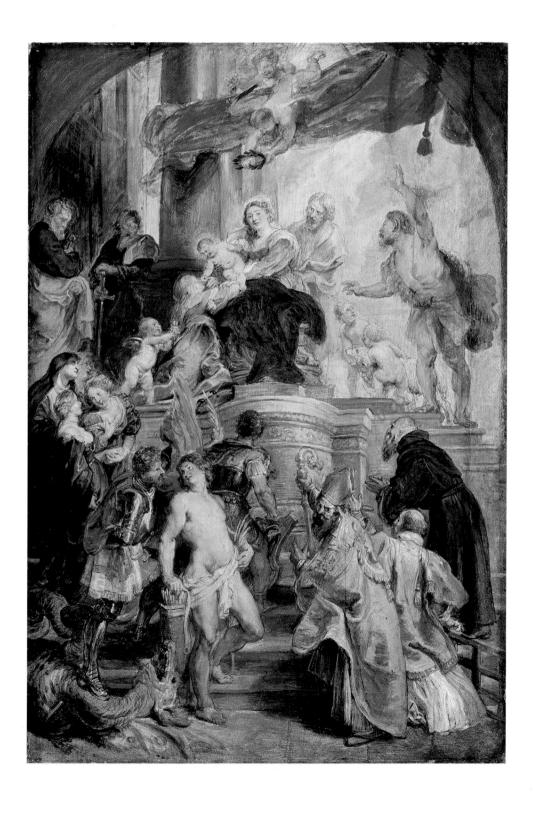

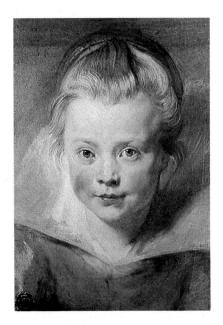

had finished grounding and painting according to the master's ideas might he take the brush again and touch up a face here and a silken dress there, or smooth out any harsh contrasts. He was confident that his brushwork could quickly impart life to anything, and he was right. For that was the greatest secret of Rubens's art - his magic skill in making anything alive, intensely and joyfully alive. We can best gauge and admire this mastery of his in some of the simple drawings, page 16, figure 1, and paintings done for his own pleasure. Figure 257 shows the head of a little girl, probably Rubens's daughter.

There are no tricks of composition here, no splendid robes or streams of light, but a simple *en face* portrait of a child. And yet it seems to breathe and palpitate like living flesh. Compared with this, the portraits of earlier centuries seem somehow remote and unreal – however great they may be as works of art. It is vain to try to analyse how Rubens achieved this impression of gay vitality, but it surely had something to do with the bold and delicate touches of light with which he indicated the moisture of the lips and the modelling of the face and hair. To an even greater degree than Titian before him, he used the brush as his main instrument. His paintings are no longer drawings carefully modelled in colour – they are produced by 'painterly' means, and that enhances the impression of life and vigour.

It was a combination of his unrivalled gifts in arranging large colourful compositions, and in infusing them with buoyant energy, that secured a fame and success for Rubens such as no painter had enjoyed before. His art was so eminently suitable to enhance the pomp and splendour of palaces, and to glorify the powers of this world, that he enjoyed something like a monopoly in the sphere in which he moved. It was the time during which the religious and social tensions of Europe came to a head in the fearful Thirty Years' War on the Continent and in the Civil War in England. On the one side stood the absolute monarchs and their courts, most of them supported by the Catholic Church – on the other the rising merchant cities, most of them Protestant. The Netherlands themselves were divided into Protestant Holland, which resisted Spanish 'Catholic' domination, and Catholic Flanders, ruled from Antwerp under Spanish allegiance. It was as

257

Peter Paul Rubens Head of a child, probably the artist's daughter Clara Serena, c. 1616

Oil on canvas, mounted on wood, 33 × 26.3 cm, 13 × 10% in; Sammlungen des Fürsten von Liechtenstein, Vaduz

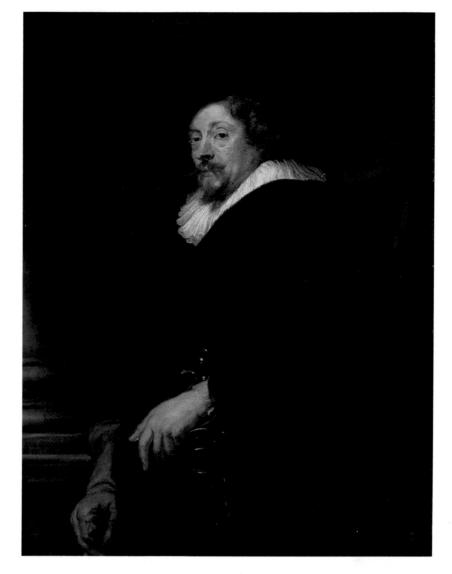

the painter of the Catholic camp that Rubens rose to his unique position. He accepted commissions from the Jesuits in Antwerp and from the Catholic rulers of Flanders, from King Louis XIII of France and his crafty mother Maria de' Medici, from King Philip III of Spain and King Charles I of England, who conferred a knighthood on him. When travelling from court to court as an honoured guest, he was often charged with delicate political and diplomatic missions, foremost among them that of effecting a reconciliation between England and Spain in the interest of what we would call today a 'reactionary' bloc. Meanwhile he remained in touch with the scholars of his age, and engaged in learned Latin correspondence on questions of archaeology and art. His self-portrait with the nobleman's sword, *figure 258*, shows that he was very conscious of his unique position. Yet there is nothing pompous or vain in the shrewd look of his eyes. He

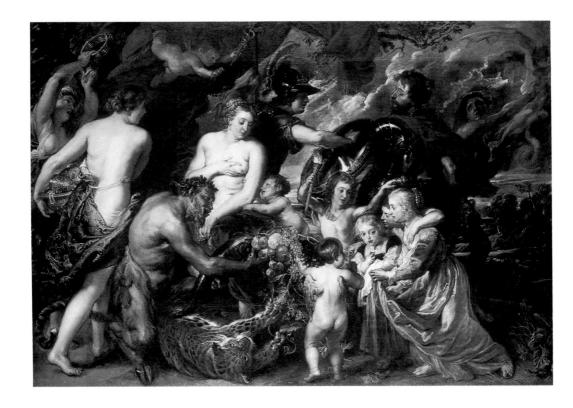

remained a true artist. All the while, pictures of dazzling mastery poured out from his Antwerp studios on a stupendous scale. Under his hand, the classical fables and allegorical inventions became as convincingly alive as the picture of his own daughter.

Allegorical pictures are usually regarded as rather boring and abstract, but for the age of Rubens they were a convenient means of expressing ideas. Figure 259 is such a picture, which Rubens is said to have presented as a gift to Charles I, when he tried to induce him to make peace with Spain. The painting contrasts the blessings of peace with the horrors of war. Minerva, the goddess of wisdom and the civilizing arts, drives away Mars, who is about to withdraw – his dreadful companion, the Fury of war, having already turned back. And under the protection of Minerva the joys of peace are spread out before our eyes, symbols of fruitfulness and plenty as only Rubens could conceive them: Peace offering her breast to a child, a faun blissfully eyeing the gorgeous fruits, figure 260, the other companions of Bacchus, dancing maenads with gold and treasures, and the panther playing peacefully like a big cat; on the other side three children with anxious eyes, fleeing from the terror of war to the haven of peace and

259
Peter Paul Rubens
Allegory on the blessings
of peace, 1629–30
Oil on canvas, 203.5 ×
298 cm, 80% × 117½ in;
National Gallery, London

plenty, crowned by a young genius. No one who loses himself in the rich details of this picture, with its vivid contrasts and glowing colours, can fail to see that these ideas were to Rubens not pale abstractions but forceful realities. Perhaps it is because of this quality that some people must first get accustomed to Rubens before they begin to love and understand him. He had no use for the 'ideal' forms of classical beauty. They were too remote and abstract for him. His men and women are living beings such as he saw and liked. And so, since slenderness was not the fashion in the Flanders of his day, some people object to the 'fat women' in his pictures. This criticism, of course, has little to do with art and we need not, therefore, take it too seriously. But, since it is so often made, it may be well to realize that joy in exuberant and almost boisterous life in all its manifestations saved Rubens from becoming a mere virtuoso of his art. It turned his paintings from mere Baroque decorations of festive halls into masterpieces which retain their vitality even within the chilling atmosphere of museums.

Among Rubens's many famous pupils and assistants, the greatest and most independent was Anthony van Dyck (1599–1641), who was twenty-two years his junior, and belonged to the generation of Poussin and Claude Lorrain. He soon acquired all the virtuosity of Rubens in rendering the texture and surface of things, whether it were silk or human flesh, but

Victoria Public Library 302 N. Main Victoria, Tx. 77901

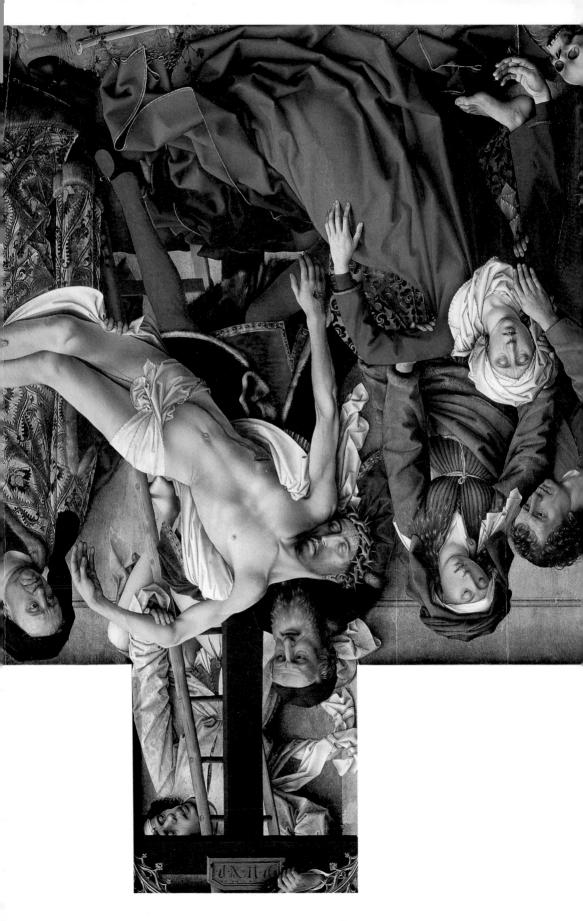

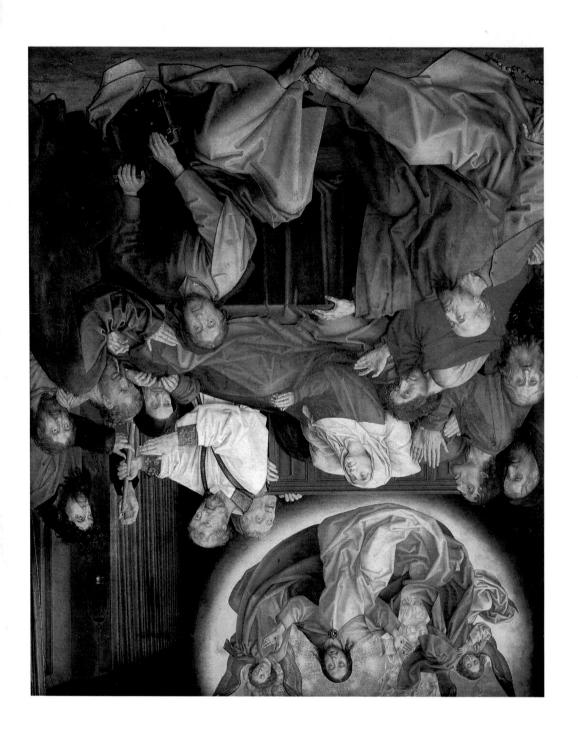

26

Anthony van Dyck Charles I of England, c. 1635 Oil on canvas, 266 × 207

cm, $104\frac{3}{4} \times 81\frac{1}{2}$ in; Louvre, Paris

262

Anthony van Dyck Lord John and Lord Bernard Stuart, c. 1638 Oil on canvas, 237.5 × 146.1 cm, 93½ × 57½ in;

National Gallery, London

he differed widely from his master in temperament and mood. It seems that Van Dyck was not a healthy man, and in his paintings a languid and slightly melancholy mood often prevails. It may have been this quality that appealed to the austere noblemen of Genoa and to the cavaliers of Charles I's entourage. In 1632 he had become the Court Painter of Charles I, and his name was anglicized into Sir Anthony Vandyke. It is to him that we owe an artistic record of this society with its defiantly aristocratic bearing and its cult of courtly refinement. His portrait of Charles I, figure 261, just dismounted from his horse on a hunting expedition, showed the Stuart monarch as he would have wished to live in history: a figure of matchless elegance, of unquestioned authority and high culture, the patron of the arts, and the upholder of the divine right of kings, a man who needed no outward trappings of power to enhance his natural dignity. No wonder that a painter who could bring out these qualities in his portraits with such perfection was eagerly sought after by society. In fact, Van Dyck was so overburdened with commissions for portraits that he, like his master Rubens, was unable to cope with them all himself. He had a number of assistants, who painted the costumes of his sitters arranged on dummies, and he did not always paint even the whole of the head. Some of these portraits are uncomfortably near the flattering fashion-dummies of later

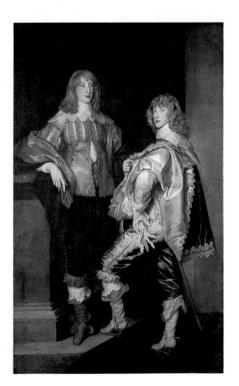

periods, and there is no doubt that Van Dyck established a dangerous precedent which did much harm to portrait painting. But all this cannot detract from the greatness of his best portraits. Nor should it make us forget that it was he, more than anyone else, who helped to crystallize the ideals of blueblooded nobility and gentlemanly ease, *figure 262*, which enrich our vision of man no less than do Rubens's robust and sturdy figures of overbrimming life.

On one of his journeys to Spain, Rubens had met a young painter who was born in the same year as his pupil Van Dyck, and who filled a position at the court of King Philip IV in Madrid similar to that of Van Dyck at the court of Charles I. He was Diego Velázquez (1599–1660). Though he had not yet been to Italy, Velázquez had been profoundly impressed by the discoveries and the manner of Caravaggio, which he got to know through the work of imitators. He had absorbed the programme of 'naturalism', and devoted his art to the dispassionate observation of nature regardless of

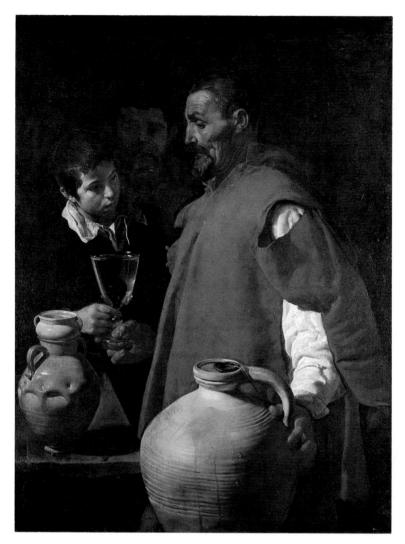

263
Diego Velázquez,
The water-seller of
Seville, c. 1619–20
Oil on canvas, 106.7 ×
81 cm, 42 × 31% in;
Wellington Museum,
Apsley House, London

conventions. Figure 263 shows one of his early works, an old man selling water in the streets of Seville. It is a genre picture of the type the Netherlanders invented to display their skill, but it is done with all the intensity and penetration of Caravaggio's 'Doubting Thomas', figure 252. The old man with his worn and wrinkly face and his ragged cloak, the big earthenware flask with its rounded shape, the surface of the glazed jug and the play of light on the transparent glass, all this is painted so convincingly that we feel we could touch the objects. No one who stands before this picture feels inclined to ask whether the objects represented are beautiful or ugly, or whether the scene it represents is important or trivial. Not even the colours are strictly beautiful by themselves. Brown, grey, greenish tones prevail. And yet, the whole is joined together in such a rich and mellow harmony that the picture remains quite unforgettable to anyone who has ever paused in front of it.

On the advice of Rubens, Velázquez obtained leave to go to Rome

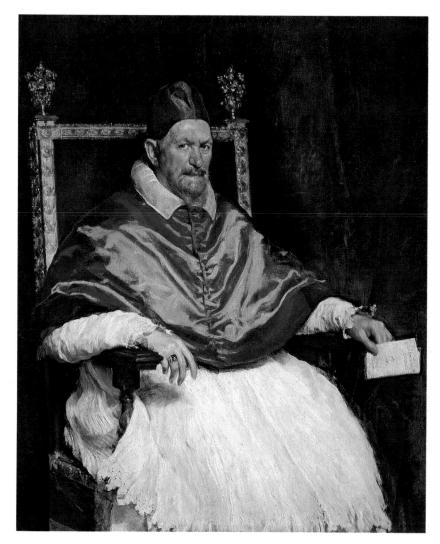

264
Diego Velázquez
Pope Innocent X,
1649–50
Oil on canvas, 140 ×
120 cm, 55% × 47½ in;
Galleria Doria Pamphilj,
Rome

to study the paintings of the great masters. He went there in 1630 but soon returned to Madrid where, apart from a second Italian journey, he remained as a famous and respected member of the court of Philip IV. His main task was to paint the portraits of the King and the members of the royal family. While few of them had attractive, or even interesting, faces, they certainly insisted on their dignity, and dressed in a stiff and unbecoming fashion. Not a very inviting task for a painter, it would seem. But Velázquez transformed these portraits, as if by magic, into some of the most fascinating pieces of painting the world has ever seen. He had long given up too close an adherence to Caravaggio's manner. He had studied the brushwork of Rubens and of Titian, but there is nothing 'secondhand' in his mode of approaching nature. Figure 264 shows Velázquez's portrait of Pope Innocent X, painted in Rome in 1649–50, a little more than a hundred years after Titian's Paul III, page 335, figure 214; it reminds us that in the history of art the passage of time need not always lead to a change in

outlook. Velázquez surely felt the challenge of that masterpiece, much as Titian had been stimulated by Raphael's group, page 322, figure 206. But for all his mastery of Titian's means, the way his brush renders the sheen of the material and the sureness of touch with which he seizes the Pope's expression, we do not doubt for a moment that this is the man himself and not a well-rehearsed formula. Nobody who goes to Rome should miss the great experience of seeing this masterpiece in the Palazzo Doria Pamphili. Indeed, Velázquez's mature works rely to such an extent on the effect of the brushwork, and on the delicate harmony of the colours, that illustrations can give only very little idea of what the originals are like. Most of all this applies to his enormous canvas (some ten feet high) which goes under the name Las Meninas (the maids of honour), figure 266. We see Velázquez himself at work on a large painting and if we look more carefully we also discover what it is he is painting. The mirror on the back wall of the studio reflects the figures of the King and Queen, figure 265, who are sitting for their portrait. We therefore see what they see – a crowd of people who have come into the studio. It is their little daughter, the Infanta Margarita, flanked by two maids of honour, one of them serving her refreshments while the other curtsies to the royal couple. We know their names as we also know about the two dwarfs (the ugly female and the boy teasing a dog), who were kept for amusement. The grave adults in the background seem to make sure that the visitors behave.

What exactly does it all signify? We may never know, but I should like to fancy that Velázquez has arrested a real moment of time

long before the invention of the camera. Perhaps the princess was brought into the royal presence to relieve the boredom of the sitting and the King or Queen remarked to Velázquez that here was a worthy subject for his brush. The words spoken by the sovereign are always treated as a command and so we may owe this masterpiece to a passing wish which only Velázquez was able to turn into reality.

But of course Velázquez did not usually rely on such incidents to transform his records of reality into great paintings. There is nothing unconventional in a portrait such as 266

Diego Velázquez Las Meninas, 1656 Oil on canvas, 318 × 276 cm, 125½ × 108¼ in; Prado, Madrid

Detail of figure 266

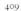

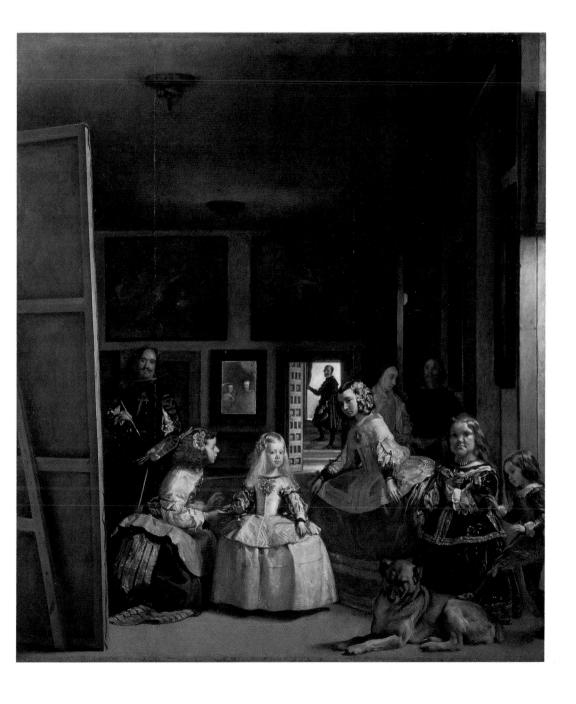

267
Diego Velázquez
Prince Philip Prosper
of Spain, 1659
Oil on canvas, 128.5 ×
99.5 cm, 50 × 39 in;
Kunsthistorisches
Museum, Vienna

his picture of the two-year-old Prince Philip Prosper of Spain, *figure 267*, nothing, perhaps, that strikes us at first glance. But in the original, the various shades of red (from the rich Persian carpet to the velvet chair, the curtain, the sleeves and the rosy cheeks of the child), combined with the cool and silvery tones of white and grey which shade into the background, result in a unique harmony. Even a little motif like the small dog on the red chair reveals an unobtrusive mastery which is truly miraculous. If we look back at the little dog in Jan van Eyck's portrait of the Arnolfini

couple, page 243, figure 160, we see with what different means great artists can achieve their effects. Van Eyck took pains to copy every curly hair of the little creature – Velázquez, two hundred years later, tried only to catch its characteristic impression. Like Leonardo, only more so, he relied on our imagination to follow his guidance and to supplement what he had left out. Though he did not paint one separate hair, his little dog looks, in effect, more furry and natural than Van Eyck's. It was for effects like these that the founders of Impressionism in nineteenth-century Paris admired Velázquez above all other painters of the past.

To see and observe nature with ever-fresh eyes, to discover and enjoy ever-new harmonies of colours and lights, had become the essential task of the painter. In this new zeal, the great masters of Catholic Europe found themselves at one with the painters on the other side of the political barrier, the great artists of the Protestant Netherlands.

An artist's pub in seventeenth century Rome, with caricatures on the wall, c. 1625–39 Drawing by Pieter van Laar; pen, ink and wash on paper, 20.3 × 25.8 cm, 8 × 10½ in; Kupferstichkabinett, Staatliche Museen, Berlin

THE MIRROR OF NATURE

Holland, seventeenth century

The division of Europe into a Catholic and a Protestant camp affected even the art of small countries like the Netherlands. The southern Netherlands, which today we call Belgium, had remained Catholic, and we have seen how Rubens in Antwerp received innumerable commissions from churches, princes and kings to paint vast canvases for the glorification of their power. The northern provinces of the Netherlands, however, had risen against their Catholic overlords, the Spaniards, and most of the inhabitants of their rich merchant towns adhered to the Protestant faith. The taste of these Protestant merchants of Holland was very different from that prevailing across the border. These men were rather comparable in their outlook to the Puritans in England: devout, hard-working, parsimonious men, most of whom disliked the exuberant pomp of the southern manner. Though their outlook mellowed as their security increased and their wealth grew, these Dutch burghers of the seventeenth century never accepted the full Baroque style which held sway in Catholic Europe. Even in architecture they preferred a certain sober restraint. When, in the middle of the seventeenth century, at the peak of Holland's successes, the citizens of Amsterdam decided to erect a large town hall which was to reflect the pride and achievement of their new-born nation, they chose a model which, for all its grandeur, looks simple in outline and sparing in decoration, figure 268.

We have seen that the effect on painting of the victory of Protestantism was even more marked, *page 374*. We know that the catastrophe was so great that in both England and Germany, where the arts had flourished as much as anywhere during the Middle Ages, the career of a painter or a sculptor ceased to attract native talents. We remember that in the Netherlands, where the tradition of good craftsmanship was so strong, painters had to concentrate on certain branches of painting to which there was no objection on religious grounds.

The most important of these branches that could continue in a Protestant community, as Holbein had experienced in his day, was portrait painting. Many a successful merchant wanted to hand down his likeness to those after him, many a worthy burgher who had been elected alderman or

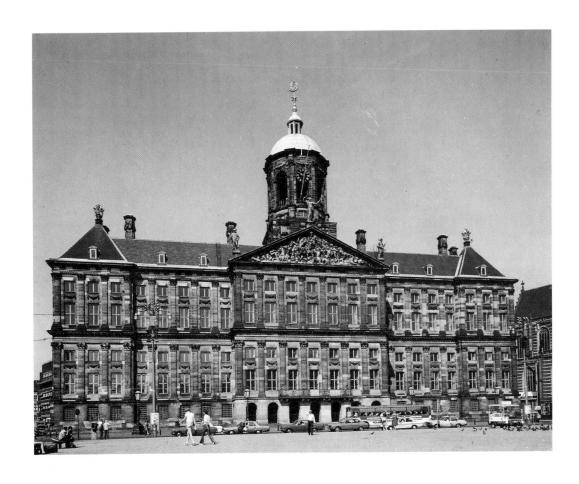

burgomaster desired to be painted with the insignia of his office. Moreover, there were many local committees and governing boards, prominent in the life of Dutch cities, which followed the praiseworthy custom of having their group portraits painted for the board-rooms and meeting-places of their worshipful companies. An artist whose manner appealed to this public could therefore hope for a reasonably steady income. Once his manner ceased to be fashionable, however, he might face ruin.

The first outstanding master of free Holland, Frans Hals (1580?–1666), was forced to lead such a precarious existence. Hals belonged to the same generation as Rubens. His parents had left the southern Netherlands because they were Protestants and had settled in the prosperous Dutch city of Haarlem. We know little about his life except that he frequently owed money to his baker or shoemaker. In his old age – he lived to be over

268

Jakob van Campen, The Royal Palace (former Town Hall), Amsterdam, 1648 A Dutch seventeenthcentury town hall eighty – he was granted a small pittance by the municipal almshouse, whose board of governors he painted. *Figure 269*, which dates from near the beginning of his career, shows the brilliance and originality with which he approached this kind of task. The citizens of the proudly independent towns of the Netherlands had to do their turn in serving as militiamen, usually under the command of the most prosperous inhabitants. It was the custom in the city of Haarlem to honour the officers of these units after their stint of duty with a sumptuous banquet, and it had also become a tradition to commemorate these happy events in a large painting. It was surely no easy matter for an artist to record the likenesses of so many men within one frame without the result looking stiff or contrived – as earlier such efforts invariably did.

Hals understood from the beginning how to convey the spirit of the jolly occasion and how to bring life into such a ceremonial group without neglecting the purpose of showing each of the twelve members present so convincingly that we feel we must have met them: from the portly colonel who presides at the end of the table, raising his glass, to the young ensign on the opposite side who is not accorded a seat, but proudly looks out of the picture as if he wants us to admire his splendid outfit.

269
Frans Hals
Banquet of the officers of
the St George Militia
Company, 1616
Oil on canvas, 175 ×
324 cm, 69 × 127½ in;
Frans Halsmuseum,

Haarlem

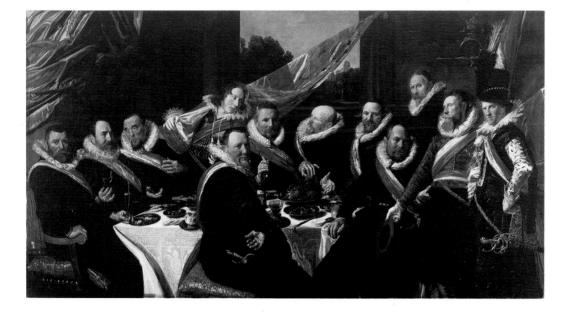

Perhaps we can admire his mastery even more when we look at one of the many individual portraits that brought so little money to Hals and his family, figure 270. Compared to earlier portraits, it looks almost like a snapshot. We seem to know this Pieter van den Broecke, a true merchant-adventurer of the seventeenth century. Let us think back to Holbein's painting of Sir Richard Southwell, page 377, figure 242, painted less than a century earlier, or even to the portraits which Rubens, Van Dyck or Velázquez painted at that time in Catholic Europe. For all their liveliness and truth to nature one feels that the painters had carefully arranged the sitter's pose so as to convey the idea of dignified aristocratic breeding. The portraits of Hals give us the impression that the painter has 'caught' his sitter at a characteristic moment and fixed it for ever on the canvas. It is difficult for us to imagine how bold and unconventional these paintings must have looked to the public. The very way in which Hals handled paint and brush suggests that he quickly seized a fleeting impression. Earlier portraits are painted with visible patience – we sometimes feel that the subject must have sat still for many a session while the painter carefully recorded detail upon detail. Hals never allowed his model to get tired or stale. We seem to witness his quick and deft handling of the brush through which he conjures up the image of tousled hair or of a crumpled sleeve with a few touches of light and dark paint. Of course, the impression that Hals gives us, the impression of a casual glimpse of the sitter in a characteristic movement and mood, could never have been achieved without a very calculated effort. What looks at first like a happy-go-lucky approach is really the result of a carefully thought-out effect. Though the portrait is not symmetrical, as earlier portraits often were, it is not lopsided. Like other masters of the Baroque period, Hals knew how to attain the impression of balance without appearing to follow any rule.

The painters of Protestant Holland who had no inclination or talent for portrait painting had to give up the idea of relying chiefly on commissions. Unlike the masters of the Middle Ages and of the Renaissance, they had to paint their picture first, and then try to find a buyer. We are now so used to this state of affairs, we take it so much for granted that an artist is a man painting away in his studio, which is packed full of pictures he is desperately trying to sell, that we can hardly imagine the change this situation brought about. In one respect, artists may possibly have been glad to be rid of patrons who interfered with their work and who may sometimes have bullied them. But this freedom was dearly bought. For, instead of a single patron, the artist had now to cope with an even more tyrannical master – the buying public. He had either to go to the market-place and to public fairs, there to peddle his wares, or to rely on

270
Frans Hals
Pieter van den Broecke,
c. 1633
Oil on canvas, 71.2 × 61

cm, 28 × 24 in; Iveagh Bequest, Kenwood, London

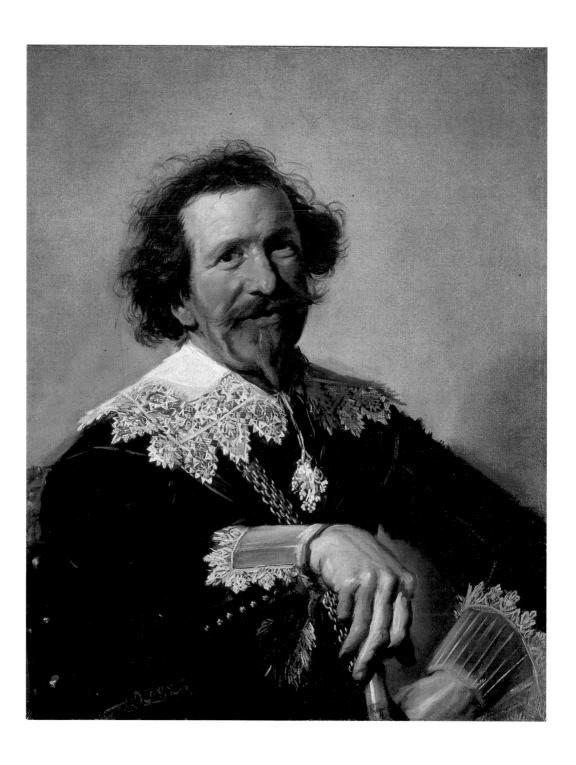

Simon de Vlieger,
Dutch man of war and
various vessels in a
breeze, c. 1640-5
Oil on wood, 41.2 × 54.8
cm, 16¼ × 21¾ in;
National Gallery, London

middlemen, picture dealers who relieved him of this burden but who wanted to buy as cheaply as possible in order to be able to sell at a profit. Moreover, competition was very stiff; there were many artists in each Dutch town exhibiting their paintings on the stalls, and the only chance for the minor masters to make a reputation lay in specializing in one particular branch or genre of painting. Then, as now, the public liked to know what it was getting. Once a painter had made a name as a master of battle-pieces, it was battle-pieces he would be most likely to sell. If he had had success with landscapes in moonlight, it might be safer to stick to that, and to paint more landscapes in moonlight. Thus it came about that the trend towards specialization which had begun in the northern countries in the sixteenth century, page 381, was carried to even greater extremes in the seventeenth. Some of the weaker painters became content to turn out the same kind of picture over and over again. It is true that in doing so they sometimes carried their trade to a pitch of perfection which commands our admiration. These specialists were real specialists. The painters of fish knew how to render the silvery hue of wet scales with a virtuosity which puts many a more universal master to shame; and the painters of seascapes not only became proficient in the painting of waves and clouds, but were such experts in the accurate portrayal of ships and their tackle that their paintings are still considered valuable historical documents of the period of England's and Holland's naval expansion. Figure 271 shows a painting by one of the oldest of these specialists in seascapes, Simon de Vlieger (1601-53). It shows how these Dutch artists could convey the atmosphere of the sea by wonderfully simple and unpretentious means. These Dutchmen were the first in the history of art to discover the beauty of the sky. They needed nothing dramatic or striking to make their pictures interesting. They simply represented a piece of the world as it appeared to them, and discovered that it could make just as satisfying a picture as any illustration of a heroic tale or a comic theme.

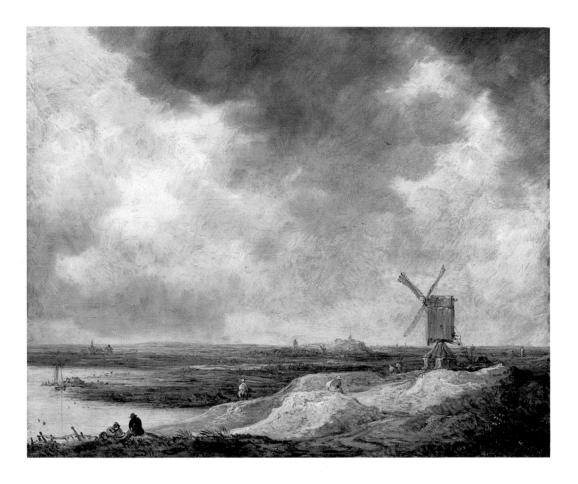

Jan van Goyen, Windmill by a river, 1642

Oil on wood, 25.2×34 cm, $10 \times 13\%$ in; National Gallery, London

One of these discoverers was Jan van Goyen (1596–1656), from The Hague, who was roughly of the same generation as the landscape painter Claude Lorrain. It is interesting to compare one of the famous landscapes of Claude, page 396, figure 255, a nostalgic vision of a land of serene beauty, with the simple and straightforward painting by Jan van Goyen, figure 272. The differences are too obvious to need labouring. Instead of lofty temples, the Dutchman paints a homely windmill; instead of alluring glades, a featureless stretch of his native land. But Van Goyen knows how to transform the commonplace scene into a vision of restful beauty. He transfigures familiar motifs, and leads our eyes into the hazy distance, so that we feel as if we were ourselves standing at a point of vantage and looking into the light of the evening. We have seen how the inventions of Claude so captured the imagination of his admirers in England that they tried to transform the actual scenery of their native land, and make it conform to the creations of the painter. A landscape or a garden which made them think of Claude, they called 'picturesque', like a picture. We have since become used to applying this word not only to ruined castles and sunsets, but also to such simple things as sailing boats and windmills.

When we come to consider it, we do so because such motifs remind us of pictures not by Claude, but by masters like de Vlieger or Van Goyen. It is they who have taught us to see the 'picturesque' in a simple scene. Many a rambler in the countryside who delights in what he sees may, without knowing it, owe his joy to those humble masters who first opened our eyes to unpretentious natural beauty.

The greatest painter of Holland, and one of the greatest painters who ever lived, was Rembrandt van Rijn (1606–69), who was a generation younger than Frans Hals and Rubens, and seven years younger than Van Dyck and Velázquez. Rembrandt did not write down his observations as Leonardo and Dürer did; he was no admired genius as Michelangelo was, whose sayings were handed down to posterity; he was no diplomatic letter-writer like Rubens, who exchanged ideas with the leading scholars of his age. Yet we feel that we know Rembrandt perhaps more intimately than any of these great masters, because he left us an amazing record of his life in a series of self-portraits ranging from the time of his youth, when he was a successful and even fashionable master, to his lonely old age when his face reflected the tragedy of bankruptcy and the unbroken will of a truly great man. These portraits combine into a unique autobiography.

Rembrandt was born in 1606, the son of a well-to-do miller in the university town of Leiden. He matriculated at the University, but soon abandoned his studies to become a painter. Some of his earliest works were greatly praised by contemporary scholars, and at the age of twenty-five Rembrandt left Leiden for the teeming commercial centre of Amsterdam. There he made a rapid career as a portrait painter, married a wealthy girl, bought a house, collected works of art and curios and worked incessantly. When his first wife died, in 1642, she left him a considerable fortune, but Rembrandt's popularity with the public declined, he got into debt, and fourteen years later his creditors sold his house and put his collection up for auction. Only the help of his loyal mistress and his son saved him from utter ruin. They made an arrangement by which he was formally an employee of their art-dealing firm, and, as such, he painted his last great masterpieces. But these faithful companions died before him, and when his life came to an end in 1669, he left no other property than some old clothes and his painting utensils. Figure 273 shows us Rembrandt's face during the later years of his life. It was not a beautiful face, and Rembrandt certainly never tried to conceal its ugliness. He observed himself in a mirror with complete sincerity. It is because of this sincerity that we soon forget to ask about beauty or looks. This is the face of a real human being. There is no trace of a pose, no trace of vanity, just the penetrating gaze of a painter who scrutinizes his own features, ever ready to learn more and more about the secrets of the human face. Without this profound

Rembrandt van Rijn Self-portrait, c. 1655–8 Oil on wood, 49.2 × 41

cm, 19% × 16% in; Kunsthistorisches Museum, Vienna

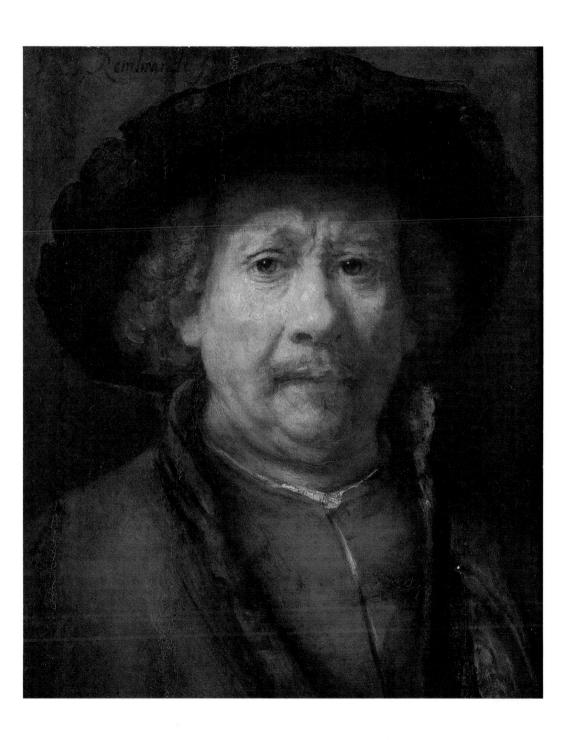

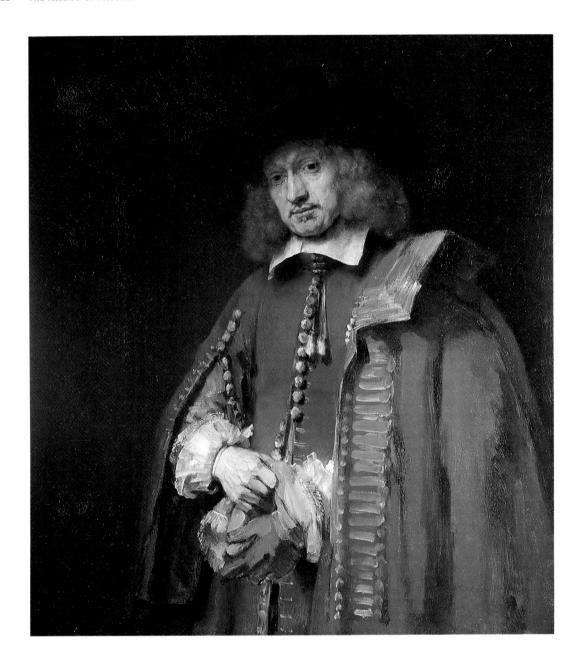

understanding Rembrandt could not have created his great portraits, such as the likeness of his patron and friend, Jan Six, who later became burgomaster of Amsterdam, *figure 274*. It is almost unfair to compare it with the lively portrait by Frans Hals, for where Hals gives us something like a convincing snapshot, Rembrandt always seems to show us the whole person. Like Hals, he enjoyed his virtuosity, the skill with which he could suggest the sheen of the gold braid or the play of light on the ruff. He claimed the artist's right to declare a picture finished – as he said – 'when he had achieved his purpose', and thus he left the hand in the glove as a

274

Rembrandt van Rijn,

Jan Six, 1654

Oil on canvas, 112 ×
102 cm, 44% × 40% in;

Collectic Six, Amsterdam

Rembrandt van Rijn Parable of the Merciless Servant, c. 1655 Reed pen and brown ink

Reed pen and brown ink on paper, 17.3 × 21.8 cm, $6\frac{3}{4}$ × $8\frac{1}{2}$ in; Louvre, Paris

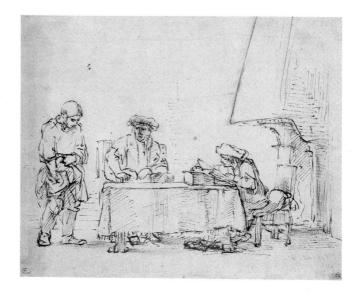

mere sketch. But all this only enhances the sense of life that emanates from his figure. We feel we know this man. We have seen other portraits by great masters which are memorable for the way they sum up a person's character and role. But even the greatest of them may remind us of characters in fiction or actors on the stage. They are convincing and impressive, but we sense that they can only represent one side of a complex human being. Not even the Mona Lisa can always have smiled. But in Rembrandt's great portraits we feel face to face with real people, we sense their warmth, their need for sympathy and also their loneliness and their suffering. Those keen and steady eyes that we know so well from Rembrandt's self-portraits must have been able to look straight into the human heart.

I realize that such an expression may sound sentimental, but I know no other way of describing the almost uncanny knowledge Rembrandt appears to have had of what the Greeks called the 'workings of the soul', page 94. Like Shakespeare, he seems to have been able to get into the skin of all types of men, and to know how they would behave in any given situation. It is this gift that makes Rembrandt's illustrations of biblical stories so different from anything that had been done before. As a devout Protestant, Rembrandt must have read the Bible again and again. He entered into the spirit of its episodes, and attempted to visualize exactly what the situation must have been like, and how people would have moved and borne themselves at such a moment. Figure 275 shows a drawing in which Rembrandt illustrated the parable of the Merciless Servant (Matthew xviii. 21-35). There is no need to explain the drawing. It explains itself. We see the lord on the day of reckoning, with his steward looking up the servant's debts in a big ledger. We see from the way the servant stands, his head lowered, his hand fumbling deep in his pocket, that he is unable to pay. The relationship of these three people to each

other, the busy steward, the dignified lord and the guilty servant, is expressed with a few strokes of the pen.

Rembrandt needs hardly any gestures or movements to express the inner meaning of a scene. He is never theatrical. Figure 276 shows one of the paintings in which he visualized another incident from the Bible which had hardly ever been illustrated before - the reconciliation between King David and his wicked son Absalom. When Rembrandt was reading the Old Testament, and tried to see the kings and patriarchs of the Holy Land in his mind's eye, he thought of the Orientals he had seen in the busy port of Amsterdam. That is why he dressed David like an Indian or Turk with a big turban, and gave Absalom a curved Oriental sword. His painter's eye was attracted by the splendour of these costumes, and by the chance they gave him of showing the play of light on the precious fabric, and the sparkle of gold and jewellery. We can see that Rembrandt was as great a master in conjuring up the effect of these shining textures as Rubens or Velázquez. Rembrandt used less bright colour than either of them. The first impression of many of his paintings is that of a rather dark brown. But these dark tones give even more power and force to the contrast of a few bright and brilliant colours. The result is that the light on some of Rembrandt's pictures looks almost dazzling. But Rembrandt never used these magic effects of light and shade for their own sake. They always served to enhance the drama of the scene. What could be more moving than the gesture of the young prince in his proud array, burying his face on his father's breast, or King David in his quiet and sorrowful acceptance of his son's submission? Though we do not see Absalom's face, we feel what he must feel.

Like Dürer before him, Rembrandt was great not only as a painter but also as a graphic artist. The technique he used was no longer that of woodcuts or copper-engraving, pages 282–3, but a method which allowed him to work more freely and more quickly than was possible with the burin. This technique is called etching. Its principle is quite simple. Instead of laboriously scratching the surface of the copper plate, the artist covers the plate with wax and draws on it with a needle. Wherever his needle goes, the wax is removed and the copper laid bare. All he has to do afterwards is to put his plate into an acid which bites into the copper where the wax has gone, and thus transfer the drawing on to the copper plate. The plate can then be printed in the same way as an engraving. The only means of telling an etching from an engraving is by judging the character of the lines. There is a visible difference between the laborious and slow work of the burin and the free and easy play of the etcher's needle. Figure 277 shows one

Rembrandt van Rijn The reconciliation of David and Absalom,

276

Oil on wood, 73×61.5 cm, $28\frac{3}{4} \times 24\frac{1}{4}$ in; Hermitage, St Petersburg

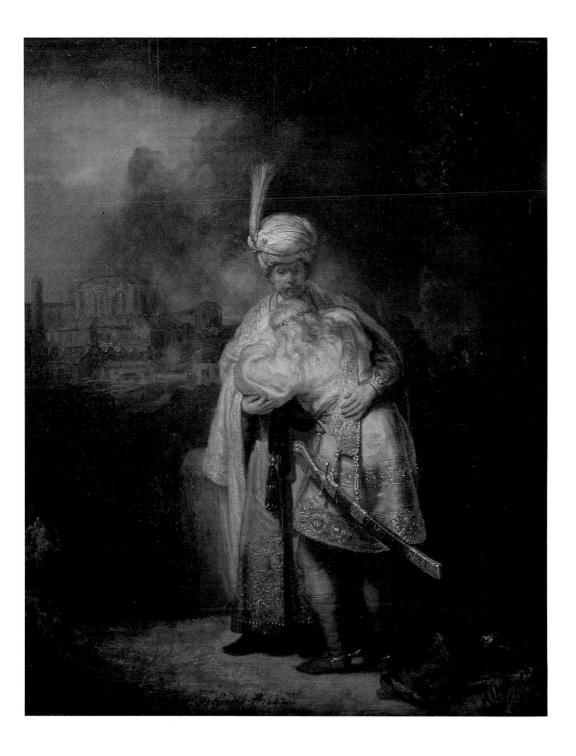

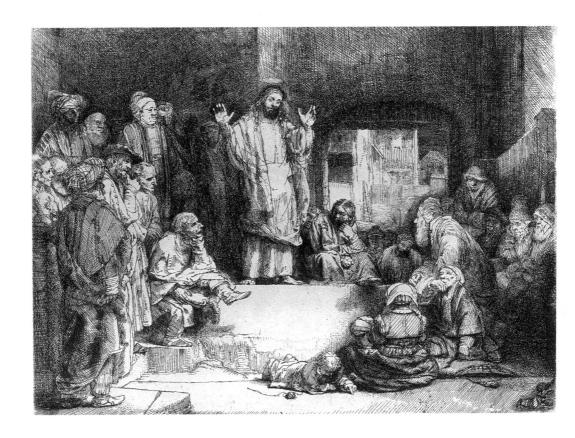

277 Rembrandt van Rijn *Christ preaching*, c. 1652

Etching, 15.5 × 20.7 cm, 61/8 × 81/8 in of Rembrandt's etchings – another biblical scene. Christ is preaching, and the poor and humble have gathered round Him to listen. This time Rembrandt has turned to his own city for models. He lived for a long time in the Jewish quarter of Amsterdam, and he studied the appearance and dresses of the Jews so as to introduce them into his sacred stories. Here they stand and sit, huddled together, some listening, enraptured, others pondering the words of Jesus, some, like the fat man behind, perhaps scandalized by Christ's attack on the Pharisees. People who are used to the beautiful figures of Italian art are sometimes shocked when they first see Rembrandt's pictures because he seems to care nothing for beauty, and not even to shrink from outright ugliness. That is true, in a sense. Like other artists of his time, Rembrandt had absorbed the message of Caravaggio, whose work he came to know through Dutchmen who had fallen under his influence. Like Caravaggio, he valued truth and sincerity above harmony and beauty. Christ had preached to the poor, the hungry and the sad, and poverty, hunger and tears are not beautiful. Of course much depends on what we agree to call beauty. A child often finds the kind, wrinkled face of his grandmother more beautiful than the regular features of a film star, and why should he not? In the same way, one might say that the haggard old man in the right-hand corner of the etching, cowering, one hand before his face, and looking up, completely absorbed, is one of the most beautiful figures ever drawn. But perhaps it is really not very important what words we use to express our admiration.

Rembrandt's unconventional approach sometimes makes us forget how much artistic wisdom and skill he uses in the arrangement of his groups. Nothing could be more carefully balanced than the crowd forming a circle round Jesus, and yet standing at a respectful distance. In this art of distributing a mass of people, in apparently casual and yet perfectly harmonious groups, Rembrandt owed much to the tradition of Italian art, which he by no means despised. Nothing would be farther from the truth than to imagine that this great master was a lonely rebel whose greatness went unrecognized by contemporary Europe. It is true that his popularity as a portrait painter decreased as his art became more profound and uncompromising. But whatever the reasons for his personal tragedy and bankruptcy, his fame as an artist stood very high. The real tragedy, then as now, is that fame alone does not suffice to make a living.

The figure of Rembrandt is so important in all branches of Dutch art that no other painter of the period can bear comparison with him. That is not to say, however, that there were not many masters in the Protestant Netherlands who deserve to be studied and enjoyed in their

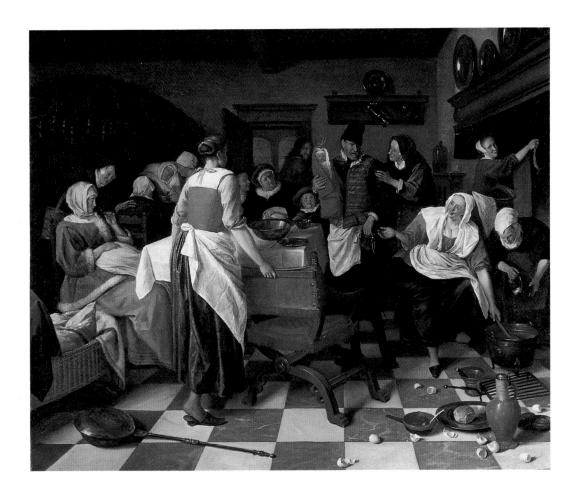

own right. Many of them followed the tradition of northern art in reproducing the life of the people in gay and unsophisticated paintings. We remember that this tradition reaches back to such examples of medieval miniatures as, page 211, figure 140, and page 274, figure 177. We remember how it was taken up by Bruegel, page 382, figure 246, who displayed his skill as a painter and his knowledge of human nature in humorous scenes from the lives of peasants. The seventeenth-century artist who brought this vein to perfection was Jan Steen (1626-79), Jan van Goyen's son-in-law. Like many other artists of his time, Steen could not support himself with his brush, and he kept an inn to earn money. One might almost imagine that he enjoyed this sideline, because it gave him an opportunity of watching the people in their revellings, and of adding to his store of comic types. Figure 278 shows a gay scene from the life of the people – a christening feast. We look into a comfortable room with a recess for the bed in which the mother lies, while friends and relations crowd round the father who holds the baby. It is well worth looking at these various types and their forms of merrymaking, but when we have examined all the detail we should not forget to admire the skill with which the artist has blended the

278

Jan Steen The christening feast, 1664

Oil on canvas, 88.9 × 108.6 cm, 35 × 42 in; Wallace Collection, London various incidents into a picture. The figure in the foreground, seen from behind, is a wonderful piece of painting, whose gay colours have a warmth and mellowness one does not easily forget when one has seen the original.

One often associates Dutch seventeenth-century art with the mood of gaiety and good living we find in Jan Steen's pictures, but there are other artists in Holland who represent a very different mood, one which comes much nearer to the spirit of Rembrandt. The outstanding example is another 'specialist', the landscape painter Jacob van Ruisdael (1628?-82). Ruisdael was about the same age as Jan Steen, which means that he belonged to the second generation of great Dutch painters. When he grew up the works of Jan van Goyen and even of Rembrandt were already famous and were bound to influence his taste and choice of themes. During the first half of his life he lived in the beautiful town of Haarlem, which is separated from the sea by a range of wooded dunes. He loved to study the effect of light and shade on these tracts and specialized more and more in picturesque forest scenes, figure 279. Ruisdael became a master in the painting of dark and sombre clouds, of evening light when the shadows grow, of ruined castles and rushing brooks; in short it was he who discovered the poetry of the northern landscape much as Claude had discovered the poetry of Italian scenery. Perhaps no artist before him had contrived to express so much of his own feelings and moods through their reflection in nature.

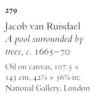

When I called this chapter 'The Mirror of Nature', I did not only want to say that Dutch art had learned to reproduce nature as faithfully as a mirror. Neither art nor nature is ever as smooth and cold as a glass. Nature reflected in art always reflects the artist's own mind, his predilections, his enjoyments and therefore his moods. It is this fact above all which renders the most 'specialized' branch of Dutch painting so interesting, the branch of still-life painting. These still lifes usually show beautiful vessels filled with wine and appetizing fruit, or other dainties invitingly arranged on lovely china. These were pictures which would go well into a diningroom and would be sure to find a buyer. But they are more than mere reminders of the joys of the table. In such still lifes, artists could freely pick up any objects they liked to paint, and arrange them on the table to suit their fancy. Thus they became a wonderful field of experiment for the painters' special problems. Willem Kalf (1619-93), for instance, liked to study the way in which light is reflected and broken by coloured glass. He studied the contrasts and harmonies of colours and textures, and tried to achieve ever-new harmonies between rich Persian carpets, gleaming china, brilliantly coloured fruit and polished metals, figure 280. Without knowing it themselves, these specialists began to demonstrate that the subject of a painting is much less important than might have been thought. Just as trivial words may provide the text for a beautiful song, so trivial objects can make a perfect picture.

This may seem a strange remark to make after the stress I have just laid on the subject-matter of Rembrandt's painting. But actually I do not think that there is a contradiction. A composer who sets to music not a trivial text but a great poem wants us to understand the poem, so that we may appreciate his musical interpretation. In the same way, a painter painting a biblical scene wants us to understand the scene to appreciate his conception. But just as there is great music without words, so there is great painting without an important subject-matter. It was this invention towards which the seventeenth-century artists had been groping when they discovered the sheer beauty of the visible world, *page 19*, *figure 4*. And the Dutch specialists who spent their lives painting the same kind of subject-matter ended by proving that the subject-matter was of secondary importance.

The greatest of these masters was born a generation after Rembrandt. He was Jan Vermeer van Delft (1632–75). Vermeer seems to have been a slow and a careful worker. He did not paint 28

Willem Kalf Still life with the drinking horn of the St Sebastian Archers' Guild, lobster and glasses, c. 1653 Oil on canvas, 86.4 × 102.2 cm, 34 × 40½ in; National Gallery, London

very many pictures in his life. Few of them represent any important scenes. Most of them show simple figures standing in a room of a typically Dutch house. Some show nothing but a single figure engaged in a simple task, such as a woman pouring out milk, figure 281. With Vermeer, genre painting has lost the last trace of humorous illustration. His paintings are really still lifes with human beings. It is hard to argue the reasons that make such a simple and unassuming picture one of the greatest masterpieces of all time. But few who have been lucky enough to see the original will disagree with me that it is something of a miracle. One of its miraculous features can perhaps be described, though hardly explained. It is the way in which Vermeer achieves complete and painstaking precision in the rendering of textures, colours and forms without the picture ever looking laboured or harsh. Like a photographer who deliberately softens the strong contrasts of the picture without blurring the forms, Vermeer mellowed the outlines and yet retained the effect of solidity and firmness. It is this strange and unique combination of mellowness and precision which makes his best paintings so unforgettable. They make us see the quiet beauty of a simple scene with fresh eyes and give us an idea of what the artist felt when he watched the light flooding through the window and heightening the colour of a piece of cloth.

Jan Vermeer
The kitchen maid,
c. 1660

Oil on canvas, 45.5 × 41 cm, 17% × 16% in; Rijksmuseum, Amsterdam

The poor painter shivering in his garret, c. 1640
Drawing by Pieter Bloot; black chalk on vellum, 17.7 × 15.5 cm, 7 × 6½ in;

British Museum, London

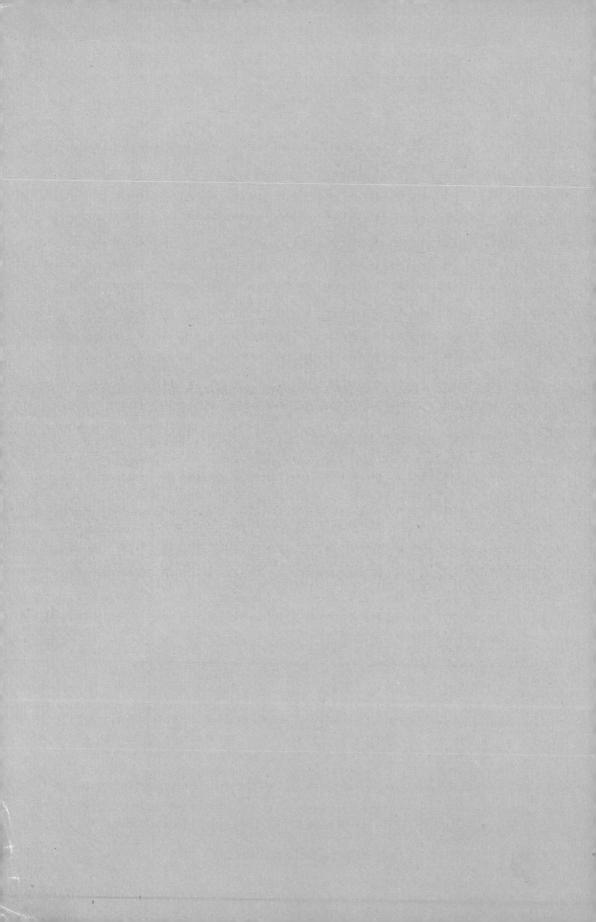

POWER AND GLORY: I

Italy, later seventeenth and eighteenth centuries

We remember the beginning of the Baroque manner of building in such works of late sixteenth-century art as Della Porta's church of the Jesuit Order, page 389, figure 250. Della Porta disregarded the so-called rules of classical architecture for the sake of greater variety and more imposing effects. It is in the nature of things that once art has taken this road it must keep to it. If variety and striking effects are considered important, each subsequent artist has to produce more complex decorations and more astounding ideas so as to remain impressive. During the first half of the seventeenth century, this process of piling up more and more dazzling new ideas for buildings and their decorations had gone on in Italy, and by the middle of the seventeenth century the style we call Baroque was fully developed.

Figure 282 shows a typical Baroque church built by the famous architect Francesco Borromini (1599–1667) and his assistants. It is easy to see that even the forms which Borromini applied are really Renaissance forms. Like Della Porta, he used the form of a temple front to frame the central entrance and, like him, he doubled the pilasters on the sides to gain a richer effect. But by comparison with Borromini's façade, Della Porta's looks almost severe and restrained. Borromini was no longer content with decorating a wall with the orders taken from classical architecture. He composed his church through a grouping of different forms - the vast cupola, the flanking towers and the façade. And this façade is curved as if it had been modelled in clay. If we look at the detail we find even more surprising effects. The first storey of the towers is square, but the second is round and the relation between the two storeys is brought about by a strangely broken entablature which would have horrified every orthodox teacher of architecture, but which does the job assigned to it extremely well. The frames of the doors flanking the main porch are even more astonishing. The way in which the pediment over the entrance is made to frame an oval window has no parallel in any earlier building. The scrolls and curves of the Baroque style had come to dominate both the general layout and the decorative details. It has been said of such Baroque buildings that they are over-ornate and theatrical. Borromini himself would hardly have understood why this should be a reproach. He wanted

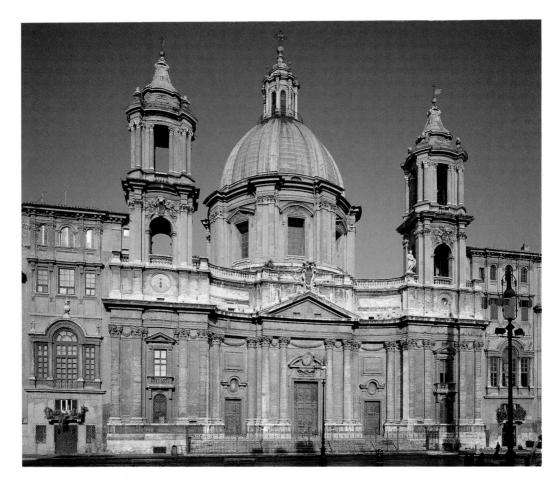

a church to look festive and to be a building full of splendour and movement. If it is the aim of the theatre to delight us with a vision of a fairy world of light and pageantry, why should not the architect designing a church have a right to give us an idea of even greater pomp and glory to remind us of Heaven?

When we enter these churches we understand even better how the pomp and display of precious stones, of gold and stucco, were used deliberately to conjure up a vision of heavenly glory much more concretely than the medieval cathedrals do. *Figure 283* shows the interior of Borromini's church. To those of us who are used to the church interiors of northern countries, this dazzling pageantry may well look too worldly for our taste. But the Catholic Church of the period thought differently. The more the Protestants preached against outward show in the churches, the more eager was the Roman Church to enlist the power of the artist. Thus the Reformation and the whole vexed issue of images and their worship,

282

Francesco Borromini & Carlo Rainaldi Church of Sta Agnese, Piazza Navona, Rome, 1653

A church of the Roman High Baroque

283
Francesco Borromini & Carlo Rainaldi
Interior of the church of
Sta Agnese, Piazza
Navona, Rome,
c. 1653

which had influenced the course of art so often in the past, also had an indirect effect on the development of Baroque. The Catholic world had discovered that art could serve religion in ways that went beyond the simple task assigned to it in the early Middle Ages – the task of teaching the Doctrine to people who could not read, *page 95*. It could help to persuade and convert those who had, perhaps, read too much. Architects, painters and sculptors were called upon to transform churches into grand show-pieces whose splendour and vision nearly swept you off your feet. It is not so much the details that matter in these interiors as the general effect of the whole. We cannot hope to understand them, or to judge them correctly, unless we visualize them as the framework for the splendid ritual of the Roman Church, unless we have seen them during High Mass, when the candles are alight on the altar, when the smell of incense fills the nave, and when the sound of the organ and the choir transports us into a different world.

This supreme art of theatrical decoration had mainly been developed by

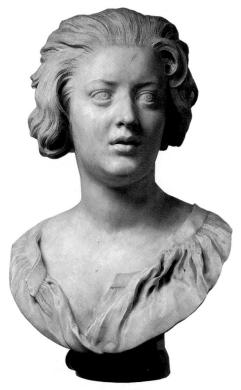

one artist, Gian Lorenzo Bernini (1598–1680). Bernini belonged to the same generation as Borromini. He was one year older than Van Dyck and Velázquez, and eight years older than Rembrandt. Like these masters, he was a consummate portraitist. Figure 284 shows his portrait bust of a young woman which has all the freshness and unconventionality of Bernini's best work. When I saw it last in the museum in Florence, a ray of sunlight was playing on the bust and the whole figure seemed to breathe and come to life. Bernini has caught a transient expression which we are sure must have been most characteristic of his sitter. In the rendering of facial expression. Bernini was perhaps unsurpassed.

He used it, as Rembrandt used his profound knowledge of human behaviour, to give visual form to his religious experience.

Figure 285 shows an altar of Bernini's for a side chapel in a small Roman church. It is dedicated to the Spanish saint Teresa, a nun of the sixteenth century who had described her mystic visions in a famous book. In it she tells of a moment of heavenly rapture, when an angel of the Lord pierced her heart with a golden flaming arrow, filling her with pain and yet with immeasurable bliss. It is this vision that Bernini has dared to represent. We see the saint carried heavenwards on a cloud, towards streams of light which pour down from above in the form of golden rays. We see the angel gently approaching her, and the saint swooning in ecstasy. The group is so placed that it seems to hover without support in the magnificent frame-can him fully provided by the altar, and to receive its light from an invisible window above. A northern visitor may again be inclined, at first, to find the whole arrangement too reminiscent of stage effects, and the group over-Bernini's altar may legitimately be used to arouse those feelings of fervid and from exultation and mystic transport at which the artists of the B aiming, we must admit that Bernini has achieved this aim in a masterly fashion. He has deliberately cast aside all restraint, and carried us to a pitch _ min

284

Gian Lorenzo Bernini Costanza Buonarelli, c. 1635

Marble, height 72 cm, 283/8 in; Museo Nazionale del Bargello, Florence

285

Gian Lorenzo Bernini The ecstasy of St Teresa, 1645-52 Marble, height 350 cm,

138 in; Cornaro Chapel, church of Sta Maria della Vittoria, Rome

bien cas

intended or promised ve mot ben for bein the

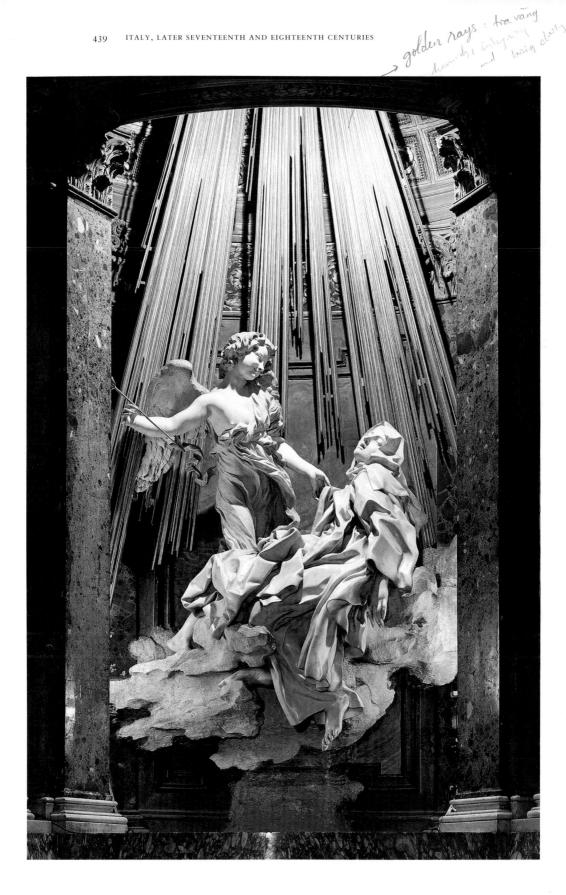

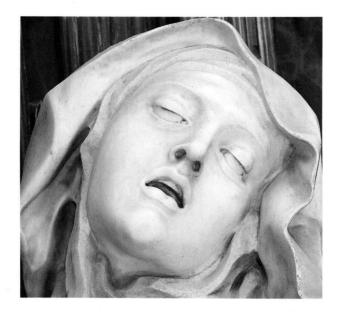

286
Detail of figure 285

287

avoid

of emotion which artists had so far shunned. If we compare the face of his swooning saint with any work done in previous centuries, we find that he achieved an intensity of facial expression which until then was never attempted in art. Looking from figure 286 to the head of Laocoön, page 110, figure 69, or of Michelangelo's 'Dying slave', page 313, figure 201, we realize the difference. Even Bernini's handling of draperies was at the time completely new. Instead of letting them fall in dignified folds in the approved classical manner, he made them writhe and whirl to add to the effect of excitement and movement. In all these effects he was soon imitated all over Europe.

If it is true of sculptures like Bernini's 'St Teresa' that they can only be judged in the setting for which they were made, the same applies even more to the painted decorations of Baroque churches. Figure 287 shows the decoration of the ceiling of the Jesuit church in Rome by a painter of Bernini's following, Giovanni Battista Gaulli (1639–1709). The artist wants to give us the illusion that the vault of the church has opened, and that we look straight into the glories of Heaven. Correggio before him had the idea of painting the heavens on the ceiling, page 338, figure 217, but Gaulli's effects are incomparably more theatrical. The theme is the worship of the Holy Name of Jesus, which is inscribed in radiant letters in the centre of His church. It is surrounded by infinite multitudes of cherubs, angels, and saints, each gazing in rapture into the light, while whole legions of demons or fallen angels are driven out of the heavenly regions,

Giovanni Battista Gaulli The worship of the Holy Name of Jesus, 1670–83

Fresco; ceiling of the Jesuit church of Il Gesu, Rome

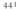

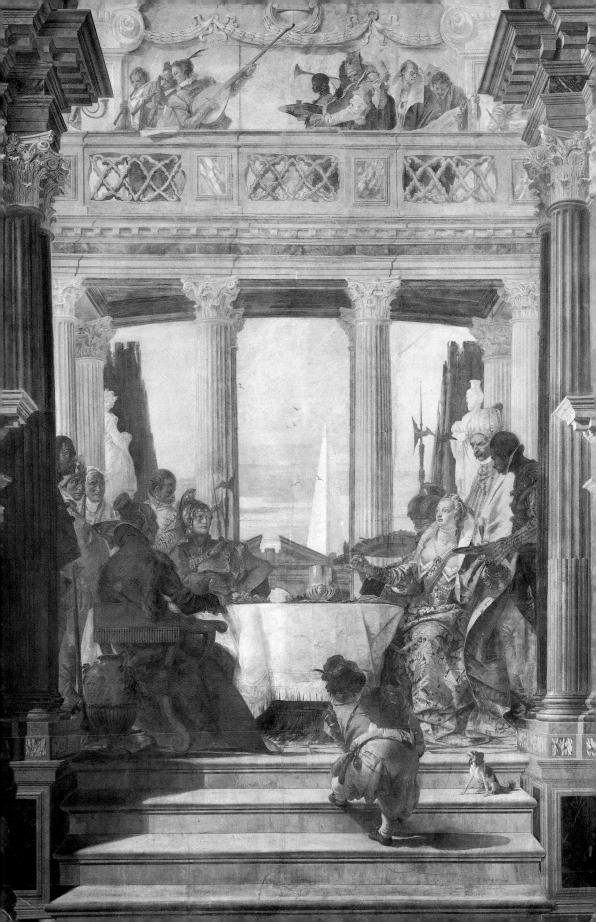

expressing their despair. The crowded scene seems to burst the frame of the ceiling, which brims over with clouds carrying saints and sinners right down into the church. In letting the picture thus break the frame, the artist wants to confuse and overwhelm us, so that we no longer know what is real and what illusion. A painting like this has no meaning outside the place for which it was made. Perhaps it is no coincidence, therefore, that, after the development of the full Baroque style, in which all artists collaborated in the achievement of one effect, painting and sculpture as independent arts declined in Italy and throughout Catholic Europe.

In the eighteenth century Italian artists were mainly superb internal decorators, famous throughout Europe for their skill in stucco work and for their great frescoes, which could transform any hall of a castle or monastery into a setting for pageantry. One of the most famous of these masters was the Venetian Giovanni Battista Tiepolo (1696-1770), who worked not only in Italy but also in Germany and Spain. Figure 288 shows part of his decoration of a Venetian palace, painted about 1750. It represents a subject which gave Tiepolo every opportunity to display gay colours and sumptuous costumes: the banquet of Cleopatra. The story goes that Mark Antony gave a feast in honour of the Egyptian queen which was to be the *ne plus ultra* of luxury. The most costly dishes followed each other in endless succession. The queen was not impressed. She wagered her proud host that she would produce a dish much more costly than anything he had offered yet – took a famous pearl from her ear-ring, dissolved it in vinegar and drank the brew. In Tiepolo's fresco we see her showing Mark Antony the pearl while a black servant offers her a glass.

Giovanni
Battista Tiepolo
The banquet of
Cleopatra, c. 1750
Fresco; Palazzo Labia,
Venice

289 Detail of figure 288

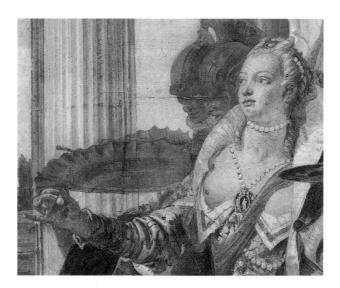

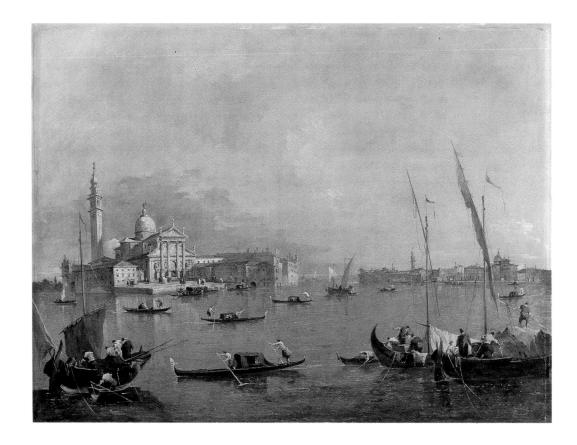

Frescoes like these must have been fun to paint and they are a pleasure to look at. And yet some may feel that these fireworks are of less permanent value than the more sober creations of earlier periods. The great age of Italian art was ending.

Only in one specialized branch did Italian art create new ideas in the early eighteenth century. That was, characteristically enough, the painting and engraving of views. The travellers who came to Italy from all over Europe to admire the glories of her past greatness often wanted to take souvenirs with them. In Venice, in particular, whose scenery is so fascinating to the artist, there developed a school of painters who catered for this demand. *Figure 290* shows a view of Venice by one of these painters, Francesco Guardi (1712–93). Like Tiepolo's fresco, it shows that Venetian art had not lost its sense of pageantry, of light and of colour. It is interesting to compare Guardi's views of the Venetian lagoon with the sober and faithful seascapes of Simon de Vlieger, *page 418*, *figure 271*, painted a century earlier. We realize that the spirit of Baroque, the taste for movement and bold effects, can express itself even in a simple view of

290

Francesco Guardi View of S. Giorgio Maggiore, Venice, c. 1775–80

Oil on canvas, 70.5 × 93.5 cm, 27³/₄ × 36³/₄ in; Wallace Collection, London

a city. Guardi has completely mastered the effects that had been studied by seventeenth-century painters. He has learned that once we are given the general impression of a scene we are quite ready to supply and supplement the details ourselves. If we look closely at his gondoliers we discover, to our surprise, that they are made up simply of a few deftly placed coloured patches – yet if we step back the illusion becomes completely effective. The tradition of Baroque discoveries which lives in these late fruits of Italian art was to gain new importance in subsequent periods.

'Connoisseurs' and antiquaries assembled in Rome, 1725
Drawing by P. L. Ghezzi; pen and black ink on buff paper, 27 × 39.5 cm, 10% × 15½ in; Albertina, Vienna

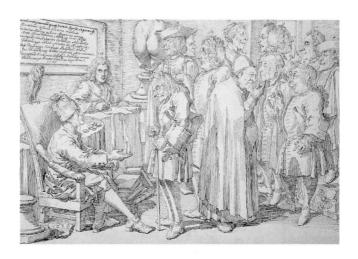

POWER AND GLORY: II

France, Germany and Austria, late seventeenth and early eighteenth centuries

It was not only the Roman Church that had discovered the power of art to impress and overwhelm. The kings and princes of seventeenthcentury Europe were equally anxious to display their might and thus to increase their hold on the minds of the people. They, too, wanted to appear as beings of a different kind, lifted by divine right above the common run of men. This applies particularly to the most powerful ruler of the latter part of the seventeenth century, Louis XIV of France, in whose political programme the display and splendour of royalty was deliberately used. It is surely no accident that Louis XIV invited Bernini to Paris to help with the designing of his palace. This grandiose project never materialized, but another of Louis XIV's palaces became the very symbol of his immense power. This was the palace of Versailles, which was built round about 1660-80, figure 291. Versailles is so huge that no photograph can give an adequate idea of its appearance. There are no fewer than 123 windows looking towards the park in each storey. The park itself, with its avenues of clipped trees, its urns and statuary, figure 292, and its terraces and lakes, extends over miles of countryside.

It is in its immensity rather than in its decorative detail that Versailles is Baroque. Its architects were mainly intent on grouping the enormous masses of the building into clearly distinct wings, and giving each wing the appearance of nobility and grandeur. They accentuated the middle of the main storey by a row of Ionic columns carrying an entablature with rows of statues on top, and flanked this effective centre-piece with decorations of a similar kind. With a simple combination of pure Renaissance forms, they would hardly have succeeded in breaking the monotony of so vast a façade, but with the help of statues, urns and trophies they produced a certain amount of variety. It is in buildings like these, therefore, that one can best appreciate the true function and purpose of Baroque forms. Had the designers of Versailles been a little more daring than they were, and used more unorthodox means of articulating and grouping the enormous building, they might have been even more successful.

291 Lot

Louis le Vau & Jules Hardouin-Mansart The palace of Versailles, near Paris, 1655–82 A Baroque palace

It was only in the next generation that this lesson was completely absorbed by the architects of the period. For the Roman churches and French castles of the Baroque style fired the imagination of the age. Every minor princeling in southern Germany wanted to have his Versailles; every small monastery in Austria or in Spain wanted to compete with the impressive splendour of Borromini's and Bernini's designs. The period round about 1700 is one of the greatest periods of architecture; and not of architecture alone. These castles and churches were not simply planned as buildings – all the arts had to contribute to the effect of a fantastic and artificial world. Whole towns were used like stage settings, stretches of country were transformed into gardens, brooks into cascades. Artists were given free rein to plan to their hearts' content, and to translate their most unlikely visions into stone and gilt stucco. Often the money ran out before their plans became reality, but what was completed of this outburst of

The gardens at Versailles

The group to the right is a copy of the 'Laocoön', page 110, figure 69.

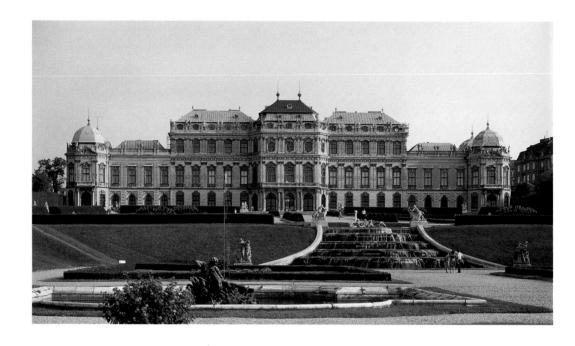

293

Lucas von Hildebrandt Upper Belvedere, Vienna, 1720–4

294

Lucas von Hildebrandt Upper Belvedere, Vienna, entrance hall and staircase, 1724 18th-century engraving

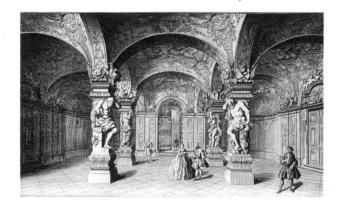

extravagant creation transformed the face of many a town and landscape of Catholic Europe. It was particularly in Austria, Bohemia and southern Germany that the ideas of the Italian and French Baroque were fused into the boldest and most consistent style. Figure 293 shows the palace which the Austrian architect, Lucas von Hildebrandt (1668–1745), built in Vienna for Marlborough's ally, Prince Eugene of Savoy. The palace stands on a hill, and seems to hover lightly over a terraced garden with fountains and clipped hedges. Hildebrandt has grouped it clearly into seven different parts, reminiscent of garden pavilions: a five-windowed centre-piece bulging forward, flanked by two wings of only slightly lesser height, and this group in turn flanked by a lower part and four turret-like corner pavilions, which frame the whole building. The central pavilion and the corner-pieces are the most richly decorated parts, and the building forms an intricate pattern, which is nevertheless completely clear and lucid in its outline. This lucidity is not at all disturbed by the freakish and grotesque ornament that Hildebrandt employed in the details of the decoration, the pilasters tapering off downwards, the broken and scrolly pediments over the windows, and the statues and trophies lining the roof.

Lucas von Hildebrandt & Johann Dientzenhofer Staircase of the castle of Pommersfelden, Germany, 1713–14

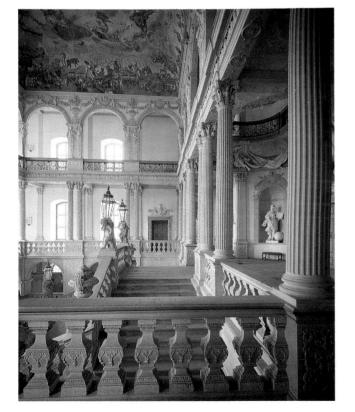

It is only when we enter the building that we feel the full impact of this fantastic style of decoration. Figure 294 shows the entrance hall of Prince Eugene's palace, and Figure 295 a staircase of a German castle designed by Hildebrandt. We cannot do justice to these interiors unless we visualize them in use - on a day when the owner was giving a feast or holding a reception, when the lamps were lit and men and women in the gay and stately fashions of the time arrived to mount these stairs. At such a moment, the contrast between the dark, unlit streets of the time, reeking of dirt and squalor, and the radiant fairy world of the nobleman's dwelling must have been overwhelming.

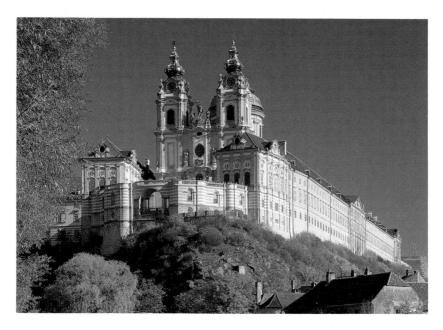

Jakob Prandtauer

Melk Monastery, 1702

The buildings of the Church made use of similar striking effects. *Figure 296* shows the Austrian monastery of Melk, on the Danube. As one comes down the river, this monastery, with its cupola and its strangely shaped towers, stands on the hill like some unreal apparition. It was built by a local builder called Jakob Prandtauer (died 1726) and decorated by some of the Italian travelling *virtuosi* who were ever ready with new ideas and designs from the vast store of Baroque patterns. How well these humble artists had learnt the difficult art of grouping and organizing a building to give the appearance of stateliness without monotony! They were also careful to graduate the decoration, and to use the more extravagant forms sparingly, but all the more effectively, in the parts of the building they wanted to throw into relief.

In the interior, however, they cast off all restraint. Even Bernini or Borromini in their most exuberant moods would never have gone quite so far. Once more we must imagine what it meant for a simple Austrian peasant to leave his farmhouse and enter this strange wonderland, *figure 297*. There are clouds everywhere, with angels making music and gesticulating in the bliss of Paradise. Some have settled on the pulpit, everything seems to move and dance, and the architecture framing the sumptuous high altar appears to sway in the rhythm of jubilation.

Nothing is 'natural' or 'normal' in such a church – it is not meant to be. It is intended to give us a foretaste of the glory of Paradise. Perhaps it is not everybody's idea of Paradise, but when you are in the midst of it all it

Jakob Prandtauer, Antonio Beduzzi & Josef Munggenast Interior of the church of Melk Monastery, c. 1738

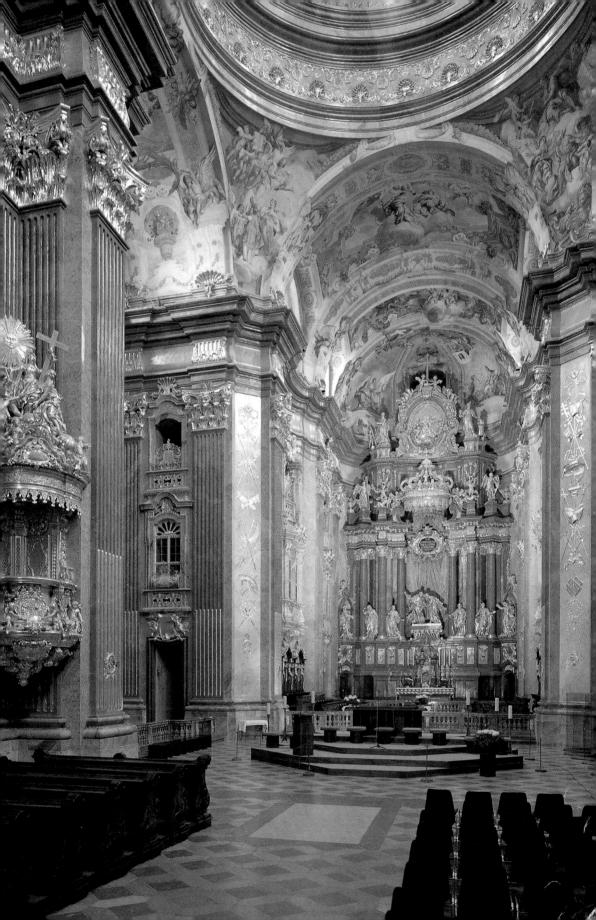

envelops you and stops all questioning. You feel you are in a world where our rules and standards simply do not apply.

One can understand that north of the Alps, no less than in Italy, the individual arts were swept into this orgy of decoration and lost much of their independent importance. There were, of course, painters and sculptors of distinction in the period round about 1700, but perhaps there was only one master whose art compares with the great leading painters of the first half of the seventeenth century. This master was Antoine Watteau (1684-1721). Watteau came from a part of Flanders which had been conquered by France a few years before his birth, and he settled in Paris, where he died at the age of thirty-seven. He, too, designed interior decorations for the castles of the nobility, to provide the appropriate background for the festivals and pageantries of court society. But it would seem as if the actual festivities had not satisfied the imagination of the artist. He began to paint his own visions of a life divorced from all hardship and triviality, a dream-life of gay picnics in fairy parks where it never rains, of musical parties where all ladies are beautiful and all lovers graceful, a society in which all are dressed in sparkling silk without looking showy, and where the life of the shepherds and shepherdesses seems to be a succession of minuets. From such a description one might get the impression that the

298
Antoine Watteau
Fête in a park, c.1719
Oil on canvas, 127.6 ×
193 cm, 50¼ × 76 in;
Wallace Collection,

London

art of Watteau is over-precious and artificial. For many, it has come to reflect the taste of the French aristocracy of the early eighteenth century which is known as Rococo: the fashion for dainty colours and delicate decoration which succeeded the more robust taste of the Baroque period, and which expressed itself in gay frivolity. But Watteau was far too great an artist to be a mere exponent of the fashions of his time. Rather it was he whose dreams and ideals helped to mould the fashion we call Rococo. Just as Van Dyck had helped to create the idea of the gentlemanly ease we associate with the Cavaliers, *page 405*, *figure 262*, so Watteau has enriched our store of imagination by his vision of graceful gallantry.

Figure 298 shows his picture of a gathering in a park. There is nothing of the noisy gaiety of Jan Steen's revelries, page 428, figure 278, in this scene; a sweet and almost melancholy calm prevails. These young men and women just sit and dream, play with flowers or gaze at each other. The light dances on their shimmering dresses, and transfigures the copse into an earthly paradise. The qualities of Watteau's art, the delicacy of his brushwork and the refinement of his colour harmonies are not easily revealed in reproductions. His immensely sensitive paintings and drawings must really be seen and enjoyed in the original. Like Rubens, whom he admired, Watteau could convey the impression of living, palpitating flesh through a mere whiff of chalk or colour. But the mood of his studies is as different from Rubens's as his paintings are from Jan Steen's. There is a touch of sadness in these visions of beauty which is difficult to describe or define, but which lifts Watteau's art beyond the sphere of mere skill and prettiness. Watteau was a sick man, who died of consumption at an early age. Perhaps it was his awareness of the transience of beauty which gave to his art that intensity which none of his many admirers and imitators could equal.

Tapestry; Musée de Versailles

THE AGE OF REASON

England and France, eighteenth century

The period round about 1700 had seen the culmination of the Baroque movement in Catholic Europe. The Protestant countries could not help being impressed by this all-pervading fashion but, nevertheless, they did not actually adopt it. This even applies to England during the Restoration period, when the Stuart court looked towards France and abhorred the taste and outlook of the Puritans. It was during this period that England produced her greatest architect, Sir Christopher Wren (1632–1723), who was given the task of rebuilding London's churches after the disastrous fire of 1666. It is interesting to compare his St Paul's Cathedral, figure 200, with a church of the Roman Baroque, built only some twenty years earlier, page 436, figure 282. We see that Wren was definitely influenced by the groupings and effects of the Baroque architect, although he himself had never been to Rome. Like Borromini's church, Wren's cathedral, which is much larger in scale, consists of a central cupola, flanking towers, and the suggestion of a temple façade to frame the main entrance. There is even a definite similarity between Borromini's Baroque towers and Wren's, particularly in the second storey. Nevertheless, the general impression of the two façades is very different. St Paul's is not curved. There is no suggestion of movement, rather of strength and stability. The way in which the paired columns are used to give stateliness and nobility to the façade recalls Versailles, page 448, figure 291, rather than the Roman Baroque. Looking at the details, we may even wonder whether or not to call Wren's style Baroque. There is nothing of the freakish or fantastic in his decoration. All his forms adhere strictly to the best models of the Italian Renaissance. Each form and each part of the building can be viewed by itself without losing its intrinsic meaning. Compared with the exuberance of Borromini, or of the architect of Melk, Wren impresses us as being restrained and sober.

The contrast between Protestant and Catholic architecture is even more marked when we consider the interiors of Wren's churches – for instance that of St Stephen Walbrook in London, *figure 300*. A church like this is designed mainly as a hall where the faithful meet for worship. Its aim is not to conjure up a vision of another world, but rather to allow us to collect

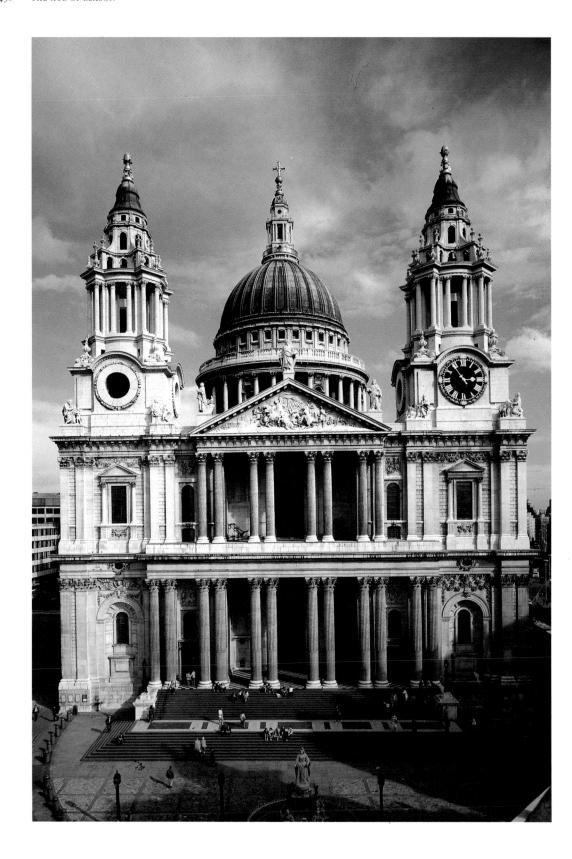

299 Sir Christopher Wren St Paul's Cathedral, London, 1675–1710

300 Sir Christopher Wren Interior of the church of St Stephen Walbrook, London, 1672

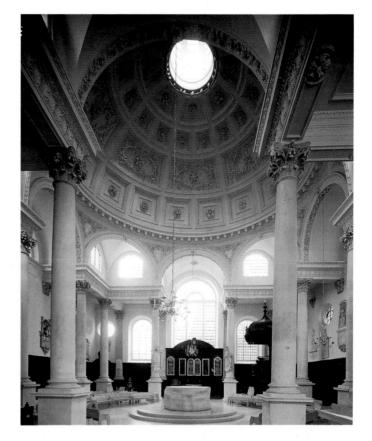

our thoughts. In the many churches he designed, Wren endeavoured to give ever-new variations on the theme of such a hall, which would be both dignified and simple.

As with churches, so with castles. No king of England could have raised the prodigious sums to build a Versailles, and no English peer would have cared to compete with the German princelings in luxury and extravagance. It is true that the building craze reached England. The Duke of Marlborough's Blenheim Palace is even larger in scale than Prince Eugene's Belvedere. But these were exceptions. The ideal of the English eighteenth century was not the palace but the country house.

The architects of these country houses usually rejected the extravagances of the Baroque style. It was their ambition not to infringe any rule of what they considered 'good taste', and so they were anxious to keep as closely as possible to the real or pretended laws of classical architecture. Architects of the Italian Renaissance who had studied and measured the ruins of classical buildings with scientific care had published their findings in textbooks to provide builders and craftsmen with patterns. The most famous of these books was written by Andrea Palladio, *page 362*. This book of Palladio's came to be considered the ultimate authority on all rules of taste in architecture in eighteenth-century England. To build one's villa in the 'Palladian manner' was considered the last word in fashion.

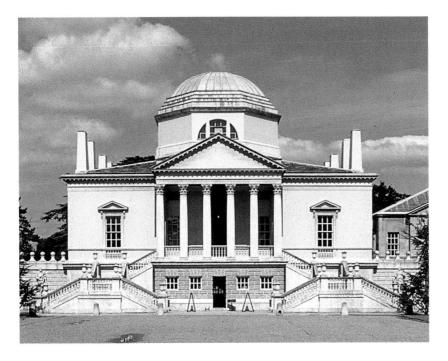

Lord Burlington & William Kent
Chiswick House,
London, c. 1725

Figure 301 shows such a Palladian villa, Chiswick House. Designed for his own use by the great leader of taste and fashion, Lord Burlington (1695–1753), and decorated by his friend, William Kent (1685–1748), it is indeed a close imitation of Palladio's Villa Rotonda, page 363, figure 232. Unlike Hildebrandt and the other architects of Catholic Europe, page 451, the designers of the British villa nowhere offend against the strict rules of the classical style. The stately portico has the correct form of an antique temple front built in the Corinthian order, page 108. The walls of the building are simple and plain, there are no curves and volutes, no statues to crown the roof, and no grotesque decorations.

For the rule of taste in the England of Lord Burlington and Alexander Pope was also the rule of reason. The whole temper of the country was opposed to the flights of fancy of Baroque designs, and to an art that aimed at overwhelming the emotions. The formal parks in the style of Versailles, whose endless clipped hedges and alleyways had extended the architects' design beyond the actual building far into the surrounding country, were condemned as absurd and artificial. A garden or park should reflect the beauties of nature, it should be a collection of fine scenery such as might charm the painter's eye. It was men such as Kent who invented the English

302

The grounds of Stourhead, Wiltshire, laid out from 1741 'landscape garden' as the ideal surroundings for their Palladian villas. Just as they had appealed to the authority of an Italian architect for the rules of reason and taste in building, so they turned to a southern painter for a standard of beauty in scenery. Their idea of what nature should look like was largely derived from the paintings of Claude Lorrain. It is interesting to compare the view of the lovely grounds of Stourhead in Wiltshire, figure 302, which were laid out before the middle of the eighteenth century, with works by these two masters. The 'temple' in the background again recalls Palladio's Villa Rotonda (which was, in its turn, modelled on the Roman Pantheon), while the whole vista with its lake, its bridge and its evocation of Roman buildings confirms my remarks on the influence which the paintings of Claude Lorrain, page 396, figure 255, were to have on the beauty of the English landscape.

The position of English painters and sculptors under the rule of taste and reason was not always enviable. We have seen that the victory of Protestantism in England, and the Puritan hostility to images and to luxury, had dealt the tradition of art in England a severe blow. Almost the only purpose for which painting was still in demand was that of supplying likenesses, and even this function had largely been met by foreign artists such as Holbein, *page 374*, and Van Dyck, *page 403*, who were called to England after they had established their reputations abroad.

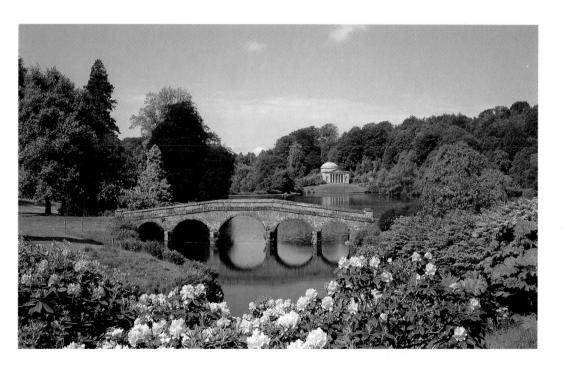

The fashionable gentlemen of Lord Burlington's days had no objection to paintings or sculptures on puritan grounds, but they were not eager to place commissions with native artists who had not yet made a name in the outside world. If they wanted a painting for their mansions they would much rather buy one which bore the name of some famous Italian master. They prided themselves on being connoisseurs, and some of them assembled the most admirable collections of old masters, without, however, giving much employment to the painters of their time.

This state of affairs greatly irritated a young English engraver, who had to make his living by illustrating books. His name was William Hogarth (1697-1764). He felt that he had it in him to be as good a painter as those whose works were bought for hundreds of pounds from abroad, but he knew that there was no public for contemporary art in England. He therefore set out deliberately to create a new type of painting which should appeal to his countrymen. He knew that they were likely to ask 'What is the use of a painting?' and he decided that, in order to impress people brought up in the puritan tradition, art must have an obvious purpose. Accordingly, he planned a number of paintings which should teach the people the rewards of virtue and the wages of sin. He would show a 'Rake's progress' from profligacy and idleness to crime and death, or 'The four stages of cruelty' from a boy teasing a cat to a grown-up's brutal murder. He would paint these edifying stories and warning examples in such a way that anyone who saw the series of pictures would understand all the incidents and the lessons they taught. His paintings, in fact, should resemble a kind of dumb show, in which all the characters have their appointed task and make its meaning clear through gestures and the use of stage properties. Hogarth himself compared this new type of painting to the art of the playwright and the theatrical producer. He did everything to bring out what he called the 'character' of each figure, not only through his face but also through his dress and behaviour. Each of his picture sequences can be read like a story or, rather, like a sermon. In this respect, this type of art was not perhaps quite as new as Hogarth thought. We know that medieval art used images to impart a lesson, and this tradition of the picture sermon had lived on in popular art up to the time of Hogarth. Crude prints had been sold at fairs to show the fate of the drunkard or the perils of gambling, and the ballad-mongers sold pamphlets with similar tales. Hogarth, however, was no popular artist in this sense. He had made a careful study of the masters of the past and of their way of achieving pictorial effects. He knew the Dutch masters, such as Jan Steen, who filled their pictures with humorous episodes from the life of the people and excelled in bringing out the characteristic expression of a type, page 428, figure 278. He also knew the methods of the Italian artists of his

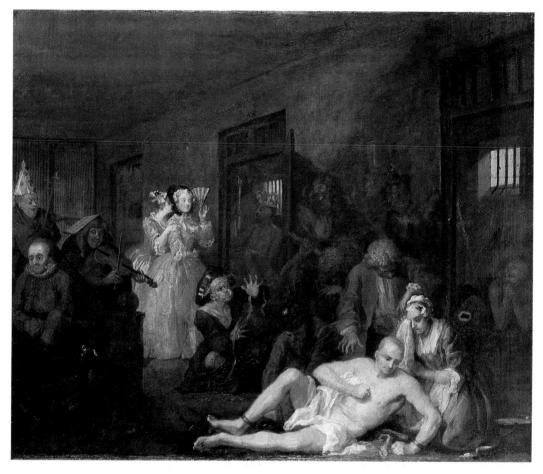

William Hogarth
The rake's progress: the
rake in Bedlam, 1735
Oil on canvas, 62.5 ×
75 cm, 24% × 29½ in; Sir
John Soane's Museum,
London

time, of Venetian painters of the type of Guardi, *page 444*, *figure 290*, who had taught him the trick of conjuring up the idea of a figure with a few spirited touches of the brush.

Figure 303 shows an episode from the 'Rake's progress' in which the poor rake comes to his end as a raving maniac in Bedlam. It is a crude scene of horror with all types of madmen represented: the religious fanatic in the first cell writhing on his bed of straw like the parody of a Baroque picture of a saint, the megalomaniac with his royal crown seen in the next cell, the idiot who scrawls the picture of the world on to the wall of Bedlam, the blind man with his paper telescope, the grotesque trio grouped round the staircase – the grinning fiddler, the foolish singer, and the touching figure of the apathetic man who just sits and stares – and, finally, the group of the dying rake, who is mourned by none but the servant girl he once left in the lurch. As he collapses, they take off his irons, the cruel equivalent of the strait–jacket. They are no longer needed. It is a

tragic scene, made even more tragic by the grotesque dwarf, who mocks it, and by the contrast with the two elegant visitors, who had known the rake in the days of his prosperity.

Each figure and each episode in the picture has its place in the story Hogarth tells, but that alone would not suffice to make it a good painting. What is remarkable in Hogarth is that, for all his preoccupation with his subject-matter, he still remained a painter, not only in the way he used his brush and distributed light and colour, but also in the considerable skill he showed in arranging his groups. The group round the rake, for all its grotesque horror, is as carefully composed as any Italian painting of the classical tradition. Hogarth, in fact, was very proud of his understanding of this tradition. He was sure that he had found the law which governed beauty. He wrote a book, which he called *The Analysis of Beauty*, to explain the idea that an undulating line will always be more beautiful than an angular one. Hogarth, too, belonged to the age of reason and believed in teachable rules of taste, but he did not succeed in converting his compatriots from their bias for the old masters. It is true that his picture-series earned him great fame and a considerable sum of money, but his reputation was due less to the actual paintings than to reproductions he made of them in engravings which were bought by an eager public. As a painter, the connoisseurs of the period did not take him seriously and, throughout his life, he waged a grim campaign against fashionable taste.

It was only a generation later that an English painter was born whose art satisfied the elegant society of eighteenth-century England - Sir Joshua Reynolds (1723-92). Unlike Hogarth, Reynolds had been to Italy and had come to agree with the connoisseurs of his time that the great masters of the Italian Renaissance - Raphael, Michelangelo, Correggio and Titian – were the unrivalled exemplars of true art. He had absorbed the teaching attributed to the Carracci, pages 390-1, that the only hope for an artist lay in the careful study and imitation of what were called the excellences of the ancient masters - the draughtsmanship of Raphael, the colouring of Titian, and so on. Later in his life, when Reynolds had made a career as an artist in England and had become the first president of the newly founded Royal Academy of Art, he expounded this 'academic' doctrine in a series of discourses, which still make interesting reading They show that Reynolds, like his contemporaries (such as Dr Johnson), believed in the rules of taste and the importance of authority in art. He believed that the right procedure in art could, to a large extent, be taught, if students were given facilities for studying

the recognized masterpieces of Italian painting. His lectures are full of exhortations to strive after lofty and dignified subjects, because Reynolds believed that only the grand and impressive was worthy of the name of Great Art. 'Instead of endeavouring to amuse mankind with the minute neatness of his imitations, the genuine painter', Reynolds wrote in his third *Discourse*, 'must endeavour to improve them by the grandeur of his ideas.'

From such a quotation it might easily appear that Reynolds was rather pompous and boring, but if we read his Discourses and look at his pictures, we soon get rid of this prejudice. The fact is that he accepted the opinions about art which he found in the writings of the influential critics of the seventeenth century, all of whom were much concerned with the dignity of what was called 'history painting'. We have seen how hard artists had to struggle against social snobbery which made people look down on painters and sculptors because they worked with their hands, pages 287-8. We know how artists had to insist that their real work was not handiwork but brain work, and that they were no less fit to be received into polite society than poets or scholars. It was through these discussions that artists were led to stress the importance of poetic invention in art, and to emphasize the elevated subjects with which their minds were concerned. 'Granted,' they argued, 'that there may be something menial in painting a portrait or a landscape from nature where the hand merely copies what the eye sees, but surely it requires more than mere craftsmanship: it requires erudition and imagination to paint a subject like Reni's "Aurora" or Poussin's "Et in Arcadia ego"?', pages 394-5, figures 253, 254. We know today that there is a fallacy in this argument. We know that there is nothing undignified in any kind of handiwork and that, moreover, it needs more than a good eye and a sure hand to paint a good portrait or landscape. But every period and every society has its own prejudices in matters of art and of taste ours, of course, not excluded. Indeed, what makes it so interesting to examine these ideas, which highly intelligent people in the past took so much for granted, is precisely that we learn in this way also to examine ourselves.

Reynolds was an intellectual, a friend of Dr Johnson and his circle, but equally welcome in the elegant country houses and town mansions of the powerful and the wealthy. And though he sincerely believed in the superiority of history painting, and hoped for its revival in England, he accepted the fact that the only kind of art really in demand in these circles was that of portraiture. Van Dyck had established a standard of society portraits that all fashionable painters

305 Sir Joshua Reynolds Miss Bowles with her dog, 1775 Oil on canvas, 91.8 × 71.1 cm, 36% × 28 in; Walace Collection, London

304
Sir Joshua Reynolds
Joseph Baretti, 1773
Oil on canvas, 73.7 ×
62.2 cm, 29 × 24½ in;
Private collection

of subsequent generations had tried to reach. Reynolds could be as flattering and as elegant as the best of them, but he liked to add an extra interest to his paintings of people to bring out their character and their role in society. Thus figure 304 represents an intellectual from Dr Johnson's circle, the Italian scholar Joseph Baretti, who had compiled an English-Italian dictionary and later translated Reynolds's Discourses into Italian. It is a perfect record, intimate without being impertinent, and a good painting into the bargain.

Even when he had to paint a child, Reynolds tried to make the picture into more than a mere portrait by carefully choosing his setting. *Figure 305* shows his portrait of 'Miss Bowles with her dog'. We remember that Velázquez, too, had painted the portrait of a child and

dog, page 410, figure 267. But Velázquez had been interested in the texture and colour of what he saw. Reynolds wants to show us the touching love of the little girl for her pet. We are told what trouble he took to gain the child's confidence, before he set out to paint her. He was asked to the house and sat beside her at dinner 'where he amused her so much with stories and tricks, that she thought him the most charming man in the world. He made her look at something distant from the table and stole her plate; then he pretended to look for it, then he contrived it should come back to her without her knowing how. The next day she was delighted to be taken to his house, where she sat down with an expression full of glee, the expression of which he at once caught and never lost.' No wonder that the outcome is more self-conscious, and much more thought out, than Velázquez's straightforward arrangement. It is true that, if we compare his handling of paint and his treatment of the living skin and the fluffy fur with that of Velázquez, we may find Reynolds disappointing. But it would hardly be fair to expect of him an effect at which he was not aiming. He wanted to bring out the character of the sweet child, and to make her tenderness and her charm live for us. Today, when photographers have so

accustomed us to the trick of observing a child in a similar situation, we may find it difficult fully to appreciate the originality of Reynolds's treatment. But we must not blame a master for the imitations which have spoilt his effects. Reynolds never allowed the interest of the subject-matter to upset the harmony of the painting.

In the Wallace Collection in London, where Reynolds's portrait of Miss Bowles hangs, there is also the portrait of a girl of roughly the same age by his greatest rival in the field of portrait painting, Thomas Gainsborough (1727–88), who was only four years his junior. It is the portrait of Miss Haverfield, figure 306. Gainsborough painted the little lady as she was tying the bow of her cape. There is nothing particularly moving or interesting in her action. She is just dressing, we fancy, to go for a walk. But Gainsborough knew how to invest the simple movement with such grace and charm that we find it as satisfying as Reynolds's invention of a girl hugging her pet. Gainsborough was much less interested in 'invention' than Reynolds. He was born in rural Suffolk, had a natural gift for painting, and never found it necessary to go to Italy to study the great masters. In comparison with Reynolds and all his theories about the importance of tradition, Gainsborough was almost a self-made man. There is something in the relationship of the two which recalls the contrast between the learned Annibale Carracci, page 300. who wanted to revive the manner of Raphael, and the revolutionary Caravaggio, page 392, who wanted to acknowledge no teacher except nature. Reynolds, at any rate, saw Gainsborough somewhat in this light, as a genius who refused to copy the masters, and, much as he admired his rival's skill, he felt bound to warn his students against his principles. Today, after the passage of almost two centuries, the two masters do not seem to us so very different. We realize, perhaps more clearly than they did, how much they both owed to the tradition of Van Dyck, and to the fashion of their time. But, if we return to the portrait of Miss Haverfield with this contrast in mind, we understand the particular qualities which distinguish Gainsborough's fresh and unsophisticated approach from Reynolds's more laboured style. Gainsborough, we now see, had no intention of being 'highbrow'; he wanted to paint straightforward unconventional portraits in which he could display his brilliant brushwork and his sure eye. And so he succeeds best where Reynolds disappointed us. His rendering of the fresh complexion of the child and the shining material of the cape, his treatment of the frills and ribbons of the hat, all this shows his consummate skill in rendering the texture and surfaces of visible objects. The rapid and impatient strokes of the brush almost remind us of the work of Frans Hals, page 417, figure 270. But Gainsborough was a less robust artist. There are, in many of his portraits, a delicacy of

306
Thomas
Gainsborough
Miss Haverfield,
c. 1780
Oil on canvas, 127.6 ×
101.9 cm, 50½ × 40½ in;
Wallace Collection,

London

shades and a refinement of touch which rather recall the visions of Watteau, page 454, figure 298.

Both Reynolds and Gainsborough were rather unhappy to be smothered with commissions for portraits when they wanted to paint other things. But while Reynolds longed for time and leisure to paint ambitious mythological scenes or episodes from ancient history, Gainsborough wanted to paint the very subjects which his rival despised. He wanted to paint landscapes. For, unlike Reynolds, who was a man about town, Gainsborough loved the quiet countryside, and among the few entertainments he really enjoyed was chamber music. Unfortunately

Thomas
Gainsborough
Rural scene, c. 1780
Black chalk and stump,
heightened with white, on
buff paper, 28.3 × 37.9 cm,
111% × 15 in; Victoria and
Albert Museum, London

308

Jean-BaptisteSiméon Chardin

Saying grace
(Le Bénédicité), 1740

Oil on canvas, 49.5 × 38.5

cm, 19½ × 15⅓ in;

Louvre, Paris

Gainsborough could not find many buyers for his landscapes, and so a large number of his pictures remained mere sketches done for his own enjoyment, *figure 307*. In these he arranged the trees and hills of the English countryside into picturesque scenes which remind us that this was the age of the landscape gardener. For Gainsborough's sketches are no views drawn direct from nature. They are landscape 'compositions', designed to evoke and reflect a mood.

In the eighteenth century, English institutions and English taste became the admired models for all people in Europe who longed for the rule of reason. For in England art had not been used to enhance the power and glory of god-like rulers. The public for which Hogarth catered, even the people who posed for Reynolds's and Gainsborough's portraits, were ordinary mortals. We remember that in France, too, the heavy Baroque grandeur of Versailles had gone out of fashion in the early eighteenth century in favour of the more delicate and intimate effects of Watteau's Rococo, page 454, figure 298. Now this whole aristocratic dream-world began to recede. Painters began to look at the life of the ordinary men and women of their time, to draw moving or amusing episodes which could be spun out into a story. The greatest of these was Jean-Baptiste-Siméon Chardin (1699–1779), a painter two years younger than Hogarth. Figure 308 shows one of his charming paintings – a simple room with a woman setting dinner on the table and asking two children to say grace. Chardin liked these quiet glimpses of the life of ordinary people. He resembles the Dutch painter Vermeer, page 432, figure 281, in the way in which he feels and preserves the poetry of a domestic scene, without looking for striking effects or pointed allusions. Even his colour is calm and

Jean-Antoine Houdon Voltaire, 1781 Marble, height 50.8 cm, 20 in; Victoria and Albert Museum, London

restrained and, by comparison with the scintillating paintings of Watteau, his works may seem to lack brilliance. But if we study them in the original, we soon discover in them an unobtrusive mastery in the subtle gradation of tones and the seemingly artless arrangement of the scene that makes him one of the most lovable painters of the eighteenth century.

In France, as in England, the new interest in ordinary human beings rather than the trappings of power benefited the art of portraiture. Perhaps the greatest of the French portraitists was not a painter but a sculptor, Jean-Antoine Houdon (1741–1828). In his wonderful portrait busts, Houdon carried on the tradition which had been started by Bernini more than a hundred years earlier, *page 438*, *figure 284*. *Figure 309* shows Houdon's bust of Voltaire and allows us to *see*, in the face of this great champion of reason, the biting wit, the penetrating intelligence, and also the deep compassion of a great mind.

Jean-Honoré
Fragonard
The park of the Villa
d'Este, Tivoli, c. 1760
Red chalk on paper, 35 × 48.7 cm, 13³/4 × 19³/4 in;
Musée des Beaux-Arts et
d'Archéologie, Besançon

The taste for the 'picturesque' aspects of nature, finally, which inspired Gainsborough's sketches in England, is also found in eighteenth-century France. *Figure 310* shows a drawing by Jean-Honoré Fragonard (1732–1806), who belonged to the generation of Gainsborough. Fragonard, too, was a painter of great charm who followed the tradition of Watteau in his themes from high life. In his landscape drawings he was a master of striking effects. The view from the Villa d'Este in Tivoli, near Rome, proves how he could find grandeur and charm in a piece of actual scenery.

The Life School at the Royal Academy with portraits of leading artists including Reynolds (with an ear trumpet), 1771

Painting by Johann
Zoffany; oil on canvas, 100.7 × 147.3 cm, 39³⁴ × 58 in; Royal Collection, Windsor Castle

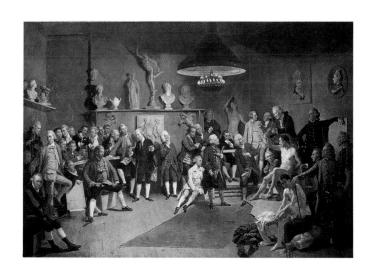

THE BREAK IN TRADITION

England, America and France, late eighteenth and early nineteenth centuries

In history books modern times begin with the discovery of America by Columbus in 1492. We remember the importance of that period in art. It was the time of the Renaissance, the time when being a painter or a sculptor ceased to be an occupation like any other and became a calling set apart. It was also the period during which the Reformation, through its fight against images in churches, put an end to the most frequent use of pictures and sculptures in large parts of Europe, and forced the artists to look for a new market. But however important all these events were, they did not result in a sudden break. The large mass of artists were still organized in guilds and companies, they still had apprentices like other artisans, and they still relied for commissions largely on the wealthy aristocracy, who needed artists to decorate their castles and country seats and to add their portraits to the ancestral galleries. Even after 1492, in other words, art retained a natural place in the life of people of leisure, and was generally taken for granted as something one could not well do without. Even though fashions changed and artists set themselves different problems, some being more interested in the harmonious arrangement of figures, others in the matching of colours or the achievement of dramatic expression, the purpose of painting or sculpture remained in general the same, and no one seriously questioned it. This purpose was to supply beautiful things to people who wanted them and enjoyed them. There were, it is true, various schools of thought which quarrelled among themselves over what 'beauty' meant and whether it was enough to enjoy the skilful imitation of nature for which Caravaggio, the Dutch painters, or men like Gainsborough, had become famous, or whether true beauty did not depend on the capacity of the artist to 'idealize' nature as Raphael, Carracci, Reni or Reynolds were supposed to have done. But these disputes need not make us forget how much common ground there was among the disputants, and how much between the artists whom they chose as their favourites. Even the 'idealists' agreed that the artists must study nature and learn to draw from the nude, even the 'naturalists' agreed that the works of classical antiquity were unsurpassed in beauty.

Towards the end of the eighteenth century this common ground seemed gradually to give way. We have reached the really modern times which dawned when the French Revolution of 1789 put an end to so many assumptions that had been taken for granted for hundreds, if not for thousands, of years. Just as the Great Revolution has its roots in the Age of Reason, so have the changes in man's ideas about art. The first of these changes concerns the artist's attitude to what is called 'style'. There is a character in one of Molière's comedies who is greatly astonished when he is told that he has spoken prose all his life without knowing it. Something a little similar happened to the artists of the eighteenth century. In former times, the style of the period was simply the way in which things were done; it was practised because people thought it was the best way of achieving certain desired effects. In the Age of Reason, people began to become selfconscious about style and styles. Many architects were still convinced, as we have seen, that the rules laid down in the books by Palladio guaranteed the 'right' style for elegant buildings. But once you turn to textbooks for such questions it is almost inevitable that there will be others who say: 'Why must it be just Palladio's style?' This is what happened in England in the course of the eighteenth century. Among the most sophisticated connoisseurs there were some who wanted to be different from the others. The most characteristic of these English gentlemen of leisure who spent their time thinking about style and the rules of taste was the famous Horace Walpole, son of the first Prime Minister of England. It was Walpole who decided that

John Papworth Dorset House, Cheltenham, c. 1825 A Regency façade

Horace Walpole, Richard Bentley and John Chute Strawberry Hill, Twickenham, London, c. 1750–75 A neo-Gothic villa

it was boring to have his country house on Strawberry Hill built just like any other correct Palladian villa. He had a taste for the quaint and romantic, and was notorious for his whimsicality. It was quite in keeping with his character that he decided to have Strawberry Hill built in the Gothic style like a castle from the romantic past, figure 311. At the time, about 1770, Walpole's Gothic villa passed for the oddity of a man who wanted to show off his antiquarian interests; but seen in the light of what came later, it was really more than that. It was one of the first signs of that selfconsciousness which made people select the style of their building as one selects the pattern of a wallpaper.

There were several symptoms of this kind. While Walpole selected the Gothic style for his country house, the architect William Chambers (1726–96) studied the Chinese style

of buildings and of gardening, and built his Chinese Pagoda in Kew Gardens. The majority of architects, it is true, still kept to the classical forms of Renaissance building, but even they were increasingly worried about the right style. They looked with some misgivings on the practice and tradition of architecture which had grown up since the Renaissance. They found that many of these practices had no real sanction in the buildings of classical Greece. They realized, with a shock, that what had passed as the rules of classical architecture since the fifteenth century were taken from a few Roman ruins of a more or less decadent period. Now the temples of Periclean Athens were rediscovered and engraved by zealous travellers, and they looked strikingly different from the classical designs to be found in Palladio's book. Thus these architects became preoccupied with correct style. Walpole's 'Gothic revival' was matched by a 'Greek revival' which culminated in the Regency period (1810-20). This is the period in which many of the principal spas in England enjoyed their greatest prosperity, and it is in these towns that one can best study the forms of the Greek revival. Figure 312 shows a house in Cheltenham Spa which is successfully modelled on the pure Ionic style of Greek temples,

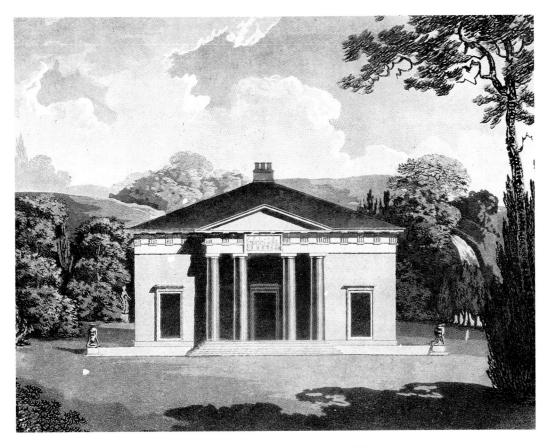

page 100, figure 60. Figure 313 gives an example of the revival of the Doric order in its original form such as we know it from the Parthenon, page 83, figure 50. It is a design for a villa by the famous architect Sir John Soane (1752–1837). If we compare it with the Palladian villa built by William Kent some eighty years earlier, page 460, figure 301, the superficial similarity only brings out the difference. Kent used the forms he found in tradition freely to compose his building. Soane's project, by comparison, looks like an exercise in the correct use of the elements of Greek style.

This conception of architecture as an application of strict and simple rules was bound to appeal to the champions of Reason, whose power and influence continued to grow all over the world. Thus it is not surprising that a man such as Thomas Jefferson (1743–1826), one of the founders of the United States and its third President, designed his own residence, Monticello, in this lucid, neo-classical style, *figure 314*, and that the city of Washington, with its public buildings, was planned in the forms of the Greek revival. In France, too, the victory of this style was assured after the French Revolution. The old happy-go-lucky tradition of Baroque

313
Sir John Soane
Design for a country
house
From Sketches in

Architecture, London, 1798

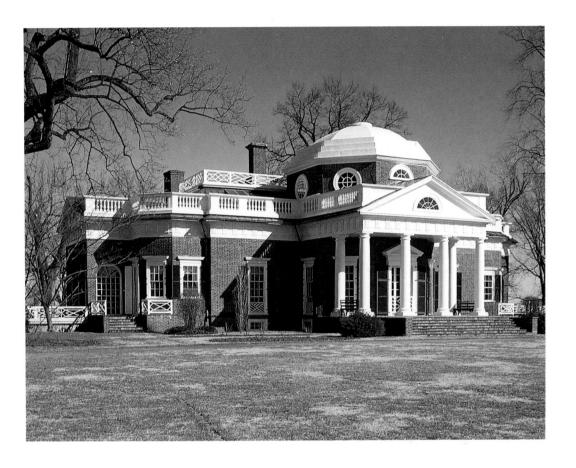

314 Thomas Jefferson Monticello, Virginia, 1796–1806 and Rococo builders and decorators was identified with the past which had just been swept away; it had been the style of the castles of royalty and of the aristocracy, while the men of the Revolution liked to think of themselves as the free citizens of a new-born Athens. When Napoleon, posing as the champion of the ideas of the Revolution, rose to power in Europe, the neo-classical style of architecture became the style of the Empire. On the Continent, too, a Gothic revival existed side by side with this new revival of the pure Greek style. It appealed particularly to those Romantic minds who despaired of the power of Reason to reform the world and longed for a return to what they called the Age of Faith.

In painting and sculpture, the break in the chain of tradition was perhaps less immediately perceptible than it was in architecture, but it was possibly of even greater consequence. Here, too, the roots of the trouble reach back far into the eighteenth century. We have seen how dissatisfied Hogarth was with the tradition of art as he found it, page 462, and how deliberately he set out to create a new kind of painting for a new public. We remember how Reynolds, on the other hand, was anxious to preserve that tradition as if he realized that it was in danger. The danger lay in the fact, mentioned before, that painting had ceased to be an ordinary trade the knowledge of which was handed down from master to apprentice. Instead, it had become a subject like philosophy to be taught in academies. The very word 'academy' suggests this new approach. It is derived from the name of the grove in which the Greek philosopher Plato taught his disciples, and was gradually applied to gatherings of learned men in search of wisdom. Sixteenth-century Italian artists at first called their meeting-places 'academies' to stress that equality with scholars on which they set such great store; but it was only in the eighteenth century that these academies gradually took over the function of teaching art to students. Thus the old methods, by which the great masters of the past had learned their trade by grinding colours and assisting their elders, had fallen into decline. No wonder that academic teachers like Reynolds felt compelled to urge young students to study diligently the masterpieces of the past and to assimilate their technical skill. The academies of the eighteenth century were under royal patronage, to manifest the interest which the King took in the arts in his realm. But for the arts to flourish, it is less important that they should be taught in Royal Institutions than that there should be enough people willing to buy paintings or sculptures by living artists.

It was here that the main difficulties arose, because the very emphasis on the greatness of the masters of the past, which was favoured by the academies, made patrons inclined to buy old masters rather than to commission paintings from the living. As a remedy, the academies, first in

Paris, then in London, began to arrange annual exhibitions of the works of their members. We may find it hard to realize what a momentous change this was, since we are so used to the idea of artists painting and sculptors modelling their work mainly with the idea of sending it to an exhibition to attract the attention of art critics and to find buyers. These annual exhibitions became social events that formed the topic of conversation in polite society, and made and unmade reputations. Instead of working for individual patrons whose wishes they understood, or for the general public, whose taste they could gauge, artists had now to work for success in a show where there was always a danger of the spectacular and pretentious outshining the simple and sincere. The temptation was indeed great for artists to attract attention by selecting melodramatic subjects for their paintings, and by relying on size and loud colour effects to impress the public. Thus it is not surprising that some artists despised the 'official' art of the academies, and that the clash of opinions, between those whose gifts allowed them to appeal to the public taste and those who found themselves excluded, threatened to destroy the common ground on which all art had so far developed.

Perhaps the most immediate and visible effect of this profound crisis was that artists everywhere looked for new types of subject-matter. In the past, the subject-matter of paintings had been very much taken for granted. If we walk round our galleries and museums we soon discover how many of the paintings illustrate identical topics. The majority of the older pictures, of course, represent religious subjects taken from the Bible, and the legends of the saints. But even those that are secular in character are mostly confined to a few selected themes. There are the mythologies of ancient Greece with their stories of the loves and quarrels of the gods; there are the heroic tales from Rome with their examples of valour and self-sacrifice; and there are, finally, the allegorical subjects illustrating some general truth by means of personifications. It is curious how rarely artists before the middle of the eighteenth century strayed from these narrow limits of illustration, how rarely they painted a scene from a romance, or an episode of medieval or contemporary history. All this changed very rapidly during the period of the French Revolution. Suddenly artists felt free to choose as their subjects anything from a Shakespearean scene to a topical event, anything, in fact, that appealed to the imagination and aroused interest. This disregard for the traditional subject-matter of art may have been the only thing the successful artists of the period and the lonely rebels had in common.

It is hardly an accident that this breakaway from the established traditions of European art was partly accomplished by artists who had come to Europe from across the ocean – Americans who worked in

England. Obviously these men felt less bound to the hallowed customs of the Old World and were readier to try new experiments. The American John Singleton Copley (1737–1815) is a typical artist of this group. Figure 315 shows one of his large paintings, which caused a sensation when it was first exhibited in 1785. The subject was indeed an unusual one. The Shakespearean scholar Malone, a friend of the politician Edmund Burke, had suggested it to the painter and provided him with all the historical information necessary. He was to paint the famous incident when Charles I demanded from the House of Commons the arrest of five impeached members, and when the Speaker challenged the King's authority and declined to surrender them. Such an episode from comparatively recent history had never been made the subject of a large painting before, and the method which Copley selected for the task was equally unprecedented. It was his intention to reconstruct the scene as accurately as possible – as it would have presented itself to the eyes of a contemporary witness. He spared no pains in getting the historical facts. He consulted antiquarians and historians about the actual shape of the chamber in the seventeenth century and the costumes people wore; he travelled from country house to country house to collect portraits of as many men as possible who were known to have been Members of Parliament at that critical moment. In short, he acted as a conscientious producer might act today when he has to reconstruct such a scene for a historical film or play. We may or may not find these efforts well spent. But it is a fact that, for more than a hundred years afterwards, many artists great and small saw their task in exactly this type of antiquarian research, which should help people to visualize decisive moments of history.

In Copley's case, this attempt to re-evoke the dramatic clash between the King and the representatives of the people was certainly not only the work of a disinterested antiquarian. Only two years before, George III had had to submit to the challenge of the colonists and had signed the peace with the United States. Burke, from whose circle the suggestion for the subject had come, had been a consistent opponent of the war, which he considered unjust and disastrous. The meaning of Copley's evocation of the previous rebuff to royal pretensions was perfectly understood by all. The story is told that when the Queen saw the painting she turned away in pained surprise, and after a long and ominous silence said to the young American: 'You have chosen, Mr Copley, a most unfortunate subject for the exercise of your pencil.' She could not know how unfortunate the reminiscence was going to prove. Those who remember the history of these years will be struck by the fact that, hardly four years later, the scene of the picture was to be re-enacted in France. This time, it was Mirabeau who denied the King's right to interfere with the

John Singleton Copley Charles I demanding the surrender of the five impeached members of the House of Commons, 1641, 1785 Oil on canvas, 233.4 × 312 cm, 92 × 123 in; Public Library, Boston,

Massachusetts

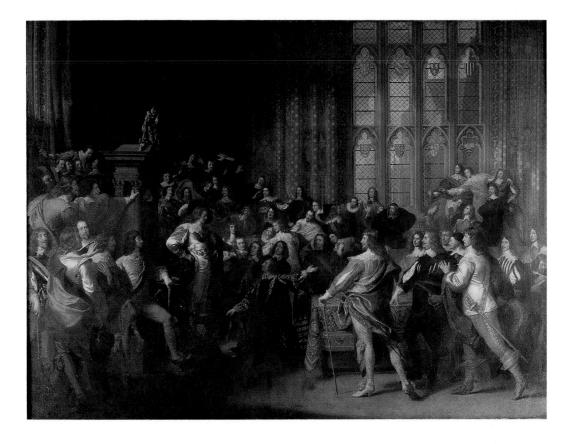

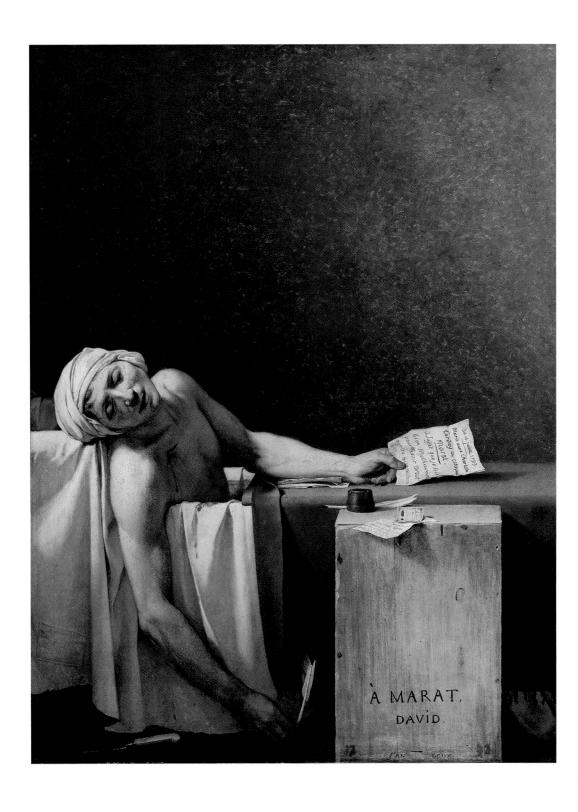

representatives of the people, and thus gave the starting signal for the French Revolution of 1789.

The French Revolution gave an enormous impulse to this type of interest in history, and to the painting of heroic subjects. Copley had looked for examples in England's national past. There was a Romantic strain in his historical painting which may be compared to the Gothic revival in architecture. The French revolutionaries loved to think of themselves as Greeks and Romans reborn, and their painting, no less than their architecture, reflected this taste for what was called Roman grandeur. The leading artist of this neo-classical style was the painter Jacques-Louis David (1748-1825), who was the 'official artist' of the Revolutionary Government, and designed the costumes and settings for such propagandist pageantries as the 'Festival of the Supreme Being' in which Robespierre officiated as a self-appointed High Priest. These people felt that they were living in heroic times, and that the events of their own years were just as worthy of the painter's attention as the episodes of Greek and Roman history. When one of the leaders of the French Revolution, Marat, was killed in his bath by a fanatical young woman, David painted him as a martyr who had died for his cause, figure 316. Marat was apparently in the habit of working in his bath, and his bath tub was fitted with a simple desk. His assailant had handed him a petition, which he was about to sign when she struck him down. The situation does not seem to lend itself easily to a picture of dignity and grandeur, but David succeeded in making it seem heroic, while yet keeping to the actual details of a police record. He had learned from the study of Greek and Roman sculpture how to model the muscles and sinews of the body, and give it the appearance of noble beauty; he had also learned from classical art to leave out all details which are not essential to the main effect, and to aim at simplicity. There are no motley colours and no complicated foreshortening in the painting. Compared to Copley's great showpiece, David's painting looks austere. It is an impressive commemoration of a humble 'friend of the people' – as Marat had styled himself – who had suffered the fate of a martyr while working for the common weal.

Among the artists of David's generation who discarded the old type of subject-matter was the great Spanish painter, Francisco Goya (1746–1828). Goya was well versed in the best tradition of Spanish painting, which had produced El Greco, page 372, figure 238, and Velázquez, page 407, figure 264, and his group on a balcony, figure 317, shows that unlike David he did not renounce this mastery in favour of classical grandeur. The great Venetian painter of the eighteenth century, Giovanni Battista Tiepolo, page 442, figure 288, had ended his days as a

316
Jacques-Louis David
Marat assassinated,
1793
Oil on canvas, 165 ×
128.3 cm, 65 × 50½ in;

Musées Royaux des

Beaux-Arts de Belgique,

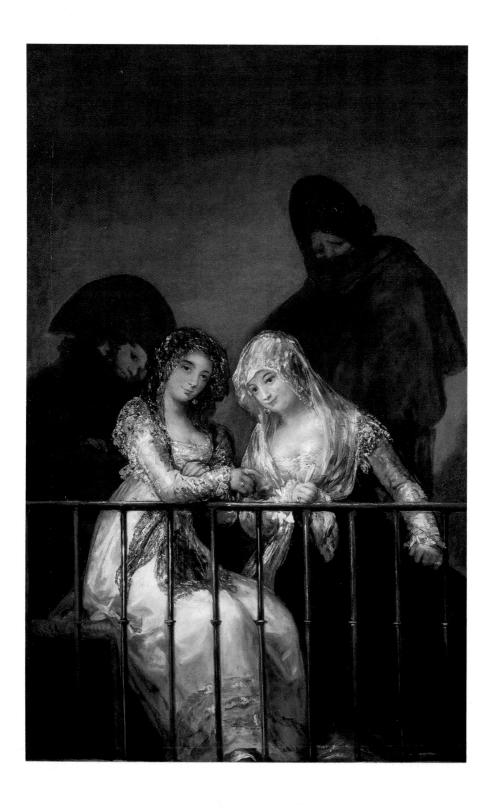

317
Francisco Goya
Group on a balcony,
c. 1810–15
Oil on canvas, 194.8 ×
125.7 cm, 76½ × 49½ in;
Metropolitan Museum of

Art, New York

318
Francisco Goya
King Ferdinand VII
of Spain, c. 1814
Oil on canvas, 207 ×
140 cm, 81½ × 55½ in;
Prado, Madrid

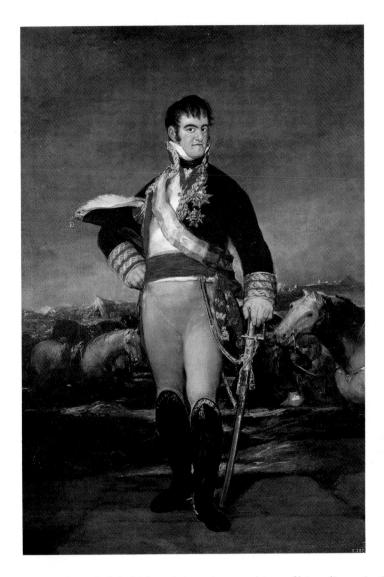

court painter in Madrid, and there is something of his radiance in Goya's painting. And yet Goya's figures belong to a different world. The two women who eye the passer-by provokingly, while two rather sinister gallants keep in the background, may be closer to the world of Hogarth. Goya's portraits which secured him a place at the Spanish court, *figure 318*, look superficially like the traditional state portraits of Van Dyck, *page 404*, *figure 261*, or of Reynolds. The skill with which he conjured up the glitter of silk and gold recalls Titian or Velázquez. But he also looks at his sitters with a different eye. Not that these masters had flattered the mighty, but Goya seems to have known no pity. He made their features reveal all their vanity

319 Detail of figure 318

and ugliness, their greed and emptiness, *figure 319*. No court painter before or after has ever left such a record of his patrons.

It was not only as a painter that Goya asserted his independence of the conventions of the past. Like Rembrandt, he produced a great number of etchings, most of them in a new technique called aquatint, which allows not only etched lines but also shaded patches. The most striking fact about Goya's prints is that they are not illustrations of any known subject, either biblical, historical or genre. Most of them are fantastic visions of witches and uncanny apparitions. Some are meant as accusations against the powers of stupidity and reaction, of cruelty and oppression, which Goya had witnessed in Spain, others seem just to give shape to the artist's nightmares. Figure 320 represents one of the most haunting of his dreams the figure of a giant sitting on the edge of the world. We can gauge his colossal size from the tiny landscape in the foreground, and we can see how he dwarfs houses and castles into mere specks. We can make our imagination play around this dreadful apparition, which is drawn with a clarity of outline as if it were a study from life. The monster sits in the moonlit landscape like some evil incubus. Was Goya thinking of the fate of his country, of its oppression by wars and human folly? Or was he simply creating an image like a poem? For this was the most outstanding effect of the break in tradition – that artists felt free to put their private visions on paper as hitherto only the poets had done.

The most outstanding example of this new approach to art was the English poet and mystic William Blake (1757–1827), who was eleven years younger than Goya. Blake was a deeply religious man, who lived in a world of his own. He despised the official art of the academies, and declined to accept its standards. Some thought he was completely mad; others dismissed him as a harmless crank, and only a very few of his

320Francisco Goya *The giant, c.* 1818
Aquatint, 28.5 × 21 cm,

 $11\frac{1}{4} \times 8\frac{1}{4}$ in

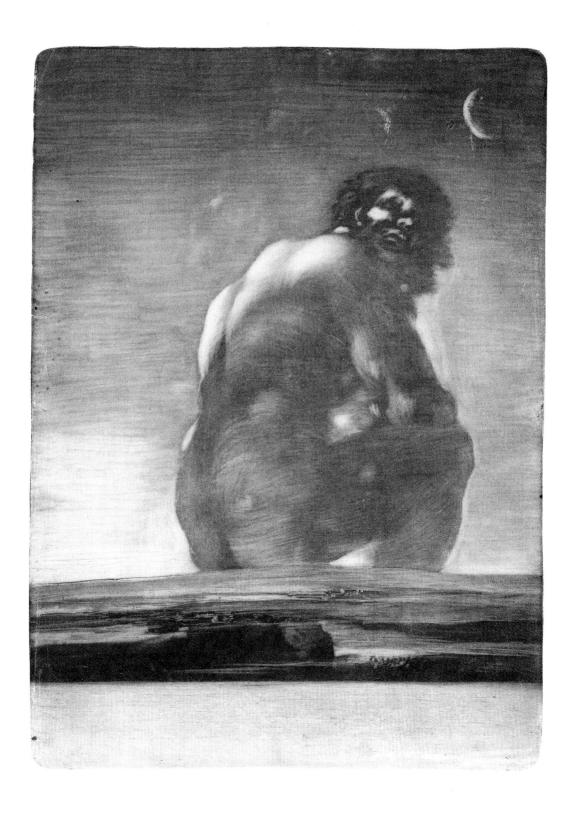

contemporaries believed in his art and saved him from starvation. He lived by making prints, sometimes for others, sometimes to illustrate his own poems. *Figure 321* represents one of Blake's illustrations to his poem, *Europe, a Prophecy*. It is said that Blake had seen this enigmatic figure of an old man, bending down to measure the globe with a compass, in a vision which hovered over his head at the top of a staircase when he was living in Lambeth. There is a passage in the Bible (Proverbs viii. 22–7), in which Wisdom speaks and says:

The Lord possessed me in the beginning of His way, before His works of old ... before the mountains were settled, before the hills was I brought forth ... when He prepared the Heavens, I was there: when He set a compass on the face of the depths: when He established the clouds above: when He strengthened the fountains of the deep.

It is this grandiose vision of the Lord setting a compass upon the face of the depths that Blake illustrated. There is something of Michelangelo's figure of the Lord, page 312, figure 200, in this image of the Creation, and Blake admired Michelangelo. But in his hands the figure has become dream-like and fantastic. In fact, Blake had formed a mythology of his own, and the figure of the vision was not strictly speaking the Lord Himself, but a being of Blake's imagination whom he called Urizen. Though Blake conceived of Urizen as the creator of the world, he thought of the world as bad and therefore of its creator as of an evil spirit. Hence the uncanny nightmare character of the vision, in which the compass appears like a flash of lightning in a dark and stormy night.

Blake was so wrapped up in his visions that he refused to draw from life and relied entirely on his inner eye. It is easy to point to faults in his draughtsmanship, but to do so would be to miss the point of his art. Like the medieval artists, he did not care for accurate representation, because the significance of each figure of his dreams was of such overwhelming importance to him that questions of mere correctness seemed to him irrelevant. He was the first artist after the Renaissance who thus consciously revolted against the accepted standards of tradition, and we can hardly blame his contemporaries who found him shocking. It was almost a century before he was generally recognized as one of the most important figures in English art.

There was one branch of painting that profited much by the artist's new freedom in his choice of subject-matter — this was landscape painting. So far, it had been looked upon as a minor branch of art. The painters, in particular, who had earned their living painting 'views' of country houses, parks or picturesque scenery, were not taken seriously as artists. This attitude changed somewhat through the romantic spirit of the late eighteenth century, and great artists saw it as their purpose in life to raise this type of painting to new

William Blake
The Ancient of Days,
1794
Relief etching with
watercolour, 23.3 ×
16.8 cm, 9½ × 6½ in;
British Museum, London

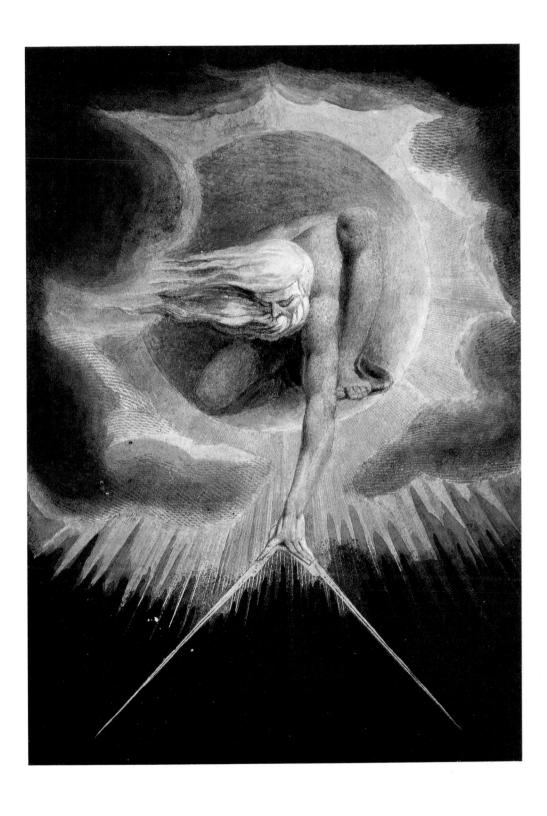

dignity. Here, too, tradition could serve both as a help and a hindrance, and it is fascinating to see how differently two English landscape painters of the same generation approached this question. One was J.M.W. Turner (1775-1851), the other John Constable (1776-1837). There is something in the contrast of these two men which recalls the contrast between Reynolds and Gainsborough, but, in the fifty years which separate their generations, the gulf between the approaches of the two rivals had very much widened. Turner, like Reynolds, was an immensely successful artist whose pictures often caused a sensation at the Royal Academy. Like Reynolds, he was obsessed with the problem of tradition. It was his ambition in life to reach, if not surpass, the celebrated landscape paintings of Claude Lorrain, page 396, figure 255. When he left his pictures and sketches to the nation, he did so on the express condition that one of them, figure 322, must always be shown side by side with a work by Claude Lorrain. Turner hardly did himself justice by inviting this comparison. The beauty of Claude's pictures lies in their serene simplicity and calm, in the clarity and concreteness of his dream-world, and in the absence of any loud effects. Turner, too, had visions of a fantastic world bathed in light and resplendent with beauty, but it was a world not of calm but of movement, not of simple harmonies but of dazzling pageantries. He crowded into his pictures every effect which could make them more striking and more dramatic, and, had he been a lesser artist than he was, this desire to impress the public might well have had a disastrous result. Yet he was such a superb stage-manager, he worked with such gusto and skill, that

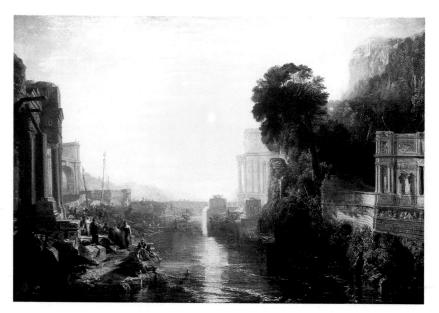

Joseph Mallord William Turner Dido building Carthage, 1815 Oil on canvas, 155.6 × 231.8 cm, 61½ × 91½ in; National Gallery, London

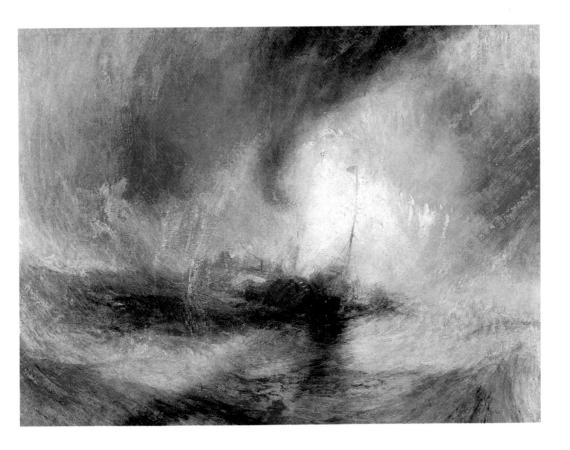

Joseph Mallord William Turner Steamer in a snowstorm, 1842 Oil on canvas, 91.5 × 122 cm, 36 × 48 in; Tate Gallery, London

he carried it off and the best of his pictures do, in fact, give us a conception of the grandeur of nature at its most romantic and sublime. Figure 323 shows one of Turner's most daring paintings - a steamer in a blizzard. If we compare this whirling composition with the seascape of de Vlieger, page 418, figure 271, we gain a measure of the boldness of Turner's approach. The Dutch artist of the seventeenth century did not only paint what he saw at a glance, but also, to some extent, what he knew was there. He knew how a ship was built and how it was rigged, and, looking at his painting, we might be able to reconstruct these vessels. Nobody could reconstruct a nineteenth-century steamer from Turner's seascape. All he gives us is the impression of the dark hull, of the flag flying bravely from the mast - of a battle with the raging seas and threatening squalls. We almost feel the rush of the wind and the impact of the waves. We have no time to look for details. They are swallowed up by the dazzling light and the dark shadows of the storm cloud. I do not know whether a blizzard at sea really looks like this. But I do know that it is a storm of this awe-inspiring and overwhelming kind that we imagine when reading a romantic poem or listening to romantic music. In Turner, nature always

324
John Constable
Study of tree trunks,
c. 1821
Oil on paper, 24.8 × 29.2
cm, 9½ × 11½ in;
Victoria and Albert
Museum, London

reflects and expresses man's emotions. We feel small and overwhelmed in the face of the powers we cannot control, and are compelled to admire the artist who had nature's forces at his command.

Constable's ideas were very different. To him the tradition which Turner wanted to rival and surpass was not much more than a nuisance. Not that he failed to admire the great masters of the past. But he wanted to paint what he saw with his own eyes - not with those of Claude Lorrain. It might be said that he continued where Gainsborough had left off, page 470, figure 307. But even Gainsborough had still selected motifs which were 'picturesque' by traditional standards. He had still looked at nature as a pleasing setting for idyllic scenes. To Constable all these ideas were unimportant. He wanted nothing but the truth. 'There is room enough for a natural painter,' he wrote to a friend in 1802; 'the great vice of the present day is bravura, an attempt to do something beyond the truth.' The fashionable landscape painters who still took Claude as their model had developed a number of easy tricks by which any amateur could compose an effective and pleasing picture. An impressive tree in the foreground would serve as a striking contrast to the distant view that opened up in the centre. The colour scheme was neatly worked out. Warm colours, preferably brown and golden tones, should be in the foreground. The

background should fade into pale blue tints. There were recipes for painting clouds, and special tricks for imitating the bark of gnarled oaks. Constable despised all these set-pieces. The story goes that a friend remonstrated with him for not giving his foreground the requisite mellow brown of an old violin, and that Constable thereupon took a violin and put it before him on the grass to show the friend the difference between the fresh green as we see it and the warm tones demanded by convention. But Constable had no wish to shock people by daring innovations. All he wanted was to be faithful to his own vision. He went out to the countryside to make sketches from nature, and then elaborated them in his studio. His sketches, figure 324, are often bolder than his finished pictures, but the time had not yet come when the public would accept the record of a rapid impression as a work worthy to be shown at an exhibition. Even so, his finished pictures caused uneasiness when they were first exhibited. Figure 325 shows the painting which made Constable famous in Paris when he sent it there in 1824. It represents a simple rural scene, a haywain fording a river. We must lose ourselves in the picture, watch the patches of sunlight on the meadows in the background and look at the drifting clouds; we must follow the course of the mill-stream, and linger by the

John Constable
The haywain, 1821
Oil on canvas, 130.2 ×
185.4 cm, 51½ × 73 in;
National Gallery, London

cottage, which is painted with such restraint and simplicity, to appreciate the artist's absolute sincerity, his refusal to be more impressive than nature, and his complete lack of pose or pretentiousness.

The break with tradition had left artists with the two possibilities which were embodied in Turner and Constable. They could become poets in painting, and seek moving and dramatic effects, or they could decide to keep to the motif in front of them, and explore it with all the insistence and honesty at their command. There were certainly great artists among the Romantic painters of Europe, men such as Turner's contemporary, the German Caspar David Friedrich (1774–1840), whose landscape pictures reflect the mood of the Romantic lyrical poetry of his time which is more familiar to us through Schubert's songs. His painting of a bleak mountain scene, figure 326, may even remind us of the spirit of Chinese landscape paintings, page 153, figure 98, which also comes so close to the ideas of poetry. But however great and deserved was the popular

Caspar David
Friedrich
Landscape in the
Silesian Mountains,
c. 1815–20
Oil on canvas, 54.9 ×
70.3 cm, 21% × 27% in;

Neue Pinakothek, Munich

success which some of these Romantic painters achieved in their day, I believe that those who followed Constable's path and tried to explore the visible world rather than to conjure up poetic moods achieved something of more lasting importance.

The new role of 'official exhibitions': Charles X of France distributing decorations at the Paris Salon of 1824, 1825–7
Painting by François-Joseph Heim; oil on canvas, 173 × 256 cm, 68% × 100% in; Louvre, Paris

PERMANENT REVOLUTION

The nineteenth century

What I have called the break in tradition, which marks the period of the Great Revolution in France, was bound to change the whole situation in which artists lived and worked. The academies and exhibitions, the critics and connoisseurs, had done their best to introduce a distinction between Art with a capital A and the mere exercise of a craft, be it that of the painter or the builder. Now the foundations on which art had rested throughout its existence were being undermined from another side. The Industrial Revolution began to destroy the very traditions of solid craftsmanship; handiwork gave way to machine production, the workshop to the factory.

The most immediate results of this change were visible in architecture. The lack of solid craftsmanship, combined with a strange insistence on 'style' and 'beauty', nearly killed it. The amount of building done in the nineteenth century was probably greater than in all former periods taken together. It was the time of the vast expansion of cities in England and America that turned whole tracts of country into 'built-up areas'. But this time of unlimited building activity had no natural style of its own. The rules of thumb and the pattern books, which had so admirably served their turn up to the Georgian period, were generally discarded as too simple and too 'inartistic'. The businessman or town committee that planned a new factory, railway station, school building or museum, wanted Art for their money. Accordingly, when the other specifications had been fulfilled, the architect was commissioned to provide a façade in the Gothic style, or to turn the building into the semblance of a Norman castle, a Renaissance palace, or even an Oriental mosque. Certain conventions were more or less accepted, but they did not help much to improve matters. Churches were more often than not built in the Gothic style because this had been prevalent in what was called the Age of Faith. For theatres and opera houses the theatrical Baroque style was often considered suitable, while palaces and ministries were thought to look most dignified in the stately forms of the Italian Renaissance.

It would be unfair to assume that there were no gifted architects in the nineteenth century. There certainly were. But the situation of their art was

all against them. The more conscientiously they studied to imitate the bygone styles, the less their designs were likely to be adapted to the purpose for which they were intended. And if they decided to be ruthless with the conventions of the style they had to adopt, the result was usually not too happy either. Some nineteenth-century architects succeeded in finding a way between these two unpleasant alternatives, and in creating works which are neither sham antiques nor mere freak inventions. Their buildings have become landmarks of the cities in which they stand, and we have come to accept them almost as if they were part of the natural scenery. This is true, for instance, of the Houses of Parliament in London, figure 327, whose history is characteristic of the difficulties under which architects of the period had to work. When the old chamber burned down in 1834, a competition was organized, and the jury's choice fell on the design of Sir Charles Barry (1795-1860), an expert on the Renaissance style. It was felt, however, that England's civil liberties rested on the achievements of the Middle Ages, and that it was right and proper to erect the shrine of British Freedom in the Gothic style – a point of view, by the way, which was still universally accepted when the restoration of the chamber after its destruction by German bombers was discussed after the Second World War. Accordingly, Barry had to seek the advice of an

327 Charles Barry & Augustus Welby Northmore Pugin Houses of Parliament, London, 1835

expert on Gothic details, A.W.N. Pugin (1812–52), one of the most uncompromising champions of the Gothic revival. The collaboration amounted more or less to this – that Barry was allowed to determine the overall shape and grouping of the building, while Pugin looked after the decoration of the façade and the interior. To us this would hardly seem a very satisfactory procedure, but the outcome was not too bad. Seen from the distance, through the London mists, Barry's outlines do not lack a certain dignity; and, seen at close quarters, the Gothic details still retain something of their Romantic appeal.

In painting or sculpture, the conventions of 'style' play a less prominent part, and it might thus be thought that the break in tradition affected these arts less; but this was not the case. The life of an artist had never been without its troubles and anxieties, but there was one thing to be said for the 'good old days' - no artist needed to ask himself why he had come into the world at all. In some ways his work had been as well defined as that of any other calling. There were always altar-paintings to be done, portraits to be painted; people wanted to buy pictures for their best parlours, or commissioned murals for their villas. In all these jobs he could work on more or less pre-established lines. He delivered the goods which the patron expected. True, he could produce indifferent work, or do it so superlatively well that the job in hand was no more than the starting point for a transcendent masterpiece. But his position in life was more or less secure. It was just this feeling of security that artists lost in the nineteenth century. The break in tradition had thrown open to them an unlimited field of choice. It was for them to decide whether they wanted to paint landscapes or dramatic scenes from the past, whether they chose subjects from Milton or the classics, whether they adopted the restrained manner of David's classical revival or the fantastic manner of the Romantic masters. But the greater the range of choice had become, the less likely was it that the artist's taste would coincide with that of his public. Those who buy pictures usually have a certain idea in mind. They want to get something very similar to what they have seen elsewhere. In the past, this demand was easily met by the artists because, even though their work differed greatly in artistic merit, the works of a period resembled each other in many respects. Now that this unity of tradition had disappeared, the artist's relations with his patron were only too often strained. The patron's taste was fixed in one way: the artist did not feel it in him to satisfy that demand. If he was forced to do so for want of money, he felt he was making 'concessions', and lost his self-respect and the esteem of others. If he decided to follow only his inner voice, and to reject any commission which he could not reconcile with his idea of art, he was in danger of starvation. Thus a deep cleavage developed in the nineteenth century

between those artists whose temperament or convictions allowed them to follow conventions and to satisfy the public's demand, and those who gloried in their self-chosen isolation. What made matters worse was that the Industrial Revolution and the decline of craftsmanship, the rise of a new middle class which often lacked tradition, and the production of cheap and shoddy goods which masqueraded as 'Art', had brought about a deterioration of public taste.

The distrust between artists and the public was generally mutual. To the successful businessman, an artist was little better than an impostor who demanded ridiculous prices for something that could hardly be called honest work. Among the artists, on the other hand, it became an acknowledged pastime to 'shock the bourgeois' out of his complacency and to leave him bewildered and bemused. Artists began to see themselves as a race apart, they grew long hair and beards, they dressed in velvet or corduroy, wore broad-brimmed hats and loose ties, and generally stressed their contempt for the conventions of the 'respectable'. This state of affairs was hardly sound, but it was perhaps inevitable. And it must be acknowledged that, though the career of an artist was beset with the most dangerous pitfalls, the new conditions also had their compensations. The pitfalls are obvious. The artist who sold his soul and pandered to the taste of those who lacked taste was lost. So was the artist who dramatized his situation, who thought of himself as a genius for no other reason than that he found no buyers. But the situation was only desperate for weak characters. For the wide range of choice, and independence of the patron's whim, which had been acquired at such high cost, also held their advantages. For the first time, perhaps, it became true that art was a perfect means of expressing individuality – provided the artist had an individuality to express.

To many this may sound like a paradox. They think of all art as a means of 'expression', and to some extent they are right. But the matter is not quite so simple as it is sometimes thought to be. It is obvious that an Egyptian artist had little opportunity of expressing his personality. The rules and conventions of his style were so strict that there was very little scope for choice. It really comes to this – that where there is no choice there is no expression. A simple example will make this clear. If we say that a woman 'expresses her individuality' in the way she dresses, we mean that the choice she makes indicates her fancies and preferences. We need only watch an acquaintance buying a hat and try to find out why she rejects this and selects the other. It always has something to do with the way she sees herself and wants others to see her, and every such act of choice can teach us something about her personality. If she had to wear a uniform there might still remain some scope for 'expression', but obviously much less. Style is such a uniform. True, we know that as time went on the scope it

afforded the individual artist increased, and with it the artist's means of expressing his personality. Everyone can see that Fra Angelico was a different character from Vermeer van Delft. Yet none of these artists was deliberately making his choice in order to express his personality. He did it only incidentally, as we express ourselves in everything we do - whether we light a pipe or run after a bus. The idea that the true purpose of art was to express personality could only gain ground when art had lost every other purpose. Nevertheless, as things had developed, it was a true and valuable statement. For what people who cared about art came to look for in exhibitions and studios was no longer the display of ordinary skill - that had become too common to warrant attention - they wanted art to bring them into contact with men with whom it would be worth while to converse: men whose work gave evidence of an incorruptible sincerity, artists who were not content with borrowed effects and who would not make a single stroke of the brush without asking themselves whether it satisfied their artistic conscience. In this respect the history of painting in the nineteenth century differs very considerably from the history of art as we have encountered it so far. In earlier periods it was usually the leading masters, artists whose skill was supreme, who also received the most important commissions and therefore became very famous. Think of Giotto, Michelangelo, Holbein, Rubens or even Goya. This does not mean that tragedies could never occur or that no painter was ever insufficiently honoured in his country, but by and large the artists and their public shared certain assumptions and therefore also agreed on standards of excellence. It was only in the nineteenth century that the real gulf opened between the successful artists - who contributed to 'official art' - and the nonconformists, who were mainly appreciated after their death. The result is a strange paradox. Even today there are few specialists who know much about the 'official art' of the nineteenth century. Admittedly most of us are familiar with some of its products, the monuments to great men in public squares, murals in town halls and stained-glass windows in churches or colleges, but for most of us these have acquired such a musty look that we pay no more attention to them than we do to the engravings after once famous exhibition pieces we still encounter in old-fashioned hotel lounges.

Maybe there is a reason for this frequent neglect. In discussing Copley's painting of Charles I confronting Parliament, page 483, figure 315, I mentioned that his effort to visualize a dramatic moment of history as exactly as possible made a lasting impression, and that for a whole century many artists expended much labour on such historical costume pictures showing famous men of the past – Dante, Napoleon or George Washington – at some dramatic turning point in their lives. I might have added that such theatrical pictures generally scored a great success in

exhibitions but that they soon lost their appeal. Our ideas of the past tend to change very quickly. The elaborate costumes and settings soon look unconvincing and the heroic gestures look like 'hamming'. It is quite likely that the time will come when these works will be rediscovered and when it will be possible again to discriminate between the really bad and the meritorious. For obviously not all of that art was as hollow and conventional as we tend to think today. And yet, it will possibly always remain true that since the Great Revolution the word Art has acquired a different meaning for us and that the history of art in the nineteenth century can never become the history of the most successful and best-paid masters of that time. We see it rather as the history of a handful of lonely men who had the courage and the persistence to think for themselves, to examine conventions fearlessly and critically and thus to create new possibilities for their art.

The most dramatic episodes in this development took place in Paris. For it was Paris that became the artistic capital of Europe in the nineteenth century much as Florence had been in the fifteenth century and Rome in the seventeenth. Artists from all over the world came to Paris to study with the leading masters and, most of all, to join in the discussion about the nature of art that never ended in the cafés of Montmartre, where the new conception of art was painfully hammered out.

The leading conservative painter in the first half of the nineteenth century was Jean-Auguste-Dominique Ingres (1780–1867). He had been a pupil and follower of David, page 485, and like him admired the heroic art of classical antiquity. In his teaching he insisted on the discipline of absolute precision in the life-class and despised improvisation and messiness. Figure 328 shows his own mastery in the rendering of forms and the cool clarity of his composition. It is easy to understand why many artists envied Ingres his technical assurance and respected his authority even where they disagreed with his views. But it is also easy to understand why his more passionate contemporaries found such smooth perfection unbearable.

The rallying-point for his opponents was the art of Eugène Delacroix (1798–1863). Delacroix belonged to the long line of great revolutionaries produced in the country of revolutions. He himself was a complex character with wide and varied sympathies, and his beautiful diaries show that he would not have enjoyed being typed as the fanatical rebel. If he was cast in this role it was because he could not accept the standards of the Academy. He had no patience with all the talk about the Greeks and Romans, with the insistence on correct drawing, and the constant imitation of classical statues. He believed that, in painting, colour was much more important than draughtsmanship, and imagination than knowledge. While Ingres and his school cultivated the Grand Manner and admired Poussin and Raphael,

328

Jean-Auguste-Dominique Ingres The Valpinçon bather, 1808

Oil on canvas, 146×97.5 cm, $57\frac{1}{2} \times 41\frac{1}{8}$ in; Louvre, Paris

Delacroix shocked the connoisseurs by preferring the Venetians and Rubens. He was tired of the learned subjects the Academy wanted painters to illustrate, and went to North Africa in 1832 to study the glowing colours and romantic trappings of the Arab world. When he saw horses fighting in Tangier, he noted in his diary: 'From the very beginning they reared up and fought with a fury that made me tremble for their riders, but magnificent for painting. I am sure that I have witnessed a scene as extraordinary and fantastic as anything that ... Rubens could have imagined.' Figure 329 shows one of the fruits of his journey. Everything in the picture is a denial of the teachings of David and Ingres. There is no clarity of outline here, no modelling of the nude in carefully graded tones of light and shade, no pose and restraint in the composition, not even a patriotic or edifying subject. All the painter wants is to make us partake in an intensely exciting moment, and to share his joy in the movement and romance of the scene, with the Arab cavalry sweeping past, and the fine thoroughbred rearing in the foreground. It was Delacroix who acclaimed Constable's picture in Paris, page 495, figure 325, though in his personality and choice of romantic subjects he is perhaps more akin to Turner

Be that as it may, we know that Delacroix really admired a French landscape painter of his own generation whose art may be said to form a bridge between these contrasting approaches to nature. He was Jean-Baptiste Camille Corot (1796–1875). Like Constable, Corot started out

Eugène Delacroix

Arab cavalry practising
a charge, 1832
Oil on canvas, 60 × 73.2
cm, 23% × 28% in; Musée
Fabre, Montpellier

Jean-Baptiste Camille Corot Tivoli, the gardens of the Villa d'Este, 1843 Oil on canvas, 43.5 × 60.5 cm, 17½ × 23¾ in, Louvre, Paris

with the determination to render reality as truthfully as possible, but the truth he wished to capture was somewhat different. *Figure 330* shows that he concentrated less on details than on the general form and tone of his motifs, to convey the heat and stillness of a summer day in the South.

It so happens that about a hundred years earlier Fragonard had also selected a motif from the park of the Villa d'Este near Rome, page 473, figure 310, and it may be worth pausing for a moment to compare these and other images, all the more as landscape painting was increasingly to become the most important branch of nineteenth-century art. Fragonard clearly looked for variety, while Corot sought for a clarity and balance that may remind us remotely of Poussin, page 395, figure 254, and of Claude Lorrain, page 396, figure 255, but the radiant light and atmosphere that fill Corot's picture are achieved with very different means. Here the comparison with Fragonard can help us again, because Fragonard's medium had compelled him to concentrate on the careful gradation of tone. As a draughtsman, all he had at his disposal was the white of the paper and various intensities of brown; but look, for instance, at the wall in the foreground to see how these sufficed to convey the contrast between shadow and sunlight. Corot achieved similar effects by the use of his palette, and painters know that this is no minor

achievement. The reason is that colour often comes into conflict with the gradations of tone on which Fragonard could rely.

We may recall the advice which Constable received and rejected, page 495, to paint the foreground a mellow brown, as Claude and other painters had done. This conventional wisdom rested on the observation that strong greens tend to clash with other colours. However faithful a photograph (such as page 461, figure 302) may look to us, its intense colours would surely have a disruptive effect on that gentle gradation of tones that also served Caspar David Friedrich, page 496, figure 326, to achieve the impression of distance. Indeed, if we look at Constable's 'Haywain', page 495, figure 325, we shall notice that he also muted the colour of the foreground and of the foliage to remain within a unified tonal range. Corot appears to have captured the radiant light and luminous haze of the scene with his palette by novel means. He worked within a key of silvery grey that does not quite swallow up the colours but maintains them in harmony without departing from the visual truth. True, like Claude and like Turner, he never hesitated to people his stage with figures from the classical or biblical past, and in fact it was this poetic bent that finally secured him international fame.

Much as Corot's quiet mastery was loved and admired also by his younger colleagues, they did not wish to follow him along this path. In fact the next revolution was mainly concerned with the conventions governing subjectmatter. In the academies the idea was still prevalent that dignified paintings must represent dignified personages, and that workers or peasants provided suitable subjects only for genre scenes in the tradition of the Dutch masters, pages 381, 428. During the time of the Revolution of 1848, a group of artists gathered in the French village of Barbizon to follow the programme of Constable and look at nature with fresh eyes. One of them, Jean-François Millet (1814–75), decided to extend this programme from landscapes to figures. He wanted to paint scenes from peasant life as it really was, to paint men and women at work in the fields. It is curious to reflect that this should have been considered revolutionary, but in the art of the past peasants were generally seen as comic yokels as Bruegel had painted them, page 382, figure 246. Figure 331 represents Millet's famous picture 'The gleaners'. There is no dramatic incident represented here, nothing in the way of an anecdote. Just three hard-working people in a flat field where harvesting is in progress. They are neither beautiful nor graceful. There is no suggestion of the country idyll in the picture. These peasant women move slowly and heavily. They are all intent on their work. Millet had done everything to emphasize their square and solid build and their deliberate movements. He modelled them firmly and in simple outlines against the bright sunlit plain. Thus his three peasant women assumed a dignity more natural and more convincing than that

Jean-François Millet The gleaners, 1857 Oil on canvas, 83.8 × 111 cm, 33 × 43³/4 in; Musée d'Orsay, Paris

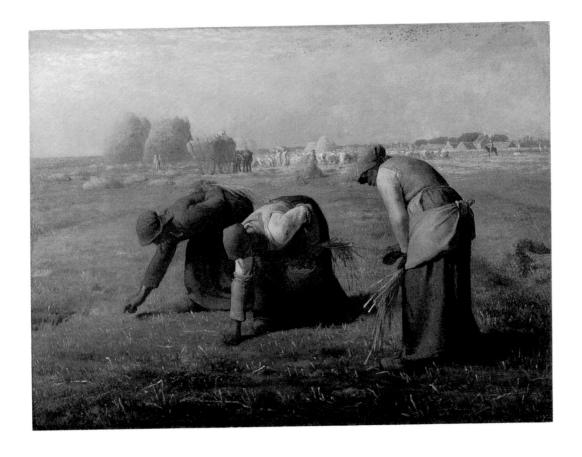

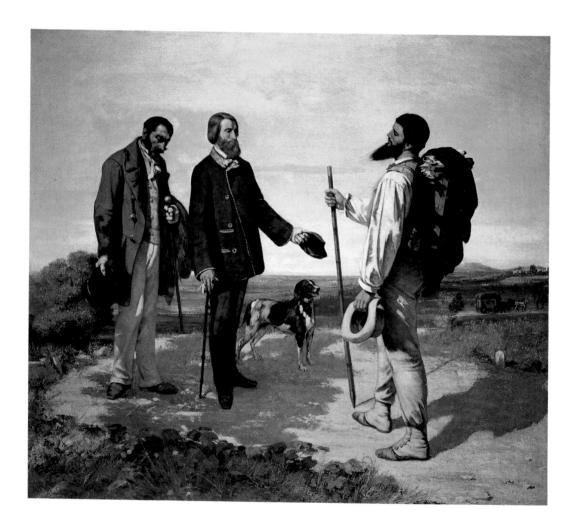

of academic heroes. The arrangement, which looks casual at first sight, supports this impression of tranquil poise. There is a calculated rhythm in the movement and distribution of the figures which gives stability to the whole design and makes us feel that the painter looked at the work of harvesting as a scene of solemn significance.

The painter who gave a name to this movement was Gustave Courbet (1819-77). When he opened a one-man show in a shack in Paris in the year 1855, he called it Le Réalisme, G. Courbet. His 'realism' was to mark a revolution in art. Courbet wanted to be the pupil of no one but nature. To some extent, his character and programme resembled that of Caravaggio, page 392, figure 252. He wanted not prettiness but truth. He represented himself walking across country with his painter's tackle on his back, respectfully greeted by his friend and patron, figure 332. He called the picture 'Bonjour, Monsieur Courbet'. To anyone used to the show-pieces of academic art, this picture must have seemed downright childish. There are no graceful poses here, no flowing lines, no impressive colours. Compared with its artless arrangement, even the composition of Millet's 'The gleaners' looks calculated. The whole idea of a painter representing himself in shirtsleeves as a kind of tramp must have appeared as an outrage to the 'respectable' artists and their admirers. This, at any rate, was the impression Courbet wanted to make. He wanted his pictures to be a protest against the accepted conventions of his day, to 'shock the bourgeois' out of his complacency, and to proclaim the value of uncompromising artistic sincerity as against the deft handling of traditional clichés. Sincere Courbet's pictures undoubtedly are. 'I hope', he wrote in a characteristic letter in 1854, 'always to earn my living by my art without having ever deviated by even a hair's breadth from my principles, without having lied to my conscience for a single moment, without painting even as much as can be covered by a hand only to please anyone or to sell more easily.' Courbet's deliberate renunciation of easy effects, and his determination to render the world as he saw it, encouraged many others to flout convention and to follow nothing but their own artistic conscience.

The same concern for sincerity, the same impatience with the theatrical pretentiousness of official art, that led the group of the Barbizon painters and Courbet towards 'Realism', caused a group of English painters to take a very different path. They pondered on the reasons which had led art into such a dangerous rut. They knew that the academies claimed to represent the tradition of Raphael and what was known as the 'Grand Manner'. If that was true, then art had obviously taken a wrong turning with, and through, Raphael. It was he and his followers who had exalted the methods of 'idealizing' nature, *page 320*, and of striving for beauty at the expense of truth. If art was to be reformed, it was therefore necessary to go

Gustave Courbet
The meeting, or
'Bonjour Monsieur
Courbet', 1854
Oil on canvas, 129 ×
149 cm, 50% × 58% in;
Musée Fabre, Montpellier

further back than Raphael, to the time when artists were still 'honest to God' craftsmen, who did their best to copy nature, while thinking not of earthly glory, but of the glory of God. Believing, as they did, that art had become insincere through Raphael and that it behoved them to return to the 'Age of Faith', this group of friends called themselves the 'Pre-Raphaelite Brotherhood'. One of its most gifted members was the son of an Italian refugee, Dante Gabriel Rossetti (1828-82). Figure 333 shows Rossetti's painting of the Annunciation. Usually, this theme was represented on the pattern of the medieval representations such as page 213, figure 141. Rossetti's intention to return to the spirit of the medieval masters did not mean that he wanted to copy their pictures. What he desired to do was to emulate their attitude, to read the biblical narrative with a devout heart, and to visualize the scene when the angel came to the Virgin and saluted her: 'And when she saw him, she was troubled at his saying and cast in her mind what manner of salutation this should be' (Luke i. 29). We can see how Rossetti strove for simplicity and sincerity in his new rendering, and how much he wanted to let us see the ancient story with a fresh mind. But for all his intention to render nature as faithfully as the admired Florentines of the Quattrocento had done, some will feel that the Pre-Raphaelite Brotherhood set itself an unattainable goal. It is one thing to admire the naïve and unselfconscious outlook of the 'primitives' (as the painters of the fifteenth century were then oddly called); it is quite another thing to strive for it oneself. For this is the one virtue which the best will in the world cannot help us to attain. Thus, while their starting point was similar to that of Millet and Courbet, I think that their honest endeavour landed them in a blind alley. The longing of Victorian masters for innocence was too self-contradictory to succeed. The hope of their French contemporaries to make progress in the exploration of the visible world proved more fruitful for the next generation.

The third wave of revolution in France (after the first wave of Delacroix and the second wave of Courbet) was started by Édouard Manet (1832–83) and his friends. These artists took Courbet's programme very seriously. They looked out for conventions in painting which had become stale and meaningless. They found that the whole claim of traditional art to have discovered the way to represent nature, as we see it, was based on a misconception. At the most, they would concede that traditional art had found a means of representing men or objects under very artificial conditions. Painters let their models pose in their studios, where the light falls through the window, and made use of the slow transition from light to shade to give the impression of roundness and solidity. The art students at the academies were trained from the beginning to base their pictures on this interplay between light and shade. At first, they usually drew from the

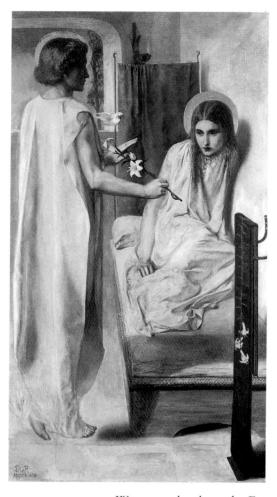

333 Dante Gabriel Rossetti 'Ecce Ancilla Domini', 1849–50

Oil on canvas, mounted on wood, 72.6 × 41.9 cm, 28% × 16½ in; Tate Gallery, London

plaster casts taken from antique statues, hatching their drawings carefully to achieve different densities of shading. Once they acquired this habit, they applied it to all objects. The public had become so accustomed to seeing things represented in this manner that they had forgotten that in the open air we do not usually perceive such even gradations from dark to light. There are harsh contrasts in the sunlight. Objects taken out of the artificial conditions of the artist's studio do not look so round or so much modelled as plaster casts from the antique. The parts which are lit appear much brighter than in the studio, and even the shadows are not uniformly grey or black, because the reflections of light from surrounding objects affect the colour of these unlit parts. If we trust our eyes, and not our preconceived ideas of what things ought to look like according to academic rules, we shall make the most exciting discoveries.

That such ideas were first considered extravagant heresies is hardly surprising. We have seen throughout this story of art how much we are all inclined to judge pictures by what we *know* rather than by what we *see*.

We remember how the Egyptian artists found it inconceivable to represent a figure without showing each part from its most characteristic angle, page 61. They knew what a foot, an eye, or a hand 'looked like', and they fitted these parts together to form a complete man. To represent a figure with one arm hidden from view, or one foot distorted by foreshortening, would have seemed outrageous. We remember that it was the Greeks who succeeded in breaking down this prejudice, and allowed foreshortening in pictures, page 81, figure 49. We remember how the importance of knowledge came to the fore again in early Christian and medieval art, page 137, figure 87, and remained so till the Renaissance. Even then the importance of theoretical knowledge of what the world ought to look like was enhanced rather than diminished through the discoveries of scientific perspective and the emphasis on anatomy, pages 229–30. The great artists of subsequent periods had made one discovery after another which allowed them to

conjure up a convincing picture of the visible world, but none of them had seriously challenged the conviction that each object in nature has its definite fixed form and colour which must be easily recognizable in a painting. It may be said, therefore, that Manet and his followers brought about a revolution in the rendering of colours which is almost comparable with the revolution in the representation of forms brought about by the Greeks. They discovered that, if we look at nature in the open, we do not see individual objects each with its own colour but rather a bright medley of tints which blend in our eye or really in our mind.

These discoveries were not made all at once or all by one man. But even Manet's first paintings in which he abandoned the traditional method of mellow shading in favour of strong and harsh contrasts caused an outcry among the conservative artists. In 1863 the academic painters refused to show his works in the official exhibition called the Salon. An agitation followed which prompted the authorities to show all works condemned by the jury in a special show called the 'Salon of the Rejected'. The public went there mainly to laugh at the poor deluded tyros who had refused to accept the verdict of their betters. This episode marks the first stage of a battle which was to rage for nearly thirty years. It is difficult for us to conceive the violence of these quarrels between the artists and the critics, all the more since the paintings of Manet strike us today as being essentially akin to the great paintings of earlier periods, such as those by Frans Hals, page 417, figure 270. Indeed, Manet violently denied that he wanted to be a revolutionary. He quite deliberately looked for inspiration in the great tradition of the masters of the brush whom the Pre-Raphaelites had rejected, the tradition initiated by the great Venetians Giorgione and Titian, and carried on triumphantly in Spain by Velázquez, pages 407–10, figures 264-7, and down to the nineteenth century by Goya. It was clearly one of Goya's paintings, page 486, figure 317, that had challenged him to paint a similar group on a balcony and to explore the contrast between the full light of the open air and the dark which swallows up the forms in the interior, figure 334. But Manet in 1869 carried this exploration much further than Gova had done sixty years earlier. Unlike Goya's, the heads of Manet's ladies are not modelled in the traditional manner, as we shall discover if we compare both with Leonardo's 'Mona Lisa', page 301, figure 193, Rubens's portrait of his child, page 400, figure 257, or Gainsborough's 'Miss Haverfield', page 469, figure 306. However different these painters were in their methods, they all wanted to create the impression of solid bodies, and did so through the interplay of shadow and light. Compared with theirs, Manet's heads look flat. The lady in the background has not even got a proper nose. We can well imagine why this treatment looked like sheer ignorance to those not acquainted with Manet's intentions. But

Édouard Manet

The balcony, 1868–9

Oil on canvas, 169 ×

125 cm, 66½ × 49¼ in;

Musée d'Orsay, Paris

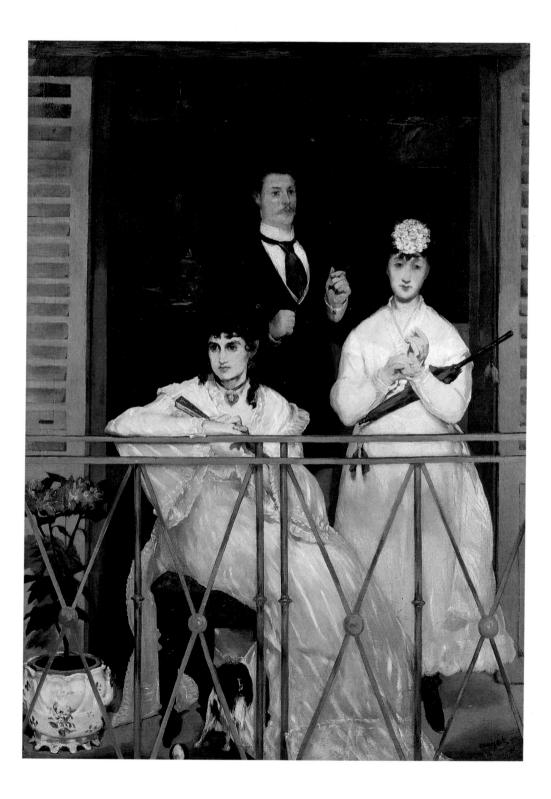

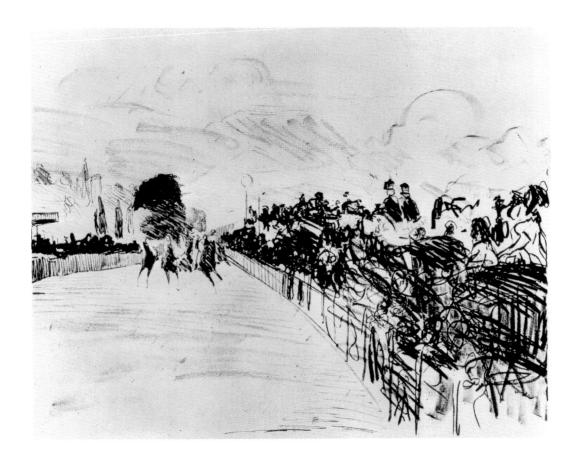

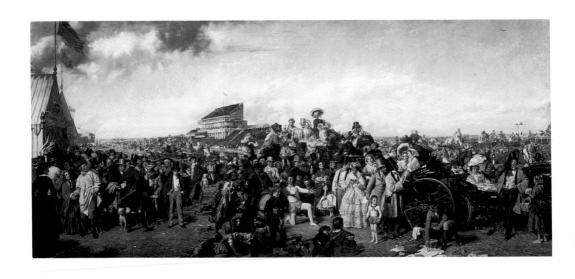

the fact is that in the open air, and in the full light of day, round forms sometimes do look flat, like mere coloured patches. It was this effect which Manet wanted to explore. The consequence is that as we stand before one of his pictures it looks more immediately real than any old master. We have the illusion that we really stand face to face with this group on the balcony. The general impression of the whole is not flat but, on the contrary, that of real depth. One of the reasons for this striking effect is the bold colour of the balcony railing. It is painted in a bright green which cuts across the composition regardless of the traditional rules of colour harmonies. The result is that this railing seems to stand out boldly in front of the scene, which thus recedes behind it.

The new theories did not concern only the treatment of colours in the open air (plein air), but also that of forms in movement. Figure 335 shows one of Manet's lithographs – a method of reproducing drawings made directly on stone, which had been invented early in the nineteenth century. At first sight, we may see nothing but a confused scrawl. It is the picture of a horse-race. Manet wants us to gain the impression of light, speed and movement by giving nothing but a bare hint of the forms emerging out of the confusion. The horses are racing towards us at full speed and the stands are packed with excited crowds. The example shows more clearly than any other how Manet refused to be influenced in his representation of form by his knowledge. None of his horses has four legs. We simply do not see the four legs at a momentary glance at such a scene. Nor can we take in the details of the spectators. Some fourteen years earlier the English painter William Powell Frith (1819–1909) had painted his 'Derby Day', figure 336, which was very popular in Victorian times for the Dickensian humour with which he depicted the types and incidents of the event. Such pictures are indeed best enjoyed by studying the gay variety of these situations one by one at our leisure. But in actual life we can only focus on one spot with our eyes - all the rest looks to us like a jumble of disconnected forms. We may know what they are, but we do not see them. In this sense, Manet's lithograph of a racecourse is really much more 'true' than that of the Victorian humorist. It transports us for an instant to the bustle and excitement of the scene which the artist witnessed, and of which he recorded only as much as he could vouch for having seen in an instant.

Among the painters who joined Manet and helped to develop these ideas was a poor and dogged young man from Le Havre, Claude Monet (1840–1926). It was Monet who urged his friends to abandon the studio altogether and never to paint a single stroke except in front of the 'motif'.

Édouard Manet The races at Longchamp, 1865 Lithograph, 36.5 × 51 cm, 14% × 20½ in

336
William Powell Frith
Derby Day, 1856–8
Oil on canvas, 101.6 ×
223.5 cm, 40 × 88 in; Tate
Gallery, London

He had a little boat fitted out as a studio to allow him to explore the moods and effects of the river scenery. Manet, who came to visit him, became convinced of the soundness of the younger man's method and paid him a tribute by painting his portrait while at work in this open-air studio, figure 337. It is at the same time an exercise in the new manner advocated by Monet. For Monet's idea that all painting of nature must actually be finished 'on the spot' not only demanded a change of habits and a disregard of comfort, it was bound to result in new technical methods. 'Nature' or the 'motif' changes from minute to minute as a cloud passes over the sun or the wind breaks the reflection in the water. The painter who hopes to catch a characteristic aspect has no leisure to mix and match his colours, let alone to apply them in layers on a brown foundation as the old masters had done. He must fix them straight on to his canvas in rapid strokes, caring less for detail than for the general effect of the whole. It was this lack of finish, this apparently slapdash approach, which frequently enraged the critics. Even

Édouard Manet

Monet working in his
boat, 1874
Oil on canvas, 82.7 ×
105 cm, 32½ × 41½ in;
Neue Pinakothek, Munich

after Manet himself had gained a certain amount of public recognition through his portraits and figure compositions, the younger landscape painters round Monet found it exceedingly difficult to have their unorthodox paintings accepted for the Salon. Accordingly they banded together in 1874 and arranged a show in the studio of a photographer. It contained a picture by Monet which the catalogue described as 'Impression: sunrise' – it was the picture of a harbour seen through the morning mists. One of the critics found this title particularly ridiculous, and he referred to the whole group of artists as 'The Impressionists'. He wanted to convey that these painters did not proceed by sound knowledge, and thought that the impression of a moment was sufficient to be called a picture. The label stuck. Its mocking undertone was soon forgotten, just as the derogatory meaning of terms like 'Gothic', 'Baroque' or 'Mannerism' is now forgotten. After a time the group of friends themselves accepted the name Impressionists, and as such they have been known ever since.

It is interesting to read some of the press notices with which the first exhibitions of the Impressionists were received. A humorous weekly wrote in 1876:

The rue le Peletier is a road of disasters. After the fire at the Opéra, there is now yet another disaster there. An exhibition has just been opened at Durand-Ruel which allegedly contains paintings. I enter and my horrified eyes behold something terrible. Five or six lunatics, among them a woman, have joined together and exhibited their works. I have seen people rock with laughter in front of these pictures, but my heart bled when I saw them. These would-be artists call themselves revolutionaries, "Impressionists". They take a piece of canvas, colour and brush, daub a few patches of paint on it at random, and sign the whole thing with their name. It is a delusion of the same kind as if the inmates of Bedlam picked up stones from the wayside and imagined they had found diamonds.

It was not only the technique of painting which so outraged the critics. It was also the motifs these painters chose. In the past, painters were expected to look for a corner of nature which was by general consent 'picturesque'. Few people realize that this demand was somewhat unreasonable. We call 'picturesque' such motifs as we have seen in pictures before. If painters were to keep to those they would have to repeat each other endlessly. It was Claude Lorrain who made Roman ruins 'picturesque', page 396, figure 255, and Jan van Goyen who turned Dutch windmills into 'motifs', page 419, figure 272. Constable and Turner in England, each in his own way, had discovered new motifs for art. Turner's 'Steamer in a snowstorm', page 493, figure 323, was as new in subject as it was in manner. Claude Monet knew Turner's works. He had seen them in London, where he stayed during the Franco-Prussian war (1870–1), and they had confirmed him in his conviction that the magic effects of light

and air counted for more than the subject of a painting. Nevertheless, a painting such as *figure 338*, which represents a Paris railway station, struck the critics as sheer impudence. Here is a real 'impression' of a scene from everyday life. Monet is not interested in the railway station as a place where human beings meet or take leave – he is fascinated by the effect of light streaming through the glass roof on to the clouds of steam, and by the forms of engines and carriages emerging from the confusion. Yet there is nothing casual in this eye-witness account by a painter. Monet balanced his tones and colours as deliberately as any landscape painter of the past.

The painters of this young group of Impressionists applied their new principles not only to landscape painting but to any scene of real life. Figure 339 shows a painting by Pierre Auguste Renoir (1841–1919) which represents an open-air dance in Paris, painted in 1876. When Jan Steen, page 428, figure 278, represented such a scene of revelry, he was eager to depict the various humorous types of the people. Watteau, in his dream scenes of aristocratic festivals, page 454, figure 298, wanted to capture the mood of a carefree existence. There is something of both in Renoir. He, too, has an eye for the behaviour of the gay crowd and he, too, is enchanted by festive beauty. But his main interest lies elsewhere. He wants to conjure up the gay medley of bright colours and to study the effect of sunlight on the whirling throng. Even compared to Manet's painting of Monet's boat, the picture looks 'sketchy' and unfinished.

Claude Monet

Gare St-Lazare, 1877

Oil on canvas, 75.5 × 104
cm, 29½ × 41 in; Musée
d'Orsay, Paris

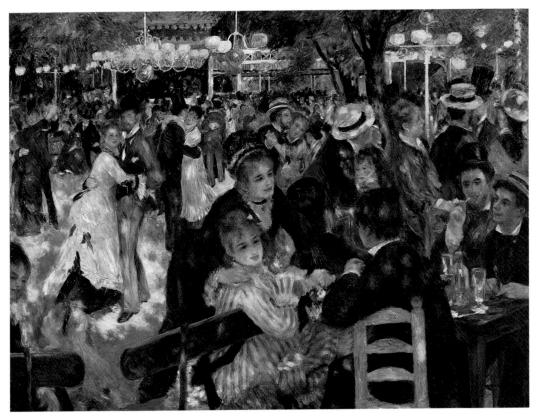

339
Pierre Auguste
Renoir
Dance at the Moulin de
la Galette, 1876
Oil on canvas, 131 × 175
cm, 30³/× × 44³/2 in; Musée
d'Orsay, Paris

Only the heads of some figures in the foreground are shown with a certain amount of detail, but even they are painted in the most unconventional and daring manner. The eyes and forehead of the sitting lady lie in the shadow while the sun plays on her mouth and chin. Her bright dress is painted with loose strokes of the brush, bolder even than those used by Frans Hals, page 417, figure 270, or Velázquez, page 410, figure 267. But these are the figures we focus on. Beyond, the forms are increasingly dissolved in sunlight and air. We are reminded of the way in which Francesco Guardi, page 444, figure 290, conjured up the figures of his Venetian oarsmen with a few patches of colour. After the lapse of a century it is hard for us to understand why these pictures aroused such a storm of derision and indignation. We realize without difficulty that the apparent sketchiness has nothing whatever to do with carelessness but is the outcome of great artistic wisdom. If Renoir had painted in every detail, the picture would look dull and lifeless. We remember that a similar conflict had faced artists once before, in the fifteenth century, when they had first discovered how to mirror nature. We remember that the very triumphs of naturalism and of perspective had led to their figures looking somewhat rigid and

wooden, and that it was only the genius of Leonardo that overcame this difficulty by letting the forms intentionally merge into dark shadows – the device that was called 'sfumato', pages 301–2, figures 193–4. It was their discovery that dark shadows of the kind Leonardo used for modelling do not occur in sunlight and open air, which barred this traditional way out to the Impressionists. Hence, they had to go farther in the intentional blurring of outlines than any previous generation had gone. They knew that the human eye is a marvellous instrument. You need only give it the right hint and it builds up for you the whole form which it knows to be there. But one must know how to look at such paintings. The people who first visited the Impressionist exhibition obviously poked their noses into the pictures and saw nothing but a confusion of casual brushstrokes. That is why they thought these painters must be mad.

Faced with such paintings as *figure 340*, in which one of the oldest and most methodical champions of the movement, Camille Pissarro (1830–1903), evoked the 'impression' of a Paris boulevard in sunshine, these outraged people would ask: 'If I walk along the boulevard – do I look like this? Do I lose my legs, my eyes and my nose and turn into a shapeless blob?' Once more it was their knowledge of what 'belongs' to a man which interfered with their judgement of what we really see.

It took some time before the public learned that to appreciate an Impressionist painting one has to step back a few yards, and enjoy the miracle of seeing these puzzling patches suddenly fall into place and come to life before our eyes. To achieve this miracle, and to transfer the actual visual experience of the painter to the beholder, was the true aim of the Impressionists.

The feeling of a new freedom and a new power which these artists had must have been truly exhilarating; it must have compensated them for much of the derision and hostility they encountered. Suddenly the whole world offered fit subjects for the painter's brush. Wherever he discovered a beautiful combination of tones, an interesting configuration of colours and forms, a satisfying and gay patchwork of sunlight and coloured shades, he could set down his easel and try to transfer his impression on to the canvas. All the old bogeys of 'dignified subject-matter', of 'balanced compositions', of 'correct drawing', were laid to rest. The artist was responsible to no one but his own sensibilities for what he painted and how he painted it. Looking back at this struggle it is perhaps less surprising that the views of these young artists encountered resistance than that they were so soon to be taken for granted. For bitter as was the fight and hard as it was for the artists concerned, the triumph of Impressionism was complete. Some of these young rebels at least, notably Monet and Renoir, luckily lived long enough to enjoy the fruits of this victory and to become

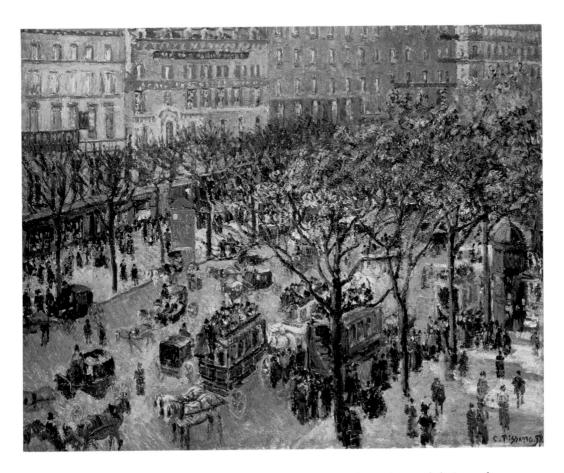

Camille Pissarro
The boulevard des
Italiens, morning,
sunlight, 1897

Oil on canvas, 73.2 × 92.1 cm, 28% × 36¼ in; National Gallery of Art, Washington, DC, Chester Dale Collection famous and respected all over Europe. They witnessed their works entering public collections and being coveted possessions of the wealthy. This transformation moreover made a lasting impression on artists and critics alike. The critics who had laughed had proved very fallible indeed. Had they bought these canvases rather than mocked them they would have become rich. Criticism therefore suffered a loss of prestige from which it never recovered. The struggle of the Impressionists became the treasured legend of all innovators in art, who could always point to this conspicuous failure of the public to recognize novel methods. In a sense this notorious failure is as important in the history of art as was the ultimate victory of the Impressionist programme.

Perhaps this victory would not have been so quick and so thorough had it not been for two allies which helped people of the nineteenth century to see the world with different eyes. One of these allies was photography. In the early days this invention had mainly been used for portraits. Very long exposures were necessary, and people who sat for their photographs had to

341
Katsushika Hokusai
Mount Fuji seen behind
a cistern, 1835
Woodblock print from
'One hundred views of
Mount Fuji', 22.6 × 15.5
cm, 9 × 6 in

be propped up in a rigid posture to be able to keep still so long. The development of the portable camera, and of the snapshot, began during the same years which also saw the rise of Impressionist painting. The camera helped to discover the charm of the fortuitous view and of the unexpected angle. Moreover, the development of photography was bound to push artists further on their way of exploration and experiment. There was no need for painting to perform a task which a mechanical device could perform better and more cheaply. We must not forget that in the past the art of painting served a number of utilitarian ends. It was used to record the likeness of a notable person or the view of a country house. The painter was a man who could defeat the transitory nature of things and preserve the aspect of any object for posterity. We would not know what the dodo looked like, had not a Dutch seventeenth-century painter used his skill in portraying a specimen shortly before these birds became extinct. Photography in the nineteenth century was about to take over this function of pictorial art. It was a blow to the position of artists, as serious as had been the abolition of religious images by Protestantism, page 374. Before that invention nearly every self-respecting person sat for his portrait at least once in his lifetime. Now people rarely underwent this ordeal

unless they wanted to oblige and help a painter-friend. So it came about that artists were increasingly compelled to explore regions where photography could not follow them. In fact, modern art would hardly have become what it is without the impact of this invention.

The second ally which the Impressionists found in their adventurous quest for new motifs and new colour schemes was the Japanese colourprint. The art of Japan had developed out of Chinese art, page 155, and had continued along these lines for nearly a thousand years. In the eighteenth century, however, perhaps under the influence of European prints, Japanese artists had abandoned the traditional motifs of Far Eastern art, and had chosen scenes from low life as a subject for colour woodcuts, which combined great boldness of invention with masterly technical perfection. Japanese connoisseurs did not think very highly of these cheap products. They preferred the austere traditional manner. When Japan was forced, in the middle of the nineteenth century, to enter into trade relations with Europe and America, these prints were often used as wrappings and padding, and could be picked up cheaply in tea-shops. Artists of Manet's circle were among the first to appreciate their beauty, and to collect them eagerly. Here they found a tradition unspoilt by those academic rules and clichés which the French painters strove to get rid of. The Japanese prints helped them to see how much of the European conventions still remained with them without their having noticed it. The Japanese relished every unexpected and unconventional aspect of the world. Their master, Hokusai (1760–1849), would represent Mount Fuji seen as by chance behind a scaffolding, figure 341; Utamaro (1753-1806) would not hesitate to show some of his figures cut off by the margin of a print or a bamboo curtain, figure 342. It was this daring disregard of an elementary rule of European painting that struck the Impressionists. They discovered in this rule a last hide-out of the ancient domination of knowledge over vision.

342 Kitagawa Utamaro Rolling up a blind for the plum-blossom view, late 1790s

Woodblock print, 19.7 × 50.8 cm, 7³/₄ × 20 in

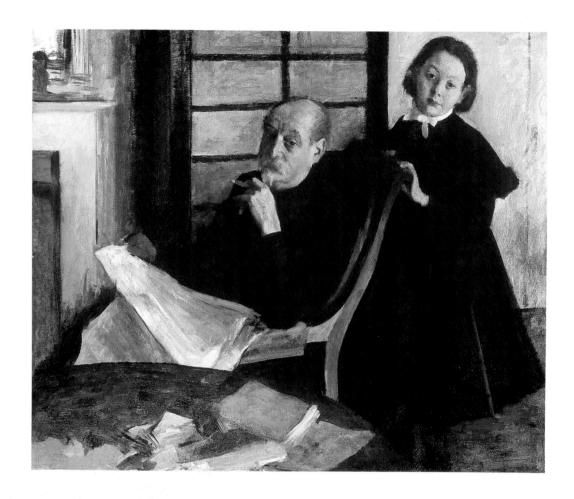

Why should a painting always show the whole or a relevant part of each figure in a scene?

The painter who was most deeply impressed by these possibilities was Edgar Degas (1834–1917). Degas was a little older than Monet and Renoir. He belonged to the generation of Manet and, like him, kept somewhat aloof from the Impressionist group though he was in sympathy with most of their aims. Degas was passionately interested in design and draughtsmanship and greatly admired Ingres. In his portraits, *figure 343*, he wanted to bring out the impression of space and of solid forms seen from the most unexpected angles. That is also why he liked to take his subjects from the ballet rather than from out-door scenes. Watching rehearsals, Degas had an opportunity of seeing bodies from all sides in the most varied attitudes. Looking down on to the stage from above, he would see the girls dancing, or resting, and would study the intricate foreshortening and the

Edgar Degas Henri Degas and his niece Lucie, 1876 Oil on canvas, 99.8 ×

343

Oil on canvas, 99.8 × 119.9 cm, 39% × 47¼ in; The Art Institute of Chicago effect of stage-lighting on the modelling of the human form. Figure 344 shows one of the pastel sketches made by Degas. The arrangement could not be more casual in appearance. Of some of the dancers we see only the legs, of some only the body. Only one figure is seen complete, and that in a posture which is intricate and difficult to read. We see her from above, her head bent forward, her left hand clasping her ankle, in a state of deliberate relaxation. There is no story in Degas's pictures. He was not interested in the ballerinas because they were pretty girls. He did not seem to care for their moods. He looked at them with the dispassionate objectivity with which the Impressionists looked at the landscape around them. What mattered to him was the interplay of light and shade on the human form, and the way in which he could suggest movement or space. He proved to the academic world that, far from being incompatible with perfect draughtsmanship, the new principles of the young artists were posing new problems which only the most consummate master of design could solve.

The main principles of the new movement could find full expression only in painting, but sculpture, too, was soon drawn into the battle for or against 'modernism'. The great French sculptor Auguste Rodin (1840–1917) was born in the same year as Monet. Since he was an ardent student of classical statues and of Michelangelo there need have been no

Edgar Degas

Awaiting the cue, 1879

Pastel on paper, 99.8 ×
119.9 cm, 39¼ × 47¼ in; private collection

345

Auguste Rodin The sculptor Jules Dalou, 1883

Bronze, height 52.6 cm, 20¾ in; Musée Rodin, Paris

346

Auguste Rodin The hand of God, c. 1898

Marble, height 92.9 cm, 36% in; Musée Rodin, Paris

fundamental conflict between him and traditional art. In fact, Rodin soon became an acknowledged master, and enjoyed a public fame as great as, if not greater than, that of any other artist of his time. But even his works were the object of violent quarrels among the critics, and were often lumped together with those of the Impressionist rebels. The reason may become clear if we look at one of his portraits, *figure 345*. Like the Impressionists, Rodin despised the outward appearance of 'finish'. Like them, he preferred to leave something to the imagination of the beholder. Sometimes he even left part of the stone standing to give the impression that his figure was just emerging and taking shape. To the average public this seemed to be an irritating eccentricity if not sheer laziness. Their objections were the same as those which had been raised against Tintoretto, *page 371*. To them artistic perfection still meant that everything should be neat and polished. In disregarding these petty conventions to express his vision of the divine act of Creation, *figure 346*, Rodin helped to